Pioneer Cemeteries

ANNETTE STOTT

Pioneer Cemeteries

Sculpture Gardens
of the Old West

University of Nebraska Press
Lincoln & London

Publication of this book has been aided by a grant
from the Wyeth Foundation for American Art
Publication Fund of the College Art Association,
as well as a grant from the Walter S. Rosenberry III
Fund at the University of Denver.

Library of Congress Cataloging-in-Publication Data
Stott, Annette.
Pioneer cemeteries : sculpture gardens of the old
west / Annette Stott.
p. cm.
Includes bibliographical references and index.
ISBN 978-0-8032-1608-2 (cloth : alk. paper)
1. Sepulchral monuments—Rocky Mountains
Region—History—19th century. 2. Cemeteries—
Rocky Mountains Region—History—19th century.
3. Pioneers—Rocky Mountains Region. I. Title.
NB1803.U6S76 2008
731′.5490978—dc22
2008015036

Set in Sabon by Bob Reitz.

Contents

Preface

Cemeteries have become comfortable places for me in recent years. I have explored so many that each new one presents familiar relief carvings, statues, mourning verses, and monuments in shapes and patterns to which I have grown accustomed. This must be how it felt to Americans in the nineteenth century, when cemeteries were better integrated into community life and monuments were revisited like old friends. There was a time when I gave cemeteries a wide berth, going there only when required for a family burial. If I thought of these places at all, it was mainly in conjunction with Halloween. But I discovered cemeteries in a new way in the 1980s while teaching the history of American art to college students at Winthrop University. Finding examples of nineteenth-century American sculpture in Rock Hill, South Carolina, was a challenge before I came across a cemetery just a few blocks from campus. There a small collection of white marble angels and statues of children opened up new perspectives in a different context for my students. A few years later, a postdoctoral appointment at Harvard gave me the opportunity to use Mt. Auburn Cemetery as my

classroom, and the wealth of scholarship and resources available made this a rich tool for understanding nineteenth-century American culture. When I moved to the University of Denver in 1991, a third region of American cemetery art unfolded, contrasting with the southern and eastern traditions in numerous ways. The contrast between scholarship about Denver's oldest cemeteries and scholarship about Mt. Auburn was particularly striking. Only the lives of those buried in the western cemeteries had been studied; no information was available about the monuments and their makers.

This raised many questions for me. When, in the history of a frontier town's development, did it begin to accumulate cemetery sculpture? Who made it? How did text and image work together to convey something about the person commemorated? Who sold cemetery sculpture, and how did they go about it in such a transitory and multicultural society? When and how did the bereaved, the dying, or the community choose sculpture for the cemetery? What roles did sculpture play in mourning or preparing for death? How did this collection of memorial art function in the community? To what extent did frontier cemeteries in the western Territories reflect practices in the United States and abroad? How much did the region's specific climate, geology, and geography shape cemeteries in unique ways? How did this sculpture—chosen, sold, viewed, and often made by people living in the west—relate to sculpture that art historians have canonized as western American sculpture?

With these questions in mind, I began investigating cemetery art in the old Rocky Mountain West, focusing on the mountain regions of five territories and states—Colorado, Utah, Wyoming, Idaho, and Montana. Although the Rockies extend into New Mexico, the strong rural Spanish Catholic and Native American heritage there contributed to the rise of a distinctive mortuary

culture that is receiving its own treatment from other scholars. The Colorado state line became the southern boundary of my research because it encloses an identifiable regional society. The Canadian Rockies have more in common with this region, but different government influences created a different context, so the U.S. border forms the northern boundary. Within this five-state region, I focused on pioneer burial grounds in what were intended to become permanent settlements, some of them now ghost towns and others major cities. Institutional graveyards (in prisons, forts, missions) arose in a different context and must wait for a future study. This study concerns pioneer community cemeteries in the heart of the American Rockies.

Following James Elkins's lead with respect to visual culture, I did not limit my study to what many would consider fine art, but included the full range of carved, modeled, and constructed grave markers and monuments, as well as the visual spectacles and viewing aids that surrounded them. Having a particular interest in the intersection of art with the lives of common people, I looked at all classes of cemetery art with regard for gender, religion, ethnicity, social class, and national origin. I considered the objects' patrons, their iconography, and the rituals associated with their creation, placement, and ongoing use. This book synthesizes the knowledge gained from that research by placing these objects in their cultural and historical contexts.

The particular qualities of the Rocky Mountain pioneer cemetery owe much to the era in which such cemeteries came into existence, 1850 to 1890. As historians have long understood, the frontier did not move steadily westward, but came from both east and west and jumped all about, so while some of the mountain towns discussed here were established as early as 1849, others were just getting started in 1890. In this book, the phrase "early

years" should be taken to indicate the first decade or so in any settlement and not a unified period of time throughout the mountains.

The Rockies formed an intermediate region where European-dominated migration from the East Coast of the United States and Canada met Asian-and Latin-influenced migration from the West Coast. People of African descent, including those fleeing slavery and the Reconstruction South, flocked to the mountains before, during, and after the Civil War. Direct migration from Europe, Asia, and South America made this not purely a venture of the United States, but an international moment in history. If the West was America, as an exhibition at the Smithsonian Institution's National Museum of American Art in 1991 claimed, then the mountain grave markers written in English, Spanish, Japanese, Chinese, Welsh, Swedish, German, French, Danish, Norwegian, and Slavic languages bore witness to the diverse national and ethnic ingredients of that America, at the same time that the repetitive visual language of obelisks, headstones, flowers, clasped hands, and other forms and motifs revealed an underlying unity of cultural desire with the United States. Themes of diversity and unity recur throughout this study.

Mountain cemeteries did not develop in isolation, but helped shape the national monument industry that was just then emerging. As such, this study of regional cemeteries provides an entry point to the much broader scope of late nineteenth-century American rural cemetery monuments, the rise of a mass market for sepulchral sculpture, and the increased professionalization and commercialization of the monument-making business near the turn of the century. The cemeteries under consideration contained both locally produced sculpture and sculpture imported into the region from other parts of North America and abroad. The reader will not find a comprehensive survey of cemeteries or a catalogue of all the types

of cemetery art. Instead, representative examples illuminate the significance of the community cemetery and its monuments in the region. In addition, the visual culture of mountain cemeteries contributed to one of the most significant enterprises undertaken by the United States in the nineteenth century: the conquering of the West. It is the social context that best reveals the importance of the visual culture of death and memory in the second half of the nineteenth century.

In the early days of many Rocky Mountain towns, the local cemetery developed into one of the first symbols of culture in what was perceived to be a wild and lawless land. Before the advent of art museums, public libraries, or civic sculpture, the western cemetery functioned as a repository of art and history. It often began as an unkempt "boot hill," reflecting the violent early days of mining camps and cattle towns, and quickly grew into a "fair mount," the western version of a rural cemetery. One of the earliest marks of the cemetery as a place of cultural refinement was the appearance of marble monuments among sticks, stones, and wooden headboards. Increasingly elaborate monuments of limestone, iron, zinc, bronze, and granite soon followed. In many towns, the objects in the cemetery, whether a simply inscribed block of local stone or an Italian marble statue of Hope, were the only art objects on public view. The emerging sepulchral garden functioned as an open-air gallery of public sculpture, at once a site for relaxation, learning, and social ritual. Widespread participation in a variety of ceremonies brought mountain communities together in the cemetery with a frequency unimaginable today. Through their exhibition of public art, retelling of local history, and community celebrations, these cemeteries became agents in the "civilizing" process that instilled American culture in the "wild west." Yet unlike Mt. Auburn and other exemplars of the eastern rural cemetery, Rocky Mountain

cemeteries retained the character of their natural topography and an independent spirit made manifest in some distinctive iconography. *Pioneer Cemeteries: Sculpture Gardens of the Old West* investigates cemeteries as centers of visual culture within this developing western landscape.

Chapter 1 concerns the cemetery as a whole, focusing on the transition from a boot hill aesthetic to a fair mount aesthetic. It also looks at variations in this pattern among developing urban centers at the base of the mountains, small towns at high altitude, and communities founded by the Latter-Day Saints, which usually skipped the boot hill stage. A brief case study of the development of Denver's cemeteries highlights some of the ways that unique geography and demography caused Rocky Mountain cemeteries to develop somewhat differently from those in other parts of the country.

Chapter 2 turns to the region's tombstone carvers and the monument makers who played an immediate role in creating sepulchral gardens. It considers the close relationship between architecture and monumental art as a factor in the changing appearance of monuments and cemeteries over time. Variations between Utah's western slopes, Colorado's front range, and the Wyoming railroad corridor reveal some of the complexity of mortuary art in the mountain region. A consideration of wooden headboards and iron markers as staples of the western cemetery throughout the late nineteenth century provides the contrasting view of a unified monumental culture. This chapter also examines the emerging use of native Rocky Mountain stones and the new techniques and visual effects these stones encouraged. The attitudes of the makers are analyzed, with an emphasis on mountain carvers such as James Byrne, who consciously made a transition from stonecutter to sculptor, from craft to art, from trade union to art exhibition.

Chapter 3 delves deeper into monument making with a look at Riverside Monument Works and the roles of owner Mary Rauh and manager Adolph Rauh in that enterprise. Gender is the key issue in this examination of the roles men played in making and maintaining cemeteries, the roles women played as patrons of monuments and mausolea, and the iconography of figurative sepulchral sculpture: portraits of real men in modern dress versus allegories of ideal women in classical garb. Parallels exist between the sculpture in its cemetery setting and figures in American paintings and exhibition sculpture of the time. Ultimately, men and women contributed in different ways to the formulation of the cemetery as a feminine gendered space.

Chapter 4 places Rocky Mountain cemeteries in the context of a national industry that saw the Rockies as another market for the sale of monuments made elsewhere in the United States and abroad. The impact of imported monuments on Rocky Mountain communities and local monument businesses was profound, culminating at the turn of the century in the increasing tendency of local monument makers and dealers to train elsewhere and to function as contractors and retailers for imported work. Although one cannot calculate the exact proportion of imports to locally made work, this chapter considers some of the ways the Rockies participated in an increasingly national and international monument industry.

Chapter 5 places sepulchral monuments in their social context. It looks at burial ceremonies, monument unveilings, grave decorating, and other cemetery rituals as it analyzes the significance of these sepulchral objects in the lives of mountain residents. Examination of fraternal rites provides insight regarding the public roles of cemetery art, while we glean hints of its private roles from individual wills and correspondence. Variations in religious views and rituals are also noted in relation to specific types of sepulchral sculpture.

The conclusion further examines the public and private nature of sepulchral art and the cemetery, looking at these private memorials set within community spaces as contributions to the public good. The cemetery became a vital institution in mountain communities that played a collective role, proudly displaying the fulfillment of Manifest Destiny—not just the occupation of western lands, but the firm planting and rooting of a new culture. This particular sense of Manifest Destiny appears to have been shared by European, Euro-American, African American, and Hispanic populations; by Catholics, Protestants, and Christian Utopianists. Asian pioneers are an exception because before 1900 they usually considered the cemetery a brief way station on the path back to their homelands. Asian grave markers served as temporary signposts to personal destinations. But for most others, sepulchral monuments became permanent physical replacements for those who established these new communities. In aggregate, they made the community's foundations visible.

Symbolically, as the bodies of pioneers were planted in the earth and monuments rose over them in town cemeteries, the history of this expansionist enterprise was written in stone and metal sculpture. Pioneers pointed to their sepulchral sculpture gardens as evidence of their success in replacing what they considered wild people (Indians, trappers, traders, itinerant miners, and outlaws) with civilized potential citizens of the United States, and in transforming the last major wilderness standing between the United States and its Manifest Destiny into a network of orderly settlements. A democratic art form, grave monuments expressed the taste and ideas of the middle class, the rich, and, to a lesser extent, the poor, as well as people of many different faiths, in a space that all could experience. By studying these grave monuments in their mountain landscape settings, we better understand the roles art played in the lives of everyday people on an American frontier.

As an aid to understanding this form of visual culture, the reader will find black-and-white illustrations, including many historic photographs, throughout this book. For color illustrations, including many that could not be presented here due to publishing constraints, please go to http://www.annettestott.com. Photographs of every extant sepulchral artwork mentioned (with many additional examples) are keyed to the chapters and page numbers of the book so that the reader may easily correlate color images with text.

Before proceeding, a word of caution is in order. The remnants of nineteenth-century burial places in the Rocky Mountain region provide some of the most basic evidence for the subject under discussion. However, all of these cemeteries have undergone many, often radical changes since the nineteenth century. Snow avalanches, rock slides, mud slides, and graves that slowly migrate downhill have caused major alterations in some burial grounds. Trees often grow up through the graves of occupants who had no family to keep them clear, swallowing up headstones. Aspen, with its underground interconnectivity, spreads rapidly across some mountainsides, creating woods where a meadow cemetery once stood. Conversely, trees and shrubs strategically planted in some early cemeteries to create a particular landscape effect have died, been uprooted, or grown beyond the vision of the cemetery planners.

Americans in the late nineteenth century preferred vertical to horizontal monuments and were especially fond of tall obelisks, columns, and square shafts. Unfortunately, these forms are more vulnerable to wind storms and many have broken more than once. The constant freeze and thaw of the mountain climate also toppled monuments from their bases. Some have been repaired; others slowly disintegrated and returned to dust, like the bodies beneath them. Even many of the fences and grave guards

erected by pioneers to protect their burial places have fallen into disrepair and disappeared. Large numbers of wooden headboards have rotted away. Some have been replaced, and a few were preserved by constant repainting, extremely arid terrain, or having been "collected" and stored indoors. We cannot know how many wooden headboards might once have stood among the stone and metal, and none has its original coat of paint intact. Heavy iron sheet markers, shaped like wooden headboards, first rusted and then sank down into the ground. Zinc monuments are brittle, breaking under the weight of falling tree branches, and vulnerable to lightning strikes, which can also explode stone. Many of the local stones with which tombstone makers experimented have proved vulnerable to the elements. Much of the imported New England marble sugared and eroded until it was discarded or only a vague outline of the original carving survives.

To these natural forces, man adds a helping hand. Often, the placement of entrance gates and cemetery paths has changed. Where industry and population have grown significantly, grave markers suffer from deterioration brought about through air pollution. Some cemeteries have gone through long periods of heavy, above-ground watering that rusts metal, rots wood, erodes stone, encourages lichens to grow, and stains all types of grave markers and monuments. Vandalism and theft have effected other changes. Monuments have been used for target practice. They have been pushed from their bases and broken by hoodlums and spray-painted by gangs. Most larger cemeteries had an area that served as the monument graveyard for broken and discarded monuments during the twentieth century. In the 1980s and 1990s, a black market for cemetery art developed, and rings of thieves operating throughout the country supplied antique dealers and others with supposed yard ornaments and garden furniture stolen from cemeteries.

Repairs to monuments often result in new configurations and the addition of substances not part of the original. Many times, as people replaced the various parts of tumbled tombstones, they did not notice that the base had a front and a back. It is common to find the die facing one direction and the family name on the base facing another. This also means that monument makers' signatures often end up in a new relationship to the rest of the monument, making it impossible to draw any conclusions about typical practices, such as placement of monument makers' signatures for advertising purposes.

Many cemeteries have been abandoned or gone through periods of total neglect. An article in the *Denver Post* in April 1967 noted that with its weeds, huge anthills, and broken headstones, a local nineteenth-century cemetery "actually more closely resembles a dump than a cemetery in this sector." The Helena, Montana, *Independent Record* ran photographs in May 1980 of hundreds of tombstones and bases "lying hither and thither" in the county gravel pit. The inscriptions dated from 1880 to 1905, and concerned citizens had been asking if road crews were desecrating an old rural cemetery. Research by the sheriff's department and the Montana State Historical Society as well as letters to the editor gradually revealed the truth. The old Catholic Cemetery near St. Mary's Church in Helena had been turned into a park in the late 1960s or early 1970s. The Booster Club of the Catholic high school had volunteered to help clear the ground, and after obtaining releases from as many descendants as could be located, the tombstones and monuments had been hauled out to the pit, where they were expected to be used as landfill. Many of the oldest cemeteries in Rocky Mountain cities met a similar fate as cities expanded, but more often the monuments were transferred to newer cemeteries. Whether monuments were moved or discarded, all trace of the original cemetery was lost in the process of

transforming it into a city park and the recipient cemeteries were also altered.

Even in the nineteenth century, cemeteries constantly changed. Those that were planned along the lines of an eastern rural cemetery often had many trees planted in the 1870s and 1880s that look like sticks in an arid plain in early photographs, but by the 1890s or 1900 had created the lush environment of a wooded park. As monuments were steadily added, the sculpture garden grew and changed, sometimes becoming a dense forest of stone. Families cared for their plots in different ways from generation to generation, planting flower beds or shrubs and adding or subtracting chairs and benches. It is one of the great ironies of this cemetery art that life constantly thwarted its primary purpose of fixing the dead in time and memory.

For the historian, there is no pristine, original state of the cemetery to try to get back to. It has always been a work in progress. Yet to understand what roles cemeteries played in nineteenth-century communities, we must attempt to circumvent the long history of twentieth-century alterations. A combination of visual evidence from extant memorials, old photographs of monuments and cemeteries, newspaper and journal articles, cemetery and court records, monument business records, and personal papers of cemetery personnel and of monument makers and patrons have been used here to reconstruct the appearance of early cemeteries and their position in early and developing settlements.

No matter how high the quality or how original the ideas or how significant its role in society, to date western sepulchral sculpture has found no place in the history of American art. It has not been allowed to shape the study of western art or even of the broader category of visual culture in the West. Bronze sculptures of cowboys and Indians by Frederic Remington and Charles Russell often

stand for all western sculpture. A few studies of public sculptures, especially twentieth-century pioneer monuments, have joined this canon. I hope that the reader will join me in discovering how important sepulchral sculpture was in the formation and promotion of western towns and in the lives of westerners. It was arguably more western than most of what is called western art, since it was often made, sold, and purchased by westerners. Frequently it was composed of Rocky Mountain stone or metal, and it was always viewed and experienced in a western environment. The reasons for its neglect include the difficulty of locating it, its general unavailability for exhibition or collection by museums and private individuals, the widespread twentieth-century dislike of death and its physical reminders, and deep-seated prejudices against art forms that occur in multiples, much less those that may be mass produced. Indeed, some will question whether anything popular enough to be recreated in dozens of versions with hundreds of small variations could be considered art at all. Whether you call it visual culture, popular media, or art, sepulchral sculpture had a greater and more constant impact in the Rocky Mountain West on a broader audience at an earlier date than the work of sculptors like Remington who are now better known. The documentary and physical evidence leads to the inevitable conclusion that the visual culture of western cemeteries contributed to the development of western societies in important ways. If allowed to, it will reshape and refine our knowledge of the arts of the American West and the role of visual culture in the development of the western landscape.

See www.annettestott.com for the complete color illustrations.

Acknowledgments

In this endeavor I have been aided by many people. I want first to thank my students, especially the graduate research class of 1999, who brought my attention to some memorials I might otherwise have overlooked. In addition, Jill Overlie, Chiara Hamilton, and Angela Pizzolato carried out specific research, supported by grants. Several of you will find your names in the footnotes, but all of you inspire me.

Second, I wish to thank the staff at the many research institutions whose collections I used to further this study: Utah State Historical Society, Salt Lake City; Family History Library of the Church of Jesus Christ of the Latter-Day Saints, Salt Lake City; Salt Lake City Public Library; Idaho Falls Public Library; Montana Historical Society Library, Museum, and Photography Archives, Helena; Helena, Montana, Public Library; Bozeman, Montana, Public Library; Gallatin County Pioneer Museum and Historical Society, Bozeman, Montana; Butte–Silver Bow Public Library, Butte–Silver Bow Public Archives, Montana; Mai Wah Society and its museum in Butte, Montana; Mansfield Library, University of Montana, Missoula; Missoula,

Montana, Public Library; Thompson Falls Public Library, Thompson Falls Town Hall, Montana; Kalispel Public Library, Montana; Coe Library, University of Wyoming, Laramie; American Heritage Center, University of Wyoming, Laramie; Albany County Public Library, Laramie; Laramie County Central Library, Cheyenne, Wyoming; Wyoming State Archives, Cheyenne; Denver Public Library's Western History Department; Colorado Historical Society Library and Museum, Denver; Colorado State Archives, Denver; Penrose Library, University of Denver; Boulder, Colorado, Public Library; Colorado Springs Public Library; City and County of Denver Courthouse; Robert Hoag Rawlings Public Library, Pueblo, Colorado; Salida Regional Library, Salida, Colorado; Lake County Public Library, Leadville, Colorado; Lake County Courthouse (Clerk of Common Courts), Leadville, Colorado; Longmont, Colorado, Public Library; Missouri State Historical Society, Columbia; Boonslick Library, Warsaw, Missouri; Missouri State Archives, Jefferson City; Kansas City Central Library, Missouri; State Historical Society of Iowa, Des Moines; Des Moines, Iowa, Public Library; Polk County Courthouse (Recorder), Des Moines, Iowa; Minnesota Historical Society, Minneapolis; Winterthur Museum, Gardens, and Library, Winterthur, Delaware; University of Delaware Library, Newark; Hagley Museum and Library, Wilmington, Delaware; New York Public Library, New York City; Library of Congress, Washington DC; Vermont Historical Society, Barre; Barre Museum & Archives, North Barre Granite Co., Barre Granite Association, Granite Museum of Barre, Rock of Ages, and Aldrich Public Library, Barre, Vermont; Barley/Howe Library, University of Vermont, Burlington; Rutland Free Library and Rutland Historical Society Museum, Rutland, Vermont; Vermont Marble Museum, Proctor; Westerly Public Library, Westerly, Rhode Island.

The staff of the cemeteries I visited were without fail

helpful and enthusiastic. See the List of Cemeteries on which this study is based; I thank everyone with whom I came in contact at these places. I also want to thank the general store owner in Rock River, Wyoming, for sending me across country to the old Carbon Cemetery. It was one of the most interesting cemeteries, and I would have missed it but for your recommendation. Zena Beth Mc-Glashan generously shared the manuscript of her book about Butte's cemeteries and lent a knowledgeable ear. Cliff Dugal at Riverside Cemetery and Nancy Niro at Fairmount Cemetery were enormously helpful as I concentrated on monuments in these places. Susan Olsen at Woodlawn Cemetery in the Bronx answered questions about Denver connections. To all of you, heartfelt thanks.

The financial support of several institutions made possible the extensive travel necessary for this research. A National Endowment for the Humanities grant at Winterthur Museum, Gardens, and Library gave me access to one of the best collections of nineteenth-century monument catalogues. A University of Denver Faculty Research Grant funded a trip to Vermont to study marble and granite sources. The Colorado Endowment for the Humanities provided a grant to further my research on the Rauhs. The new PROF fund at the University of Denver made possible my research in Idaho, Montana, Wyoming, and Utah, and both the Wyeth Foundation for American Art Publication Fund of the College Art Association and the Walter Rosenberry Fund provided subventions to underwrite the press's illustration publication costs. For all of this support, I am extremely grateful.

Finally, and most profoundly, I want to acknowledge my family, to whom no amount of thanks would be enough. My parents, Pete and Jean Pierce, became interested in

gravestones and took many photographs for me of monu-
ments in Wisconsin and Illinois, which provided excel-
lent comparative material. My brother, Dave Pierce, sent
me examples from Minnesota; cousin Laura provided
room and board on my various trips to the Midwest and
a bit of research on the Lincoln Marble Co., and cousin
Elise and her husband, Ray, took me to a cemetery near
Columbia Falls, Montana. My husband, Don Stott, has
been a tower of strength, accompanying me on my lon-
gest cemetery journeys, taking an interest in my findings,
and patiently waiting while I plowed through material in
local libraries and historical societies. I turned to him to
troubleshoot all of the technical challenges presented by
this project, and he took on the mammoth job of printing
all of my photographs.

Cemeteries

Colorado

Black Hawk: Dory Hill Cemetery
Boulder: Columbia Cemetery; Green Mountain Cemetery
Buena Vista: Mt. Olivet Cemetery
Canon City: Greenwood Cemetery
Central City: City Cemetery; Catholic Cemetery;
 IOOF Cemetery
Colorado Springs: Evergreen Cemetery
Denver: Fairmount Cemetery; Mt. Olivet Cemetery; Riverside
 Cemetery; Golden Hills Cemetery; Emanuel Cemetery
Empire: Empire Cemetery
Fort Collins: Grand View (now Grandview) Cemetery
Franktown: Franktown Cemetery
Georgetown: Alvarado Cemetery
Golden: Golden Cemetery
Idaho Springs: Idaho Springs Cemetery
Kremmling: Kremmling Cemetery
Leadville: AOUW Cemetery; Catholic Cemetery;
 Evergreen Cemetery; Hebrew Cemetery
Longmont: Burlington Cemetery; Mountain View Cemetery;
 Ryssby Church Cemetery
Loveland: Lakeside Cemetery
Manitou Springs: Crystal Valley Cemetery
Morrison: Morrison Cemetery

Ouray: Cedarhill Cemetery

Pueblo: Pioneer Cemetery; B'nai Jacob Cemetery;
 IOOF Cemetery; Roselawn Cemetery

Russel Gulch: Russel Gulch Cemetery

Salida: Woodlawn Cemetery (also called Woodland);
 Fairview Cemetery

Silver Plume: Pine Grove Cemetery

Silverton: Hillside Cemetery

Trinidad: Masonic Cemetery; Catholic Cemetery

Walsenburg: Masonic Cemetery

Idaho

Blackfoot: Grove City Cemetery

Coeur d'Alene: Forest Cemetery

Idaho Falls: Rose Hill Cemetery

Kellogg: Greenwood Cemetery

Mullan: Mill Street Cemetery; Mullan City Cemetery

Murray: Murray Cemetery

Osburn: Day's Cemetery

Pocatello: Mountain View Cemetery (central portion
 originally called Mt. Moriah)

Wallace: Nine Mile Road Cemetery; United Miners Union
 Cemetery

Montana

Bigfork: Bigfork Cemetery

Billings: Boothill Cemetery

Bozeman: Sunset Hills Cemetery; Pioneer Cemetery

Butte: Jewish Cemetery (now B'nai Israel); Chinese Cemetery;
 Mt. Moriah Cemetery; St. Patrick's Cemetery

Columbia Falls: Columbia Falls Cemetery

Demersville: Demersville Cemetery

Diamond City: Diamond City Cemetery

Elkhorn: Elkhorn Cemetery

Helena: Greenwood Cemetery (now Benton Avenue
 Cemetery); Helena Cemetery (now Forestvale Cemetery);
 Jewish Cemetery; IOOF Cemetery; Resurrection Cemetery

Kalispell: Fairview Cemetery; Conrad Memorial Cemetery.

Missoula: Missoula Cemetery; St. Mary's Cemetery

Nevada City: Nevada City Cemetery

Sheridan: Sheridan Cemetery

Thompson Falls: Wild Rose Cemetery (originally Missoula
 County Cemetery)
Virginia City: City Cemetery; Boot Hill Cemetery;
 St. John the Evangelist Church Cemetery
Wild Horse Plains: Plains Cemetery

Utah

Brigham City: Brigham City Cemetery
Ogden: Ogden City Cemetery
Provo: Provo City Cemetery (includes Pioneer Burial
 Grounds)
Salt Lake City: City Cemetery; Mt. Calvary Cemetery;
 Mt. Olivet Cemetery

Wyoming

Buffalo: Willow Grove Cemetery
Burntfork area: private cemeteries
Carbon: Carbon Cemetery (sometimes called Old Carbon City
 Cemetery)
Cheyenne: Lakeview Cemetery (originally called City
 Cemetery); Beth El Cemetery; IOOF Cemetery
Green River: Riverview Cemetery
Laramie: Greenhill Cemetery
Medicine Bow: Trails End Cemetery
Rock Springs: Mountain View Cemetery
Saratoga: Saratoga Cemetery
Sheridan: Mt. Hope Cemetery

Glossary

Monument terminology presents some challenges. For example, there is no precise word for the iron and zinc markers that look like headstones; a *metal* head*stone* is an oxymoron. The use of broader terms may avoid such problems. On the other hand, people commonly interchange terms for burial places and monuments that actually have different connotations. This glossary explains the terminology used in this book:

burial ground: Any place where human remains are laid to rest in graves, tombs, and mausolea.

cairn: A pile of natural rock used to mark a grave site.

cemetery: A burial ground with some natural landscape improvements, such as curving paths, graded plots, planted trees, shrubs and flowers, and usually more elaborate monuments. Literally, a sleeping place.

cenotaph: A memorial placed at a site other than the grave.

die: The main part of a monument on which the inscription is intended to be placed.

exedra: A monument in the form of a long, low wall or bench, often slightly curved with defined ends.

footstone: A stone marker placed at the foot of the grave, usually significantly smaller than the headstone and often sold as a matching pair with a headstone.

grave guard: An object that surrounds or covers a grave, often taking the form of a low fence or a stone or metal plate.

gravestone: Any marker or monument made of stone.

graveyard: An unimproved burial ground.

headboard: An upright wooden board placed at the head of the grave, often carved and/or painted, and likely to stand from twelve inches to five feet tall.

headstone: Any stone marker or monument placed at the head of the grave.

marker or grave marker: An object of material and visual culture placed on a grave to identify its site and usually its occupant(s). Normally used in reference to smaller objects of this class.

mausoleum: A sepulchral building in which members of a family are entombed. Plural *mausolea*.

memorial: Any marker or monument that indicates the identity of the interred in an attempt to preserve their memory.

monument: An object of material and visual culture placed on a grave or on a multigrave plot to identify those buried there, either as individuals or as a family or group. It connotes a more substantial form than a marker and is normally used in reference to larger objects of this class.

obelisk: A monument in the shape of a very tall upright whose sides taper steadily toward the top and end in a point, often with a sharper degree of pitch on the topmost section. Egyptian in origin.

sarcophagus: A stone tomb, traditionally limestone to hasten decomposition. When used in reference to a style of monument, it takes the shape of a tomb but does not contain a body.

sepulchral sculpture: Any marker or monument that has been carved, molded, or modeled to any degree, including simple lettering.

shaft: A type of monument that takes the form of a pier with a square cross-section, usually set on multiple bases. It is shorter and squatter than an obelisk and may terminate in a rounded or pyramidal shape, in four pediments, and/or it may form the pedestal for an urn or statue. White bronze monument makers called it a cottage monument in the late nineteenth century. It has been called a vaulted obelisk more recently, but since it usually lacks the proportions of an obelisk and has no vaulting, this term is not used here. Shaft can also refer to the central section of any upright monument.

statue: A sepulchral sculpture made in the form of someone or something, most often a human figure, animal, or tree.

tomb: A burial box above ground that holds a body or gives the appearance of containing a coffin.

tombstone: Any marker made of stone, but especially those headstones of the classic "gateway" shape, an upright rectangular slab with a rounded or squared off top.

white bronze: A specific set of markers and monuments made of zinc that carried the trade name "white bronze" and was designed or produced by a related group of companies, beginning with the Monumental Bronze Co. in Bridgeport, Connecticut.

zinc: Markers and monuments made of zinc, especially those not produced under the trade name white bronze.

Pioneer Cemeteries

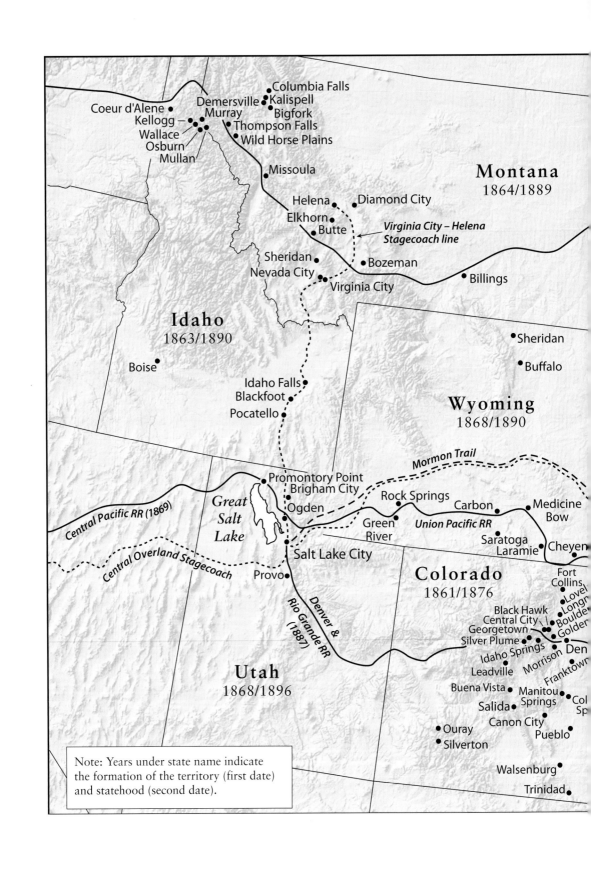

Coeur d'Alene
Demersville • Columbia Falls
Kellogg — Murray • Kalispell
Wallace • Thompson Falls • Bigfork
Osburn
Mullan • Wild Horse Plains

Missoula

Montana
1864/1889

Helena • Diamond City
Elkhorn •
• Butte
Virginia City – Helena Stagecoach line

Sheridan •
Nevada City • • Bozeman
Virginia City • Billings

Idaho
1863/1890

• Sheridan

• Buffalo

Boise •

Idaho Falls •
Blackfoot •
Pocatello •

Wyoming
1868/1890

Mormon Trail

Promontory Point
Brigham City
Great Salt Lake • Ogden
Rock Springs • Carbon • Medicine Bow
Green River • *Union Pacific RR*
Saratoga
Laramie • Cheyen
Central Pacific RR (1869)
Salt Lake City

Central Overland Stagecoach
Provo •

Colorado
1861/1876

Fort Collins •
• Lovel
Black Hawk • • Longr
Central City • • Boulde
Georgetown — • • Golder
Silver Plume • •
Idaho Springs • Morrison • Den
Leadville • • Franktown

Denver & Rio Grande RR (1887)

Utah
1868/1896

Buena Vista • Manitou
Salida • Springs • Col Sp
Canon City
• Ouray Pueblo •
• Silverton

Walsenburg •

Trinidad •

Note: Years under state name indicate
the formation of the territory (first date)
and statehood (second date).

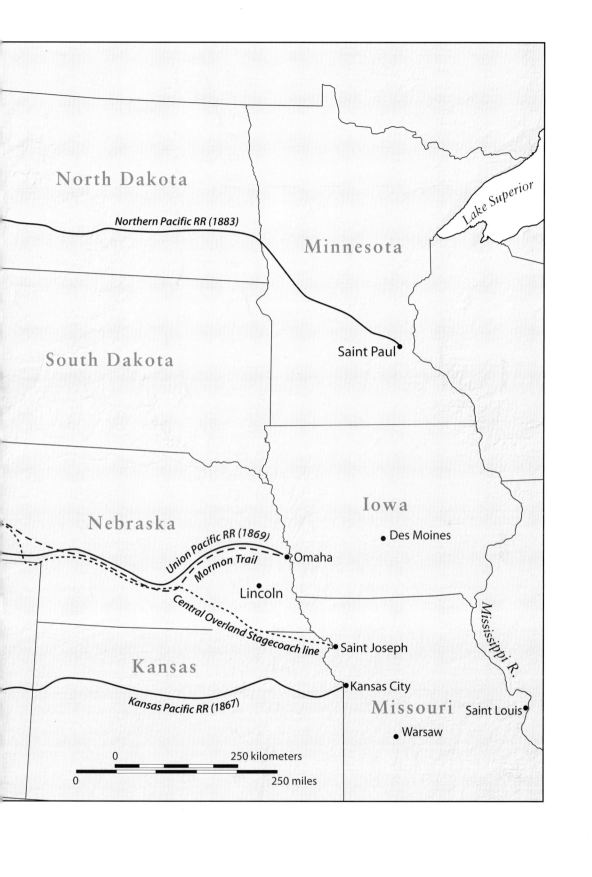

North Dakota

Minnesota

Northern Pacific RR (1883)

Lake Superior

South Dakota

Saint Paul

Iowa

Nebraska

Des Moines

Union Pacific RR (1869)

Omaha

Mormon Trail

Lincoln

Central Overland Stagecoach line

Saint Joseph

Kansas

Kansas City

Kansas Pacific RR (1867)

Missouri Saint Louis

Warsaw

Mississippi R.

0 250 kilometers

0 250 miles

From Boot Hill to Fair Mount

The Transformation of the Western Cemetery

Eyewitness accounts confirm that death and burial played highly public roles in the earliest days of most Rocky Mountain mining and cattle towns. These accounts tell a story of open conflict among people with competing interests: cowboys, sheepherders, Indians, homesteaders, miners, claim jumpers, business competitors, cattle rustlers, horse thieves, and cavalry men. Sudden death was common. Horace Greeley, editor of the *New York Tribune*, traveled to the gold camp settlements on Cherry Creek at the foot of the Rockies in the summer of 1859, before they were yet a year old. Having observed that an inordinately influential class of westerners were "prone to deep drinking, soured in temper, always armed, bristling at a word, [and] ready with the rifle, revolver or bowie knife," Greeley summed up the violent character of the settlements that would eventually become Denver with these words: "I apprehend that there have been, during my two weeks sojourn, more brawls, more fights, more pistol shots with criminal intent in this log city of one hundred and fifty dwellings, not three-fourths completed nor two-thirds inhabited, nor one-third fit to be,

than in any community of no greater numbers on earth."[1] Similarly, the well-known cattleman Charles Goodnight, who drove cattle from Texas to Wyoming, compared Cheyenne unfavorably with a Texas town that he described as full of outlaws, thieves, cutthroats, and prostitutes, concluding: "I think it was the hardest place I ever saw on the frontier except Cheyenne, Wyoming."[2]

Lacking formal law and order, vigilantes dealt out rough justice that was often as suspect as the activity of the criminals. In his well-known defense of the Montana vigilantes published in 1866, Thomas J. Dimsdale argued that because of their gold, the mountains attracted a larger number of low characters than other frontiers had, and that the prospect of quick wealth soon turned these men to murder and theft. "It is not possible that a high state of civilization and progress can be maintained unless the tenure of life and property is secure," wrote Dimsdale in explanation of the vigilantes' goals.[3] On January 14, 1864, vigilantes hanged five members of the Plummer Gang—Jack Gallager, Helm Boone, George Lane, Hayes Lyons, and Frank Parish—then two hours later, cut them down and buried them in unmarked graves on Boot Hill. As many as six thousand people gathered in Virginia City, Montana, to witness this hanging.[4] In time the vigilantes also caught and hanged the leader, Henry Plummer, who happened to be the sheriff of Virginia City. This gang is just one of many whose lawless lives and notorious deaths contributed to the "wild west" image.

Such public exhibitions as the hanging of the Plummer Five impressed potential criminals with the need to maintain basic rules of conduct, said vigilantes, and paved the way for the "high state of civilization and progress" they intended to bring to the mountains. Crowds of settlers, cowboys, miners, and merchants attended duels, shoot-outs, and hangings throughout the mountain region. In Denver City, nearly two hundred spectators were

1. The original marble headstone, by an anonymous carver, was erected in 1878 in the old Helena cemetery: "In memory of my dear Husband and our Beloved Father Charles M. Kenck. A native of Philippsburg Baden. Germany. Born Jan. 22, 1844, Killed by the Nez Perces Indians in the Yellowstone National Park. August 26, 1877." The body was exhumed in 1929, positively identified as Kenck by his short leg, and reburied at Forestvale Cemetery in Helena. The marble was probably reset in granite at that time.

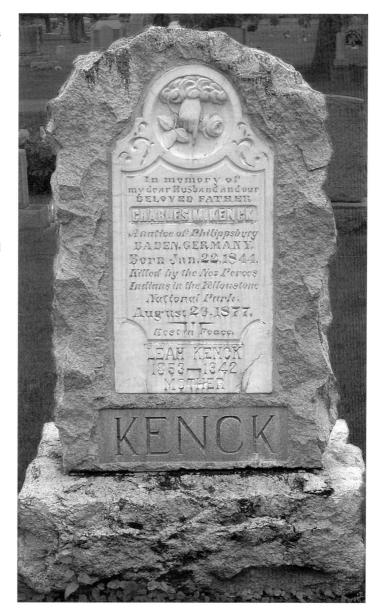

reported to have gathered near Cherry Creek to witness a duel between Richard Whitsitt and W. P. McClure around the time of Greeley's visit.[5] Newspapers dutifully reported makeshift courts, executions, and burials, while photographers recorded outlaw deaths for posterity. These events not only publicized the enforcement of law and order, as if trying to convince the world with visual evidence

that social order could be imposed on the wild men of the West, but they also made death highly visible and burial places an early necessity. Citizens of Leadville, Colorado, are said to have held their first public hanging right in the graveyard, and an Idaho newspaper reported that in Idaho Territory "the cemeteries are full of the corpses of veterans in crime and their victims."[6]

It was not only the criminals and their victims who focused attention on early Rocky Mountain cemeteries. Most mountain communities believed they had unusually high mortality rates, and the efforts of town promoters to counter such thinking drew more attention to the issue.[7] Any number of monuments, like that for Charles Kenck, memorialize settlers who were killed by Indians (fig. 1). Kenck's case received much publicity, for he was part of a reported massacre of Montana citizens by Chief Joseph's band of Nez Perce Indians in Yellowstone National Park, from which survivors kept emerging, until finally Kenck proved to be one of only two of the travelers who had not escaped. It took nearly two weeks to locate his body and over two months before it was brought to Helena for reburial. By this time Kenck's widow entertained doubts that the body produced had belonged to her husband.[8]

Indian slayings often received the most publicity, but victims of accidents and disease were much more numerous. A dark gray marble monument in the old Carbon City Cemetery, Wyoming, for John and James Watson notes that John was "dragged to death by a horse," while James "lost his life in the Hanna mine explosion." Several other markers in this cemetery also remember some of the 169 men who died in that particular explosion in one of the Union Pacific Railroad's coal mines. Accidents with dynamite, collapsing mine shafts, and mine gasses were common throughout the region. Nevertheless, an early writer in Leadville, over 10,000 feet above sea level, claimed that pneumonia caused most of the deaths in

2. A. K. Prescott supplied several monuments for Elkhorn's diphtheria victims, including this marble arch for young Beatrice and Clara Roberts, who died within a month of each other in 1889. Their parents had the arch inscribed: "Here rests the sweetest buds of hope," an expression of the lost future. Elkhorn Cemetery, Elkhorn, Montana.

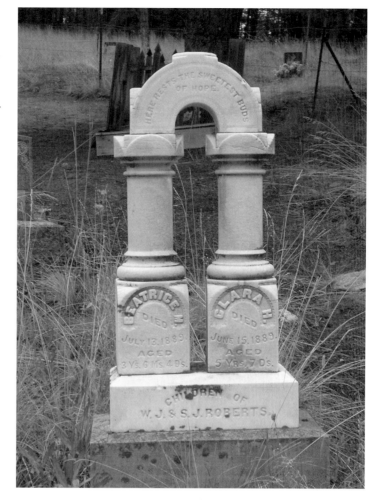

this mining camp during its first two years of existence. "The pioneers had but little shelter other than their blankets," he explained, "and many of them not being used to the rigors of a mining camp, succumbed to the fell destroyer."[9] Extreme cold, heavy snows, lack of adequate shelter, nonexistent sanitation, and the scarcity of medicine and doctors all contributed to a range of fatal diseases. Harsh mountain conditions may have affected children disproportionately. Elkhorn Cemetery, high in the Montana mountains, filled with monuments for children who died in an 1889 diphtheria epidemic (fig. 2).

Unpredictable severe weather continued to claim lives

3. Citizens of Leadville, Colorado, ordered this large zinc statue of Grief from the Western White Bronze Co. of Des Moines, Iowa, in memory of the ten men who had chosen to continue working the Homestake Mine over the winter of 1885 in an attempt to recoup their losses when the mine company failed. Small zinc markers indicate the graves of the eight who were buried around its base in Evergreen Cemetery, Leadville, Colorado.

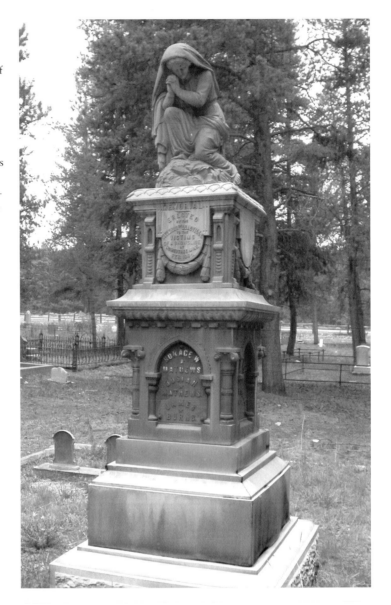

long after towns became well established. Eight years after the first cabins were erected in Leadville, word arrived that a February snowstorm had caused a terrible snowslide at the Homestake Mine, eleven miles northwest of town, crushing all the buildings. Search parties went out from several places in the vicinity, and after a day of digging, all ten miners at the Homestake were uncovered. They had been buried alive two months earlier.[10] The

Homestake Disaster, like similar events throughout the region, gripped the imagination of area residents, who decided to bury and memorialize the miners at public expense (fig. 3). Incidents like this, and the monuments that commemorated their victims, served to remind pioneers of the power of a wilderness environment and the fragility of their existence. It was understood that the manner in which people chose to treat the dead said a great deal about their relative state of civilization, from the primitive violence and unmarked burials of a months-old Cherry Creek gold camp to the more cultured approach of eight-year-old Leadville, whose citizens held Masonic burial services for the avalanche victims and placed a white bronze sculpture with due ceremony in the town cemetery.

Before settlement, while traders and trappers and wandering miners moved about the area, individuals were buried near where they died, if they were fortunate enough not to die alone. Most graves of that presettlement period went unmarked, but occasionally one finds natural stone roughly carved, like that for R. R. Chen (fig. 4). The unexpected discovery of forgotten earlier burial places was common in the late nineteenth century. In July 1879, the Leadville newspaper reported that a party of ladies picking wildflowers "came upon an old graveyard that must have had an existence long before Leadville had an existence. It is located on Freyer Hill and holds a half dozen unmarked graves."[11] A newspaper in Helena reported in 1893 that heavy rains had washed away a hillside, exposing "a coffin in which lie the remains of some early-day resident. The side board carried away exposes the body, which is that of a tall person, dressed in the garb of a miner. The features are well preserved, and the hair and whiskers, grown long, are decidedly red."[12] Such discoveries reminded people that the gold rush pioneers were not the first nonnatives to inhabit these mountains, only

4. When R. R. Chen died in 1841, someone carved his name on a natural stone marker. This anonymous, retouched photograph was taken in Old Pioneer Cemetery, west of Park City, Montana, in 1952, probably for publication in a newspaper. Montana Historical Society Archives, 941-695, Helena.

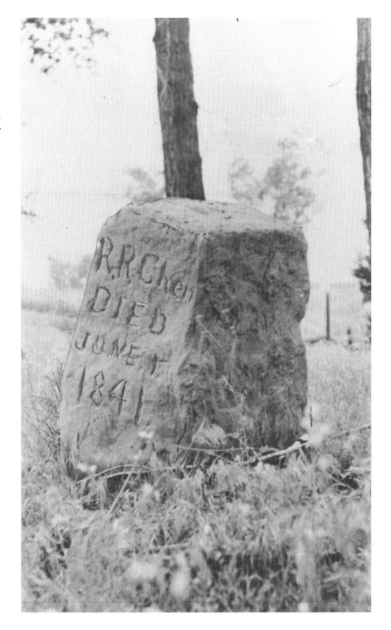

the first to establish permanent settlements. As soon as enough people had arrived in a spot and efforts toward permanent settlement became evident, a community burial site was chosen.

The first common burial ground in mining and cattle towns usually took the form of a rough-and-ready boot hill, although it often had no formal name beyond "the

graveyard." Within a few years, though, boot hills in still growing towns almost always developed into a western variation on the rural cemetery—a landscaped garden or park-like cemetery located outside of eastern cities, such as Mt. Auburn in Boston and Laurel Hill in Philadelphia—that was filled with increasingly elaborate monuments and memorials as the years went by. This western version of the rural cemetery normally received a formal name, such as Fairmount Cemetery in Denver, and constituted a type that is well characterized by the term *fair mount*. Many towns transformed their boot hill into a fair mount, while others abandoned the former for the latter. Creede, Colorado, from its rather late inception in 1890, simply maintained two different burial grounds: Boot Hill for gunslingers, criminals, and prostitutes, and Sunnyside for "respectable" citizens.[13] Virginia City, in Montana Territory, also kept its original boot hill burying place, which had served all the earliest settlers, while developing a more artistic cemetery at the other end of the same ridge that soon became more popular. However a community managed it, the rapid introduction of a fair mount cemetery, to which pioneers could point as evidence of their cultured condition and proof that they were no longer part of the wild west, became a milestone of civic development.

Boot Hill

Boot hill is an appropriate designation for many of the earliest burial grounds in pioneer settlements. The name refers to an attitude toward death that can be summed up in the phrase "to die with your boots on," meaning suddenly, while fully engaged in living. It suggested a devil-may-care attitude toward death that anyone could adopt but that has become especially associated with the dangerous living of gamblers, gunslingers, and miners. Such adventurers were unlikely to die barefoot in their

sleep of old age. This attitude seems to have been especially prevalent in the Rocky Mountain West, where people acknowledged the uncertainty of life in an environment of unpredictable violent weather, far-flung shelter and services, and unchecked crime. For some, the "boots on" approach to death and burial represented a welcome freedom from civilization. Boot hill burial grounds were normally located on the nearest hill or mountain peak outside of town, making boot hill a literal appellation as well as a figurative one. Silver Plume's graveyard occupied an outcropping with such a steep climb from the town that pallbearers had to work in relays to carry the coffins up.[14]

The boot hills of the Rocky Mountains were characterized by haphazardly placed graves in arid ground surrounded by natural grasses and, in some areas, cacti. Just as death was unplanned and unprepared for, so was the burial ground. It grew organically, as chance dictated. Graves occasionally had to be blasted out of the hard rock in mining towns. Paths wound around the natural topography from grave to grave. Simple wooden crosses, headboards, or rock cairns marked the last resting spots of some people. Partly due to the "die with your boots on" attitude toward death, there is a notable lack of memento mori imagery in boot hills. People infected with gold fever focused more on the future than the past. They had little time or energy for landscaping and permanent memorials. In fact, graves often remained unmarked. The overall effect of scattered graves on dry rocky ground scavenged by wild animals reflected the disordered state of life in the first months and years of many mining camps and cattle towns.

Victims of the harsh climate, accidents, disease, Indian wars, and lawlessness, as well as people from many different places of origin with a variety of trades and religious beliefs, were buried together in the earliest Rocky

Mountain graveyards. Catholic, Protestant, Jew, or of unknown religion, all were likely to end in the same burial grounds at the beginning, except in a few places where a church had been started with burials in its yard. Race presented few barriers on boot hills, nor was class a decisive factor. The African American baker Oliver Davis, who was shot and killed by his African American landlord, was most likely buried near Thomas Biencroff, a white man who was shot and killed by his brother-in-law, in the common burial ground with prostitutes, miners, and merchants during Denver's first year of life.[15] Even after Denver built a more fashionable rural cemetery, the rule was to bury people where they desired and could afford to buy, without regard to race or class. The ability of anyone to make a quick fortune through mining or investing in mining, and as quickly lose it, helped remove some of the social distinctions to which easterners more often adhered.

As an exception to this generally democratic disposition of bodies, it appears that relatively few Indians were buried in early town cemeteries.[16] Many photographs of platform and tree-top "burials" document the preferred mortuary customs of native mountain peoples. Sometimes when an Indian died in a town, documentation exists showing that relatives removed him or her for traditional burial. However, little or no documentation exists for most boot hill burials. In places like Denver, where some of the original "settlers" were well-educated, gold-prospecting Cherokee Indians and the Indian wives of former trappers like John Smith, it seems reasonable to suppose that if any died during this very early period, they would have been buried in the local graveyard. Sometimes native peoples became part of a community or died without nearby family to handle the arrangements, and in these cases too, it is likely that they were buried in the same boot hill cemetery as everyone else. Unfortunately, there

is no positive evidence in most communities during this earliest settlement time, and we must rely rather heavily on circumstantial evidence. For example, even after fair mounts came into being, Native Americans were sometimes interred there, as in Butte, Montana, where an entry in the sexton's book for the Catholic Cemetery says simply "three Indians."[17] Although Boulder's pioneer cemetery no longer exists, an account of it written in the early twentieth century, by someone whose father had taken him there in the 1910s and recounted many of the inhabitants' stories, records the presence of a red sandstone marker that had an Indian head carved on it. It was larger than life size and considered by the writer to be "a fine piece of work . . . that I'll never forget."[18] It may have marked the last resting spot of a Native American, but there is no documentation for this long-lost burial ground. Perhaps the best documented boot hill cemetery is that in Leadville, Colorado, and it makes no mention of race, only noting nationality in a few instances where it was known. Nevertheless, it provides a good case study of the boot hill phase of a mining town.

Leadville was a typical boomtown whose rapid development is seen in its attitude toward disposition of the dead. Colorado's California Gulch had seen sporadic panning for placer gold since the ore was discovered there in 1860, but did not attract many people until 1877, when a gold miner tested the black grit that had been clogging his machinery and found that it was carbonate of lead with a high silver content. The previously mentioned six unmarked graves discovered by ladies seeking flowers probably date from this era before a town had commenced. In 1877 there were only six log cabins and perhaps two hundred people in the gulch. By 1879, more than a thousand frame buildings had been erected and up to thirty thousand people had arrived to seek their fortunes in silver and gold, concentrated in the town of Leadville.[19]

Lacking sufficient shelter to cope with such a rapid influx, men paid to sleep in eight-hour shifts on beds of straw strewn on the dirt floor of canvas tents. Disease was common. Rich silver deposits invited claim jumping and murder. The impromptu police force was often inadequate to the task.

A reporter for the *Leadville Daily Chronicle* became fascinated with Leadville's first common burial ground. Unnamed and unadorned, it became for this journalist a symbol of the lack of civility in Leadville and the beginning of a campaign to make the burial ground a place of refinement that would help propel the community into a new, more cultured phase. A year and a half after Leadville and its graveyard first came into existence, he wrote a detailed record of the burial ground, one of our best eyewitness accounts of a boot hill: "At the foot of Chestnut street, a little distance from the Leadville smelting company's works, is an acre plot of ground unfenced, and with the carbonate-like earth thrown up into little heaps. On a closer inspection, the stranger will see that many of these carbonate mounds are marked by pieces of boards, slabs and sticks. Two or three have marble slabs and as many more are marked by pine boards painted in imitation of marble."[20] The reporter further described this burial place as a "barren red clay-colored plot [with] no flowery lawns, spouting fountains, shady nooks, grassy plats, nor artistically carved marble." Only one wooden marker held a poem, and many had been knocked over by roving animals. He added in another article: "A worse or less inviting spot for the repose of the dead could not have been found within the environs of our city. Here all the vast transportation of a great mining camp passes in daily bustle and confusion, and the sleep of our dead is forever disturbed by the oaths and the 'black snake' of the irreverent freighter."[21]

Not only the lack of ornamentation, but the lack of

decorum and ritual struck this reporter. Burial was simple. There was no charge for the land, just as there were no rules, death certificates, or burial records, and usually little ceremony. One could dig a grave where one pleased or pay the sexton $7.00 to provide grave diggers. Bodies could be disposed of here without anyone knowing the manner of death, the concerned reporter pointed out, and no one would ask questions. Determined to preserve the history of some of Leadville's earliest inhabitants and to inform easterners of the final disposition of relatives they may not have heard from since their departure for the western territories, the reporter decided to record, "so far as could be learned from the rude penciling on the slabs at the head of the graves" and from questioning the new sexton, every burial that had taken place here.[22] He recorded natives of Scotland, Wales, England, and Italy, as well as two headboards written in French. From the first burial on November 17, 1877, of sixty-three-year-old miner Sullivan Breece, to a newly arrived engineer who was hastily buried by an undertaker while the reporter was in the cemetery, 251 people could be listed. These included the first sexton, who took to his grave any knowledge of the interments in unmarked graves.

The Leadville paper identified the burial grounds as having an "uncivilized appearance" and urged this "semicivilized community" to do something more in keeping with the cultured metropolis they aspired to become.[23] As more and more businesses were established, houses built, and churches, schools, and civic services were introduced, the town became a thriving city. After two years, Leadville abandoned its first graveyard, thereafter called "the old cemetery," in favor of a more picturesque spot with greater potential for development.

Other Rocky Mountain towns established their boot hill graveyards both earlier and later than Leadville, but most maintained this type of cemetery, with its casual

burials, roving animals, unpretentious markers, and natural landscape, for only a very short time. The sentiment of one Coloradan regarding the local boot hill reflects a widespread attitude in pioneer mountain towns, one that generally led to change within a short time: "In many respects, the locality where we now deposit the remains of our friends is an outrage upon the most sacred human feelings. . . . When death has claimed a loved one, the thought of carrying the dead form to that bleak and barren bluff—destitute of everything but desolation—must add to pangs already too deep for human endurance."[24]

Fair Mount

By contrast with boot hill, within a few years of the first burial, the cemetery in early Rocky Mountain towns often developed into a fair mount, becoming one of the first public emblems of culture. The fair mount was an orderly park with neatly laid out burial plots, planned pathways, mountain vistas, and white marble monuments. A fence around the perimeter separated the cemetery from open range. Where no trees grew naturally, they were often planted, along with ornamental shrubs and flowering bushes. Various irrigation schemes kept these plants alive, from artificial ponds and ditches to wells with windmills. Smaller towns and those with arid cemeteries that could not be watered nevertheless arranged their fair mount with either a grid or an organic park plan and filled it with carved sandstone, limestone, and marble monuments. Benches invited citizens to enjoy the beauty of a quiet moment in a hard work week and to contemplate the passing of friends, neighbors, and strangers. Before the advent of art museums, public libraries, or civic sculpture, fair mounts functioned as sculpture gardens that recorded local history.

In November 1879, Leadville's new Evergreen Cemetery opened on the northern edge of town. During the next

two years it was the recipient of "many elegant and refined monuments," and the *Daily Chronicle* proclaimed it "a place more in harmony with the refined taste and culture of our people."[25] In contrast to the sticks and boards marking boot hill grave sites, the *American Journal of Progress* noted that "expert stone workers and skilled sculptors" in Denver were creating and shipping to cemeteries throughout the Rocky Mountain region "original work [that] would adorn an art gallery, so perfect is its workmanship and so genuinely artistic its design."[26] In this era, cemeteries were almost the only place that publicly available, museum-quality sculpture could be found in the Rocky Mountains. As fair mount replaced boot hill, real marble took the place of wooden boards painted to look like marble, and deeply carved or three-dimensional stone sculptures of every sort began to outnumber wooden slabs.

Partly a matter of marketing and public relations, the transformation from unkempt boot hill to beautiful fair mount was consciously effected in most towns by citizens who sought permanence. They were often landholders involved in real estate sales and owned businesses that catered to potential settlers. They were usually the ones with the most to gain from convincing people to settle or invest in their town. One or more local undertakers often took an interest in cemetery development, joining the board of the local cemetery association or functioning as the sexton. With the help of sextons, undertakers, clergy, stone carvers, and monument importers, these businessmen transformed burial grounds into sepulchral sculpture gardens. On the day that Evergreen Cemetery opened, the *Leadville Daily Chronicle* boasted, "Hereafter when the excursionist and the visitor comes to look upon our city, and its vast carbonate fields, the Leadvillian may with pride carry him over Capital Hill to look upon Evergreen Cemetery, the city of the dead."[27] It is hard to imagine

city governments today luring new businesses by showing off their cemeteries, but in the nineteenth-century Rocky Mountain West a beautiful park cemetery was considered a sure sign of culture.

Fair mounts had many names: Mt. Hope (Sheridan, Wyoming), Mt. Moriah (Pocatello, Idaho), Aspen Grove (Aspen, Colorado), Forestvale (Helena, Montana), Greenhill (Laramie, Wyoming), and Fairmount (Denver, Colorado) are just a few examples. All had distant roots in the rural cemeteries of the East Coast. Boston had started the rural cemetery movement in the United States with the creation of Mt. Auburn in 1831. This was a movement away from churchyard burials and inner-city graveyards to park-like settings on the outskirts of the city with carefully calculated picturesque landscaping effects, marble obelisks, chapels, elaborate entrance gates, and meandering carriage roads. Rocky Mountain cemeteries placed the same emphasis on serenity. Westerners imported many of their monuments from Vermont, New Hampshire, Massachusetts, and the Midwest. They strove for the same statement of culture that had helped eastern rural cemeteries establish sculptors of fine art.[28] However, western geography, environment, character, and culture also created some distinct differences.

Unlike boot hills, fair mounts consciously sought an aesthetic ideal and instituted rules and regulations to bring it about. The larger the town, the higher the ambition for a true sculpture garden. However, cemeteries differed from the museums and civic spaces that would eventually replace them as the primary sites of public sculpture. Rarely can one identify a person who functioned as the curator of a fair mount in its first decade. Families and individuals bought the monuments they wanted or could afford, making the aggregate result a true reflection of community taste. People were limited only by personal finances and the rules that cemetery associations put in place to

5. This anonymous high-relief granite sculpture of an angel, either comforting a mourner or escorting a new soul to heaven, adorns the Greek stelai-style monument on the family plot of millionaire dry goods merchant William Garrett Fisher in Fairmount Cemetery, Denver, Colorado. The same design, for the Horne family of Pittsburgh, was disseminated by Bliss Brothers Monumental Photographers in the 1890s and can be found in cemeteries throughout the country. It was probably inspired by the work of the British sculptor John Flaxman.

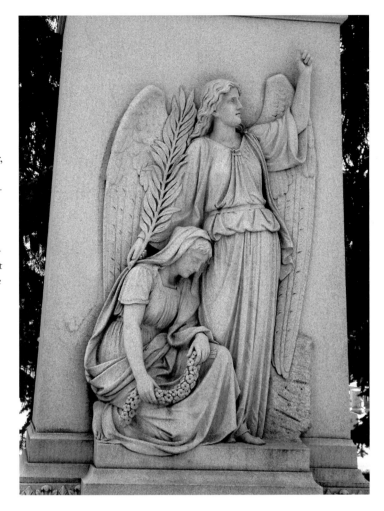

ensure overall aesthetic merit and the continued salability of lots. These included some fairly universal rules, such as the requirement that foundations be put in place by the cemetery before monuments could be erected, no matter what their size. This measure attempted to ensure that all markers and monuments stood erect throughout the landscape. Some fair mount cemeteries encouraged a particular appearance or more elaborate sculptural forms by banning materials that rust or rot and by setting aside prominently located plots for wealthy families to erect large monuments. Smaller towns tended to be more inclusive of homemade and simple markers, but still sometimes exercised their authority to ensure aesthetic merit.

The themes of the sepulchral sculpture garden followed its mortuary function. Not unlike other rural cemeteries throughout the country, Rocky Mountain monuments of the late nineteenth century focused on death and resurrection, with an emphasis on reuniting with loved ones in heaven. Angels, mourning women, and souls in heaven are just a few of the common images (fig. 5). Preservation of the region's history through monuments to its earliest residents formed another of the fair mount cemetery's themes. Residents in many towns understood themselves as part of the great enterprise of Manifest Destiny, spreading American culture and Christianity across the continent. They actively sought to fill their role in this enterprise by subduing or annihilating the native peoples, pulling from the earth its natural resources, and establishing permanent settlements. Some groups placed more emphasis on establishing their specific religious or cultural communities in a new land of opportunity, including substantial numbers of African Americans, Latter-Day Saints, and Jewish pioneers who founded towns. Memorials to the leaders in these enterprises constituted a recorded history.

The use of the word *pioneer* to describe themselves and the formation of pioneer societies are indications of this self-awareness of one's part in history. The earliest arrivals in each of the territories helped establish exclusive pioneer clubs. Arrival in a territory by a specified date not only allowed membership, but also gave one the right to put the word pioneer on one's tombstone or monument. Obituaries in the 1890s always stressed pioneer status, even of those who had not arrived quite early enough to enroll in a state pioneer association. Other inscriptions noted death fighting Indians or attempting to convert them to Christianity, equal indications of individual roles in achieving Manifest Destiny.

Another characteristic of the transition from boot hill

to fair mount, in addition to the aesthetic shift and historical consciousness, was the establishment of strict physical boundaries among social groups. Leadville's first boot hill graveyard saw the itinerant miner buried next to the mine owner, next to a prostitute, next to the town marshal, and so on. No geographic separations acknowledged differences in religion, economic status, race, or nationality, and when various groups began requesting their own sections, the sexton simply told them there was no room. This may have been an additional motivation for the creation of a fair mount. When the town established Evergreen Cemetery the paper applauded the fact that the cemetery was "large enough to accommodate all classes," and numerous groups purchased or were offered separate sections of the cemetery for their exclusive use.[29] The result was a cluster of cemeteries and sectioned areas for the Odd Fellows, Masons, Catholics, Jews, and Protestants.

Russel Gulch Cemetery in Colorado took a different approach, with divisions for Welsh, Italian, Cornish, and Austrian communities.[30] By contrast, the new Helena Cemetery in Montana, begun in 1890 and now called Forestvale, seems to have had only one such division, a corner of the cemetery known as "China Row." The lot ownership book identifies Lot 2 as the first sold in China Row to Soo Kun Acin on October 17, 1892, for the standard fee of $5.00. Unlike all other purchases, those in China Row are recorded in a separate section at the very back of the lot ownership book. The recorder underestimated the Chinese population that would desire burial. After only nineteen sales, most listed simply as "Chinaman," the recorder ran into the back cover and had to choose an earlier page to pick up with the sale of Lot 20 to Soon Ber in March 1894. Sales and burials continued throughout the 1890s at the rate of six or seven per year, including such notations as China Tim and China Emma.[31] The singular treatment of the Chinese may not

be as unusual as it seems, however, since Helena already had separate cemeteries for its Catholic and Hebrew residents and was soon to add an Odd Fellows cemetery.

Class distinctions may be hidden in some of these ethnic, racial, religious, and fraternal categories, but the basic economic distinction of a separate paupers' field for the poor was pretty standard throughout the region. The Helena Town Council even considered making a distinction within its pauper section between the truly poor, who would be buried on one side of the street, and "those who are too poor to buy, and yet are not proper subjects for the pauper's field," who would be buried on the other side.[32] All were charity cases for whose plots and burials the town would bear the expense, but some had been prominent citizens before losing their fortunes, a not uncommon fate in mining towns. The town council apparently sought to preserve their earlier social standing with this geographic separation after death.

Each town handled its cemetery divisions differently, but almost all fair mounts had them. Butte maintained three contiguous cemeteries, one for the Catholic congregation of St. Patrick's, a Jewish cemetery that is now known as B'nai Israel, and Mt. Moriah for Protestants and all others.[33] Entries in the earliest extant sexton's book for Mt. Moriah include some entries of "Chinaman" in 1886 but no notation about where they were buried within the cemetery. They may have been placed in a separate area on the western edge of the cemetery, either at their own request or by the larger community's will, in order to accommodate their distinctive funeral, burial, and exhumation practices.[34] By 1890 the Chinese Cemetery had been defined just west of Mt. Moriah and was listed separately in the city directories. With separate sections or separate cemeteries for different religions, ethnicities, races, economic or social strata, and fraternal or other social orders, differences in the treatment of memorialization

and in the rituals surrounding burial and remembrance became more apparent in mountain society.

Some cemeteries attracted a lot of figurative and decorative sculpture, while others focused on classically simple markers. The U.S. Congress established Mt. Olivet Cemetery in Salt Lake City as a nonsectarian public burial ground in 1877. A single block in Mt. Olivet contains five full-length allegorical figures, eight three-dimensional urns on pedestals, a dead dove at the base of a tree stump, a couple of realistic stone tree trunks, and a range of blocks with ornamental carvings, in addition to relief sculptures. Generally, the wealthier and longer established the community, the more figurative sculpture and large ornate tombstones it held.

Cultural factors also played a role in the appearance of the sculpture garden. Catholic cemeteries tended toward the ornate and figurative, while Jewish cemeteries tended toward simpler, more abstract carved monuments. Traditional attitudes toward depicting saints, Jesus, Mary, crosses, and lambs on the one hand, and on the other an old prohibition against graven images that was not strictly observed but inclined some people toward abstraction, help account for such differences. The Serbian and other largely Orthodox populations of Idaho and Montana appear in cemeteries immediately after 1900 and tend toward separate sections dominated by their distinctive monument types.

Chinese and Japanese monuments were often the most beautifully simplistic, although nineteenth-century examples are difficult to find today. There are many extant examples from 1900 to 1920; these are almost always vertical stone shafts or plain upright tablets, from one to three feet tall, with incised Chinese or Japanese characters simultaneously providing information and ornamentation (fig. 6). A few exceptions in the Japanese section of the Salt Lake City Cemetery used standard marble monument

6. This marble marker in the Salt Lake City Cemetery for Juichiro Araki typifies the first generation of permanent Asian gravestones in the Rockies. Simply inscribed on each side, it indicates that Araki died in October 1917 at the age of thirty-three. Like earlier Asian markers in the West, this one also gives his place of origin: Okayama-Ken (prefecture), Yoshibi-gun (county), Sousha-mahi Kodera (Japan). *Translation of old Kanji by Michiko Croft.*

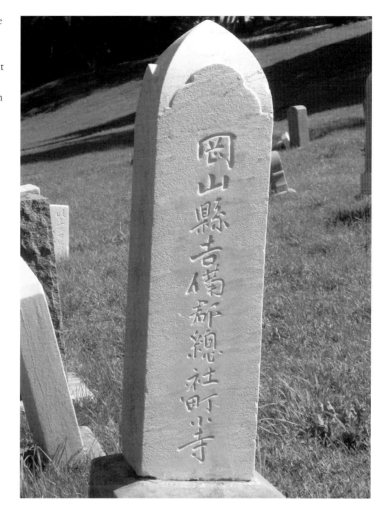

岡山縣吉備郡總社町寺

stock with precut ornament or motifs. One has relief drapery and a shield shape. Another old-fashioned tablet used for Kinjiro Hishida's grave in 1914 features a relief bird standing on a branch in a concave circle, and others display lightly incised decorative motifs in their shaped pediments. But for the most part, Asian Americans in the Rockies chose fairly plain vertical markers, and it was the elegance of the calligraphy that gave them visual interest.

In contrast, Pacific Woodmen of the World—members of a fraternal order of white men ages twenty-one to fifty that was especially popular in the Rockies—often chose tree and log imagery for their tombstones. The Woodmen

of the World section of Evergreen Cemetery in Colorado Springs is entered through a stone tree gateway and contains some typical stylized tree trunk monuments. The trees symbolized this order's credo of "woodcraft," or charitable works and neighborliness. Other fraternal orders sometimes marked their section of a cemetery with an iron gate that featured their symbol—three links of a chain for the Odd Fellows, for example—and such insignia are commonly found carved on monuments in these sections.

All these variations in monuments express specific beliefs and ideals of communities that chose to segregate themselves in death, as they often had in life. They also illustrate the wealth of cultures that typified the pioneer American West. Fair mounts quickly developed into highly organized rural cemeteries full of statues and monuments, regulated by increasingly complex sets of rules.

The Distinctiveness of the Rocky Mountain Cemetery

While fair mounts copied eastern rural cemeteries in the forms of many of their monuments, standard verses, and to a lesser extent their plans, they stood apart in other ways. Unlike eastern rural cemeteries, such as Mt. Auburn, western fair mounts almost always retained the character of their natural topography and a sense of the independence that flourished in this rugged environment. As a result, the landscape effects are more often dramatic or sublime than pastoral and picturesque. The English garden aesthetic had influenced the choice of Mt. Auburn's hilly wooded site, and ongoing projects to thin trees, plant additional woods, combine bogs and ponds into large reflective sheets of water, and build meandering paths and carriageways completed the effect of a garden cemetery.[35] By contrast, western topography dictated a variety of effects, from flat meadow cemeteries in broad mountain valleys to the gentle slopes of foothills to steeply terraced grave sites on mountainsides.

7. Buena Vista means "good view." Simple monuments such as this marble cross in Buena Vista's Mt. Olivet Cemetery gained significance from the grandeur of the Colorado mountains, which spoke to many nineteenth-century Americans of God's presence in the land.

Nineteenth-century westerners rarely created man-made versions of hills, lakes, and rocky outcroppings in search of the picturesque effects so prized in the East. Such manipulation would have been superfluous in the natural setting of the Rockies (fig. 7). Cemeteries on relatively flat ground at the foot of the mountains remained flat, relying on planted trees, flowers, and perhaps a fountain to suggest a park. Many smaller mountain cemeteries and those of the Latter-Day Saints applied a grid system of walks rather than an organic plan, reflecting the desire to assert order on the environment. This may be interpreted as another instance of a civilizing impulse emerging in the

8. Fenced walled plots, private stairways, and steep alleys once characterized the otherwise grid-like plan of the Idaho Springs Cemetery.

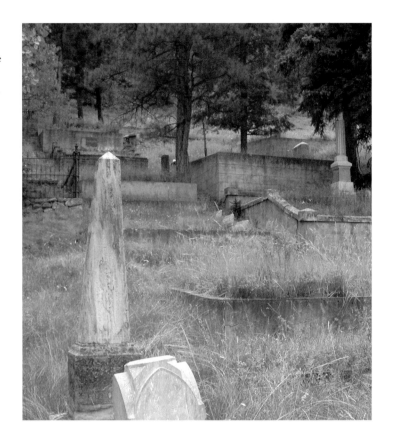

cemetery. Even when isolated picturesque effects were achieved, as in the terraced cemetery at Idaho Springs, Colorado (fig. 8), the cause was often pragmatic. Retaining walls prevented heavy rains and snows from unearthing bodies and kept coffins from migrating downhill over time. The principal alteration of some fair mount landscapes was the creation of ponds or ditches for the practical purpose of watering an environment that was often too arid to support trees without such aids.

When Helena contemplated the creation of a new rural cemetery, the paper noted that a citizen had proposed a spot that "can be artificially beautified."[36] In this case, "artificially beautified" meant building a windmill to pump water for irrigation, planting trees, and constructing a fountain from a small walled pool and standpipe. Otherwise, Forestvale Cemetery remained a plain, without hills,

lakes, rocks, or other picturesque features. At Butte, where the local paper complained that not even grass would grow, the injurious effects of smoke from the many copper smelters was blamed for nature's inability to flourish. "Perhaps it is in keeping with the rough exterior of a western mining camp that the graves of its dead are not covered by the flowers and grass which invariably mark the final resting place," rationalized the local editor.[37]

Rather than create a picturesque topography in the cemetery, many towns in the region chose a cemetery site from which picturesque views were possible, thus maximizing the Rocky Mountain setting. Riverview Cemetery in Green River, Wyoming; Grand View Cemetery in Fort Collins, Colorado; and Mountain View Cemeteries in Pocatello, Idaho; Rock Springs, Wyoming; Longmont, Colorado; and Butte, Montana, are all named for what can be seen from the cemetery, rather than describing the appearance of the cemetery. Like rural cemeteries in the East, those in the West emphasized panoramic views as a means of inspiring the soul and creating a sense of the sublime. But the nature of those views differed substantially from eastern panoramas.

The independent spirit of westerners may also be evident in their refusal to expend energy and resources in altering the landscape any more than necessary. Many mountain cemeteries in small towns were neither irrigated nor planted, relying on the rapid invasion of natural grasses to cover new graves. Private fences around each grave or around a family plot helped locate the grave after nature reclaimed it. Wooden fence posts and pickets were popular in many towns, including Nevada City, Montana, and Old Carbon, Wyoming (fig. 9). Ornamental iron fences of the same type that might be erected around the yard of a residence in town, often with elaborate gates, became the norm in other places. Such fences divided Leadville's Evergreen Cemetery into a gridwork of partitioned lots.

9. This wooden fence surrounds the grave of "Katie, Dau. of Isaac & Bertha Smith" in the Old Carbon City Cemetery, Wyoming. Its corner posts, each constructed of four boards with a solid cap, represent one of several common styles of grave fences.

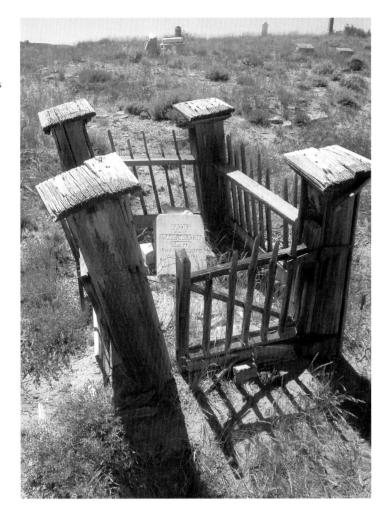

One of the monuments found fairly commonly in Rocky Mountain cemeteries is a metal grave guard consisting of four corner posts surmounted by cast iron urns or vases, connected by side railings of pipe and usually decorated with chains and metal ornaments (fig. 10). When used for adult memorials, diagonal iron straps or pipes often formed a canopy frame over the grave. A stone or metal nameplate was sometimes attached to the pipe rails to provide information about the deceased. In other instances, the grave guard was paired with a more traditional stone monument. The common occurrence of these metal grave enclosures in rather isolated mountain

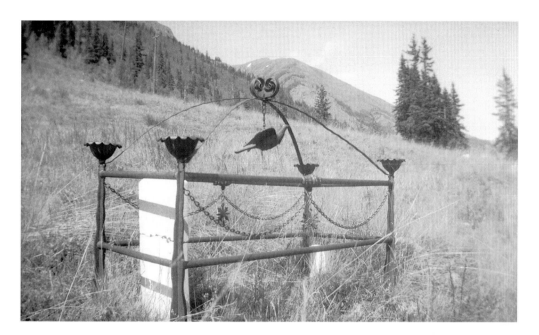

10. Muriel Sibell Wolle photographed this pipe grave fence in Hillside Cemetery, Silverton, Colorado, in 1959. Today the canopy has collapsed, the flying dove is missing, and the structure is falling into the ground. The headstone and footstone have fared better. Denver Public Library, Western History Collection, Wolle X1781.

cemeteries suggests an attempt not only to mark the boundaries of the grave mound, making it visible in tall grass, but to keep animals and people off the grave. This function may explain why they are less often found in large urban areas. Greenwood (now Benton Avenue) Cemetery in Helena, Montana, provides an exception to the rule, and it is possible that other city cemeteries also once held such metal grave guards. In some rocky locales, residents may have paved the grave mound with a layer of rocks for the same purposes.[38]

Another characteristic of the western fair mount cemetery that derived from its geography and set it apart from its eastern counterparts was the presence of Rocky Mountain stones as the substance of much sepulchral sculpture. Early stone carvers scoured the Rockies for deposits suitably hard, fine-grained, and evenly colored for monumental purposes. Sandstone deposits existed all along the southern Front Range, varying in color from buff to red.[39] Over the centuries, these deposits had eroded into marvelous natural rock formations that eventually became tourist attractions, including the Garden of the Gods in

Colorado Springs and the Red Rocks natural amphitheater outside of Denver. The same qualities that created the Garden of the Gods made this a poor choice for sepulchral sculpture. The soft stone usually eroded into unidentifiable masses, and most monuments made from it have long since disappeared. Nevertheless, at one time sandstone tree trunks were especially popular grave markers and the characteristic bright red stone highlighted many of the area's cemeteries, contrasting well with imported white marble.

Sandstone found on the western slopes of the Rockies proved more reliable than that on the Front Range. Not far from Salt Lake City, Ogden, and Brigham City, canyons yielded sandstone ledges at the surface that produced beautiful orange, red, yellow, gray, and buff colors. The ledges split easily and yet produced a sedimentary rock hard enough to hold the crisp edges of letters and ornamental motifs. Rooi Lacott cut a double headstone from a block of this orange sandstone for twenty-year-old Sarah Tanner and her infant son, John Jr., carving it with a low-relief funerary urn in the large gothic pediment over Sarah's name and a broken rose in the smaller pediment over John's name.[40] Except for a few minor cracks, water stains, and two chips that were probably caused by a lawn mower hitting it, this Utah marker remains in pristine condition over 140 years after it was carved. One easily reads the inscription John Sr. chose for his wife and son, who both died in October 1863, within two weeks of John Jr.'s birth: "Farewell, my dear wife, I bid you adieu, and this our dear babe I have laid here by you. May heaven's kind angels guard o'er your grave, until from its powers you are eventualy [sic] saved."

Since marble was the preferred stone for monuments in the United States in the 1860s, it was eagerly sought by some of the earliest monument makers in the Rockies. Limestone metamorphoses into marble over a long

period of time under the right conditions, but there are many states in between. Robert Richens & Co. of Manitou, Colorado, cautiously named the product of their quarry "white stone" when they offered it to the building trade in 1874, but others were quick to pronounce their finds marble.[41] Colorado's Governor Routt discovered a marble deposit on his farm in Larimer County and had it tested around 1880. He had at least one monument made as an example, but without sufficient capital to establish a quarrying operation it remained undeveloped throughout the 1880s and early 1890s.[42] This was the story with many small quarries and known but undeveloped stone deposits throughout the Rocky Mountains. Lacking the capital necessary to build railroads through often very steep and rocky terrain, owners removed only small quantities and laboriously transported them to the nearest facility for finishing.

Another white stone used fairly extensively on the Front Range may be seen in the Bessie Campbell monument in Franktown, Colorado. A chalky limestone with pronounced crystalline formation, fossils, and occlusions, its composition made it difficult to carve. The anonymous carver of the Campbell shaft used a point to create a pebbly background for his low-relief geometric design. Local stones often presented such challenges, sometimes resulting in unique carving techniques and limiting their use to the immediate locale.

By the 1880s it was becoming apparent that many of the local marbles, sandstones, and limestones might not hold their crisp carving into the next century. Nationally, too, people recognized that most marbles lose their integrity as sculpture in the North American climate after seventy-five to one hundred years. Granite gained ground as an alternative, even though its larger grain and additional hardness made it difficult to carve into fine shapes. At first, Rocky Mountain monument firms imported

partially finished granite monuments and markers from Quincy, Massachusetts, and even from Aberdeen, Scotland, and Sweden. However, the widespread availability of Rocky Mountain granite invited experimentation and development of local alternatives. By 1883, at least two Colorado granites were regularly employed for monuments in the southern mountain region, gray Silver Plume granite from quarries around Brownville in Clear Creek County and a coarser, red Platte Canyon granite. By 1889, the first shipment of high-grade Colorado granite to be sent so far east was reported on its way to monument makers in Michigan.[43]

The erection of state capitol buildings by Rocky Mountain territories entering the Union spurred the development of additional quarries. Colorado became a state in 1876 and decided to use local marble and granite in the early 1880s to build a state capitol in Denver. Stone samples poured in from every part of the state and were placed on public display as the committee considered its choices. Denver's monument makers and dealers were able to learn what stones the mountains could produce for carving purposes, even if quarries had not yet been developed, and they could contract for the amounts they needed. The rapid development of local stone sources can be seen in a comparison of the conditions in 1880, when the state boasted only six stone quarries and Denver had fifty stone buildings (only twelve entirely of stone), with 1890, when seventy quarries employed 2,500 workers and 308 buildings in Denver were made of stone. That year, the stone quarriers and dealers organized a state association at a stone convention held in Longmont.[44]

The increase in monumental granite became very visible in the cemeteries during the 1890s, by which time monument makers employed twelve distinct types of Colorado granite.[45] One of the last developed and most successful for monument making was Salida blue granite. The high

11. This monument by Bayha and Bohm for the Denver brewer Philip Zang, who died in 1899, took advantage of one of the best Rocky Mountain granites for monumental work, Salida dark or Salida blue. Zang purchased the plot in Riverside Cemetery in 1888 and buried his wife there in 1896.

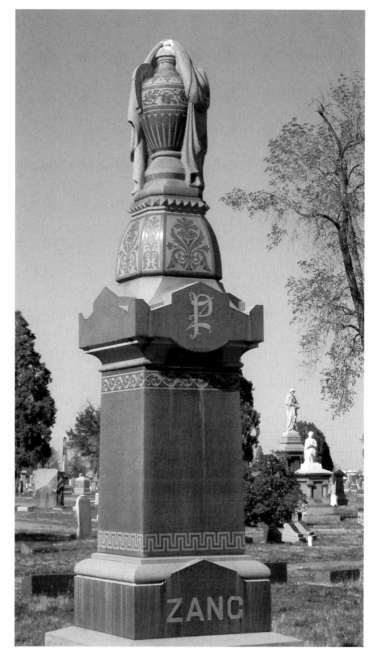

contrast between its light even gray hammered state and its black highly polished state made it ideal for inscriptions and carving three-dimensional forms. The Denver monument firm of Bayha and Bohm owned a Salida blue quarry around 1900. They cut the draped urn memorial

for German-born brewer Philip Zang from this stone. It provides a good example of how the contrast between polished and matte surfaces causes the fine sharp details of the sculpture to stand out (fig. 11). Salida blue was used in only relatively small quantities from private quarries until 1904, when the Salida Granite Co. was incorporated to quarry Turret mountain.[46] In 1897 a report on the state's granite industry found about fifty monuments and many more markers in Denver's Riverside Cemetery that were made of Silver Plume granite.[47] As stone from the Rocky Mountains began to fill the cemeteries, they took on a regional aspect, although the untrained eye may not discern the difference between Colorado granites and those from Georgia or Vermont. A Denver granite cutter wrote with pride to his union's trade journal just after the turn of the century, "The forest of sandstone tree stumps that were once such conspicuous ornaments in our cemeteries have been uprooted and in their places now stand artistic granite monuments. The casual visitor to our cemeteries can not but notice it."[48]

Even as granite gained popularity among monument makers and cemetery superintendents, marble remained popular with the general public. Some excellent new sources of marble were discovered in the Rockies. One of the most promising marble deposits had been recognized as early as 1873 in a formation geologists call Leadville limestone, but the first small quarry did not open until 1884. After that, several people staked claims along Yule Creek to quarry sections of blue and white marble. When the Colorado Midland Railroad gained title to some claims in the late 1880s, a good road was built to the site, which would later become the bed of a railroad.[49] A steady but small output of extremely high quality marble made its way to Denver to be fashioned into monuments throughout the late 1880s and the 1890s. Of a hardness equal to the famous Italian Carrara marble and with similar whiteness, this was an

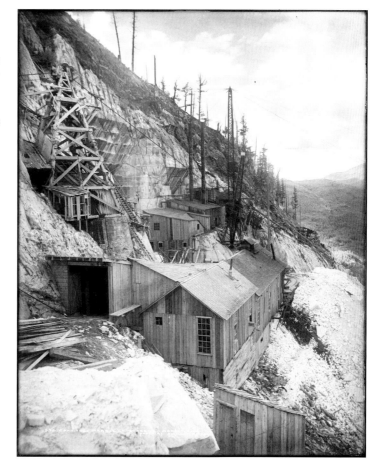

12. The Colorado-Yule Marble Co. developed its quarry near a mountaintop and became the most prolific of the quarries in the vicinity of Marble, Colorado. This photograph and others of the quarry's interior by Louis C. McClure are believed to date from 1913. Denver Public Library, Western History Collection, McClure Mcc1995.

important development for the Rocky Mountain monument industry. Unfortunately, a more difficult place of access would be hard to find (fig. 12). Having perched their operation on a mountainside, quarry workers removed stone to create a level surface or floor of solid marble. Two steam-powered channeling machines cut narrow parallel channels across the floor about six feet deep. Another channel was cut along the back wall. Then the partially defined blocks were released from the marble mass by drilling many holes at the base of the channels and lifting out the blocks.[50] The town of Marble was incorporated in 1899 and the Colorado-Yule Marble Co. was incorporated in 1905, with Col. Channing Meek as its president. Nestled in a very high valley below the quarry, Marble contained

workers' housing, a church, stores, and a large finishing and shipping plant where the blocks of marble were sawn into slabs for headstones, squares and rectangles for obelisks, and blocks for building and decorative purposes. The steep four-mile journey from the quarry down to the plant caused the death of Colonel Meek when a new electric tram car was installed in 1912. On its very first trip down the slope it ran away. Other passengers jumped off, but Colonel Meek was tossed against a rock pile and later died from his injuries.[51]

One of the largest monuments created from Colorado-Yule marble is the Kountze-Best cross. Together with his brothers, Charles B. Kountze formed the Colorado National Bank in the 1860s and at his death in 1911 was considered one of the richest men in Colorado.[52] His daughter Florence married Walter Best and the two families shared the plot where this massive Latin cross rises almost eighteen feet on its three bases. Its simple lines and plain surfaces impress the visitor through the sheer magnitude of pure white marble. All these local experiments in Rocky Mountain stone contributed a regional flavor to fair mount cemeteries, even as difficult local conditions kept foreign stones competitive.

Denver

How did cemeteries actually go from boot hill to fair mount? Tracing the history of cemetery development in Denver, a town with cultural aspirations that became the center of the monument industry on Colorado's Front Range, will provide one example among a variety of different tales. Settlement began in the fall of 1857, when a group of Cherokee Indians and white traders from the state of Georgia set up camp near the confluence of the Platte River and Cherry Creek to pan gold. According to an early written account, a trapper named John Smith built the first house of logs and sod that autumn on the

southwest side of the Creek.[53] It formed part of a series of shelters called Indian Row, either a reference to the homes the Cherokee built here or those of the Arapaho, whose territory it was and who camped in this spot. The following spring, a party of traders returning from Salt Lake City to the United States stopped at this camp and carried east with them news and evidence of gold, contributing to a rapid influx of miners to the area. By the fall of 1858, William Larimer had arrived with another party of pioneers and built a log and sod cabin on the northeast side of the Creek. For a short time, these two gold camps functioned as rival towns on either side of Cherry Creek. The first was called Auraria after a town in Georgia and the second Saint Charles, although it changed its name within months to Denver City, in honor of a governor of Kansas Territory. By the spring of 1859, Auraria boasted over one hundred cottonwood and dirt cabins, two stores, a bakery, a blacksmith shop, two saloons, a carpenter's shop, and a jewelry store. A bit smaller, Denver City also expanded rapidly as men brought in stock to trade to those gold seekers bound for the mountains in the great Pike's Peak gold rush of 1859. Masons organized a lodge, ministers arrived to establish churches, and Nathaniel Byers set up a newspaper. A government was established through elections in March 1859 and Arapahoe County was organized as part of Kansas Territory. Thus, within one and a half years of the first encampment, two communities were thriving that would soon consolidate into Denver.

Where the two nascent towns buried their dead in this period of development is unclear. Early accounts chronicle one shooting after another but do not indicate the final resting place. There may have been multiple spots, but it is likely that one of those spots developed into the first city cemetery. It has been reported that William Larimer Jr., treasurer of the Denver City Town Co., rode out

in November 1859 to locate a community cemetery, and that he chose a hill east of the camps, looking back over the downtown that had been laid out for Denver City.[54] Very likely some burials had already taken place here, and finding it suitable, Larimer set out boundaries for an extensive cemetery. It was optimistically named Mt. Prospect, probably a reference to the view of the Rocky Mountains to be had from this hill, as the spot was barren of trees and water and was not much of a prospect itself. Its name and distance from the town are the only indications that it might have been intended to become a rural garden cemetery. Given the lack of water for irrigation, Larimer probably gave little thought to the cemetery's appearance, just wanting to consolidate burials in a single place. The historian David Halaas notes that Larimer did not even have title to this land, which properly belonged to the Arapaho nation, but suggests that he and his associates attempted to forestall any legal problems by writing to the Kansas Territorial Assembly for approval of their scheme.[55] On February 2, 1860, the Assembly passed an act to incorporate the Mt. Prospect Cemetery Association and empowered it to purchase and hold land for "a cemetery or burying ground"—another indication that the founders had not been clear about their intentions as to the exact character of the enterprise, boot hill or fair mount. Later that month, the local paper described Mt. Prospect Cemetery:

> It is a beautiful site, covering the rounding summit of a ridge, and commanding one of the most grand and magnificent landscapes in the world. The cities beneath in the valley, the valley itself, and the winding Platte and Cherry Creek for scores of miles, the many streams leaping down from the mountains, their courses marked by belts of timber; the limitless plain, stretching away to the south and east; the great rocky barrier, sweeping around, crowned

in the distance by the glittering snow range, stretching for hundreds of miles to the right and left—only limited by the power of vision.[56]

This emphasis on a panoramic view can also be found in descriptions of eastern rural cemeteries, but there vision was rapidly obscured by woods and hills. Here the focus on grand views of limitless plains and magnificent mountains, "only limited by the power of vision," underscores the spaciousness of the West and the overriding importance of the view in making the cemetery.

Burials had already been taking place as early as November 17, 1859, when the local newspaper reported that twenty-nine-year-old A. F. Gerrish was followed to his grave in Mt. Pleasant (*sic*) by "many sympathizing friends."[57] Thereafter, regular notices of death and burial in Mt. Prospect appeared in this paper. Yet Mt. Prospect remained an unimproved burying ground. In stark contrast to the admiring assessment above, only a week earlier a local citizen had complained in the same paper about "that desolate and utterly neglected hill side," and asked "that something may now be done to render it less abhorent [*sic*] to all the higher and most worthy sensibilities of our natures."[58] Later, another wrote still more passionately: "Who has not felt that it was a disgrace to the City of Denver that its Grave Yard was so neglected, having none of the adornments to be found about those of a country meeting house, and who that has dear ones resting there is not pained upon visiting such a barren and desolate spot."[59] Mt. Prospect functioned as a typical boot hill, as this writer suggested, even less desirable than the church graveyards that the original rural cemeteries were intended to replace.

Around 1862, the local undertaker John J. Walley joined William Larimer in taking what should have been the first step in the transformation to fair mount,

when they laid out the grounds into sections for Catholics, Protestants, and Jews, subdivided into blocks and lots. They began advertising "suitable burial lots . . . for heads of families and the different denominations of Christians," urging owners to decorate and improve their lots for burial of the dead.[60] Unfortunately, this put the entire responsibility for the appearance of the cemetery on the lot owners, leaving the landscape to its natural appearance. Early in 1863, the *Rocky Mountain News* published an exposé condemning the unfenced burial ground as a "shame and disgrace to Denver."[61] People purchased lots and erected what monuments and markers they could, but as the *News* pointed out, roaming cattle and wild animals knocked over many board planks or wore the inscriptions off them. Early plank headboards were often four or five feet tall and must have looked like excellent scratching posts to cattle on this treeless range. The writer noted that "a few have enclosed the graves of their deceased friends with pickets, but the great majority of graves have received no attention except perhaps the planting of a head board, and as things are going now, in a very few years no trace will remain of scores of graves."[62] This bleak assessment ignores the marble headstones that were also erected. Some people may have had marble monuments freighted in on the long trains of mule and ox teams that brought all manner of goods to Denver in its first years. The stone carver Edward Gaffney advertised "marble monuments, grave stones and table tops," available in his Denver stone shop throughout 1862 and 1863.[63] Still, this boot hill was obviously not managing the transition to fair mount, even three years after its creation.

In 1866, eight years after the first cabin was erected in Denver, the city's Masons gave up waiting for Mt. Prospect to improve and opened their own Acacia Cemetery on the opposite side of town. They chose the crown of

a hill overlooking the Platte River on one side and the mountain range on the other. By May 3 they were ready to announce in the *Rocky Mountain News* that ten acres of land had been laid off, four lots to a block, with four-foot alleys between lots and twenty-foot streets separating blocks. In this way the grid of city streets and alleys was reproduced and no one's property would directly adjoin another's. Like the geography throughout this area, Acacia was treeless and arid. Rather than focus on the cemetery in their first promotional news article, its creators waxed poetic about the long-range views to be obtained from the new cemetery: "Directly in the line of Ferry, Cherry, Front, E, F, G, and H Streets, [it] affords one of the finest and most perfect views of Denver to be had anywhere. It also commands an unobstructed and magnificent view of the mountains, including a sweep of the snowy range for full two hundred miles."[64] On Saturday, May 4, the town's Masons were invited to walk the grounds and choose their lots. A ten-by-twenty-foot lot cost $10. The promoters noted that they were in the process of erecting a fence around the cemetery and owners were encouraged to plant and ornament their lots upon completion of the fence. A vague plan to obtain water from the Clear Creek ditch was never acted on, however, and the waterless cemetery required every penny from lot sales to pay for the original land purchase and the fence.

Within ten years, Acacia Cemetery had failed. Some people received certificates exchanging land in Acacia for new plots in Mt. Prospect, probably located in a section newly reserved for Masons. Other bodies remained in Acacia even after it began to be developed as a residential area, but within a short time no trace of Acacia Cemetery remained above ground. In 1873 the City of Denver received official notice from the federal government of its right to hold and operate Mt. Prospect, henceforth known as City Cemetery. The part known as Mt.

Calvary was deeded to the Catholic Church that had been overseeing it, and the Jewish section continued to be operated by the Hebrew Burial and Prayer Society under the informal designation Hebrew Cemetery.[65] This made the three partitions laid out by Larimer and Walley into three functionally separate cemeteries.

City Cemetery struggled with the same issues as when it had been called Mt. Prospect. Although Denver's citizens erected increasingly beautiful monuments and the cemetery boasted a good collection of sculpture, the city government did nothing to improve the weed-strewn, animal-trampled grounds. Many people expressed dissatisfaction with City Cemetery's appearance and, increasingly, with the fear that its location on a hill that drained across the city to the river posed a health hazard.

A group of twenty men decided to take the matter into their own hands. In 1876, the year that Colorado became a state, they incorporated as the Riverside Cemetery Association and opened a new cemetery on the Platte River, downstream from the city. The prospectus that introduced Riverside Cemetery to citizens explained that "to provide a place . . . more in harmony with the refined taste and culture of our people has been the aim of this Association."[66] Finally, Denver had its first rural cemetery and could develop a true fair mount.

Unlike Mt. Prospect and Acacia, Riverside's promoters realized that they must provide improvements and not rely on lot owners to beautify the cemetery on their own. They understood that beautiful marble monuments would be erected, as they eventually had been in Mt. Prospect, and set about creating the proper setting to display the sculpture so that Denverites could enjoy the full aesthetic and cultural experience of a wooded sepulchral park. With reference to Mt. Prospect and Acacia, Riverside's prospectus noted, "The dreary enclosures to which alone we have heretofore had recourse, owing to the dryness of

13. The 1876 plan for River-side Cemetery, Denver's first successful rural cemetery, incorporated winding carriage roads and walking paths among planted trees, a mausoleum row overlooking the Platte River, and concentric circles for the wealthiest citizens at the center of the plan. Fairmount Cemetery Co. Archives, Fairmount Heritage Foundation, Denver, Colorado.

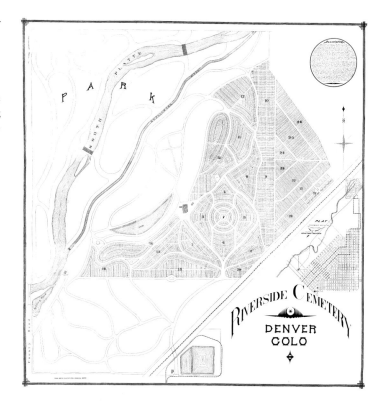

the climate and consequent aridity of the soil, afford no opportunity for esthetic embellishment except in so far as marble and granite contribute to that result; and however happy the devices of the artist in these, however meritorious his work, unrelieved by suitable surroundings, such as trees, shrubbery or flowers, the most pleasing effects are lost."[67]

To ensure those pleasing effects, Riverside was laid out by the civil engineer H. C. Lowrie in what the cemetery association proclaimed "perhaps the most elaborate and ornamental [design] of any work of this character in the State" (fig. 13). Lowrie constructed a system for raising water by hydraulic pump from a river reservoir and then pumping it through iron pipes to irrigate the grounds. Avenues, drives, and walks were graded and planted with trees and shrubs in an attempt to emulate "the landscape or park plan, which excludes fences, coping and all such

useless and expensive incumbrances [*sic*]," although "it must be borne in mind that we labor under great disadvantages as compared with our Eastern friends, for whom a more fruitful soil and the gracious rains do so much, but it is the determination of the management to spare no pains or expense to make Riverside a cemetery worthy of the community."

It would take decades of growth for the planted saplings and shrubs to fully achieve the desired effect, but before long Denverites were boasting that "the general prosperity of Colorado is shown by the great number of fine monuments erected recently at Riverside." The sculpture in its park setting, however modest, stood as a testimonial to the city's emergence from frontier town to cultural city. It was in this environment that the hiring of a Boston stone carver "who is not only a practical cutter, but also a thorough designer and architect" became newsworthy. One reporter encouraged Denverites to visit the Denver Marble Works to see "elaborate monuments" and purchase "a very superior character . . . of fine work" carved by the newly arrived talent, Edwin Forrest. Like Leadville, Denver touted its new cemetery and the sculpture in it as evidence of the West's successful transformation.[68]

On July 12, 1876, the *Weekly Times* announced that a receiving vault had been constructed at Riverside and, more optimistically, that parties were contracting to have family mausolea built.[69] In fact, only three were ever constructed, but these were the first in the area and constitute a significant advancement over the boot-hillish Mt. Prospect. Hartsville F. Jones, a well-known Denver saloon keeper and liquor wholesaler, had the first mausoleum built of local red sandstone with intricately carved ornamentation. The relief images adorning the façade suggest an unusual and as yet unexplained iconography. Although Jones buried two of his four wives and a son at Riverside before he died and was buried there himself in 1900, no

body occupies the mausoleum today.[70] Jones may have lost the title to the building during the financial woes following his unsuccessful bid for mayor of Denver in 1888. He buried his third wife, Mary, in the ground behind the vault. A substantial double marble monument, with an empty die apparently awaiting Hartsville's inscription, marks her grave. By the time of his death, he had lost all his money and had been working as a janitor for a number of years. He was buried without any further memorial in an undisclosed spot on the large plot holding both his mausoleum and Mary's marker. The local architect John James Huddart designed a mausoleum for Martha T. Evans around 1889 in a heavy Romanesque Revival style, and the third mausoleum was built for Ovander J. Hollister, publisher of the *Daily Mining Journal*, who died in 1892.[71]

Riverside is unusual among fair mount cemeteries in that it did not designate areas by religion or nationality or race. Anyone could be buried in the plot they could afford, although a pauper section was designated for charity cases. Miguel Antonio Otero, described as belonging to "one of the leading Spanish families of New Mexico, and who for three terms represented that territory as a delegate in Congress," established a mercantile business in Colorado in the 1870s and helped found the town of La Junta, originally named Otero.[72] He is buried near the center circle of Riverside, one of the most prestigious locations in the cemetery, with a very large granite obelisk fashioned by the same East Coast monument firm that provided the cemetery's centerpiece, the Iliff monument. The African Americans Lewis Price, Barney Ford, and Jeremiah and Emily Lee are also buried near the central circles. Ex-slaves, they all made important contributions to early Colorado history. Price founded the first black newspaper west of the Missouri River, the *Denver Star*; Ford owned and managed a luxury hotel in downtown

Denver; Jeremiah Lee made his fortune in mining near Central City; and Emily Lee was a nurse midwife. It may be significant that three prostitutes who were murdered in 1894 were buried in Block 25, on the outskirts of the cemetery, but more likely this, too, was an economic issue. When the sister of one of them decided to move her grave closer to the inner circles and erect a white marble angel over it, no one stood in her way.[73]

Groups did buy large plots for their exclusive use, but this generally occurred in the 1890s or later. The Elks, for example, have a separate area, and Japanese and Russian Orthodox sections were started in the early twentieth century. At Riverside's establishment in 1876, though, Denver already had separate Catholic and Jewish cemeteries. As a commercial enterprise, Riverside presented itself as a nonsectarian place for anyone who could afford to be buried there.

In the beginning, Riverside authorities made only one rule concerning monuments: that they not be placed in a way that would interfere with neighboring lots.[74] It was soon reported that "some fine monuments are already in position, and the family of the late John W. Iliff is about to erect a magnificent monument to his memory."[75] Widely known as the Cattle King, John Iliff was one of the wealthiest and most influential Coloradans by the time of his death on February 9, 1878, and his widow determined to erect a monument worthy of his memory (fig. 14). Accordingly, she looked eastward to the New England Granite Works and ordered an exact replica of a monument they had designed for Mayor William F. Havemeyer of New York City.[76] Havemeyer had died three years earlier, and his monument was erected by the New England Granite Works in Woodlawn Cemetery.[77] Mrs. Iliff's choice of a preexisting monument may indicate a lack of confidence in her own aesthetic judgment or it may suggest the belief that a monument designed by an

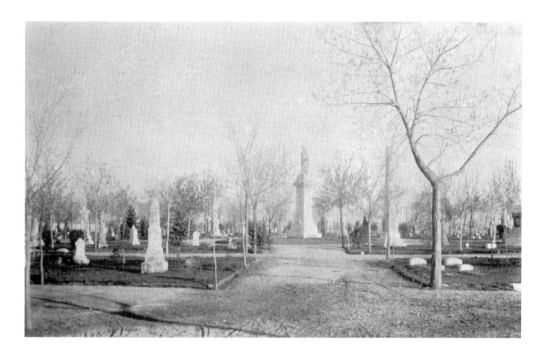

14. This historic photograph of Riverside Cemetery, before the trees had grown, shows the cemetery's circular carriage roads with the Iliff monument in the center. When Fairmount Cemetery became more fashionable, the Iliff family moved its monument. Fairmount Cemetery Co. Archives, Fairmount Heritage Foundation, Denver, Colorado.

East Coast sculptor, Charles Conrads, and fabricated by a major East Coast firm for a former mayor of New York would indicate to the world the esteem in which a western cattle baron should be held. In any case, she provided the Rockies with the first sculpture by this acclaimed firm west of the Missouri River. At a cost of $7,500 plus shipping, it was the most expensive, as well as the most impressive, monument to be erected in Denver for many years thereafter. Riverside Cemetery made it the centerpiece of their sculpture garden by allocating the center circle to the Iliff monument.[78] Mrs. Iliff's contract with New England Granite Works specified that the pedestal and statue be made of white Westerly granite from the firm's Rhode Island quarry, and that it rise over thirty-two feet into the air on a nine-foot square base. The statue on top, referred to as "Memory" in the New England Granite Works order book, depicts a standing allegorical figure holding a memorial wreath.[79] One could see the monument from throughout the cemetery.

As the trees grew and families not only erected monu-

ments but planted shrubs and flower beds, Riverside began to look and function like a park. With the city's elite electing to place their departed at Riverside, many families began the process of having those previously buried in Mt. Prospect moved. As a result, Riverside soon took on a well-established appearance, and to this day it has many tombstones from Denver's earlier years. Burials still took place at the three downtown cemeteries throughout the late 1870s and the 1880s, but with the exception of Mt. Calvary, they became the distant second choice for most Denverites. Lack of sufficient funds for a Riverside plot, or a desire to keep an entire family together, kept City Cemetery going until public outcries against its dilapidated condition and fears of disease, as well as increasing real estate values, caused the city to forbid any more burials in the 1890s.

Even while some of their members were choosing Riverside, local Hebrew congregations began raising funds for their own new cemeteries. An advertisement in a March 1887 newspaper announced a "Grand Masquerade Purim Ball under the auspices of Congregation Shomro Amunoh to be given in aid of the Funds for a new Jewish Burial Ground." Tickets cost fifty cents for this event at Music Hall.[80] Finally, in 1896, after the city had banned further burials in Hebrew Cemetery, Congregation Emanuel purchased 6.75 acres in Riverside Cemetery.[81]

Between 1870 and 1880 Denver experienced the biggest population increase of any city in the United States, jumping from 4,759 to 34,000 inhabitants. It continued to grow throughout the 1880s, and some people in Denver began to see the need for another cemetery. In addition, the site that had started out so propitious for Riverside lost some of its luster as the city's industrial area pushed closer. The railroad track that had to be crossed to enter the cemetery had once seemed a harbinger of progress, but now became a nuisance in some people's minds.

In 1890 a group of businessmen founded a new rural cemetery, farther out of town on the southeast side. With 560 acres, Fairmount Cemetery was by far the largest cemetery to serve the city. Fairmount Cemetery Association designated specific areas for the burial of African Americans and Euro-Americans and sold sections to various social groups for their exclusive use. Its founders invested $30,000 in a stone chapel, gateway lodge, graded avenues, trees and shrubs, a professional arborist, and a water system. It promised to provide a second sculpture park to the city, and for the first time, it would be a fair mount with most of the hallmarks of an eastern rural cemetery. Also for the first time, Riverside found itself with serious competition.

About the same time that Fairmount published its prospectus, Riverside brought out a lavishly illustrated booklet that named the board of trustees, listed the prominent Denverites already buried there, detailed the cemetery's merits, provided a defense against its detractors, and recited a list of rules and regulations. As they competed with one another, both cemeteries took a greater interest in the monuments erected on their premises. To ensure the overall neat appearance of the cemetery, both required that all monuments have foundations provided by the cemetery at the owners' expense. Riverside announced that in future, no wooden headboards would be allowed, "except in certain blocks, where for special reasons, headboards are allowed." The special reasons were not explained, but since there were already many such headboards in the cemetery, the trustees probably wanted to avoid giving offense to lot owners, while using the prohibition to encourage more carved stone monuments. Because thin marble headstones broke easily, minimum specifications were issued. No headstone over two feet tall or less than four inches thick would be allowed on the grounds. The trustees also reserved the right to reject any planned

"monument headstone or marker that may be considered by the officers of the Association inappropriate, either in material, design, workmanship or location." Theoretically, this gave the Riverside Association a curatorial function, regulating the aesthetic merit and placement of the collection of statues and monuments in the cemetery. In reality, any desire to prohibit or remove memorials had to be tempered by the business necessity of maintaining satisfied customers and continued sales. The choice of a memorial to a deceased loved one involved personal taste and was often emotionally charged, so the trustees had to tread carefully. Nevertheless, Riverside Cemetery announced its right to remove without notice "any objectionable ornaments, chairs, settees, vases, glass cases [over statues], artificial flowers, toys or any articles that may be considered objectionable." At the same time, a close reading of the rules demonstrates the trustees' interest in making the cemetery a highly regarded sculpture garden. They reassured potential patrons that "on extra fine work" exceptions could be made to any of their monument rules.[82]

Fairmount's more diplomatic rules were no less restrictive: "The Board of Directors have no wish to unnecessarily interfere with the taste of individuals in regard to the style of their monuments, but, in justice to the interests of the Association, they reserve to themselves the right of preventing or removing any structure or object which they shall deem injurious to the general good appearance of the grounds, and particularly of adjoining lots."[83] The move toward centralized control over privately owned monuments was national, and it corresponded with the professionalization of the cemetery industry. As cemetery sextons and superintendents formed professional associations, with journals and conventions, they saw themselves increasingly as the proper arbiters of public taste in the cemetery.

The competition between Riverside and Fairmount heated up through the 1890s, as each attempted to gain an edge through the greater beauty of their landscape and the higher artistic merit of their sculpture. Fairmount issued still more prohibitions on what it considered lesser arts, in what sometimes appear to be direct attacks on Riverside's monument collection: "The Association desires to discourage the placing of large slabs of marble or granite on graves, because they soon become unsightly. . . . Not more than one monument will be allowed on a plot. . . . No foot-stones for graves will be allowed. . . . No monument or grave marker will be admitted to the cemetery when made of other material than granite, marble or real bronze. . . . No monument or grave marker will be admitted which is cut in imitation of dogs, cattle, or any grotesque figure."[84] As the older cemetery, Riverside had gone through periods when sandstone, limestone, and iron markers were popular. It had also accumulated a large number of "white bronze" monuments made of zinc, that is, not real bronze. Fairmount could more readily unify the appearance of its sculpture garden by specifying only three materials, two of which—marble and bronze—had an ancient pedigree in fine art as the favored sculptural materials of the Ancient Greeks and Romans.

Fairmount's prohibition of images of dogs and cattle is even more interesting. Two of Riverside's more distinctive sculptures were a life-size marble dog on the grave of thirteen-year-old Frank Shy (fig. 15) and a life-size horse on a tall granite pedestal erected for Addison Baker. The horse had been published in a national monument journal as an example of an interesting memorial, and Riverside was justly proud of it. In prohibiting statues of dogs and cattle, a term often used to refer to working horses in the nineteenth century, Fairmount implied that Riverside's monuments were inappropriate, perhaps even in vulgar

15. Carved dogs began to appear in American cemeteries in the first half of the century, with examples such as Horatio Greenough's sculpture of a Saint Bernard for the Perkins family plot in Mt. Auburn Cemetery, Cambridge, Massachusetts. The Colorado sheep ranchers John and Hannah Shy placed this marble dog on their thirteen-year-old son's grave at Riverside Cemetery after his death in October 1879. They inscribed it with the words, "We Loved Our Boy."

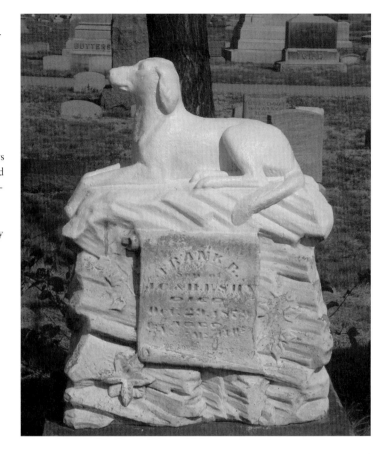

taste. As a modern cemetery, Fairmount would not countenance anything as low as marble dogs or grotesques on its grounds. Angels and allegorical figures were apparently considered more fitting and more easily understood as high art. When push came to shove though, Fairmount did accept the Hoeckel Hutchinson Monument, which includes a carved dog in a pose similar to that of the Shy dog at Riverside.

Ultimately, Riverside lost its bid to be recognized as Denver's most fashionable cemetery. Struggling financially, the Riverside Cemetery Association agreed to dissolve its board as part of terms of consolidation between the two cemeteries, and the Fairmount Cemetery Association took the reins in 1900. A booklet issued that year for both cemeteries combined all previous rules and added

some new ones, coming to a total of 120.[85] Symbolically, the fall of Riverside from social favor became undeniably apparent in 1920, when the Iliff family moved their monument to Fairmount, leaving the center of Riverside empty.

Social and economic competition played an important role in the development of these sepulchral sculpture gardens, but Fairmount and Riverside were not the only rural cemeteries in nineteenth-century Denver. Just a year after Fairmount Cemetery opened, the Catholic diocese established Mt. Olivet Cemetery on land bequeathed for the purpose by Bishop Macheboeuf. The *Rocky Mountain News* called it the "most magnificent of its kind in every particular anywhere in the West."[86] About eight miles west of Denver's center, with springs used to create an artificial lake for irrigation, it soon began to attract monuments, statues, and mausolea. Around the turn of the century many monuments and bodies would be transferred from Mt. Calvary to Mt. Olivet. Both Catholic cemeteries acquired statues of Mary and Jesus and crucifixes in larger numbers than the other cemeteries, but in other respects, Mt. Olivet matched Riverside and Fairmount as a sculpture center.

As we have seen, Denver's path from boot hill to fair mount took a longer and more circuitous route than many mountain settlements, but by 1900 it had three of the largest and most elaborate sepulchral sculpture parks in the region. This slow progress owed something to the city's continuous rapid growth and the need to abandon successive rural sites as the city absorbed them. Mt. Calvary became the site of the city's botanical gardens, and Mt. Prospect and Hebrew Cemetery became Congress Park, later called Cheesman Park. Yet urban growth, with its attendant wealth, also made the collection of impressive monuments possible. Other towns may have transformed their graveyards into show places more quickly, as Leadville did,

but Denver went through most of the same stages, starting with its unimproved Mt. Prospect and Acacia Cemeteries, moving to a still unimproved but religiously segregated City Cemetery with marble monuments, and then on to the picturesque plan of an irrigated and graded Riverside Cemetery. Finally, the socially segregated and rule-bound but beautifully developed Fairmount Cemetery met all the expectations of a true Rocky Mountain fair mount. These later cemeteries—Riverside, Fairmount, and Mt. Olivet—instituted practices and increasing numbers of rules to encourage the most artistic monuments and mausolea that they could attract as well as a park-like environment with the cultivated effects needed to display the city's cultural status. As intended, each had become a place "in harmony with the refined taste and culture of our people," but they did not remain long in the public eye.

In the first decade of the twentieth century, several more cemeteries opened in the area, including Crown Hill, sections of which operated on the new lawn plan with flat plaques in the ground. The cost of carving monuments, even with new machines, soon became prohibitive, and sepulchral taste turned away from the elaborate and representational sculpture of the previous era to low rectangular granite blocks with minimal, flat-relief ornamentation. Early in the twentieth century, Denver's Mayor Speer embarked on a city beautiful plan that included civic parks and avenues with sculpture that would become the new public sculpture of the twentieth century. The Denver Art Museum traces its roots to the start of an artists club in 1893, although it would be many years before this developed into a city art collection with permanent exhibition space.[87] As the capital city, Denver's public buildings and their grounds also began to fill with works of public art. The cemeteries' role as sculpture parks, the most prominent sites of public art, drew to a close as these other cultural institutions and spaces emerged.[88]

Conclusion

Throughout the Rocky Mountain Region, the earliest mining camps and cattle towns established boot hills as central burying places. Left in their natural state, these places accommodated all burials equally. Many of the randomly placed graves were unmarked, and those with markers ranged from sticks and piles of natural stone to painted, penciled, and carved boards. Boot hills seldom lasted more than five years and often much less, with citizens quickly calling for a more cultured approach and either transforming their boot hill into a fair mount or abandoning it as a paupers' cemetery in favor of a new spot. Fair mounts were increasingly organized and ever more aesthetically sophisticated cemeteries that usually reflected the social divisions of developing western societies. They adapted to a variety of local topographies, focusing on mountain views, rather than radically transforming their own landscapes. Accented throughout with carved wood, sandstone, limestone, and marble monuments, enhanced by plants and trees, they became active centers in the early life of the western town, preserving history, presenting art, and functioning as sculpture garden parks. As each town grew older, its cemetery acquired more and more sculpture, turning increasingly to zinc, bronze, and granite as the century neared its end. The fair mount cemetery was a cultural oasis in the wild west, both an agent of change and a self-consciously developed proof of the successful transformation from uncivilized cattle and mining frontiers to cultured urban centers. Denver followed this pattern, but was unusual in the length of time it took to transition from boot hill to fair mount and in developing a fair mount that did not make social distinctions beyond its paupers' field.

There was one major exception to the common scenario of a desolate burying ground preceding an increasingly organized and elaborately decorated sepulchral sculpture

garden: the cemeteries in communities founded by Latter-Day Saints. The Latter-Day Saints, or Mormons as they were called by outsiders, settled in the Rocky Mountain region quite early, founding Salt Lake City in 1847 and rapidly establishing outlying communities. Because they came west as part of an organized settlement effort and had a strong church authority in place from the very beginning, they did not normally go through the disorderly and lawless period associated with the wild west and with boot hill burial grounds. As an agriculture- and craft-based community attempting to develop a self-sustaining economy, the Latter-Day Saints avoided many of the difficulties that plagued mining boomtowns. They often established their cemeteries in the places they ended up and tended to organize them on a grid plan. Some early grave markers took the form of wooden headboards, but from an early date, Latter-Day Saints quarried local sandstone to make tombstones such as the one discussed earlier for Sarah Tanner and her baby.

In addition, the church recruited stone carvers from England as part of its missionary efforts, with the specific purpose of building beautiful temples, even before they emigrated to what would become Utah and Idaho. Many of the stonemasons whose primary dedication was to temple building and decoration carved tombstones on the side or during periods when weather prohibited construction work. This resulted in a high quality of sepulchral carving from the very beginning, as well as a distinctly English character to the memorials.[89] Although badly eroded, the gothic-style sandstone memorial erected by Thomas Steven Williams in 1857 for members of his family in the Salt Lake City Cemetery exhibits ornamental heads of a type typically found on gothic cathedrals (fig. 16). The detailed finials along the top of the monument are such as would adorn a gothic rooftop and the inscriptions are precisely chiseled. Nothing like this can be found so early

16. Thomas Williams erected this yellow sandstone monument in March 1857 when he was thirty, for family associated with his first wife, Albina Merrill. It commemorated their daughters, Albina and Cyrene, who had died at one year of age in 1850 and 1853, respectively; his older brother, Francis; and his wife's nineteen-year-old nephew, Adelbert Merrill, who had just passed away five months earlier. Inscriptions for his wife's parents were added later. It stands in the Salt Lake City Cemetery.

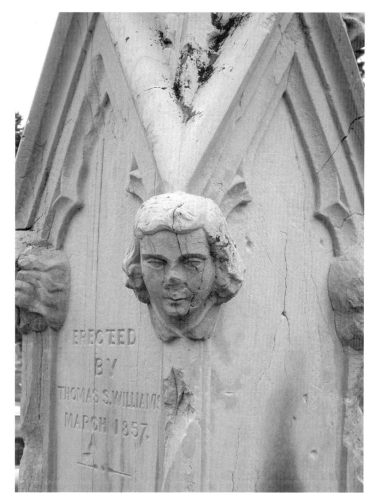

in other parts of the Rockies. Once past the initial period of settlement, communities founded by the Latter-Day Saints developed their cemeteries in much the same ways as other communities, adding marble and then zinc and granite monuments, placing sculptures among planted trees, and relying on the majestic mountains around them to provide visual inspiration.

Tombstone Carvers and Monument Makers
of the Rocky Mountain West

The earliest producers of grave markers in the Rocky Mountains often regarded this as a sideline to their primary business, or as a one-time activity to fill the needs of friends, family, or community. In some smaller towns, local amateurs might supply the majority of grave markers for many years, their only competition the occasional stone or metal marker for which a family wrote away or the rare visit of a traveling monument salesman. The advent of a professional monument-making establishment usually signaled a town's attainment of sufficient size to ensure that someone could make a living from grave markers. Sometimes it just meant a stone or wood carver had become discouraged with gold prospecting and decided to return to his trade for a while. But from an early date, both amateur and professional monument makers operated in Rocky Mountain area communities, creating sculpture for the cemeteries.

The first professionals had trained in a variety of places in the United States and Europe. They brought different styles with them, worked in many materials, and served the various religious and language needs of a diverse

population. As time went on and cities emerged, monument makers clustered in a few centers—Denver, Salt Lake City, Butte-Helena—from which they sent their products throughout the mountains. Major changes in preferred materials, forms, and imagery reflect similar trends nationally, but a small percentage of monuments reveal the unique culture of the Rockies.

Tombstones of the Latter-Day Saints

Established in 1847 by Brigham Young and his following of Latter-Day Saints, Salt Lake City became one of the first permanent Rocky Mountain settlements. In her detailed study of four Salt Lake City monument carvers of the period between the city's founding and the arrival of the railroad in 1869, Carol Edison concludes that these English-trained stonemasons produced gravestones similar in design and composition to others throughout the Anglo-American world, but with personally recognizable styles. Their designs included the broken rosebuds, urns, and flowers so popular in Victorian culture, but no motifs with specific Latter-Day Saints iconography. Two of the four, Charles Lambert and William Warner Player, converted to the Latter-Day Saints' religion in England and moved to Nauvoo, Illinois, to work on the temple construction there. Player became the principal setter of building stone, supervising all the masonry work, and Lambert cut ornamental architectural stonework for two years until the Nauvoo temple's completion in 1845. Both migrated to Salt Lake City with the Saints and helped build that city. A third early tombstone carver, William Ward Jr., arrived in Salt Lake City in 1850 and became foreman of the stonecutters working on the temple complex there. In addition to their architectural work, all of them shaped and lettered tombstones in the form of upright sandstone slabs from two to four inches thick.[1]

17. Emma Dixon Chase had not quite attained her seventeenth birthday when she died in 1863. The Salt Lake City carver Charles Lambert compressed the inscription into the top half of her headstone, perhaps anticipating the eventual addition of her husband, but Emma remained the sole occupant of this memorial. A monument erected years later by Mitchell Brothers of Ogden, shown in the background, commemorates her husband, Dudley, and two additional wives. Ogden City Cemetery, Utah.

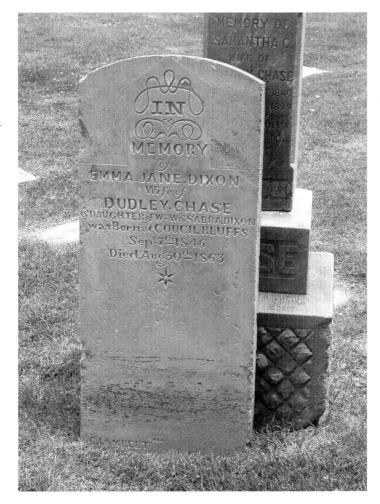

A red sandstone marker for Emma Jane Dixon Chase, carved by Charles Lambert in 1863, provides a typical example (fig. 17). Lambert carved crisp v-shaped letters to form an inscription that extends from one edge of the stone to the other. In typical Latter-Day Saints' style, the names of Emma's parents, her husband, and her place and date of birth are all given on the stone to clearly identify her. Around the words "In Memory," Lambert inscribed decorative looping lines that Edison has identified as characteristic of his style. He also used periods and commas liberally and interchangeably in his idiosyncratic way. The omission of an N in Council Bluffs is the kind of mistake

one frequently finds on hand-carved memorials. Like other early Utah carvers, Lambert gave his signature a prominent place at the bottom of the marker.

Charles Lambert's diary says nothing about his design choices or thoughts, but in chronicling what he did each day, he gives us a picture of a typical tombstone carver in the early years of the Latter-Day Saints' colonization of the Salt Lake valley.[2] Throughout the fall and winter of 1857, 1858, and 1859 Lambert recorded numerous trips to the sandstone quarry in a nearby canyon, where he and helpers quarried stones to be used as millstones, a door-step for a neighbor, tombstones, flagstones for hearths, mantels, and building stones. On each trip he retrieved a specific type of stone, often with a patron already wait-ing for the product. Sometimes he prospected for better sources of stone. In the spring and summer he spent more time digging out stumps, plowing, planting and digging vegetables, clearing away brush, helping neighbors dig wells, painting and whitewashing, repairing his farm im-plements, tending cattle, and participating in community projects than he did making monuments. The self-suffi-ciency for which the Saints strove in all their communities demanded this kind of well-rounded work from everyone. But every now and again, Lambert records another trip to the quarry or an evening spent lettering a stone or setting up a completed tombstone on a grave. He also records the injuries to fingers and hands that were a hazard of his profession.

From Lambert's diary we learn that it took two days to shape and letter a tombstone for G. S. Thatcher and three days for another gravestone. Tombstone cutters in com-munities of Latter-Day Saints often traded their skills for labor or produce. For example, "Brother Jackson" paid Lambert one hundred weight of sugar and $2.00 to have a gravestone cut for a Mr. Carpenter, who was shot by one of his working men in a disagreement.

From fall 1859 until May 1860, Lambert's chief help in all of his endeavors was his English-born apprentice, Joseph Watson. Watson was about nineteen when he arrived in Salt Lake City in 1859 and had probably already received training in England. Lambert complained bitterly when Watson left him to work in the nail factory, where Watson thought he could better his position more rapidly: "another instance of the inconsistency of men—just as he was going to be able to make some amends and do something; was off leaving me to do the best I could."[3] And yet Watson's work with Lambert included as much tree removal and plowing as stonecutting. They soon patched their differences, and Watson not only cut stones for the construction of the Salt Lake City temple, but in 1864 he joined his older brother James to create the firm of Watson Brothers, builders and monument carvers. Lambert went on to work with a number of other carvers, including W. W. Player, on joint monument projects.[4]

Lambert may have been the principal monument maker in the city at this time. The 1861 city directory lists his profession as "stone cutter and gravestones." Although there are several stonemasons in this directory, some of whom are known to have made monuments, only Lambert is listed this way. Census records reveal Lambert's steady progress economically. In 1850 he had real property of $300 and supported a household of five. In 1860 his household had increased to nine people and he had real property of $600 as well as personal property of $300. By 1870, he had a household of eleven, $3,000 in real property, and $150 in personal property. The profession of tombstone maker and stonecutter/mason appears to have provided a decent living in this early western city. Charles Lambert remained in Salt Lake City and focused on building and contracting throughout the 1870s, listing his profession as farmer in the 1880 census. Although he had made tombstones for Ogden families before 1870, he

should not be confused with the younger, English-born marble cutter Charles P. Lambert, who lived in Ogden and made monuments there from about 1879 on.

After 1869, when the transcontinental railroad was completed, many Utah stone carvers turned their skills from native sandstone toward marble. Marble had been imported in small quantities earlier, but now carloads of rough and partially finished marble blocks were shipped from Vermont. Much of the surviving work of the Watson Brothers is in this material. For example, they carved the tall marble tombstone in the Salt Lake City Cemetery for Catherine Roberts, who was born in Wales and died in Utah in December 1877. Joseph had just returned that month from a missionary and genealogy-gathering trip to the British Isles. His biographer reports that on his return voyage "he visited several of the leading cities of the United States in the interest of his business," most likely to establish additional contacts with stone suppliers in the East and possibly to explore new outlets for Watson Brothers' work.[5] The marble has not weathered as well as the sandstone, and the relief carving of clasped hands in an oval on the Roberts tombstone is soft from erosion, but its overall appearance is more reminiscent of national types than earlier Salt Lake carvers' work.

With the means to more easily obtain a variety of stones and ship finished work throughout the region, Utah monument makers developed larger output. Elias Morris came from his native Wales to Utah in 1852 at the request of the Latter-Day Saints, to which religion he had converted three years earlier. After helping establish a sugar beet factory and iron foundry in other parts of the valley, he moved to Salt Lake City and worked on the temple construction. Morris had trained with his father in Wales as a contractor and mason. In 1862 he opened a grave monument and construction firm, often working with a partner. From 1869 until Samuel Evans's death in 1881,

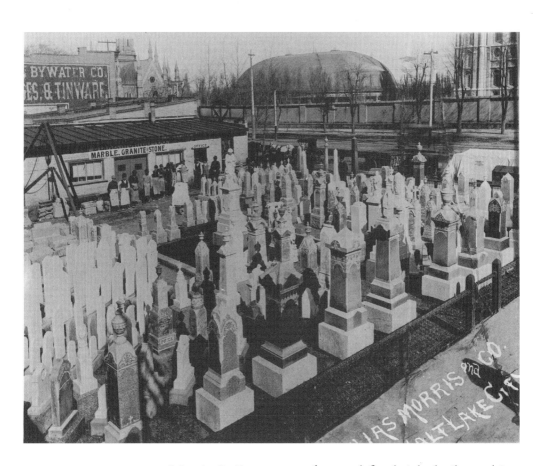

18. Employees of Elias Morris & Co. stand in their leather work aprons for a photograph taken around 1890 in the company's extensive Salt Lake City show yard. Simple headstones and shafts dominate the inventory, with a lone carved figure in the center of the yard. Used by permission, Utah State Historical Society, all rights reserved.

Morris & Evans manufactured fire brick, built smelting furnaces, constructed buildings, and produced gravestones. A large display of monuments attracted attention at their well-situated show yard on South Temple and Main, across from the temple complex (fig. 18). Morris & Whifenbach produced a draped obelisk for Elizabeth C. Smedley's grave in Mt. Olivet Cemetery that proclaimed her "a true woman."[6] The pall, with its four corner tassels, is realistically draped over the obelisk in a waterfall of sharp folds on each side. In addition to the firm's name on the base, the initials GSLC appear, for Great Salt Lake City. Monument makers in this area also used GSL, Salt Lake, and simply City as references to the center of Utah monument making.

Eventually, Morris's sons mastered the business and Elias Morris & Co. became Elias Morris & Sons in 1893.

19. This marble memorial for George Albert Smith in the Salt Lake City Cemetery has suffered damage, but most of the inscriptions are still easily legible some 130 years after they were cut. Latter-Day Saints often emphasized text over image in their sepulchral sculpture.

A consummate businessman, Morris also had interests in a tannery, a soap factory, the Utah Cement Co., and a slate quarry; he helped develop a gravity sewer for Salt Lake City and served as president of the Utah Sugar Factory. Morris was very active in the church, filling the positions of elder, ward bishop, president of the High Priests' quorum of the Salt Lake Stake for ten years, member of the High Council for nearly twenty years, delegate to the Utah Constitutional Convention, and city councilman. His high profile helped his company sell monuments statewide. Morris died at the age of seventy-two when he accidentally fell through an open trapdoor in a building

where he was meeting with his Cambrian association. His descendants carried on the business.[7]

Inscriptions seem to dominate monuments of the Latter-Day Saints. Lettering was, therefore, quite an important skill among monument carvers in Mormon communities. It took a steady hand to carve the small, tightly packed script letters that fill the dies and bases of George Albert Smith's monument (fig. 19).

Two factors contributed to Latter-Day Saints' tombstones and monuments becoming filled with inscriptions. The first was founder Joseph Smith's emphasis on multiple marriages and the large numbers of children that polygamy often produced. George Albert Smith was Joseph Smith's first cousin and a faithful follower of the tenets of the church. One die of his monument is filled with the names of his seven wives and twenty children. The other reason for long inscriptions was the ordinance of Baptism of the Dead and related beliefs.[8] Joseph Smith taught his followers to seek out the names of those who had died without knowing the restored gospel (the teachings of the Latter-Day Saints) and to baptize them in absentia so that their souls would be prepared for salvation. Because the Saints believed that the work of the faithful began before birth and continued after death, and that the work consisted of bringing the restored gospel to everyone who had not yet heard it, genealogy became critical. To keep track of the Saints and to determine who still needed to be baptized and given the chance to be saved, records were made at every opportunity. Another die on George Albert Smith's monument names a long list of his ancestors. The two remaining sides are devoted to his spiritual biography.

Smith's monument is particularly full of text because of the prominent roles he played in the church, in pioneering communities in the Salt Lake Valley, and in founding the territory of Utah. An additional, more personal reason for the lengthy inscriptions on this monument may be Smith's

position as the official historian and general recorder of the Church of Jesus Christ of Latter-Day Saints from 1854 until his death in 1875.[9] Other monuments simply filled up over the years with the addition of names on all the bases, shafts, and pediments, as generation after generation of large families were buried in a family plot.

The large families typical of nineteenth-century Latter-Day Saints not only affected the composition of monuments, but also the monument business itself. John Henry Bott came to Utah in 1874 as a young man and found employment running errands for Brigham Young. Soon he was sent to Brigham City and there he married in 1876, 1880, and 1882. He had two houses and lived with his first wife in one of them and with his other two wives in the other. His daughter Esther Bott Freeman wrote an account of her father's life from which we learn that, unlike earlier carvers in Utah, the monument business was his primary occupation, although he also raised the food for his family, as did most of the Saints in the nineteenth century. In the 1880s, the Bott monument business was located on Main Street in Brigham City. It was operated by the power of a single horse, with a rub bed to polish the stones and several hired men to help with cutting, lettering, and polishing. For a time, the federal government tried to crack down on polygamists, and many of Esther's memories of her father involve his escaping from one house to another and hiding from the U.S. Marshals in the cemetery. Eventually he was caught and imprisoned. Throughout this time, he left his business in the hands of his hired men. After the Latter-Day Saints agreed to cease the practice of plural marriages, Bott concentrated his family, some of whom had moved to Idaho for safety, in Brigham City again. He rapidly expanded his business, buying a flour mill and converting it to a stone mill. By this time he had many children who could help him. Esther said she polished stones in the mill for ten years, an

20. Lavinia M. Gardner Watkins died in childbirth in 1888, three weeks shy of her eighteenth birthday. The back of this marble headstone by John H. Bott once held her photograph, bordered by the same drooping rose and tulip that adorn the front. It stands in the Brigham City Cemetery, Utah.

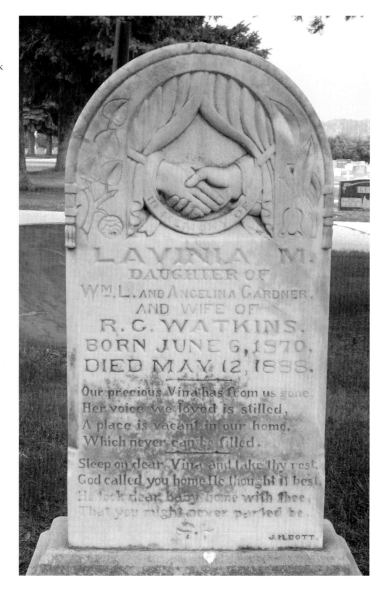

LAVINIA M.
DAUGHTER OF
WM. L. AND ANGELINA GARDNER,
AND WIFE OF
R. G. WATKINS,
BORN JUNE 6, 1870,
DIED MAY 12, 1888.

Our precious Vina has from us gone
Her voice we loved is stilled,
A place is vacant in our home,
Which never can be filled.

Sleep on dear Vina, and take thy rest.
God called you home He thought it best,
He took dear baby home with thee,
That you might never parted be.

J. H. BOTT.

unusual documented instance of a woman making monuments. Their output was large enough that "several men were kept busy canvassing the State of Utah and many sections outside the state for orders for monuments and headstones."[10]

The Lavinia Watkins tombstone is a good example of a Bott memorial (fig. 20). According to Esther Bott, the marble was shipped by railroad in large blocks from Vermont or Georgia to Brigham City. Bott took his heavy

wagon, pulled by four teams of horses, to the rail yard to pick up the stone blocks and from there hauled them to the mill. Blocks were transferred from the wagon by means of a derrick to a flat car that ran on rails into the basement of the mill. There, water-powered saws cut the large marble block into slabs suitable for headstones. Lavinia's was carved with a low-relief design under the rounded top depicting clasped hands between parting curtains. A wilted rose and a drooping tulip ornamented the stone outside of the curtain, and a tasseled cord provided a border for the whole scene. A letterer filled the rest of the space with information about Lavinia and her antecedents, as well as two personalized poems. Additional poetry fills up the back of the tombstone.

Many monuments of all descriptions, granite obelisks, marble horseshoes, columns, and more, bear the name J. H. Bott throughout northeastern Utah and southeastern Idaho. When he died of appendicitis in 1914, John Henry Bott left twenty-six living children, many of whom carried on the monument business and taught their children. Today, Bott descendants own monument businesses in Salt Lake City, Bountiful, and Murray, Utah. Early practice of polygamy combined with the craft tradition to produce large families of tombstone makers among the Saints.[11]

Several scholars have noted the prevalence of the handclasp on the monuments of Latter-Day Saints. It is an international gravestone motif that is extremely common throughout the mountains. It was sometimes read as a farewell to loved ones on earth, a reunion with already departed family members in heaven, or as a more earthly emblem of friendship related to the various secret handclasps that formed part of virtually every fraternal order's repertoire.[12] There is, as yet, no reason to believe that it was more often carved on the monuments of Latter-Day Saints than on others. Nevertheless, as the folklorist Richard Poulsen explains, the Saints may have used the

handclasp image in relation to their beliefs about man's relationship with God as a symbol of the hand of God clasping the hand of man in communication.[13] Both the handclasp motif and the general composition of the Watkins gravestone seem to have lasted longer among Latter-Day Saints than among others in the Rocky Mountains and throughout the United States. It was considered old-fashioned by 1890 elsewhere, but scholars such as George Schoemaker have identified its use in the Latter-Day Saints community until the 1930s.[14]

Popular motifs that are noticeably absent from many Latter-Day Saints' grave markers include angels, souls, and images of heaven. The scholar Mary Ann Meyers provides insight into this exclusion: "The Mormon view of death is that of a mere episode in man's progression. . . . While the Mormons manifested great concern for the unbaptized and unsealed dead, death itself was, for the Saints, a minor event. . . . Death was not an event of salvation or damnation according to whether it was encountered in faith or in disbelief; it was, in the Mormon's view, a prescribed, logical step in the individual's march toward godhood."[15] Richard H. Jackson has observed that mausolea and portraits are also uncommon in the cemeteries of Latter-Day Saints.[16] As the most expensive form of cemetery memorial, mausolea were actually uncommon throughout the Rocky Mountain region before the end of the century, even in the largest cemeteries. Butte's St. Patrick's Cemetery had only one, and Denver's Riverside Cemetery had a total of three. Portraits appear to have been replaced on Latter-Day Saints' markers by the extensive text-based identification.

Many other Utah monument makers are worthy of note, but all operated much as Elias Morris and John Henry Bott. The William Brown Marble Works was particularly active in Salt Lake City from 1885 through the late 1890s, often signing stones "Brown Wk's City."

This work is in marked contrast to the earlier inscribed sandstone headstones, since it is characterized by raised inscriptions in marble and often includes sculptural elements, such as lambs and draped urns. Swedish-born Carl Oscar Johnson owned and operated the Salt Lake Marble and Monumental Works in the 1890s,[17] advertising in the 1898 Polk City Directory for Salt Lake City, "As my profession is exclusively Monumental Work, I am able to guarantee my customers all work erected by me to be first class, and at lowest figures." In this way he distinguished his business from the many monument companies that were also in the construction business, although Johnson had helped build the temple, as had most monument makers in Salt Lake City. He also advertised Vermont and Italian marble, as well as granite. Thomas Child of Springville and L. L. Fuller of Provo provided many monuments for cemeteries in this region, exhibiting many of the characteristics mentioned above. S. Thomas worked with a unique compositional style, both on his own and for the Provo Marble Works. He lettered inscriptions so that the years appear very large and inserted month and day of birth or death inside the loops of the numbers 8, 6, or 9. C. F. Middleton & Co. of Ogden, Utah, did a large business in marble monuments around the turn of the century, as did McKenzie & Strobel in Salt Lake City.

As the century progressed, the volume and complexity of monument businesses increased, but there are still examples of individuals carving tombstones from the native rock. Nelson Wheeler Whipple may have made only one tombstone in his lifetime. A sawyer and a carpenter by trade, he ran the Big Cotton Wood Saw Mill and was probably more comfortable carving wood than stone. Nevertheless, in 1884 at the age of sixty-six, he carved a headstone from a slab of red sandstone in memory of his first wife, Susan Baily, who had died at twenty-eight, their one-year-old daughter, Harriet, who died soon after

her mother, and a daughter, Cynthia, by his second wife. Susan and Harriet had died in 1856 and Cynthia in 1859, twenty-five years before Whipple made the headstone. In the meantime, he married again and raised many children. His lack of experience as a monument maker shows in the size and spacing of the letters. They are largest at the top of the stone and became smaller as he worked his way down and ran short of space. Similarly, when it looked like he would run out of room on a line, he changed from capital letters to lowercase and reduced their size to fit everything in. Yet the whole is beautifully crafted, and one reads a certain amount of pride in the inscription on the back of the tombstone in fairly large letters: "Done June 6th. 1884. By N. W. W. Aged 66 Y." He died three years later.

The self-sufficiency of these religious communities, their doctrines concerning marriage and salvation, the order imposed by a highly regulated socioreligious system, and the recruitment of British stonemasons to serve the communities' needs all helped shape their memorial art and their cemeteries.

Front Range Monuments

While the English-born and -trained monument makers of the Latter-Day Saints carved headstones from local sandstone on the western side of the Rockies in the late 1840s, a slightly different direction developed a decade later on the eastern side, or front range, of the Rocky Mountains in what would become Colorado. Here most of the earliest monument makers hailed from Canada, the United States, and continental Europe. Like the Latter-Day Saints, they searched out local sources of stone, but what they found dictated different shapes and styles of monument. The earliest documented monument shop on the front range was that of Edward Gaffney on Front Street in Denver. The *Rocky Mountain News* noticed his work in 1861 with an article about the 7½ foot tall monument

with crossed bayonets carved in relief on its shaft that Gaffney had just completed for William H. Raney, a military man. Founded eleven years later than Salt Lake City, Denver was only about three years old at this point. Gaffney worked with a local stone that he called marble. It is no longer clear exactly where he derived his stone, and it has deteriorated to the extent that no known example of his work survives, but it was probably a crystallized limestone having the appearance of marble. The *News* described the Raney monument as consisting of "the beautiful variegated marble, so abundant near this city. . . . [The base] is white freestone, and the shaft different varieties of the veined, clouded and tinted marble."[18]

Already in 1860 the Canadian emigrant George Morrison had opened a quarry near Mt. Vernon, Colorado, and advertised cut stone: "I am now prepared to furnish to order all kinds of DRESSED STONE of both FREESTONE & MARBLE."[19] Freestone existed as boulders or large chunks of rock on the surface rather than the solid ledges that often required removal of surface dirt and stone before quarrying. The Mt. Vernon quarry was said to contain a stone almost as white as snow and could be cut into blocks ten feet square or larger. It is possible that Gaffney acquired some of his stone from Morrison and equally possible that Morrison was a competitor in the tombstone business as early as 1860. This is suggested by an advertisement in 1864 that stated "STONE CUTTING, in all its branches, is still carried on at Mt. Vernon by GEORGE MORRISON, who, thankful for past patronage, solicits orders for Tomb Stones and every description of cut stone for building."[20] Prospecting and quarrying building stone, as well as producing lime for mortar, constituted the largest portion of Morrison's business. Before the end of the decade he had opened quarries in Bear Creek Canyon and established the Morrison Stone Lime and Town Co. He founded the town of Morrison on Bear Creek in 1874.

Until Edward Gaffney disappeared from the Denver scene in the spring of 1867, he advertised himself as a stonecutter with the following products for sale: "MARBLE MONUMENTS, Grave Stones, Table Tops, Building Stones and Grindstones; also Plaster and Lime, constantly on hand."[21] This is not far different from George Morrison's line of products, but Gaffney emphasized cemetery work, where Morrison focused on wholesale building stone, and Gaffney was more advantageously located for the monument business. As a result, Gaffney received important commissions that helped propel his business forward. None made more of an impact than the Soule monument. In April 1865 a notorious assassination occurred on the streets of Denver. Capt. Silas S. Soule of the First Colorado Calvary, in charge of the Provost Guard of Denver and environs, was lured from his home, where he had just retired with his wife of one month. He was gunned down by a man named Charles Squires, who was later arrested in Las Vegas but escaped from prison.[22]

Soule was a controversial figure. He had been with Colonel Chivington when the colonel attacked Black Kettle's encampment on the banks of Sand Creek in eastern Colorado. Black Kettle had camped there in peace, with the army's assurance that his people would be safe, but Chivington ordered his men, including Captain Soule, to attack. The result was once called the Sand Creek Battle and is now known as the Sand Creek Massacre. Unprepared and with most young warriors away on a hunt, the Cheyenne could do little to prevent the ensuing slaughter, mostly of their women and children. Captain Soule gained notoriety when he refused to attack or to allow his men to attack, and subsequently testified against Chivington. Some considered him a traitor and others a hero. In the course of his subsequent duties patrolling the city of Denver, he received many threats against his life. Nevertheless, he had his supporters, and the *Rocky Mountain*

News was one of them. In November 1865 the newspaper announced that a subscription for a sepulchral monument in honor of Captain Soule totaled $300 and the fund continued to grow.[23]

On January 19, 1866, the newspaper described the monument under way in Edward Gaffney's shop as "a very neat affair."[24] The base stood six feet high and the shaft seven, for a total height of thirteen feet, probably in the shape of an obelisk. It was made from what the paper described as "a sort of bastard marble from the quarries of Turkey Creek." Located about twenty miles southwest of Denver, just south of the town of Morrison, Turkey Creek had extensive limestone quarries. The *News* stated that all but $100 of the subscribed amount had been paid, explaining that some of the parties who had not yet paid had gone back to the States. It called on unpaid subscribers to make good their promises and suggested that the monument committee ask individual citizens to make up the difference. By June 19, 1866, Gaffney had erected the monument in Mt. Prospect Cemetery and the widow Hersey Soule had published a note of thanks for those who placed "the beautiful and enduring monument over the remains of her deceased husband."[25] The body was later moved to Riverside Cemetery and the monument no longer exists.

According to tax records in the Colorado State Archives, Gaffney's property was assessed at $250 in 1865. The next year, after completion of the Soule and other monuments, the same property was valued at $500 and he had added a carriage, four horses, and personal property worth an additional $350. Competition came to town that year, as the Austrian-born brothers George and Joseph Koch set up shop on Holladay Street between E and F streets. An early example of Joseph's work has survived in Riverside Cemetery, although broken and repaired. Jacob Engl died August 22, 1866, at the age of fourteen and

Koch formed his headstone from a local stone, perhaps limestone or white "marble," in a gothic revival style. It takes the form of a pointed arch with deep rim and trefoil decoration. He carved the larger letters in raised block with considerable depth and some italic, and incised the smaller letters.

The very next year, another monument maker set up business in Gaffney's vacated quarters. Eli Daugherty had started his Denver City Marble Works in I. L. McCormick's carpentry shop, which was located in the rear of the post office. This doubling and tripling up of businesses in scarce space was common in the early years of many towns. Daugherty's move to a regular stone shop where he had more space and equipment was of great advantage to him. He, too, worked primarily in marble, but he imported his marble from the East and advertised his ability to cut the slabs into any desired style. The earliest surviving example of his work found to date is a large fragment of a headstone for one J. H. Miller's wife who died June 9, 1869, and was buried in the Burlington Cemetery near Longmont, Colorado. It has since been embedded in cement and the letters are beginning to soften, but comparison with an Eli Daugherty headstone in the Franktown Cemetery for Clara Kelly, who died one year later, reveals the same hand at work on the lettering. In contrast to the severity of the back, on the front of the Kelly marble, a shield holds her first name, a handful of flowers points heavenward, and rich moldings remind one of architectural finishes.

A native of Pennsylvania, Daugherty considered his greatest competition to be imported finished monuments from establishments east of the Rockies, rather than local carvers, so he advertised that his rates were as low as those in the East.[26] He opened his business in 1867 with $450 capital, and by 1870 he was worth $1,800 and had another stonecutter and an unskilled laborer working for

21. In May 1878, Cherry Creek flooded, sweeping away the Larimer Street bridge and the banks on which the Denver Marble Works rested but leaving the monuments standing in the yard. Denver Public Library, Western History Collection, W. G. Chamberlain photograph, x29356.

him.[27] He profited from the growing population of Denver and its reputation as a manufacturing and retail center for the front range. The new railroads allowed him to import both raw stone and finished monuments. By 1871 he advertised himself as a "dealer in and worker of foreign & domestic marble." Joseph Koch and George Morrison continued to provide his chief local competition, the latter using agents to sell his work in Denver.

In the early 1870s, three new monument businesses came to town. The German immigrant Adolph Rauh and his partners are discussed in depth in the next chapter. L. M. Koons and Ruel Rounds opened the Denver Marble Works on Larimer Street next to Cherry Creek in 1873. They do not appear to have been stone carvers themselves, but hired others to do the work.[28] A surviving headstone for Sarah Simpson in the Burlington Cemetery is signed "Koons & Rounds Denver," and the lettering identifies it as the work of Eli Daugherty, who had stopped advertising on his own account the previous spring and apparently began working for the Denver Marble Works. In

1875 William E. Greenlee and partner George W. Drake formed Greenlee & Co., which acquired the Denver Marble Works and established what would become one of the longest lived and most prolific of the Denver monument making concerns (fig. 21).[29] Drake had learned the mason's profession in Illinois and opened a marble shop in Boulder, Colorado, two years before joining with Greenlee in the Denver enterprise. Together, Greenlee and Drake produced marble headstones and monuments similar in style to others at this time, but as early as 1877 they also began advertising granite monuments. This would become the real specialty of Greenlee & Co., reflected in their changed name, Denver Marble and Granite.

From this point, the array of monument makers, dealers, stonecutters, and quarriers on the front range expanded with great rapidity. The Denver Board of Trade stated that in 1882 all of Denver's marble works combined had $50,000 of capital invested, employed fifteen men, and produced $4,500 worth of product.[30] By 1897 a report on Colorado's monument industry revealed twelve monumental firms operating in Denver, one in Pueblo, one in Boulder, two in Colorado Springs, and one in Leadville. This account underestimated the state's productivity, but the dominance of Denver on the front range is still clear. In Denver alone at the turn of the century William Greenlee was still running Denver Marble and Granite Co.; Eli Ackroyd owned the Colorado Steam Cut Stone Works; Adolph Rauh managed M. Rauh monuments; the Bills Brothers called themselves monumental builders but sold all kinds of memorials; David B. Olinger and Thomas M. Carrigan each ran his own monument and statuary business; Clifton Gray operated the Eureka Monumental Works; the separate partnerships of Bayha & Bohm, Robert & Jones, and Green & Bird operated monument concerns; Paul Parsons managed N. M. Parsons marble works; Ernest E. Howard had his own monument works,

as did Denver Monumental Works; McGilvray Stone Co. and Geddis & Seerie Stone Co. did more volume in building stone but both supplied other companies with monumental stone and occasionally produced monuments and markers themselves; Denver Onyx and Marble Co. may have made some memorials; and James A. Byrne, William H. Ivers, Robert Houghton, and August J. Wirgler all operated as independent monumental carvers and sculptors. All of the firms employed additional cutters and carvers, some of whom would open their own firms, and many of the principals above had started out working for one another. Firms also tended to take over one another's stone yards, so that the same address might host four or five different marble and granite works over time. This was a close alliance of professional men, in competition with one another.

The Monument Industry in Wyoming's Railroad Towns

Temples drew the first stone workers to towns founded by the followers of Brigham Young in the late 1840s. Two decades later, roundhouses, train sheds, and workshops attracted the first stone workers to towns established as termini by the railroads in Wyoming. The Union Pacific Railroad pushed straight west across Wyoming in 1867 and 1868 in the great effort to connect the East and West Coasts by rail. That effort succeeded when the Central Pacific Railroad met the Union Pacific at Promontory Point, Utah, in May 1869. The Union Pacific sent stonemasons to Laramie as soon as it finished laying out the town and the track reached that point, so that the railroad's needs would be met with buildings resistant to the fires so easily started by coal-burning steam engines, forges, and foundries. Although some of the earliest grave markers were wood, like the town's earliest buildings, the railroad immediately made all sorts of materials and skills available. Some of the Union Pacific masons who built the stone

22. This unsigned marble headstone for two-year-old Charles H. Dunn, who died in 1878, typifies the relief floral and geometric ornament and the varied lettering found on many tombstones in Laramie in the 1870s. Despite damage it still stands in Greenhill Cemetery, Laramie, Wyoming.

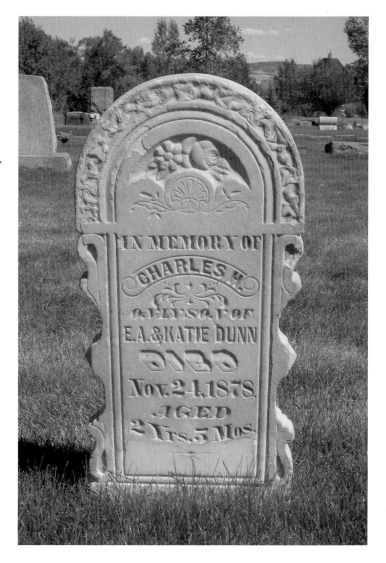

engine houses and rolling mills for turning out rail almost certainly produced some of the unsigned marble tombstones that have survived in Laramie.

Indeed, John L. Roberts advertised his services as an "ornamental stone cutter" in the 1875 Laramie directory, in addition to cutting and dressing building stone and laying it up in walls. He did not mention tombstones, but he was the only one of the five stone workers in town whom the directory called a stonecutter rather than a mason.[31] Some of the beautifully carved but unsigned marble

monuments in Greenhill Cemetery from the 1870s, such as the Charles H. Dunn headstone, with its elaborate lettering and ornamental trim (fig. 22), may be Roberts's work.

The difficulty of identifying early tombstone and monument carvers in Wyoming railroad towns is noteworthy. Unlike city directories in other western towns, which normally included a category for marble works as soon as the town was deemed large enough to merit a directory, Cheyenne and Laramie directories did not list monument makers or marble works as a business category from 1868 through 1895. Nor did local monument makers advertise in the four newspapers from this region surveyed between 1867 and 1887. Residents seeking a carver to mark the family grave would have had to rely on word of mouth or imported monuments. In other mountain regions, the local cemetery served as a three-dimensional catalogue where people could stroll among the memorials, reading the signatures and addresses of the local monument makers, but the citizens of Laramie and Cheyenne would have searched their cemeteries in vain. The seeming scarcity of monument carvers along the path of the railroad in southern Wyoming suggests that cemetery art was not a significant industry in this part of the Rockies.

By 1885, two new cemeteries replaced Cheyenne's discontinued "old city cemetery," and it required two undertakers to handle the business of death. Many of the graves held monuments. Yet the directory still listed no monument makers or dealers. This rapidly growing town had seventy-eight carpenters, six cabinet makers, two architects, three stonemasons, and seven stonecutters who must have filled at least some of the town's sepulchral needs. Several of the stone workers had addresses in the same area, near Thomes and Twentieth Streets, suggesting that a stone-working district existed near the railroad. The majority of their work may have been building construction,

but it is likely that some local gravestone carving was going on. Further study of the Wyoming monument industry may prove differently, but at this point, the evidence suggests that the presence of the railroad at the inception of towns like Cheyenne and Laramie may have inhibited the growth of local monument making.

The previous three sections have suggested the diversity and varied foci of the early monument industries in different Rocky Mountain regions, depending on local materials and conditions, the background and training of the carvers, and dominant religious or economic cultures in these regions. The next three sections look at monument types found throughout the Rockies.

Headboards

A plain wooden board, cut with a rounded top and carved with a name and death date is perhaps the image most characteristic of the mythologized wild west burial. Wooden markers of all kinds had been common on frontier graves throughout the American West. In many places, wood was the most readily available material and the least expensive. Most boys learned basic woodworking skills as a necessity of life, and many men, as well as some women, were quite skilled at whittling and carving. In September 1861, when the War Department established the first uniform system for marking military graves by issuing General Order 75, it was the round-headed wooden board that was specified, thereby institutionalizing what was already a common practice at many frontier forts. The white marble upright slabs now associated with military graves were adopted for their longevity after the Civil War. The War Department estimated that a headboard would remain upright and legible for only five years in many regions of the United States, and at a cost of $1.23 each, the long-term expense of keeping the graves of veterans marked in wood was too great.[32]

Just as on other frontiers, the Rocky Mountain pioneers often chose to mark graves with wooden planks. They commonly formed the earliest examples from hardwood, one to three inches thick and four or five feet tall. Over time, many headboards rotted at the ground line and had to be reburied, shortening them in the process. But shorter boards were also used, particularly in the 1880s and later. Some headboards have a squared-off top, while others are rounded or shaped. Those with straight edges often had additional strips of wood or metal nailed across the top and sometimes down the sides. These framing members may have had the purpose of preserving the wood from the effects of rain and snow by covering the open grain end, in addition to providing a visual border.

Although wood was one of the fastest materials to work into a marker, carvers of Rocky Mountain headboards did not always use the easiest or quickest process. Few markers can be found, for example, with the letters gouged out of the wood by cutting two lines slanted toward one another to make a v-shaped cut. Straight letters could easily have been formed this way. Instead, extant wooden boards show a marked preference for raised block letters. This usually involved a laborious process by which the carver cut away the mass of wood from around the letters with a knife or chisel, reducing the whole background by at least an eighth of an inch, often more. Even before making the first cut, the carver would usually draw all the letters on with a pencil, using a straight edge to ensure proper composition and balance of the lettering within the space available. Some headboards appear to have been lettered using stencils and display the same typefaces commonly found in newspapers, signs, and waybills at that time. Serifs and italics are common.

In other instances where we now see only slightly raised letters, usually with smoothly rounded edges, James Milmoe has proposed that the board was never carved.[33]

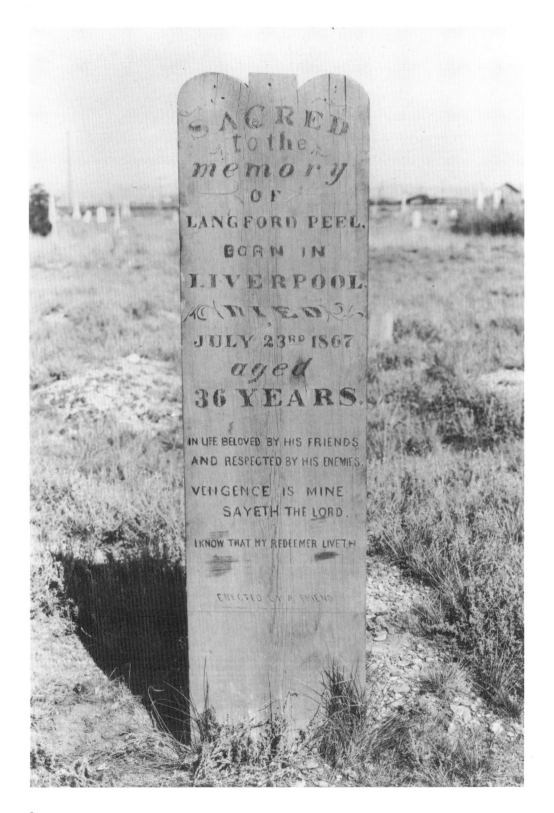

SACRED
to the
memory
OF
LANGFORD PEEL,
BORN IN
LIVERPOOL
DIED
JULY 23ᴿᴰ 1867
aged
36 YEARS.

IN LIFE BELOVED BY HIS FRIENDS
AND RESPECTED BY HIS ENEMIES.

VENGENCE IS MINE
SAYETH THE LORD.

I KNOW THAT MY REDEEMER LIVETH

ERECTED BY A FRIEND

Instead, the inscriptions were painted on unprotected wood. The paint preserved the lettered areas while the exposed wood around them weathered away over the years. Regular repainting of the letters for a period of years would have increased this effect. People also painted headboards after carving inscriptions to make the lettering stand out visually and to help preserve the wood. Although the evidence is minimal, it appears that black letters against a white ground may have composed a popular palette.

The marker that once stood over the grave of Langford Peel provides an excellent example of an early Rocky Mountain headboard (fig. 23). It has been preserved in fairly good condition because a local man removed it from its original place in the old Catholic burying ground near the Helena high school when Peel's body was moved to the Benton Avenue Cemetery.[34] He put the headboard in his attic until January 1928, when he gave it to the Montana Historical Society. Constructed from a heavy oak board almost two inches thick and sixteen inches wide, it probably stood a little over four feet tall when one end was buried in the earth. The raised inscription states that it is "Sacred to the Memory of Langford Peel, Born in Liverpool Died July 23rd 1867 aged 36 years." It originally had an additional wooden or metal piece attached to the front of the board near the top and protective strips on the cut edges. Only nail holes remain. It has weathered to a gray color with remnants of black paint on the raised letters.[35]

Langford Peel was a notorious character in the old West, and his untimely end received a lot of play in the Helena and Virginia City, Montana, papers. According to these reports, Peel served as a bugler in the military between 1846 and 1852. He married "a lady of very good family" in St. Louis, and they had two children, but he abandoned her to follow the life of a gambler after being discharged from the service in Santa Fe, New Mexico.

23. This photograph of the Langford Peel marker, ca. 1867, is believed to have been taken by L. H. Jorud of Helena, Montana, on May 9, 1937, but may be earlier because the heavy oak headboard that it depicts was already in the collection of the Montana Historical Society by this date. It is also uncertain whether Peel's grave is shown and which cemetery this represents. Photograph is in the Montana Historical Society Archives, 944-309, Helena.

While at Salt Lake City in the late 1850s he shot a man over a gambling disagreement. A reward was offered for his capture or death. Friends helped him escape and then made it known that he had been killed so that they could collect the reward. Peel then traveled to San Francisco and back to Virginia City, Nevada, adding more killings to his reputation, until he came to Montana. In Helena, Langford Peel, better known by the alias Farmer Peel, met a former friend and partner with whom he had had a falling out. On July 23, 1867, their differences came to a head in the Bank Exchange Saloon. John Bull accepted Peel's challenge and went home to get a gun. When Peel emerged from the saloon, Bull shot him three times before Peel could fire. Summing up his character, the *Montana Post* wrote in Peel's obituary that he "had the reputation of being one of the coolest and most desperate men in the country. . . . He was a man of many generous impulses, princely in his dealings with his friends, and to his enemies implacable. Altogether he was one whom few cared to have any dealings with."[36]

One of Langford Peel's friends erected the wooden marker on Peel's grave. After the inscription about Peel, he added these testimonials: "In Life Beloved by his Friends and Respected by his Enemies" and "Erected by a Friend." It is perhaps revealing of Peel's character that only twenty-five years later "an old-timer" recalled reading the headboard many times and recounted it from memory: "Loved by his Friends and Feared by his Enemies."[37]

The high-quality hardwoods seen in some extant headboards might also explain their longevity. Some people made headboards by recycling the boards from their wagons, and others from the sawn boards being manufactured locally for building construction in some mountain towns. Six months before Peel's death, Virginia City's paper, the *Montana Post*, had carried an advertisement for the Helena merchant John How that boasted the availability of

24. The inscription on Mary A. Spiegel's wooden grave marker states that she died in 1868 at the age of 30 years, 9 months, and 6 days. Such precision was common on both children's and adults' markers during the nineteenth century in places where death seemed always imminent and every day of life counted. Photographed in the Diamond City Cemetery, the marker was later given to the Montana Historical Society. Montana Historical Society Photograph Archives, 946-736, Helena.

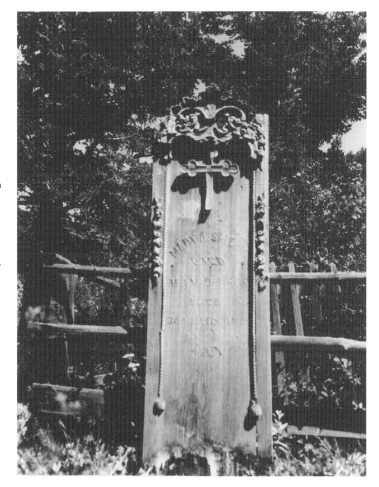

"imported Oak and Ash lumber, any size wanted, never before seen in Montana Territory."[38] This may have been the source of the oak for Peel's grave marker.

There is no clear evidence that would allow us to name the makers of Peel's or most other wooden headboards in the Rockies. City directories list carpenters and furniture makers in every town who would have had the necessary skills, but they did not generally advertise headboards. Some headboards are quite elaborate, such as the one that commemorates Mary A. Spiegel (fig. 24). A carved cord with tassels forms a border around most of the board and garlands of flowers add more decoration along the outer edges. An elaborate baroque carved

wooden shell and scroll motif decorates the top. It stands out from the headboard, forming a canopy over an ornate carved cross with trefoil ends that is attached to the center of the board above the inscription. These pieces were carved separately and attached to create high-relief ornamentation. When Lawrence Heberle photographed it in 1958 in the Diamond City Cemetery in Montana, it was described as the best preserved wooden headboard in that ghost town. Mary Spiegel's great-grandson gave it to the Montana Historical Society the next year. The Spiegel marker is quite tall and represents the work of a gifted carver, perhaps someone who also created the furnishings and ornaments for rural Catholic churches. It is not what most people envision when they picture the old West, but suggests that we should expand our image of the pioneer wooden grave marker.

More common are the simpler boards, like an undated one "In Memory of Our Dear Children. Ernest. Joseph. Samuel. Myrtle. Mary. Rawlings," or a short stenciled one for Julina P. Slusher who died in 1888, both in Leadville. Some were carved and others simply painted. Some letters can still be read on the boards in the cemetery at Golden, Colorado, but they are worn and split, and often the grain has become so prominent from rain soaking into the exposed wood that the raised letters are distorted. Unlike the Leadville boards, which appear to have been repainted through time, no trace of paint remains on the Golden headboards, which have the rounded letters suggestive of long erosion.

These simpler wooden boards are probably the type that Chinese pioneers most often erected. An article in the *Helena Herald* in 1869 refers to headboards on the graves of the Chinese buried there, but does not describe them.[39] The custom before 1900 was usually to exhume the bones after a few years and send them back to China for reburial where the graves could be tended by family members

as part of a tradition of ancestor reverence. Scholars of Chinese-Australian and Chinese-American deathways outside of the Rockies have shown that wooden markers were sometimes inscribed with black ink to identify who was buried, when they died, and where they came from in China. The same information was also recorded on a brick or other material placed inside the grave. It seems unlikely that the Chinese pioneers who made the wooden grave markers mentioned in the *Helena Herald* would have lavished much time on temporary objects whose only purposes were to locate the body after decomposition and direct survivors where to send the bones. This meager evidence suggests that Chinese Americans discarded their wooden markers when they exhumed the bodies and explains why no nineteenth-century headboards with Chinese inscriptions have yet been found in the Rocky Mountains.[40]

Most likely, professional sign painters did the original painting on many uncarved English-language headboards, and possibly even designed them. Sign painters performed an essential task in the intensely competitive marketplace of young boom towns (fig. 25). The gold fields attracted

people of all nationalities and native tongues. Picture signs such as that over the watchmaker's establishment on Helena's main street in 1868 could be read by anyone. Other signs consisted only of text, and the composition helped make them stand out from their neighbors. Professional sign painters had command of many letter styles, and one can readily detect the similarity between commercial signs in early photographs of mountain towns and the letters on early headboards, which are also a kind of sign.

The first city directories for most towns included painters. They usually specialized in house and sign painting, but could be pressed into service for any related need. For example, the Denver firm of Reitze & Gregory, Painters, advertised that "all kinds of House, Sign and Carriage Painting . . . Imitation of Wood and Marble, Glazing, Paper Hanging, Calumining, Wall Coloring, etc. . . . will be executed in an artistic manner, on the shortest notice, and guaranteed for durability."[41] The owners of newly established hotels and saloons pressed these painters into service decorating the interiors of their establishments with false marble columns, scenic murals, and wood graining that dressed up pine boards as something more exotic. Some people undoubtedly took advantage of Reitze and Gregory's and of other house and sign painters' talent for painting imitation marble to make their wooden headboards look like carved marble headstones. There is no longer any way to know how extensive this practice was, but city directories document the prevalence of painters with those skills in many towns. The Leadville newspaper documented several examples of wooden grave markers painted to look like marble in Leadville's first graveyard.

The erection of wooden headboards throughout the nineteenth century testifies to the continued popularity of this form of memorial. Long after marble and granite tombstones became readily available and cost as little

26. This late example of a wooden headboard in Butte, Montana, illustrates some of the changes in fashion but also reminds us that the choice of wood was not solely an economic one; many people continued to prefer it. A modern metal funeral home marker with a cross is wired to this headboard marking Earnest Pera's grave.

as $5.00 apiece, many people continued to prefer wood, perhaps made by a family member in loving memory of a cherished relative. The boards themselves appear to have become shorter and thinner later in the century, as the source of wood changed from heavy hardwood planks to the more precisely finished wood boards sold in standard sizes for building purposes. The Earnest Pera headboard may serve as an example (fig. 26). According to burial records in the Butte Public Archives, where his last name was given as Pena, Earnest was born in March 1903 with multiple sclerosis and died three months later in Meaderville, Montana. His family buried him in St. Patrick's Cemetery in Butte, placing the board inside a wire mesh enclosure made to look like a child's bed. Thinner than earlier headboards, this one has not been carved to create raised letters. It was once painted with black letters against a white ground, and there appear to be multiple

27. Several iron markers of this shape adorn graves in Salt Lake City cemeteries. Others include relief images cast with inscriptions. Leona A. Pedersen's iron grave marker, ca. 1896, Salt Lake City Cemetery.

layers of paint on the letters. The fence may have been ordered from an iron and wire works catalogue. Its shape completes the notion of resting in peace, as it was meant to keep wildlife off the grave and to symbolize the sleep of death from which the body would be resurrected on Judgment Day.

Iron Markers

Iron markers also appear in cemeteries throughout the Rocky Mountain region (fig. 27). Most are unsigned and undated, or they have sunk too deep into the soil to read signatures without excavation. Like headboards, they are often difficult to attribute to a maker. Early mountain

towns attracted blacksmiths, whose services were required for most commercial operations, as well as such daily necessities as horseshoes. At first, fabrication of simple and sometimes unique grave markers fell within the blacksmith's purview. Soon businessmen established iron foundries, often in connection with railroads and mining operations. Among southern Wyoming's natural resources are deposits of iron and the coal to fuel foundries. The Union Pacific Railroad set up an iron foundry in its Laramie rail yards in 1875 with the purpose of casting "everything wanted in that line by the U. P. Company from a car-wheel to a door-handle or a stove door," as well as "all kinds of castings wanted by the public, from a stove griddle to an iron front for a brick block."[42] The Union Pacific operated coal mines not far from Laramie and planned to recycle scavenged iron until it could open new iron mines and smelters in a few years. Although the company did not specifically advertise grave markers, this was one of the products "wanted by the public," and the Laramie foundry, like any similar operation, could rapidly produce multiple markers inexpensively by casting.

Iron markers assumed many forms, but most appear as a variation on the basic shape of a traditional headstone. Comprised of a single flat sheet of metal, from one-eighth to one-third of an inch thick, many were simply lettered in pencil or paint. These closely resemble the form of wooden headboards. Pipe framed some; a flat rim similar to the rim of an iron wagon wheel bound the edge of others. Foundries also cast many custom markers with raised letters. The simple iron marker for Elizabeth Ferguson Admire, who died in 1879 and was buried in the Salt Lake City Cemetery, contains not only her inscription in raised letters, but also the name of the maker, "Silver Iron Works of S. L. City." A shallow rim frames its sides and slightly arched top.

The Star Foundry and Machine Co. produced much more elaborate box-like markers for Utah residents. By

attaching the cast metal front containing the inscription to a flat back by means of a two-inch-wide sheet of iron along the sides, Star Foundry formed a hollow headstone of more traditional proportions than the solid iron markers. Molded posts at the sides provide ornamentation, as do the lightly etched organic motifs in the pediment area and an urn or finial that could be screwed into the top. Two rusty examples still stand in the Salt Lake City Cemetery, their sharply defined, raised letters easily read.

Wrought iron and wire crosses, as well as a variety of shaped crosses, such as two cut from sheet iron marking Italian graves in Silver Plume, Colorado, were also manufactured throughout the mountain region. As with other materials, the maker of an iron cross memorial need not himself have been Christian. Most monument makers served their communities, seeing the production of a Christian cross, a Hebrew inscription, or a Masonic emblem as a matter of business.

Artificial Stone

Monument makers in the Rockies experimented with all sorts of artificial and exotic materials. One of the first mentions of such an enterprise on the Front Range is a listing for the Denver Artificial Stone Co. in the 1874 city directory. Six years later, A. E. Carter and E. J. Martin opened the Star Stone Works, advertising artificial stone and marble at 270 Larimer Street in Denver. The following year, the same address housed Garner Mitchell & Co., makers of artificial stone and marble, possibly the same company with new owners. In 1889 Colorado Portland Stone Co. advertised stone composition.

One process for creating imitation marble, recorded in 1862, involved soaking plaster of Paris in a solution of alum, baking it in an oven, and then grinding it to a powder that could be reconstituted with water.[43] Another process required soaking slabs of chalk in chemical baths to

alter their color and hardness. In both, the finished product was described as hard enough to carve ornaments or letters and able to hold a high polish. A British mason's guide reported four types of artificial stone manufactured there in the 1860s, three of them with a clay base that had to be fired to harden it.[44] Some artificial stones produced in the United States combined cement with stone chips, sand, or dust to create a pliable material that could be cast or modeled. One patent for artificial granite called for cement powder, slag, borax, charcoal, lead, salt, sand, rosin, and pulverized baryta in the mixture. By the twentieth century, such work was often referred to as concrete. The book *Ornamental Concrete without Moulds* gave detailed instructions "for molding any style of concrete monument as well as placing inscriptions on it, how to mold several styles of urns and . . . grave markers." Another book explained how to face sand molds with crushed granite or marble so that cast cement gained a stone-like surface.[45]

Given the abundance of lime and silica in the Rockies it is no surprise to see concrete and artificial stone companies emerging, but none of those listed above lasted more than a year. Presumably they could not compete with real stone and metal. One of the drawbacks of artificial stone may have been a tendency to disintegrate. Ironically, the Stone family chose a combination of concrete and artificial veneers for their memorial in Ogden, Utah. It has deteriorated so much that one can no longer tell what it originally looked like.

Often indistinguishable from artificial stone, extant ceramic memorials are especially difficult to locate. One example may survive in the small figure of a sleeping child marking the grave of Mabel Sobolewski (fig. 28) in Lakeside Cemetery, Loveland, Colorado. Although this statue could have been formed in a mold and then carved, it also gives the appearance of having been modeled from red clay. The pedestal has a light yellow surface and it rests on

28. Possibly a rare example of a nineteenth-century ceramic or "artificial stone" grave marker, this small figure of a child identifies the last resting place of Mabel Sobolewski in Lakeside Cemetery, Loveland, Colorado. Mabel lived for just over five months in 1886. This could also be a modern figurine.

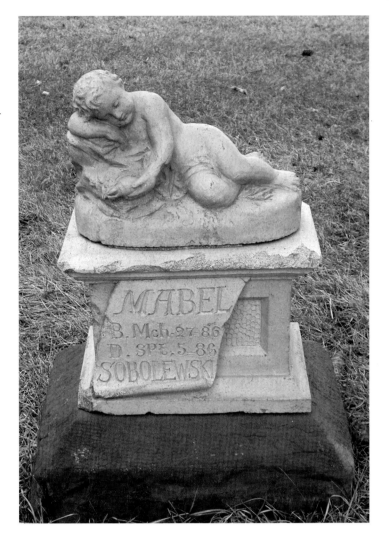

a dark red sandstone base. The Sobolewski child died in 1886 at the age of almost six months. Her parents could have turned to any one of the ceramic businesses in the Rockies that produced a large range of goods, including some grave wares. However, the monument is unsigned and undated. It may have been one of many manufactured by a nineteenth-century production potter, much as garden statues are mass-produced today, or it may be of much more recent origin. It is also difficult to say whether it actually falls into the class of artificial stones, but it was certainly intended to look like a ceramic piece.

29. The professional auctioneer Henry C. Clark erected this impressive monument to his young wife, Anna, who died December 8, 1866, leaving behind a three-year-old daughter. The flamboyant Clark, who had recently ordered a watch made of native Colorado silver with a view of the Rockies on one side and the Territorial coat of arms on the other, chose a unique shell-encrusted material for the obelisk he had erected in Denver's Mt. Prospect Cemetery. The city moved it to Fairmount Cemetery in 1895, and it has since lost its surface finish.

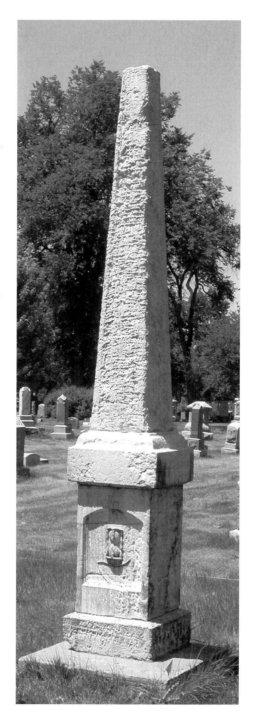

A few memorials of undetermined origin employed exotic materials, like Anna M. Clark's oyster-shell-encrusted obelisk (fig. 29). Most of the original surface has popped off from repeated freeze-thaw cycles, leaving only the forms of empty shells from a section of ancient seabed, but fragments remain that hint at a once lush surface. At one time the shaft probably shimmered with mother-of-pearl or a pink quartz-like material that still fills a few of the shell shapes. The base was cut so that fine layers of silt in the sedimentary rock create a vertical pattern against which the carved relief hourglass and inscription stand out. The unusual choice of materials and careful working of them must once have made a striking sculpture.

The Intramountain Monument Business

Marble headstones and monuments rapidly spread throughout the Rocky Mountain region, proving as popular there in the 1870s and 1880s as throughout the rest of the American states and territories. Many specific marble businesses and carvers who were working on the western slopes of Utah, the front range in Colorado, and southern Wyoming have already been mentioned. Salt Lake City, Helena-Butte, and Denver all became monument-making centers, sending their products throughout the region.

Denver's Willis Z. Bills partnered with William R. Pierce from 1881 through 1883, and their monuments can be found in several Wyoming cemeteries. Later, in partnership with his brothers, Bills shipped monuments to Utah, New Mexico, Arizona, Kansas, and Nebraska as well.[46] The work of Greenlee & Co. is common as far south as Trinidad, throughout the Colorado mountains, and north into Wyoming. In 1884 the Pueblo city directory listed Greenlee, Drake & Co. as the only monument company in Pueblo, Colorado. The next year, the Pueblo Marble Works began production and soon sent work west across

30. The Montana monument maker Leland F. Prescott worked from a storefront in Butte that was typical of such businesses by the 1890s. He used this photograph to advertise his business.

the mountains to Canon City, Salida, and Ouray. The Elias Morris & Co. of Salt Lake City sent monuments throughout Utah and up to Pocatello, Idaho. The work of another Salt Lake firm, William Brown, can be found in Green River, Wyoming.

Whereas these firms each remained fixed in one city and shipped their work, some other monument men relocated frequently. Alonzo K. Prescott became one of the most prolific manufacturers of marble monuments in the Montana mountains. The *Helena Independent* announced on May 1, 1885, that A. K. Prescott was opening a marble yard on lower Main Street, having already built up a trade in Montana Territory through extensive travel during the previous two years. Helena city directories list A. K. Prescott Monuments through 1897, but extant correspondence shows he remained active in the business at least until early 1905, by which time he was also deeply

MONTANA MARBLE COMPANY. R. C. WALLACE, President. O. F. SMITH, Manager. W. B. EDGAR, Vice President
Manufacturers of American and Italian Marble Monuments, Headstones and Tablets. All Kinds of Montana and Imported Granite. Cemetery Work of All Kinds Executed in the Neatest Style. Special Designs and Estimates furnished on Application Office and Yard, 435 LOWER MAIN STREET, HELENA, MONTANA.

FORGOTTEN REMEMBERED

31. Whereas most monument company advertisements pictured a representative gravestone or the company's marble yard, the Montana Marble Company imagined neighboring family plots, where a loving family honors its members with monuments and plants while a negligent family's ancestors are forgotten under weeds and cobwebs.

involved in a number of other business ventures. Prescott opened a branch on South Montana Street in Butte by 1890, managed for a time by Robert A. Ketchin and then by Prescott's nephew, Leland F. Prescott. In 1897–98, this branch became L. F. Prescott Marble and Granite Works (fig. 30), and Ketchin operated a rival monument firm in Butte. Both the Helena and Butte Prescott Monument companies did a large business throughout Montana and Idaho.[47] They advertised extensively in newspapers, city directories, and magazines, and their representatives traveled throughout the territory. The Helena-based Montana Marble Company also covered a fairly large area in Montana, extending into northern Idaho. They used an advertising strategy that employed guilt, making the patron feel responsible for whether the deceased lived on in memory or died forever (fig. 31). Advertising became a critical component in extending a business throughout the region.

Even as Salt Lake City, Denver, and Butte-Helena developed into monument centers, tombstone makers struggled to establish themselves in smaller or more remote cities where they might dominate a local market. The highly mobile mountain population and competition from monument centers made this a challenge. For example,

in Leadville's early years, a succession of marble workers tried their luck and moved on, including George Weaver Jr., B. A. Robinson, and the Ciphy Brothers, whose name and Leadville location adorn a marble monument in nearby Buena Vista. Throughout this time, many Leadville residents turned to Denver or looked even farther abroad for their grave monuments. Not until Herbert H. Judson established the Leadville Marble Works in 1882 was continuity attained. Active in the Young Men's Christian Association and other Protestant organizations, Judson quickly made a name for himself in the community and within a year was said to be employing three stonecutters who turned out $4,000 worth of monuments per year. Judson moved his marble works to the grounds of Evergreen Cemetery by 1885, a convenience for the business and its patrons alike. His unexpected death two years later left a void, soon filled by Ansel E. Bull. Bull's wife, Nancy, had divorced him less than a year earlier and Ansel took up residence at Evergreen Cemetery, serving as its caretaker. He also assumed control of the marble works at the cemetery and worked them until he left town about 1889.[48]

The next important figure in Leadville monuments was William L. Malpuss. He started in the business in partnership with his brother Charles in 1894, jointly running the Leadville Marble Works under the name Malpuss Brothers. This must have been a difficult year, since William lived in Como on the other side of a mountain from his brother and the marble works. He soon moved to Leadville, where he managed the business under his own name. Several limestone monuments in the form of tree trunks bear his signature, including a short stump for Ellen Powell and seven-foot-tall ones for Woodmen of the World members John C. Kolb and B. W. Black (fig. 32). The Kolb and Black monuments were each carved from a single block of limestone to appear as if they have a bird

32. The Leadville monument maker William Malpuss received the standard payment of $100 for this carved limestone tree trunk in the summer of 1896. The Woodmen of the World had verified that he had erected it on the grave of Woodman John C. Kolb, in the Ancient Order of United Workmen section of Evergreen Cemetery, Leadville, Colorado. The inscription for the twenty-two-year-old Kolb reads: "We loved him, Picture of the mother, was our sweet bud and darling brother."

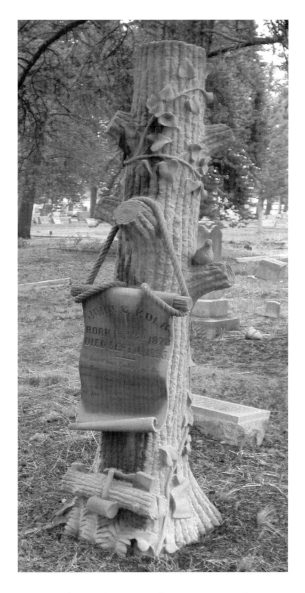

sitting on one branch, a scroll containing the inscription tied on by means of a rope, the insignia of the fraternal order in a still life composition of ax, mallet, and wedge, and a twining ivy vine with a small scroll giving the signature "W. L. Malpuss Leadville Colo."[49] Malpuss's success, like that of Judson, owed much to his involvement in the community. He joined the Woodmen of the World, one of the largest fraternal orders in the northwest, and advertised in its member newspaper. This allowed him to

become acquainted with many people who had purchased Woodmen insurance, with its guarantee of a monument paid for by the association at death. Although the official monument maker for the Pacific Jurisdiction Woodmen was located in Denver, many camps preferred to give their business to one of their own local members; this strategy worked well for Malpuss, whose name appears regularly in Woodmen financial records.

After the turn of the century, David B. Olinger expanded his Denver monument business by acquiring the Leadville Monument Works. In 1906 he hired as secretary and treasurer William Youe, a twenty-year resident of Leadville with a work history that included laundry owner, bookkeeper, wagon driver, and dance instructor. Within a couple of years, Youe had become the proprietor of the Leadville Monument Works and a successful agent for the Cincinnati-based Stewart Iron Works, which provided fencing for cemetery plots. Previously, the Bills Brothers of Denver had represented Stewart fences in Leadville. Leadville's monument history is a history of competition with Denver, the biggest monument center of the region, but Leadville's location so high in the mountains and the desire of many Leadvillians to patronize local businesses worked in favor of the local monument makers.

Like other industries, monument making constantly changed as new materials and techniques gained favor. By 1890, granite had begun to overtake marble in popularity. Like monument makers farther east, those in the Rockies added a line of granite to their marble stock-in-trade. The larger urban firms often gained the advantage when they had the capital to modernize or could lease equipment from a neighboring company. Pneumatic tools were invented in the 1880s, in part to deal with the density of granite, and they came into common use in the 1890s. The pressure from a compressor pushed air through a hose to the chisel's mobile cutting head. This removed the need

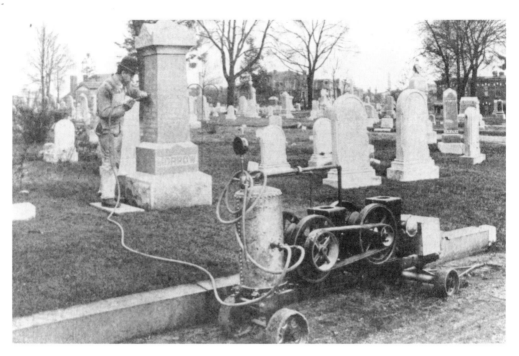

33. A letterer uses a seven-hundred-pound "mobile" pneumatic chisel to add to or correct the inscription on a granite monument sometime around 1910. From *Monumental News*, March 1913, p. 225.

for a mallet and replaced the force of the arm's striking blow with the force of air pressure. The skilled hand of the carver still controlled the tool. This equipment was even mobile enough to take to the cemetery when additional inscriptions were desired (fig. 33). The Denver monument maker Richard A. Swanson discovered that the same cylinder of carbonic acid gas that charged water at the soda fountain could be used to power his pneumatic tools in the cemetery.[50] Without pneumatic tools, granite could not have been used for gravestones in the ways that earlier types of stone had. With them, monument centers produced even more tombstones and monuments to be sent throughout the Rockies.

Technical innovations always take time to catch on, so even though most businesses made the transition within a decade or so of new equipment becoming available, in 1913 the national trade journal *Monumental News* pointed out that some smaller shops around the country had yet to make the switch. By way of incentive, it noted that a lettering job that took twenty hours with hand tools

34. Frank Beck's granite monument provides a good example of rock face, the carefully contrived appearance of a natural rock surface that at first became popular for use in large monuments commemorating outdoorsmen such as Beck. His wife, Agnes, may have requested the portrait of Frank's faithful setter pointing down at the grave in Mt. Moriah Cemetery, Butte, Montana.

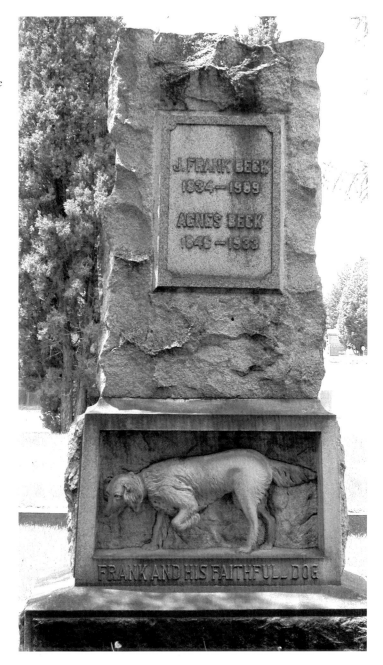

required only eight with air tools.[51] Around 1910, some urban plants began installing electrically driven chisels and grinders, making it even easier to work with hard stones such as granite.

A new style of surface finish for grave markers appeared

35. An anonymous carver simulated rock face on the polished marble surface of the Driscoll monument in Pocatello, Idaho, resulting in a highly stylized effect. This pseudo rock-face texture gained some popularity after 1900.

throughout the country with the introduction of granite, which is such a hard, granular stone that finely carved and highly polished surfaces cost more to produce. Granite fractures along rough bowl-shaped lines, and workers discovered that repeated chipping with hand tools rapidly produced the appearance of a natural rock surface. Dubbed "rock face," this inexpensive finish became especially popular for large monuments in the 1890s (fig. 34). Monument dealers recommended it as the appropriate style with which to remember outdoorsmen and people

of strong character, but it quickly became popular for all sorts of monuments, giving rise to controversy within the industry. Some carvers and dealers considered it inappropriate for small markers; others thought it had become too common, and in filling cemeteries it brought down the general quality of sepulchral art.[52] Others advocated it as a chance to bring something different into cemetery art. The presence of imitation rock face on white bronze monuments, artificial stone such as the cast example in the Salt Lake City Cemetery for Elizabeth Ferguson Admire, and even on marble monuments, whose inherent properties made a natural rock-face effect impossible, bears witness to the popularity of rock face work (fig. 35). The Denver Marble and Granite Co. made a specialty of it.

The intramountain monument business required that monument centers produce a diversity of work. Rocky Mountain pioneers came from all over the world and nineteenth-century monuments had to be lettered in many languages. Some may have been carved by native speakers, especially in the case of some Italian, German, and Scandinavian stone workers, and even miners and quarriers who were used to working with rock and could have carved their own markers. An example in Swedish for twenty-one-year-old I. Aldrich Peterson who died in Carbon, Wyoming, in 1887 and is buried in Green River bears the somewhat cruder lines of an untrained letterer or folk carver and may well have been executed by a fellow Swede. Some monument firms in the southern Rockies may have been owned by native Spanish speakers, and others almost certainly employed some Spanish-speaking carvers. Hebrew inscriptions are common on Jewish grave markers and some of the earliest stone carvers in the Rockies were Jewish. However, it was not actually necessary for a tombstone carver to understand the inscriptions he carved. The skill of cutting stone into any shape of ornament or letter was shared by the early freehand carvers,

as long as they had an image to follow. Of course, some were better at this than others. There is, as yet, no clear evidence of any individual carver working in his native tongue. Nor is there documentation for the assumption by many scholars that non-English-speakers took their handwritten inscriptions to English-speaking monument carvers to be traced or stenciled onto their tombstones before 1900. However, there is evidence of this practice fairly early in the twentieth century.

The records of the Butte Tombstone Co. in the Montana Historical Society include three large sheets of tracing paper with characters of unidentified Asian origin, two with Hebrew inscriptions, and one with Serbian letters in sizes intended for transferal to the stone for carving. One Asian design carried an additional English inscription stating that the person memorialized died April 21, 1919, and in pencil the notation that Fritz commenced work on the stone at 2:45 on October 7, 1919, and finished at 3:40 on October 8. Two other Asian inscriptions have no date, but one contains a note to the effect that Max completed the work in three and a half hours at a cost of $5.45. These examples may mean that by 1920, foreign-language inscriptions were being carved from traced or transferred images by English-speaking stone carvers. Although I have suggested that inscriptions on the earliest wooden markers at Chinese and Japanese graves may have been painted or drawn by native speakers, it is possible that stone markers also existed in the nineteenth century with carved or painted Asian-language inscriptions. Several headstones in Missoula's City Cemetery, for Japanese railroad workers who died in the 1890s, may eventually prove to have been carved in the nineteenth century. The Northern Pacific Railroad had exhumed these remains from a burial ground in Wild Horse Plains, Montana, and removed them to Missoula around 1903 because the railroad was going to be relocated through their original burial ground.

Several of the headstones now marking the graves bear the signatures of the Missoula monument maker George Pringle or of the Missoula Marble Works, but it is not clear whether they had been ordered at the time of death and were moved from Plains during the relocation or were carved and erected in the twentieth century. Several of uniform design bear the notation "erected by J.M.B.A.," possibly the Japanese Memorial and Burial Association, about which little is known. So far, neither nineteenth-century carved stone markers in Japanese or Chinese nor documentation of their existence has been found in the mountains. Serbian-language monuments also typically date from the twentieth century.

Those who created the monuments that turned Rocky Mountain graveyards into sculpture gardens used their varied training and a wide range of materials to put some variety into the standard forms of cemetery monuments. They served a diverse and mobile population. They also came from different categories of the labor pool and approached their tasks with different goals.

Cutter, Carver, Sculptor

There is a great divide, psychologically, between the craftsman or artisan stonecutter, who was often called a mechanic in the mid-nineteenth century, and the sculptor, who saw himself as an artist. Michele Bogart has discussed this division with regard to civic sculpture erected in New York City between 1890 and 1930, with particular attention to the difficulties prominent sculptors encountered in working with union cutters and carvers.[53] The situation was rather different with regard to sepulchral sculpture of the Rocky Mountain West, where cutters and carvers also served as designers and rose to management positions in the firms that controlled monument production. Traditionally, stonecutters learned their trade through apprenticeship. The new apprentice was assigned simple

tasks that taught him (almost never her) about the nature of the various types of stone, the proper use and care of the tools, and basic design and processes. He learned to shape stone and polish it to a high finish. He might later be put to cutting simple moldings, turning columns, and hammering finishes. If he proved skilled, he would be given ever more elaborate ornaments to carve and would be taught the techniques of lettering. Even after he left his apprenticeship, he would continue to develop his skills and might move from the classification of a polisher to that of a cutter to that of a carver. In some areas, carvers received higher wages than cutters. For example, New York City marble cutters received $3.50 in 1891 for an eight-hour day, while marble carvers received $4.00 for the same period of time.[54] Both cutters and carvers could belong to the same unions; the distinctions within the ranks of craftsmen were based on levels of skill. In the 1860s, Edward Gaffney received notice that the contract for an important monument to be erected in New Mexico would be divided up, with the ornamental carving to be done in the East and the "rougher work" to be done "in the Territory, by its own mechanics."[55] The common assumption that artists and artisans in the United States had greater skill than those in the western territories handicapped the earliest monument makers of the West.

Reflecting on his long life in the business, Carroll M. Bills noted that in the 1850s and 1860s, monument makers throughout the country commonly worked from rubbings of existing monumental ornament or from crude, freehand sketches.[56] They bought their marble rough cut from the Vermont quarries and did all carving and lettering themselves, hiring additional carvers for big jobs. Early monument carvers throughout the Rockies worked with hand tools: chisels and a mallet. They often moved from firm to firm and town to town looking for employment and they carried their tools with them. As time went

on, the monument-making business became increasingly specialized and professionalized. Trained draftsmen and designers invented designs and rendered them in scale drawings from which cutters and carvers worked. The one-person, carver-owner shop became a complex business with separate departments for designers, cutters, carvers, polishers, letterers, and salesmen. Wholesalers distinguished themselves from retailers and separate unions or associations formed around each branch of the monument business. The *Granite Cutters' Journal* began publication in 1877 in New England, followed by the *Monumental News* for monument makers and dealers, which began publication in 1889 in Chicago. The Stone Cutters' Association of Denver met in the early 1880s; by 1893 both the Stone Cutters' Union and the Granite Cutters' Union were active there. The Stone Cutters' Union met every other week, and its leadership usually came from the ranks of the quarriers and building stone dealers. The Granite Cutters' Union met only when called by its secretary, the monument maker Frank Hoenes. These national unions were intended to regulate the quality of craftsmanship and help improve working conditions and wages.

In the last quarter of the century, those carvers who wanted to excel in the business, and especially any with aspirations to owning their own monument shop, often took classes at an art or design school in drawing, architectural drafting, and modeling from life. James Henry Whitehouse trained as a stonemason and ran his own Steam Stone Works in New York City in the early 1880s, where he also carved architectural ornaments for St. Patrick's Cathedral. Moving west through Chicago and Kansas City, he arrived in Denver by the end of the decade. Here he carved architectural ornaments for the Brown Palace hotel, St. Joseph's Church, and many residences. He also designed grave monuments. His effects,

preserved in the Colorado State Historical Society, include a beautiful drawing of a nude male model, typical of an academic art education, many books of ornament, several volumes of the work of the Danish sculptor Albert Bertel Thorvaldsen, architectural journals, materials from the World's Columbian Exposition, and catalogues of Catholic statuary, all indications of his attempts to supplement apprenticeship training with a fine art education.

The building-stone-worker roots and artistic aspirations of carvers like Whitehouse could reasonably intersect in the cemetery. Many grave markers exhibit architectural features, even setting aside the mausoleum and the solid miniature cabins that mark a number of graves. A single column on a base formed a fairly common monument. Some were shaped to appear as if broken; many began as complete columns, but have since broken. Some have statues or carved baskets of flowers on top, and others are indistinguishable from their counterparts holding up a downtown building. By the end of the century, colonnades and canopies had replaced single columns in popularity. Roofless arcades such as a Romanesque example on the Montana family plot of Annie and William Thompson (fig. 36) probably descended from the fabricated "ruins" in eighteenth-century English landscape gardens. Walls, upright shafts terminating in four pediments, and exedra all became popular family monuments. Peggy McDowell and Richard E. Meyer have looked at the revival styles of architecture in the late nineteenth-century American cemetery context, and all of the styles they discuss can be found in the Rocky Mountain region.[57] This architectural character of so many cemetery monuments is a product of the close historical relationship between architecture and sculpture down through the ages, as well as the predictable result of monument makers training in the building stone industry and often serving both markets simultaneously. Yet no matter how artistically rendered the column,

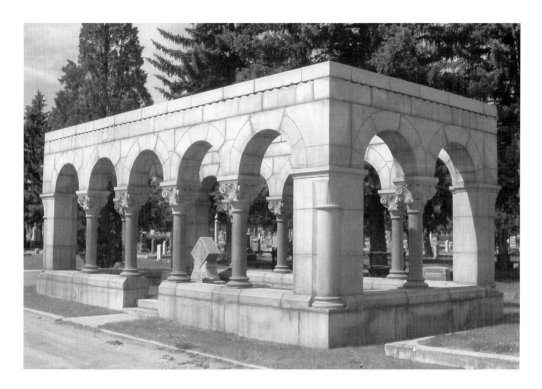

36. The Thompson arcade was dedicated "to the memory of Father William Thompson and Mother Annie M. Thompson whose righteous lives have been an inspiration to their children." Its physical reference to medieval cloisters suggests a sacred space enclosing individual monuments for family members, including infant son Arthur, who died in 1887. Mt. Moriah Cemetery, Butte, Montana.

arch, or pediment, these monument forms remained in the realm of building industry skills. Those who wished to rise to the realm of the artist required additional training.

An article in the *Monumental News* in 1906 discussed the artistic training available to monument makers at the Chicago Art Institute, Minneapolis School of Fine Arts, Pennsylvania Academy of Fine Arts, School of Industrial Art of the Pennsylvania Museum, and Maryland Institute in Baltimore. Leslie Miller, principal of the Pennsylvania Museum's school, wrote that times had changed and the old apprenticeship methods could no longer work. Instead, even the sons and daughters of monument men were choosing to be educated in schools. The Maryland Institute submitted that "drawing and modeling, with a knowledge of historical ornament, are most essential to the stone-carver who wishes to become a high-grade artisan, and often leads to a higher development. A goodly number of our best sculptors came from the ranks of the stonecutters who have devoted their spare time to study."[58]

Probably the largest group of working stone men was found in the Art Institute of Chicago's night school, where three hundred people enrolled at fifty cents per week. The sculptor Charles Mulligan ran the sculpture classes.

By the late 1890s and just after the turn of the century, young men from the Rockies began going to Barre, Vermont, where they could attend night school for art with a focus on monumental design and also apprentice in one of the many granite monument finishing plants there. Donald Harold, a long-time monument maker and proprietor of Pueblo Marble Co. in Colorado, sent Donald Harold Jr. to Barre for three years, even though the son must already have learned a great deal about the business at his father's side.[59]

The craftsman/artisan perspective varied from the sculptor/artist perspective in subtle ways. Both took pride in craftsmanship, but the former considered this a job for hourly wages where the identity of the individual doing the work was not important, only the quality of the work. These stonecutter/carvers often moved around the country picking up work where they could. The sculptor/artist valued originality, creativity, and ideas as much as craftsmanship and attempted to promote his work as an individual of exceptional talent. These two perspectives tended to blur at the point where excellent carvers, trained through apprenticeship to the craft and usually loyal members of a union, took on independent jobs carving figurative work. The *Granite Cutters' Journal*, a union paper, argued that "while granite carvers are esteemed and appreciated because of their skill, that is not a good reason why they should consider themselves a sort of an aristocracy in our trade. . . . It does not follow that because a man is a carver he is always a better mechanic than a good granite cutter, for some of those men who have made records for themselves cutting eagles or romanesque ornaments, if put to cut a fine moulded piece of granite, could not

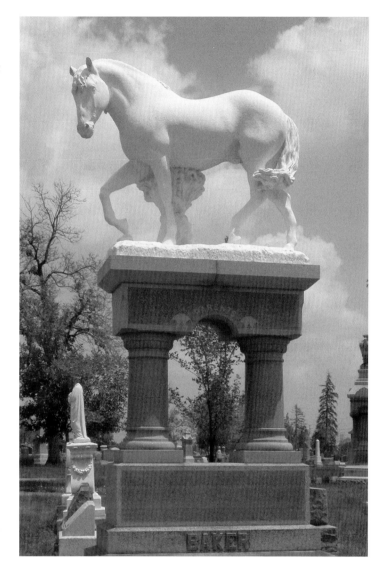

37. The marble cutter James A. Byrne set out to prove his worth as a sculptor with this life-size marble horse for the Addison E. Baker family, 1884–1886, Riverside Cemetery, Denver.

make the same headway as other members of the trade who have made a specialty of such work."[60] The unions always stressed brotherhood over individuality. Equal pay and equal working conditions for cutters and carvers was part of their message, so it was hard for one to excel out of the ranks of the union workers into the class of the fine artist, where individuality had been stressed since the Italian Renaissance. Yet a number of carvers did exactly that, consciously remaking themselves into sculptors.

James A. Byrne exemplifies the apprentice-trained, union

stonecutter turned marble monument carver and sculptor. He arrived in Denver in 1879 at the age of forty-three with a wife, three sons, and a daughter. Born in Boston, he had already learned the trade of marble cutter and spent a number of years in St. Louis improving his art before he made this final move west. In Denver he formed a partnership with Ernest Kuster to produce monuments, and when that failed in 1882 he became a marble cutter for the firm of Bills & Pierce.[61] The next year, the city directory listed him as a marble carver, suggesting a step up the ladder in that firm. Byrne's big break came in 1884, when Lily Baker Snell commissioned him to carve a life-size marble horse for her parents' burial plot at Riverside Cemetery (fig. 37). She was particularly close to her father, Addison E. Baker, with whom she shared a love of horses. Addison had come to Denver in its early years and provided the first water service by putting spring water in barrels and delivering it to residents. A drover in New York, he continued to raise horses in Denver, and according to his daughter, his favorite was a white Arabian named Frank. When Addison died on June 20, 1884, Lily conceived the plan of placing a replica of Frank over his grave. She told a local reporter, "'To have the statue of his best-loved horse placed over my father's grave was entirely my idea . . . and I did it only because he loved horses almost more than his own blood-kin.'"[62] One can hear affectionate amusement in this statement, but it has ever since been misquoted. By omitting the word "almost," local newspapers have transformed her statement into the more dramatic "he loved horses more than his own kin." She also stated that her brother, Nathan Addison Baker, was not enthusiastic about the plan, so she set out to find a sculptor herself. That sculptor was James A. Byrne.

Byrne told Lily Snell that he expected the statue to provide good advertising for him so he would make her an especially good price: $2,500.[63] She was reportedly worth

$100,000 upon her father's death and agreed to Byrne's terms. Byrne supposedly ordered a single, eight-ton block of Carrara marble and set up a studio in a local barn. Lily provided the horse for his model and he set to work on a task that challenged his abilities. Fearing that the weight of the body would snap the thin ankles, Byrne carved the horse with a shock of wheat and a small sickle under its belly. This provided an additional mass of marble to support the upper part of the sculpture and could be read symbolically as the harvest of death. A wheat shock with a sickle was a common symbol of death on grave markers and monuments at this time, particularly popular among Christians because of its association with sacramental bread and the body of Jesus Christ.

A schoolgirl who stopped at the barn to see Byrne's progress each day later reminisced about it. She remembered that Byrne left a chunk of marble on top of the horse's head until the very end, uncertain how to carve the ears. "Then one day I heard him chipping away. He said: 'The horse decided me about the ears. I said to him: 'How will I make your ears?' He turned and crooked his neck and pricked up his ears, so that is the way I carved them.'"[64] Byrne may have continued to have trouble with the ears, however, as one of them broke only a few years later and Mrs. Snell reported hearing that it had actually broken during the carving process. She thought the cement Byrne applied to fix it had failed. Eventually, two of the legs would also break and be repaired. Byrne spent six or seven months carving the horse and signed it on the side of the base, where it is visible from the ground, "J. A. BYRNE." When it was complete a local monument firm, perhaps Willis Z. Bills, with whom Byrne had recently been associated, erected it on top of a tall granite pedestal. It quickly became a local wonder and was even photographed and reproduced in a national journal of monuments and sculpture.[65]

That Byrne saw himself as having made the leap from carver to sculptor is suggested by the appearance of the word "sculptor" and his own address after his name in the city directories of 1885 through 1888. He also began to carve and exhibit work unrelated to the cemetery. In 1886, a local newspaper reported that he was working on a marble bust of Roger W. Woodbury, a man who helped establish the city's first public library and was president of the Chamber of Commerce, a bank, a smelter, and a railroad company, in addition to owning the *Denver Times*. Unfortunately, Woodbury lost his fortune in the silver panic of 1893 before the sculpture was completed, and the bust's location is now unknown. It was apparently not a commission, but Byrne must have had high hopes that it would find a purchaser from among the city's elite. He exhibited it in unfinished condition at the Manufacturer's Exposition in Denver in 1886, hoping to showcase his portrait-making talent for would-be patrons.[66]

In 1893 a controversy broke out among Denver artists when a group of influential women proposed that they pay for a sculpture by Preston Powers—son of perhaps the most famous American sculptor before the Civil War, Hiram Powers—to be executed in bronze and sent to represent Colorado at the World's Columbian Exposition in Chicago. Preston Powers had a studio in Denver and taught sculpture at the University of Denver. He had proposed a composition called *The Closing Era*, showing a Sioux Indian with a dying buffalo. As soon as this proposal was made public, John Howland, a local painter who specialized in buffalo pictures, protested that it was "thoroughly bad," because the sculptor did not know his subject. Howland obviously held a grudge against Powers that he freely expressed in a long diatribe against *The Closing Era*, but of particular interest are his comments on cemetery sculpture. Noting that Preston Powers had approached Howland to design an earlier sculpture and

prepare the sketches and that Powers would not pay How-
land's price of $500 for this service but thought he should
simply do it for a brother artist, Howland went on, "I said
I did not regard him as an artist, but simply as a clever me-
chanic, able, perhaps to cut an ivy leaf on a woman's cor-
sage, but that all his work I had seen was simply graveyard
sculpture."[67] This is clearly meant as a put-down. How-
land then immediately reversed himself, suggesting that
if a local artist was required to represent Colorado at this
all-important world's fair, then "Mr. James A. Byrne, who
carved the horse at Riverside cemetery—a really remark-
able achievement," would be a better choice than Pow-
ers to do it. The mixed message in Howland's interview
replicates the mixed feelings some carvers had about the
lines between sepulchral sculpture as craft and art. How-
land seems to be saying that symbolic ornament, such as
the ivy leaves so commonly found on grave monuments,
represented the stonecutters' craft, while a free-standing
figurative sculpture with an original composition, even if
placed on a grave, represented fine art.

Byrne did prepare an entry for the World's Fair, called
The Wounded Buffalo. Unlike Preston Powers's work,
which was cast in bronze through the auspices of the gov-
ernor's wife and her friends and now decorates the state
capitol grounds, Byrne modeled his composition in plas-
ter. He exhibited it in Denver before sending it to Chicago,
where it received brief mention in the national journals
Art Amateur and *Monumental News*, but it has since dis-
appeared and no image of it is known. This was the begin-
ning of a period when Byrne actively sought to improve
the artistic quality of sepulchral sculpture nationally. He
sent a letter to the *Monumental News* suggesting that a
congress of sculptors be held in Chicago in conjunction
with the fair. That idea met with little favor from promi-
nent sculptors.[68]

As the place where the highest forms of sculpture and

38. Even the simplest of gravestones, such as a small marble marker for a baby in Helena's Forestvale Cemetery who died before she had even been named, often display elegant lettering and some form of ornament. In this case a cut rosebud symbolizes an early death.

popular forms met, the cemetery seemed to Byrne, and like-minded individuals, a fertile ground for educating the public in art. In 1895 he wrote a long letter to the *Monumental News* asking monument workers to pay more attention to the artistry of smaller markers and inexpensive monuments. He conceded that large monuments and the country's prominent sculptors had made great strides, pointing to the well-known sculptor of bronze monuments, Daniel Chester French, as an example of someone who took an old theme and gave it a new face. "For instance, the career of Mr. Daniel C. French, so ably discribed [*sic*] in the January number of the MONUMENTAL NEWS by Lorado Taft. From the carving of a frog in a turnip, to the master-piece his 'Angel of Death, and the Sculptor.' Here an old theme has been so ingeniously changed

as to become new and original, we see nothing here of the skull and cross bones to represent death, neither the draped skeleton, with his ruthless spear; his death is a well formed female figure."[69]

Byrne argued that so many small monuments were erected every year throughout the country that they could provide a great education in art for the general public if they were made with good proportion, originality of design, and excellent craftsmanship (fig. 38). He gave three examples of the type of work that could be made into a small monument and the symbolic meanings that would be derived therefrom, concluding: "Thus it will be seen, that with a little study many of the old emblems can be so changed as to arrangement that they will look new and original." In pointing to a well-known sculptor from the world of fine art as his model for such original reworking of old themes, both Byrne and the trade journal were endeavoring to elevate the sights of monumental workers in the cemeteries. The journal regularly reported on sculptors, exhibitions of sculpture, and other fine art matters, in addition to the business of monuments.

Byrne envisioned himself as gaining the status of a great sculptor without leaving the field of sepulchral art. The same year that he submitted *The Wounded Buffalo* in Chicago, he also carved an elaborate group for Mt. Olivet Cemetery in Denver (fig. 39). In subject, it was conventional, but in conception, original. It consists of a central cross flanked by a kneeling angel and a standing angel on a rocky mound. The wings have broken in recent years, but the original idea is still clear. One angel takes the pose of the Angel Gabriel as he announced to Mary that she would bear the son of God. This is a pose familiar from Renaissance paintings and may have been intended to bring to mind the absent figure of Jesus. However, this kneeling angel is female and clasps her hands and lifts her head in supplication. The other angel stands above

39. James A. Byrne carved two angels, a cross, and a plaque with a poem in marble and placed them on a rock cairn carved from another piece of stone. The 1893 memorial bears no family name but may be associated with the nearby grave of Elizabeth Frances Countess Cassell in the Catholic Cemetery, Mt. Olivet, Denver.

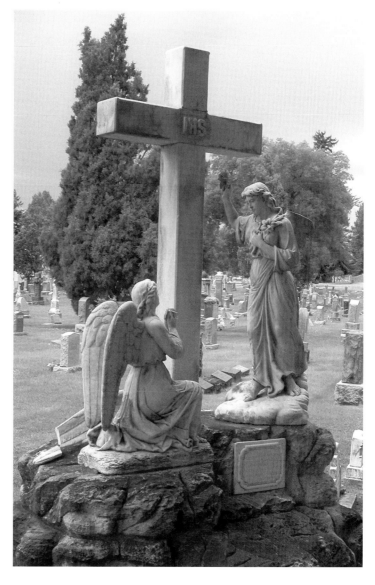

the first and looks down at her. She holds resurrection lilies and lifts her hand toward heaven. The empty cross (although it bears the initials IHS) tells its Catholic audience that Jesus has risen; his body is no longer on earth. The artist signed this monument "J. A. Byrne, sc. Denver, 1893," in a continued use of the title sculptor.

Byrne finally completed his bust of Roger Woodbury and exhibited it in the third annual Artists' Club Exhibition of 1896 in Denver. The Daughters of the American

Revolution commissioned a sundial for the Colorado capitol grounds, and he also carved a fountain for the YMCA that was designed by another local artist, Henry Read. There is no indication of any further large-scale statue commission after the horse and the angels and cross. To support himself and his family, Byrne also accepted carving jobs from local monumental and building firms. From 1889 on, he often worked for the large regional construction firm of J. D. McGilvray, including a nineteen-month stint in California carving a frieze at Stanford University. He carved the elaborate ornamentation over the doorways of the El Paso County Court House in Colorado Springs, and at his death he had the contract to execute the eagles over the windows of the U.S. Mint in Denver. During this time, he sometimes reverted to using the title carver or cutter, and one senses that he had a difficult time making ends meet. He was seventy-two years old and still working when he died of Bright's disease in 1908.[70]

Other stonecutters advanced to the rank of carver and then sculptor, without becoming involved in exhibitions or attempting to associate themselves with art schools. This was especially true of a group of Italian immigrants who came to the mountains at the turn of the twentieth century, fully trained. Even the lowest caste of stone carver in Carrara, Italy, reputedly attended several years of art school training, and this background often made a difference in the much smaller professional arena of the American West. The Italian-born and-trained Oreste Gariboldi (often written Garibaldi) came to Denver at the turn of the century and listed himself as a sculptor in the city directory. He soon went to work as a granite carver for Denver Marble and Granite Co. In 1910, the *Granite Cutters' Journal* announced, "Brother Gariboldi, our sculptor and carver has completed the erection of a good sized shop, and being equipped with all the most modern improvements, has started business on his own account."[71]

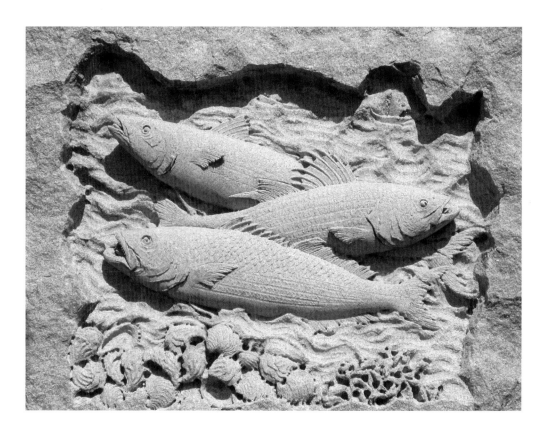

40. Oreste Gariboldi carved the rock-face Pell monument from an eight-by-five-by-three-foot block of Silver Plume granite. The central relief panel depicts a blue fish, a striped sea bass, and a blue-black mackerel over an oyster bed, the favorite fish of famous Denver restaurateur and fish merchant George Washington Pell. Fairmount Cemetery, Denver.

Gariboldi actually took another Italian carver, Ambrogio Bonicalzi, as his partner in the short-lived Western Monumental Co. It was probably around this time, 1911 or 1912, that Gariboldi carved the Pell monument, a unique memorial to Denver's best-known fish and oyster merchant, George Washington Pell (fig. 40).[72]

Pell came to Denver in 1870 with a circus, operated a stage line for a time, and then engaged in the fish business, which he had learned in New York as a young man. An eccentric character, he was beloved in Denver and is said to have designed his own monument to represent his best-selling products. He also operated the Pell Fish and Oyster House until his death in 1911, when his son, George Washington Pell Jr., took over. Pell Jr. described the monument as a tribute to this family tradition, which he planned to pass on to his son of the same name. The initials of these three generations of Pell men, G. W. P.,

adorn the back of the monument, which reportedly cost $1,000.[73]

Oreste Gariboldi also carved the more conventional, nearly life-size granite angel standing in front of a large rock-face cross for the Frazzini family plot in Crown Hill Cemetery, Wheatridge, Colorado. This design can be seen in rural cemeteries across the country, but the Frazzini monument was carved from a difficult piece of black granite containing fairly large chunks of pink quartz and other irregularities that challenged the carver.[74]

Like Gariboldi, but with perhaps less reason, the carver Almond Ernest Pascoe also simply declared himself a sculptor. He was born in England and apprenticed there as a marble mason with his older brother, John Pascoe, who was a master mason. He came to Butte, Montana, about 1904 and spent several years as a marble cutter there, possibly working for the Butte Tombstone Co., but he signed the Edward Nicholls monument "A. E. Pascoe. Sculptor Butte." This is not a monument with a lot of re-lief ornament or three-dimensional carving, just a typical pedimented shaft with a gothic cross finial. Rather than the usual engraved inscription, Pascoe used a European technique to carve narrow letters and ornament, into which he hammered lead wire or sheet lead, producing dark letters flush with the white marble surface. Never-theless, Pascoe thought of himself as a sculptor and as-serted that identity.[75]

The Italian-born Texas sculptor Pompeo Coppini wrote, "It is as wrong to separate the cemetery-monument from the work of the sculptor, as it would be to-day to separate the writer from the printer. . . . Every one who is a high class cutter is, and has the right to be called, a sculptor."[76] He proposed that a special school be developed and sup-ported by the National Retail Monument Dealers Asso-ciation in which to train monument dealers in the art of the monument. Like Byrne, Coppini argued that artistic

originality was the key and he felt that dealers needed to be able to recognize and encourage it in monument makers as well as to educate buyers. He went on, speaking to monument dealers, "The fault that has separated you from the fine art, has been, no doubt, to a great extent, created by commercialism, cold commercialism. . . . You sell your stones like the iceman sells ice, at so much the pound." The repetition of designs in almost exact detail was the great complaint of all who wanted to elevate monumental carving to the status of fine art. By receiving training in the history of art, particularly the very long and prestigious history of sepulchral art, and in proportion and perspective and other aesthetic matters, Coppini believed that "it will not be long before the monument dealer will be looked upon as a real artist, and not simply as the manufacturer of commercial tombstones." Certainly that was the ideal for which James A. Byrne strove, and probably Gariboldi and Pascoe as well.

To understand the extent to which some cutters and carvers regularly succeeded in surpassing the craft to attain fine art, even while mass-producing commercially viable monuments, it is worth turning to a particular class of monuments, those produced for children's graves.

Children's Memorials

Children's deaths often inspired cutters, carvers, and sculptors to exert their best efforts. As sociologists have explained, the death of a child carried double power because communities mourned not only the loss of the child, but also the lost adult he or she would have become. This death of potential sometimes expressed itself in the inscription "How many hopes lie buried here." This phrase is found on the markers for eight-year-old Bertie Collier and twenty-seven-year-old John D. McDonald alike. Regardless of age, their parents felt the loss of their sons to have occurred before each had fulfilled his destiny.

41. An anonymous limestone sculpture of a little boy in Cedarhill Cemetery in Ouray, Colorado, marks the grave of Arthur Raymond Stevenson, son of I. L. and Julia L. Stevenson, who died September 10, 1897, age 2 months and 8 days.

Many of the most visually sculptural grave markers in late nineteenth-century mountain towns were those dedicated by their parents to children. It was considered appropriate for a monument's size to reflect the age as well as the status of the person to whom it was erected, so young children's markers are often relatively small. This also made it possible to indulge in elaborate carving without greatly increasing production time or costs. One of the best examples artistically is a stone carving of a small boy seated on a rock in the mining town of Ouray, Colorado (fig. 41). He wears a dress typical of very young boys in the nineteenth century. Its lobed collar frames his face

42. This marble gravestone for Willie A. and Roy P. Campbell, brothers who never knew one another, uses sleep as a reference to death, but their upright poses and grip on the inscription scroll undermine the iconography. Heavy watering has produced the black growth and stains on the marble. Fairview Cemetery, Salida, Colorado.

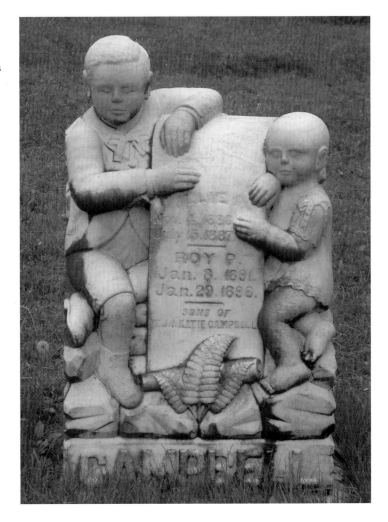

like a flower as he sits with one arm resting on a rock. His distinctive face, believably pudgy hands, and unusual hair style with a curl in the middle of his forehead suggest a portrait, but it is just as likely to be a generic child statue carved by someone who had never seen the deceased.

More iconic are the two boys carved into a marble rock cairn in very high relief for the graves of Willie and Roy Campbell in Salida, Colorado (fig. 42). Willie died in 1887 from "cholera infantum" at eight months of age and Roy died in 1896 from heart trouble brought on by typhoid pneumonia when he was five years old. Their father, William J. Campbell, was an engineer for the Denver and

Rio Grande Railroad, and the death of Roy hit him especially hard. Roy's lengthy obituary was unusual for such a young child, but both parents were apparently well liked and the newspaper noted that "a large converse of friends and members of orders to which the parents belong were in attendance" at Roy's funeral and interment.[77] Upon Roy's death, the Campbells decided to order a significant memorial for both children and probably contacted the Pueblo Marble Co. for it.

Among grave markers for children there are endless variations on the motif of the child figure. A monument for four of the Horn children, whose ages ranged from two months to thirteen years at death, depicts a young boy asleep in a rock grotto, leaning against an older sleeping girl who holds a drooping lily, symbol of resurrection. A monument very similar to this one for Dodo, Della, Aty, and baby Horn has been photographed by Gary Brown in a cemetery in Illinois.[78] The sepulchral motif of two entangled sleeping children derives from Thomas Crawford's *Babes in the Woods* of 1851 (Metropolitan Museum of Art, New York City) and William Henry Rinehart's *Sleeping Children* of 1869 (Pennsylvania Academy of the Fine Arts, Philadelphia), which were inspired by English church memorials. The carver of the Horn monument remains anonymous, but the Denver monument company of Bills & Pierce supplied it to Trinidad's Masonic Cemetery in Colorado. It is finely carved and reflects the pride taken by its carver in his work.

Rocky Mountain cemeteries also contain many anonymous statues depicting a child lying on top of a marker. The scholar Ellen Marie Snyder has demonstrated that these were quite popular nationally.[79] She posits that beginning in the late 1830s the concept of childhood innocence was coming into vogue and that sepulchral statues of children with domestic artifacts "conveyed visual messages about the sanctity of childhood and its separateness

from the marketplace and the adult world of insincerity."[80] One of the more unsettling, yet common variations on this theme depicted the child lying dead at the base of a tree stump. Probably intended to invoke the babes in the wood motif, it also suggests the close relationship of nature and death.

Numerous monument makers depicted angels as the focus of memorials for children. George and Lizzie Marsh chose a child angel to mark the grave of their beloved, nearly eight-year-old son Georgie who died in Montana in 1883 (Mt. Moriah Cemetery, Butte). This full-round marble angel sleeps at the base of what was probably a cross, in virtually the same pose as the child in the Sobolewski monument. He holds a memorial wreath in one hand and a scroll with the other that announces, "Our angel boy at rest." Well known in Butte because of his "remarkable size," Georgie was publicly mourned when an attack of laryngitis inexplicably proved fatal.[81] The sleeping angel was a popular method to doubly symbolize death and resurrection, since sleep implied a future awakening into new life and the angel wings revealed a soul accepted into heaven. Another version of the sleeping angel motif depicts a very small girl angel in high relief lying on her side on the rock shelf of a scroll-draped cairn. Examples of this monument can be seen in cemeteries in Cheyenne and Helena.

Still more graphic in its reference to death is the badly damaged marble sculpture of a girl wearing a nightdress seated on top of her coffin in Denver's Riverside Cemetery. A memorial wreath once decorated the end of the coffin and a palm frond on its lid symbolizes victory over death, an idea also referenced by the fact that she is portrayed as no longer in her grave. The portrayal above ground of what actually exists below it—a girl child and a coffin—is unusual for this time and place. However, there are a number of similar, much larger sculptures in other parts of the

country for adults. Slightly more common in the Rockies is the nightgown-clad girl seated on a rock cairn either praying or recording a name. Contemporary scholars may read sexual messages into the child's nightgown falling off one shoulder, but innocence was surely the intended message.[82] One in Colorado Springs and another in Denver are almost identical. An old photograph also shows such a monument in downtown Denver, apparently waiting to be inscribed with a name.

More numerous on children's graves are monuments featuring children's clothing. There are many examples, mostly unsigned, of socks and shoes on scroll-covered rock cairns from Walsenburg, Colorado, to Bozeman, Montana. One high-top buttoned shoe usually stands upright, while the other lies on its side, and a sock sometimes hangs down the back of the monument. The image of empty shoes vividly calls to mind the absent body of the child. It is a poignant reminder that the child's body now lies in a box at the foot of the carved marble monument, and that socks and shoes will never be needed again. A signed example in Sunset Hills Cemetery, Bozeman, by the Helena monument maker A. K. Prescott marks the grave of Jamie D. Yerkes, who died in 1890 when he was five and a half. Jamie's father, the publisher of the *Bozeman Chronicle*, was critically ill in New York City when Jamie died of pneumonia and did not learn of his eldest son's death until after his own recovery.[83] He and his wife presumably placed the marble socks and shoes monument on the grave within a year or two of Jamie's death. As the real body disintegrated, this vision of abandoned shoes invoked his invisible spirit.

Another socks and shoes monument in Butte's Jewish Cemetery carries the inscription "Infant Baby Died at Birth." This child never learned to walk and the parents' choice of monument imagery and inscription causes the viewer to focus on the loss of the child's future.

One of Prescott's specialties was a marble child's tufted armchair monument with ornamental cloth swags between the chair legs, a small cloak with tasseled cords draped over one side of the chair back, and a wide-brim sun hat with a ribbon around its crown resting on the chair's cushioned seat. Three of these marble chair memorials for children who died in the winter of 1885–86 during a diphtheria epidemic sit within twenty paces of one another in Helena's Benton Avenue Cemetery, two bearing the A. K. Prescott signature. The monuments' clothing is that of a little girl, but patrons purchased the monument for boys and girls alike. Another good example may be seen in Mt. Moriah cemetery in Butte for two children of General Charles S. and Mittie A. Warren, pioneers who were active in the social and political development of Montana. Little Charley Warren was born two years after his sister Clarita died, but he was his father's namesake and it was his death in 1886, at not quite four years of age, that prompted the erection of this monument.[84] Rather than represent both girls' and boys' clothing, the Prescott carver created a memorial identical to others, with tasseled cloak, sun hat, shoes, and stockings.

One or more of Prescott's carvers may have specialized in the chair monument, but it was not unique to this firm. One of the most poignant examples is the memorial for Hedley Harold in Pueblo (fig. 43). Hedley succumbed to pneumonia in 1891 when he was four and a half years old.[85] He was the son of a monument carver, so it is entirely possible that his father carved this unsigned monument. The 1886 city directory lists Hedley's father, Donald Harold, as a carver for the Pueblo Marble Co., which was owned and operated by A. L. Bonney. Within three years, Harold had gone into partnership with Jonathan W. Finn to take over the Pueblo Marble Co. and about 1890 he became the sole proprietor. In this position he could also have had one of the company's carvers create

43. Little Hedley Harold's monument marked his grave in Mountain View Cemetery, Pueblo, Colorado, from his death in 1891 until the grave and monument were moved to Roselawn Cemetery in 1901. In that year Hedley's mother died and his father purchased a family plot in the newer cemetery, where they could lie together. Hedley's marble monument resembles others in the Rocky Mountain region that created a sense of nostalgia through detailed still life arrangements of children's abandoned clothing. It was probably supplied by the Pueblo Marble Co.

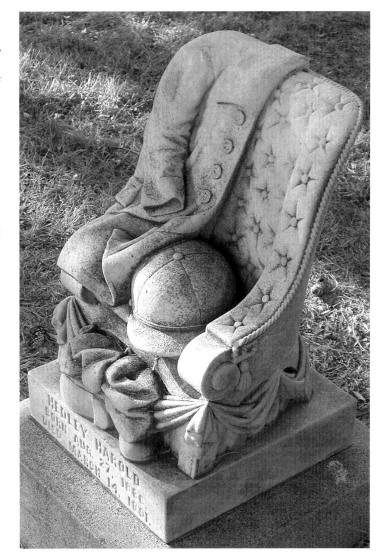

his son's memorial or ordered it from a larger firm. Unlike the chairs just described (and similar compositions found in other parts of the United States), this one has a cloth cap on its seat rather than a straw sunbonnet, and a boy's buttoned coat over the back. Soon after Donald Harold laid his wife to rest with a simple marker, he moved to Denver, where he built a marble and granite finishing plant in 1904. He operated Donald Harold Monuments there, sometimes in partnership with other men, until his death in April 1916.

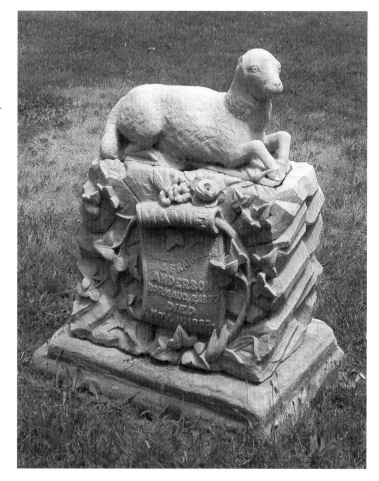

44. The Salt Lake City marble carver and manufacturer William Brown provided this elaborate lamb memorial for Mamie Anderson's grave in Mt. Olivet Cemetery around 1884. Brown was one of hundreds nationwide who produced the ever popular lamb markers, but unlike many others, both a signature and the deeply carved ivy, flowers, and pristine inscription bear witness to the carver's skill.

Even more common than statues of children or their clothes were statues of resting lambs (fig. 44) and dead doves (fig. 45). Some of these are quite unremarkable. The stock lamb lying at the foot of a very short tree stump could be ordered from any local monument maker or from national suppliers. More individualized lamb monuments also abound, such as a pet lamb lying on a round cushion that marks the grave of three-year-old Lessie Erickson in Blackfoot, Idaho. The carefully curled lamb's wool, alert pose, and individually carved cushion tassels by the Logan, Utah, carver P. O. Hansen set it apart from more generic examples. For Christians, a lamb monument referred simultaneously to the child as a lamb of God—one of Jesus'

45. The tree stump background typical of dead dove and lamb markers is derived from ancient Greek sculpture, where it had provided physical support for figurative sculpture. But in late nineteenth-century sepulchral monuments it often assumed the form of a rustic cross, playing symbolic and compositional roles rather than structural. Henry J. Tenney monument, ca. 1894–1900, marble, Evergreen Cemetery, Leadville, Colorado.

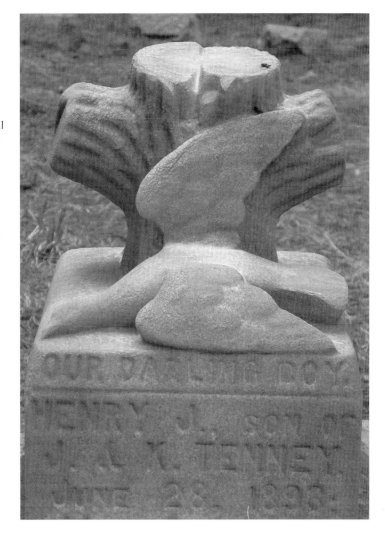

flock—and to Jesus as the lamb who gave his life on the cross to save the souls of Christians. For Jews, it referred to the Paschal lamb whose blood saved the lives of the Israelites' first-born sons at Passover. Lambs also held a place in Victorian children's culture, so these monuments invoked nursery decorations and popular rhymes such as "Mary Had a Little Lamb." The combination of various religious iconographies, children's culture during an era of increased focus on children, and a tradition in the history of sepulchral art going back to ancient Greek and early Christian sarcophagi, suited these lamb memorials

to a wide range of patrons and viewers, including child viewers who visited cemeteries with their parents.

Very similar to the standard child's lamb memorial, with its sleeping lamb at the base of a short tree stump, is a dead dove with the same backdrop (fig. 45). Usually, the bird is posed with one wing spread open against the tree stump to suggest the broken wing that brought it to earth. Symbolically, this is a somewhat contrary memorial, since the dove in art had been a widely recognized symbol of the Holy Spirit, peace, and the human soul. In this vein, other memorials depict a bird rising into the air to indicate that the life spirit or soul has left the body in the ground at the base of the monument and is rising to heaven. Many show a living dove in relief or full round, suggestive of ever-lasting life. The dead dove memorial focuses on the body rather than the spirit, reveling in the poignancy of a small broken body that once flew high and free. Named for its mournful cry, the mourning dove rather than the dove of peace creates the sentimental effect that Victorian Americans hoped to achieve with this monument. Although it is most commonly found on the graves of children, there are also instances of the dead dove memorial on adult graves. An example sits on the plot of D. W. Ramey in the Grove City Cemetery near Blackfoot, Idaho; Ramey died in 1895 at the age of forty-three. Large numbers of relief and three-dimensionally carved children's monuments attest to the range of work produced by union cutters, aspiring carvers, and self-proclaimed sculptors.

Conclusion

As the first permanent towns were settled in the Rocky Mountains, both amateur and professional monument makers began to contribute work to local cemeteries. The early sepulchral art followed the course of local architecture, with first wood workers and then stonemasons making grave markers as a sideline to their principal business

of building up the towns. Professional sign painters and ornamental wood workers probably made some of the earliest markers, relatively few of which have survived. As stone buildings appeared in towns, so did stone monuments in cemeteries, often taking architectural forms, such as columns, pediments, and moldings. Early monument makers developed local sources of stone and regional variations soon became apparent. English masons in early Utah specialized in local sandstone slabs on which they carved lengthy inscriptions and often minimal relief icons (a flower, clasped hands, a dove, fraternal symbols). Early front range carvers preferred the local white "marble," a crystallized limestone, from which they created obelisks, shafts, columns, pedestal monuments, and headstones. Southern Wyoming lagged behind in developing a carving industry, as the railroads made it so easy to import work from Denver or points east. Montana carvers worked primarily with imported marble.

The great majority of monument makers were men, although a few daughters of carvers among the Latter-Day Saints learned aspects of the trade. As populations grew, professional monument makers replaced builders and amateurs. A few distinctly western monuments, such as the Riverside horse and a red sandstone Indian in Boulder (now lost and presumed destroyed), carry the stamp of the old West. Some of the most inspired efforts graced the graves of children. By the 1880s granite began to gain favor in cemeteries. Abundantly available in the mountains, it was also increasing in popularity nationally. With it came new techniques and appearances: pneumatic and electric tools, rock-face finishes, shallower and less undercut statues. Also by the 1880s monument makers had congregated in a few urban centers from which they sent work throughout the Rocky Mountain region. Independent monument makers in smaller mountain towns competed for business with these centers and imports from

farther abroad, often relying on their social connections and town loyalty to bring in business. Some mechanics strove to become sculptors, passing through stages as cutter and carver, educating themselves in design and art history, and calling for more unique and individual approaches to well-known sepulchral themes.

From wood and sandstone markers to elaborate marble and granite sculptures, early carvers developed an industry that utilized Rocky Mountain resources and contributed to the economic growth of the region. In the process, they transformed Rocky Mountain burial grounds into sculpture gardens.

M. Rauh, Riverside Marble Works, and the Gendered Cemetery

Historians of the American West, at least since Dee Brown's *The Gentle Tamers*, have explored and problematized the notion that women brought culture and civility to the American West. As Joan M. Jensen and Darlis A. Miller explain, "*The Gentle Tamers* elaborated and codified the assumption that white males 'tamed' the West in its physical aspects and that white women, who followed the men, gently tamed the social conditions (including, of course, white men). . . . A newer, ethnically broader and more varied image of women in the West is today challenging that older view." They cite historians who have shown that in parts of Colorado women homesteaders proved up their claims more often than did men, and thus were tamers of some of the same physical aspects of the West as men. Scholars have deconstructed stereotypes of western women as "gentle tamers, sunbonneted helpmates, hell raisers, and bad women," and contributed many case studies concerning real women from different ethnic, racial, and class backgrounds.[1] Yet with all this additional analysis, the association remains between an increased presence of women

and children on the frontier and a higher level of social order and cultural achievement.

This book has argued that the fair mount cemeteries of the Rockies functioned as the earliest sites of public art and as public repositories of local history, in the process visibly proclaiming the taming of the West. Each community cemetery became an ongoing public statement about the level of civilization and cultural sophistication that community had attained. What roles, then, did men and women and notions of gender play in creating the sepulchral sculpture gardens of the Rocky Mountain West?

Since our popular media use the terms "sex" and "gender" interchangeably, it may be useful to pause here a moment and reiterate the difference between sex, a biologically determined trait, and gender, a social construct. The three sexes—female, intersex, and male—are determined by considering such biological traits as anatomy, chromosomes, and body chemistry.[2] They are not absolute categories because no exact boundaries define them and it is possible to move from one sex to another through medical intervention. Most people in the nineteenth century recognized only male and female sexes and understood them to be opposites. In contrast, gender provides an infinite number of possibilities, each associated with a sex or with a sexual orientation and each subtly shifting as society changes. Gender consists of commonly accepted ideas within a social group about how one should express one's sex or sexual orientation in terms of dress, behavior, body type, odor, styles of communication, and other sensory cues. Not only is gender particular to a time and place, but class, race, ethnicity, and many other factors contribute to its composition. Unlike sex, gender can be changed easily and quickly at the will of the individual, who may choose to adopt the traits of one gender today and another tomorrow. The existence of gender was not recognized in the nineteenth century, although its presence was felt in

such formulations as the antebellum "true woman" and the 1890s "new woman." Instead, gender traits tended to be understood as the "natural state" of man and woman, a presumption that biology or God determined them as absolutes. In this way gender remained fused with sex in nineteenth-century thinking. For our purposes, however, it is useful to distinguish between sex and gender. As this chapter will demonstrate, the female sex had relatively little to do with the appearance of Rocky Mountain cemetery sculpture, but gender played a huge role.

To begin with the obvious, both men and women died and were buried in Rocky Mountain cemeteries. However, a higher proportion of men than women lived in the region, especially in the early years. Men outnumbered women 34:1 in Colorado in 1860, 8:1 in Idaho and Montana in 1870, and 6:1 in Wyoming in 1870.[3] Below the surface of the cemetery, neither sex nor gender exercised a real presence in the late nineteenth-century Rocky Mountain region, despite the larger numbers of men. Undertakers appear to have treated male and female bodies alike in the manner of entombment and burial, and nature pursued the process of decomposition impartially. Above the surface, where the living walked among memorials to the dead, it was a different story. Men organized the cemeteries, designed and maintained them, carved and placed the sepulchral sculptures that would fill them, and therefore remained more visible as a living presence in the cemetery. At the same time, statues of women outnumbered images of men by a wide margin, and they portrayed a particular gendered ideal that positioned woman as emotionally sensitive, spiritually pure, aesthetically ideal, meditative or melancholy, and nonsexual. No set of monuments was considered more appropriate for women's graves, nor did dealers market particular monuments for the graves of men, so the allegorical and ideal female figures that populate the cemetery are as likely to mark the graves of

men as women. The result is that inanimate female images dominated the sepulchral sculpture garden, while living men made both the sculpture and the garden.

Makers of the Sepulchral Garden

We have already seen the extent to which men dominated the monument-carving industry. The only Rocky Mountain women known definitely to have worked in a nineteenth-century tombstone-carving shop were the daughters of Utah tombstone maker John Henry Bott, who polished, fetched, and carried, and some of whom may have also designed, carved, or lettered. Daughters of other Latter-Day Saint monument makers will undoubtedly be discovered to have carved and polished stone for the cemetery, given gender expectations of daughterly duty within this patriarchal society and the Saints' struggle for self-sufficiency. Even so, women constitute a very small minority of those who created the monuments that transformed western burial sites into sculpture gardens.

Recognizing that women had successfully entered the fine art field of sculpture in the early nineteenth century and that some had established international reputations, notably Harriet Hosmer and her followers, the *Monumental News* set out in 1901 to determine whether the female sex had also infiltrated the ranks of monument makers. In response to its call for female monument cutters and carvers to identify themselves, the journal learned of only three women practitioners in North America, none of whom hailed from the Rockies. All three were unmarried and had been trained by their fathers. Lucy Daniel of Exeter, Missouri, had taken full charge of her father's shop in 1885 and was planning to retire at the turn of the century to homestead in western Kansas. Pearl Sams of Great Bend, Kansas, began monumental work at the age of seventeen. In the seven years of her career she had graduated from lettering footstones to tracing and cutting

inscriptions on more expensive monuments. The youngest of the three, Alice Rigg of Windsor, Ontario, specialized in designing, tracing, carving, and lettering ornamental work.[4]

The *Monumental News* was careful to point out that two of the women did not do the stonecutting or heavy work of the shop, but restricted themselves to lettering and ornamental carving, thereby suiting their actions to more traditional gendered notions of feminine behavior. In addition, Sams was quoted as saying, "I love my trade and expect to follow it as long as my name is Miss Pearl Sams," leaving one to suppose that she would leave her profession as soon as she married. The avoidance of cutting rough rock and the assumption that marriage must trump career are the only concessions to the earlier nineteenth-century definition of a "true woman," however. The entry of even a few women into the male-dominated monument trade was seen by the journal as an indication that the modern woman was "deserting the needle and taking up the chisel."[5]

The *Monumental News* survey did miss at least one woman who had recently entered the field and would soon contribute a monument to the Rocky Mountain region. Nellie Verne Walker was born in Red Oak, Iowa, in 1874 and learned stone carving in her father's monument works. Like Daniel, Sams, and Rigg, she remained single, but unlike them she had aspirations toward fine art. Walker carved a bust of Abraham Lincoln for the 1893 World's Columbian Exposition while still a teenager, studied at the Art Institute of Chicago before becoming a sculpture teacher there, and accepted numerous commissions for portraits and other nonmortuary art. She is important to this study, however, because she received the commission to design a monument for the Colorado Springs pioneer Winfield Scott Stratton after he died in 1902. Walker modeled a group representing Charity

reaching out to the poor that was executed by the Charles G. Blake & Co. monument works in Chicago. The figures are just discernable emerging from an eight-foot tall block of rock-face granite on Stratton's grave in Evergreen Cemetery, Colorado Springs.[6]

Although very few female stonecutters or monument makers can be documented in the Rocky Mountain region before 1900, one does find women sculptors in all the major cities of the Rockies near the end of the century. Ida Stair, Alice Cooper, and Elsie Ward are three of the Denver sculptors who actively sought and won commissions and awards in the American art world. Cooper is best known for her statue of Sacajawea in Portland, Oregon. Ward won a controversial commission for a soldiers' monument intended for the capitol of Colorado, and Stair competed unsuccessfully to design the figure on top of the capitol building. All exhibited their sculpture in group art shows. As far as is yet known, neither they nor their counterparts in cities throughout the Rockies designed or executed sepulchral sculpture before the twentieth century.

The presence of women with the skills to contribute sculpture to the cemeteries and the apparent absence of such work points again to the strong gender bias of the monument industry. Slower to accept women into their ranks, mortuary stonecutters and carvers apparently considered the execution of monuments too physically demanding, even while the fine art world's emphasis on ideas and creativity opened the door for women to demonstrate their ability to handle the physical work of sculpting. This discrepancy also indicates a class issue. The acceptance of women into the ranks of professional artists during the nineteenth century grew out of such earlier genteel accomplishments as fancy stitching, wax modeling, sketching, china painting, and watercolors. Once seen as essential traits of the upper-class, Euro-American lady and aspired to by many middle-class women of different racial and

ethnic backgrounds, such artistic activities were considered both feminine and socially elite. Aspects of this upper-class feminine gendering colored the fine art making of men as well.[7] Late nineteenth-century mortuary sculpture, on the other hand, was more closely associated with wage labor and the quarrying and construction industries, as well as with trade, all areas with lower-class and more masculine-gendered identities than fine art. Thus, creative women in the Rockies (and elsewhere) were more likely to study fine art and become sculptors than to apprentice to a monument maker and become a sepulchral stone carver. Unlike sculptors in other fields, makers of cemetery sculpture, especially in the Rocky Mountains before the twentieth century, were almost exclusively male in both sex and gender.

The first landscape specialists to design Rocky Mountain cemeteries were also men, as were the trustees who governed the cemeteries and the sextons who managed them. Male grounds personnel planted trees and shrubs, kept up the flower gardens, and prepared the footings for monuments, and male monument makers set their statues in place on the grounds. Men constructed the fair mount cemetery because it required outdoor work and a type of manual labor that did not suit most popular, post–Civil War notions of women's proper sphere, even in an era of women wage earners. Due to these gendered notions of the differing natures of men and women, members of the female sex did not normally occupy positions of authority over the cemetery. Instead of real women, classically inspired pure white marble sculptures of ideal and symbolic female figures populated the sepulchral garden, reinforcing a Euro-American notion of civilization.

M. Rauh

Before turning to these marmoreal women, there is one important exception that proves the rule. In Denver's Riverside Cemetery, a large number of marble monuments

signed "M. Rauh." A quick glance at any city directory after 1878 reveals that M. Rauh was the proprietor of the Riverside Marble Works, but in no source except the U.S. Census is M. Rauh further identified as Mary. The company's advertising, city directories, state business directories, and newspaper articles about the firm always used the initial instead of the name, and occasionally added the title "Mr.," further obscuring her sex. The lack of any photograph of M. Rauh contributes to her mystery. Whether Coloradans were reading about the wonderful artistry of Mr. M. Rauh in the newspaper or seeing an advertisement for the firm "M. Rauh Marble Works" or "Riverside Marble Works, M. Rauh proprietor," they would have assumed that M. Rauh was a man. If they went to the marble yard, as several reporters did, and asked for the management, they would have been introduced to Adolph Rauh, sealing the impression of masculine identity. Mary's husband, Adolph, had owned and operated a monument business in his own name until his marriage to Mary, when the name of that business changed to M. Rauh. As the only monument company in nineteenth-century Denver where a woman appears to have played a significant management-level role, M. Rauh Marble Works bears closer examination. The range and originality of its monuments also testify to the importance of this firm, which was one of the largest and most prominent in early Front Range sepulchral art.

The roots of M. Rauh and Riverside Marble Works go back to 1870 or 1871, when Adolph Rauh came to Denver.[8] Born in Bavaria in 1836 or 1837, he had emigrated to the United States at the age of seventeen, settling in New York City. By the time he moved to Denver, Adolph had lived throughout the West and had worked with many aspects of stone, from mining and quarrying to carving. He is reported to have spent two years studying design in St. Louis. When he arrived in Denver and located his marble

works at Larimer and F Streets in the busy downtown, the city was only a decade past its gold-rush camp days. With a population of five thousand in 1870, Denver was growing fast and already supported two monument-carving businesses, those of Eli Daugherty and Joseph and George Koch. Rauh would eventually outpace both of them and take George Koch on as an employee, but he started out tenuously, suffering rapid changes of fortune.

Rauh first went into partnership with Timothy Ryan, with whom he had apparently traveled to Denver. They manufactured building stone for the growing city as well as carved marble keystones, sills, mantles, monuments, and gravestones. According to tax records, Rauh had $100 invested in merchandise, and Ryan brought over $600 worth of animals and some household property to the partnership.[9] None of their monumental work has been identified, but they advertised "sculpture and ornamental work done in a superior style," and a description of the monument they made from native Colorado sandstone at the request of General Case—a rustic cross wrapped in ivy standing on a rock cairn—sounds typical of the deeply carved work that Rauh's later business ventures produced.[10] Francis M. Case had been appointed surveyor general of Colorado Territory by President Lincoln and later became mayor of Denver, so this was an important commission for the young firm. Nevertheless, Rauh and Ryan Marble Works lasted only about a year.

By the end of 1871, Adolph Rauh had taken a new partner. Together, Rauh and Francis Frotzscher produced carved keystones and other sculptural decorations for the Brown Palace hotel, still standing in Denver. They also introduced Denver's first steam-powered stone works, the Pioneer Marble and Stone Steam Mill. The local paper reported their creation of a nine-foot-tall white marble column with "a wreath of flowers very finely executed and almost life like" for the son of Joseph Estabrook, the

owner of a prosperous livery stable.[11] Rauh and Frotzscher were probably doing all of their own carving at this point. The monument cost $450, a small fortune at the time. In fact, the price of that one monument equaled a fourth of the value of Rauh and Frotzscher's entire business. This, too, was an important commission. The accidental drowning of Charles Joseph (Joe) Estabrook at the age of twenty received extensive coverage in the Colorado papers. The mile-long funeral procession from the Presbyterian church where he had been a trustee to the Masonic Cemetery included 110 carriages. The senior Joseph Estabrook's livery business included a fancy, horse-drawn hearse, advertised rather extensively in the years before Joe Jr.'s death, that was undoubtedly pressed into service. Joseph Sr. must have ordered the monument soon after the burial, for it was completed little more than six months later and was set up in the Masonic Cemetery. Eight years after that it would be moved to the new, and much more fashionable, Riverside Cemetery, where the eroded remnant of this monument still stands.[12]

Rauh probably took a back seat in the monument business when his health deteriorated in the spring of 1872 and the name changed from Rauh and Frotzscher to F. R. Frotzscher and Co.[13] The Estabrook monument actually carries the name of Frotzscher and Co., but the newspaper reporter still put Rauh's name first in speaking of this work of art. Frotzscher and Co. advertised extensively in newspapers from the *Colorado Springs Gazette* to the *Rocky Mountain News*. In April 1873, the firm doubled its machinery and announced that it had the capacity to produce more work more quickly than ever.[14] Nevertheless, by year's end, Frotzscher and Rauh had dissolved their partnership.[15] Rauh carried on the business at the Pioneer Stone sawmill in West Denver alone beginning on New Year's Day 1874, but almost immediately acquired a new partner in C. C. Alvord. Alvord & Rauh, also known

as C. C. Alvord, lasted less than six months, selling the mill works to Ed Chittenden in June.[16] Again, Rauh stayed on as superintendent of the mill. About this time, he produced a monument for the grave of Clark Boughton, a pioneer printer, editor, and superintendent of schools in Fort Collins, Colorado. It is reminiscent of the Estabrook monument in its general form, an obelisk with beveled corners on a tall die with ornamental lettering. Instead of a wreath, it features a scroll that announces the occupations of the deceased.

In 1876 Rauh finally opened his own shop, Adolph Rauh Marble Works, at 372 Arapahoe Street. It was sometimes called Pioneer Marble Works, an echo of his earlier stone mill. A scroll type of headstone from this era in the Odd Fellows Cemetery at Central City, Colorado, for Elcenia Fairbairn is signed "Rauh Denver" and bears a wreath in high relief. Floral tributes of marble appear to have been one of Adolph Rauh's specialties. An upright marble headstone for Nancy Henderson in the Franktown, Colorado, cemetery provides evidence of another type of Rauh monument, bearing the motifs of a floral wreath and clasped hands.

This brief account of Adolph Rauh's first five years in Denver suggests the rapid changes in his fortunes and partners, as well as the exclusively male nature of his business dealings. He had a shaky beginning as a monument maker, made no easier by his marriage to the young widow Emma Brooks in 1873 and the birth of two daughters in rapid succession.[17] In 1877, Adolph Rauh had a growing regional reputation as an excellent carver of tombstones and monuments, a still new business that needed his full attention, and two motherless daughters. The historical record is not clear about what happened to his wife, but she was suddenly out of the picture.

Adolph Rauh had yet to achieve stability in his monument business when Mary DeVille came into his life. Not

only had she recently escaped from an unhappy marriage to a madman, presumably making her a woman ready for domestic felicity, but she owned substantial properties in and around Denver, making her wealthy in her own right. Adolph and Mary wed on December 8, 1877, and instantly solved two problems for Adolph.[18] Mary took over the care of his children, who were both under the age of three, and she provided property well situated for an expanded marble works, a new home, and assets for collateral. Within a few months, M. Rauh's Pioneer Marble Works began advertising in the *Rocky Mountain News*, giving the address on Arapahoe previously occupied by Adolph Rauh Marble Works. M. Rauh also began appearing as a resident in the city directories from this time forth.

As the owner of a rejuvenated Pioneer Marble Works, did Mary Rauh take an active role in the business, signing paychecks and making decisions, or was she largely a figurehead? Her background is more obscure than her husband's, not an unusual situation for a married woman in late nineteenth-century America. Mary DeVille was born in Hanover, Ohio, about 1847 and moved to a farm in northern Indiana with her parents, John and Catherine DeVille, and her brother Nicholas before she was five. She grew up on the farm, the eldest of six siblings. In her early twenties she spent some time as a housekeeper, living with a blacksmith and his family in Iowa City, Iowa. L. M. and Lydia Rice had two children, a son and daughter ages sixteen and thirteen in 1870, for whom Mary may also have been providing some child care. The children were near the age of independence, though, and Mary moved on to Denver near the end of that year.[19]

On June 1, 1871, she married Gottlob Herman Bock, a twenty-eight-year-old baker and saloon keeper by profession and, like many Rocky Mountain residents, a sometime gold and silver miner. Mary was about twenty-three.

Bock served as secretary of the German Church Society, which met at his saloon, and he initiated a lawsuit against a local wagon maker with whose work he was displeased, but other than that, we hear nothing of either Mary or Herman Bock until May 9, 1877.[20] On that day, Sheriff David Cook of Arapahoe County threw Herman Bock in jail and two days later reported him to the county judge as a "furiously insane person . . . so disordered in his mind as to endanger his own person and the persons and property of others."[21] Sheriff Cook also testified that Bock had no relations except his wife, and that he was utterly destitute. A jury was immediately appointed and an inquest held, which determined that Bock was a dangerous "maniac" and could not be allowed to go free. The exact course of events remains unclear, but only nine months later, Mary Bock married Adolph Rauh using her maiden name. Bock certainly did not suddenly become so insane that it took only two days to have him permanently removed from Mary's life. More likely, his violent episodes had become more frequent over time and she worked with the sheriff to liberate herself. She must have acquired her Colorado property after she came to Denver, during the time she was married to Bock, and it seems reasonable to suppose that she did so by taking over her husband's assets before he was declared insane. That is the only way she would not have become destitute herself when he was incarcerated. That Mary DeVille did not purchase her properties in the usual way is evident from real estate records that show her paying taxes on property for which she had no proper title.[22] Her ownership was recognized, nevertheless, and she later sold these holdings.

This sketchy history does not reveal that Mary DeVille had any knowledge of stone carving or monument making before she married Adolph Rauh. Although she grew up in Indiana, the best source of sculptural limestone and limestone carvers, her family lived about 150 miles away

from the limestone-producing area of Bedford and her father, a farmer, is unlikely to have taught her anything about it. Given her probable lack of knowledge about monument carving and the need to set up a new household at the Arapahoe Street marble works and care for two small children, it seems unlikely that she actively ran the marble business. The 1880 census gave her profession as "keeping house," the normal phrase for all wives working at home. On the other hand, as a property owner who apparently knew her way around the legal complexities of her situation, she certainly could have been keeping the books and signing the legal documents of the business she owned.

In 1882, M. Rauh sued the Burlington Colorado Railroad Co. for the destruction of a granite monument worth $1,800 that the railroad was transporting. Adolph Rauh appeared as M. Rauh's agent in the case because "the facts and matters in said complaint set forth are within his own knowledge."[23] Women had the right to represent themselves in legal matters such as this, but it was not unusual for a man to represent his wife in court. Although Adolph's representation of Mary in court does not prove anything, it does suggest that Adolph continued as the more active business partner and decision maker, while Mary's primary contributions to their partnership may have been financial and domestic.

Within two years of Mary Rauh's appearance on the scene, the local paper provided this glowing report about the business:

> One of the most progressive and growing institutions of Denver is the Pioneer Marble works of M. Rauh. These are located on Arapahoe Street, between Fifteenth and Sixteenth. The specialty of this house is to execute work in marble, according to the latest and finest designs in monuments, mantels, statuary and figures. The establishment is

filled, both in yards and workshops, to its full capacity with marble—both Italian and American—of such purity and delicacy of grain and color as to make it in great demand, and renders it peculiarly fitted for all decorative purposes. . . . The works are the largest and best equipped in the state, and have a large capacity for turning out work. Yet with all this, and the great number of skilled hands constantly employed, orders are arriving from all sections of the country to such an extent as to render it necessary for the proprietor to contract for machinery and steam power in order to meet the demand.[24]

That M. Rauh was in demand throughout the region from Colorado Springs to Carbon, Wyoming, is apparent from surviving monuments, such as the floral wreath-draped marble obelisk that friends of the murder victim Robert Widdowfield ordered after Widdowfield's death in August 1878. It still stands in the Carbon cemetery, although the town no longer exists. It also seems that the newspaper did not exaggerate the quantity of output. A notice in July 1879 announced that "Mr. M. Rauh does a large business in all kinds of marble work for cemetery purposes. Yesterday he put up nine monuments at Riverside."[25] M. Rauh also published a notice around this time, stating that Edmund F. Wright was no longer an employee and was not authorized to make sales or collect payments.[26] This provides evidence that the Rauhs' concern was large enough to need a sales force.

As their manufacturing business increased and the downtown area of Denver that they occupied became more crowded with upscale mercantile and lodging establishments, the Rauhs decided to move the marble works closer to Riverside Cemetery. Riverside had opened in 1876 and quickly established itself as the cemetery of choice for the middle and upper classes of Denver and environs. A move closer to the place where they delivered

and set up much of their product made sense, and Mary owned a property at 36th and Blake that would make an appropriate site. They moved the business and their home early in 1881. With the move to Blake Street, the firm abandoned the name Pioneer Marble Works in favor of Riverside Marble Works in order to associate themselves more closely with Riverside Cemetery in the minds of the public. An old insurance map shows the ideal situation of the new marble works, consisting of six lots fronting Blake Street and backing onto the Union Pacific Railroad, a spur of which ran across the marble yard to the Rauhs' stable and stone sheds. A two-story brick office building anchored a series of single-story, wood-frame buildings, including a show room and workshops. Together with the stone yard this created a substantial environment for the production and sale of marble monuments. The family probably lived above the office in the beginning, but eventually built a $5,000 stone-front residence called Rauh Terrace on another of Mary's properties across the street.[27]

With the move to Blake Street, more original designs began to appear. Tombstones for the children of a Denver gambler and racehorse owner, Col. Clifton Bell, are a good case in point. The earliest commemorated nine-month-old Stella, who died in Idaho Springs, where her mother had taken her in hopes of finding a cure for "the relentless Destroyer," tuberculosis.[28] This monument dates from late 1879 or early 1880, before the move, and is the most conventional of the three. The small carved figure of a sleeping child lies across the top of the gravestone, surmounting a typically sweet verse and the dates of Stella's short life. There is nothing unusual about this design, and it was not remarked upon at the time. One year later, in May 1881, Colonel and Mrs. Bell lost their eldest son to a paralyzing disease. For the beloved four-year-old heir, Harley Carlile, they asked Rauh to provide something special. Eight

months after Harley's death, Rauh completed a relief image in marble depicting little Harley on his hobbyhorse. It was based on a photograph taken shortly before Harley's death, and this time the newspaper took note: "Riverside will shortly be beautified by the addition of one of the handsomest monuments yet erected there. . . . In design it is original and unlike anything before seen here. . . . The perfect finish of the carving shows the work of an artist."[29] The Bells were so pleased with it that they immediately ordered another memorial in the same style to mark the grave of their daughter Gracie. This marker was also about five feet tall and shows Gracie seated on a sofa holding her doll. Both monuments were originally capped with draped urns. It would be too much to say that they were unique, but they were new on the Front Range.

Equally unusual for the area at that time was the detailed carving of a tree trunk holding a woven basket full of flowers that Riverside Marble Works provided for Dr. Salmon W. Treat. Dr. Treat died in 1882 at seventy-one years of age, still practicing medicine. He had come to Denver in 1864 by covered wagon and began advertising himself as an "eclectic physician and surgeon." Dr. Treat developed a wide following among the city's poor as someone always willing to take charity patients. These words from his obituary reveal more of the man than was commonly the case in such notices: "The death of a man so widely known and respected for his manly worth deserves more than a passing notice. His utter disregard of the rules and conventionalities of so-called polite society stamped him as a man of strong convictions, . . . independent in thought and action . . . he would wade through mud and snow at the midnight hour to render gratuitous services to some poor unfortunate."[30] The carver literally covered the surface of the tree with ferns, calla lilies, oak branches, ribbons, ivy, and other flora. Dr. Treat's funeral and elaborate funeral procession were organized by the

Masons, whose emblem also graces this monument. Although softened by the sugaring of the marble, one can still see the deep and skillful carving that characterized the output of M. Rauh.

In 1885 M. Rauh Marble Works had $2,000 of capital invested in the business, $1,000 of raw materials, and $4,500 worth of finished product. The firm employed three skilled male workers over sixteen years of age who worked ten-hour days, except in the winter, when fewer daylight hours shortened the workday to eight hours. M. Rauh paid marble workers $2.50 per day, a bit below average for Denver. Around this time the firm expanded to include granite monuments, charging $145 to $285 for American or Scotch granite memorials and $70 to $225 for Italian marble. The types seen so often in the past had become standardized in their advertisements: "Italian marble drapery monument with urn, with wreath, 7 ft. 6 in. high $225." One could acquire a headstone from Riverside Marble Works for as little as $10 for a child or as much as $55 for a four-foot-tall, six-inch-thick adult model.[31]

In 1888 M. Rauh claimed to be three times larger than any other monument company in Denver, with three times as much stone stock on hand.[32] But a reference in their advertising to how cheaply Rauh would sell a granite marker of the type on the Iliff plot, which the New England Granite Co. of Rhode Island had provided, suggests that Rauh was feeling the ever increasing competition. Around 1889 Riverside Marble Works made a major new statement of the artistic quality and uniqueness of their sepulchral art work by producing a scale-model mining cabin carved from solid limestone for the grave of Lester Drake (fig. 46). It is one of the largest monuments M. Rauh produced, and its inscriptions actually say more about the maker than about the person it is supposed to memorialize. Under the eaves, large raised letters spell out

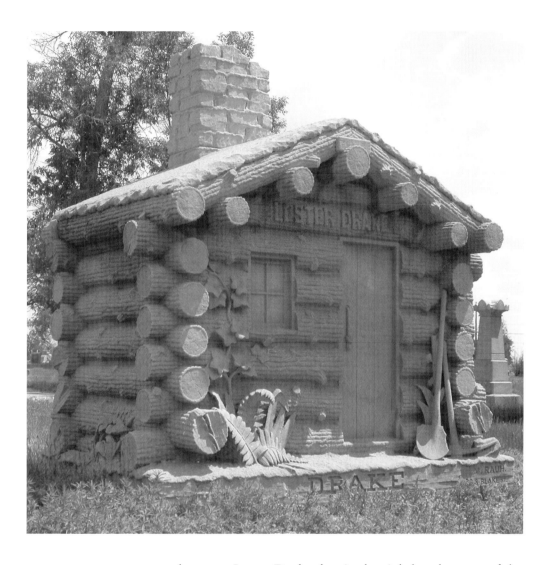

46. The name and address of the producer of this solid limestone mining cabin in Denver's Riverside Cemetery are unusually prominent in the lower right corner: "M. Rauh 36 & Blake St." The name of the carver, Ole Rustad, is typically absent. Rustad carved it between 1889 and 1893 to commemorate Lester Drake.

the name Lester Drake, but in the righthand corner of the cabin's base additional letters give the name M. Rauh and the address 36 and Blake St. These letters are larger than most monument makers' signatures, easily legible from a distance. Conspicuously absent are Lester Drake's birth and death dates or anything else about him.

Lester Drake came to Colorado with his wife, Eliza, and three children in July 1860, making them pioneers of the state. He settled in Central City and became active in the Sunday School movement, serving as a vice president of Central's United Circle, a Sunday School Society. Drake

was a farmer for most of the time he lived in Colorado, but a farmer with a risk-taking personality. He raised and raced trotting horses and gambled on numerous ventures. In 1870 he owned real estate valued at $10,000, including Drake's Ranch and a house in Lake Gulch, but he risked losing it more than once through failure to pay the taxes. He invested in gold and silver mines, and both of his sons, Alonzo and Lester Eugene (known as Gene), were miners. In the late 1870s Lester Drake worked a mine on the Williams lode near Black Hawk, removing $42,000 worth of smelting ore and minerals in a two-year period. Having developed it sufficiently to show that it was profitable, he sold it to the Gilpin County Mining Co. in 1879 in a deal that gained him the Estabrook Ranch near Denver, stock in the mining company, and an untold amount of cash. Drake engaged in numerous similar ventures, including prospecting the Washington and Mary Miller mines. His fortunes waxed and waned, as his obituary noted: "He has made many rich strikes and seen rapidly accumulating wealth fall to his lot and has seen it dissipated by unfortunate investments and mining projects, and then has set to work again with spirit to once more build up fortune anew." Drake moved to Denver in 1886 and died there three years later from "liver and kidney complaint." He was sixty-six. His obituary called him "an eccentric man in many ways," and one of those eccentricities appears to have been the desire to have a replica of his mountain mining cabin placed above his last resting place.[33] In many ways, Lester Drake was the prototypical mining pioneer of the Rockies, and his mining cabin monument symbolized the region better than most sepulchral sculpture.

The Norwegian immigrant Ole J. Rustad actually carved the Drake cabin, according to oral tradition among Rustad's descendants.[34] Ole Rustad came to Denver the year before Lester Drake died and advertised himself as a stonecutter. City directories confirm that he worked for

M. Rauh from 1889 until 1893, when he met an untimely death at the age of thirty-one. According to Rustad's niece, his death was the result of complications from an accident when Ole was helping to unload the Drake monument from a wagon in the cemetery. The several-ton block of carved stone slipped, throwing a crushing weight on Rustad.

Ole Rustad remained a bachelor who lived with his parents and siblings in Denver. His father, Embret J. Rustad, and brother Carl were tailors and his sister Annie a dressmaker. Given his five years with M. Rauh, Ole Rustad undoubtedly carved other monuments waiting to be discovered. His carving reveals a highly skilled and experienced hand. Although it looks like cement to many people, the Lester Drake monument was carved from one block of Bedford limestone. Among the details that enliven the log cabin, a nearly life-size shovel and pickax lean against the façade, ferns and ivy grow near the front door, a sod roof covers the whole cabin, and cactus and a stone chimney can be seen from the back. Like most log cabin monuments, this one has its latchstring out to signify welcome. What is most unusual are the realistic proportions. It measures six feet wide by four and a half feet deep by five feet tall at the roof peak. Doubling those figures would create a fairly normal-size cabin.

Far more common among log cabin monuments are the tall shallow models with overly large logs, like those on the graves of six-year-old Blanche Dunton in Idaho Springs and twenty-one-year-old William R. Walter (fig. 47) in Central City, Colorado. These two limestone monuments are almost identical, with vertical log roofs covered by a plank, a flat raised area under the eaves with a very large rendition of the family name in rustic lettering, round logs that cross tightly at the corners, a small four-pane window beside the door, and a brick chimney on the narrow end. They were made for people who died within

47. Samuel and Amelia Walter erected this more common style of cabin monument in Central City's IOOF cemetery for their twenty-one-year-old son, William, who died in 1899.

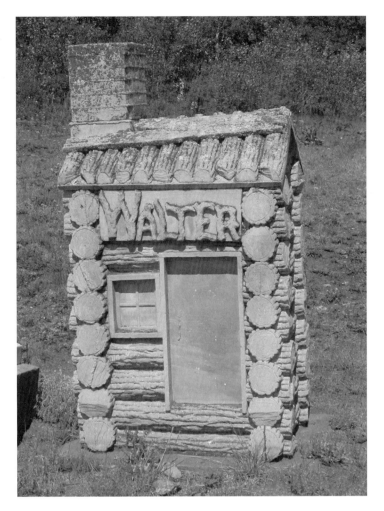

two weeks of one another in November and December 1899, in mining towns that are not very far apart. The same anonymous carver may have made both. Both are about three feet wide by two feet deep by five and a half feet tall, making them only half the depth and width but a bit more than the height of the earlier Drake cabin. This gives them an unnatural, dollhouse appearance.

Cabin monuments in other parts of the country also tend to be tall and shallow. Examples exist in Rogersville, Wisconsin; Allen County, Ohio; and North Platte, Nebraska. People may have preferred tall narrow proportions because they better approximated traditional upright

monumental forms of the nineteenth century, required less stone, and were less expensive to make and move. In contrast, Lester Drake's nearly square cabin looks more cabin-like and less headstone-like in its proportions and it was expensive and is extremely heavy.

Lester Drake's cabin is also unusual because it is so obviously a mining cabin. That makes it particularly suited to the Rocky Mountains, where mining was one of the major activities of the pioneers. By the end of 1918, three men named Lester Drake had been buried here: father, son, and grandson.[35] Two of them were miners. A photograph of the Drake monument was published in the national monument carvers' and dealers' trade journal, *Monumental News* in November 1896, as an example of an "unusual" monument. Visually, it is one of the most unique, yet regionally representative monuments in the Rockies. As an example of how sex and gender operated in the cemetery, it represents the handicraft of one man, produced under the management of another man, set up in the cemetery by men, but signed with the gender-neutralizing initial and name that referred to a woman whose exact role in the enterprise remains as much a mystery today as it was a secret in her own time. Commissioned by the men in the family, the distinctly masculine image of the mining cabin also carries the name of the men it memorializes.[36] It stands as an impressive testament not only to the sepulchral sculptures produced by Riverside Marble Works, but also to the mythologized masculinity of the mining frontier.

On December 30, 1896, after twenty years as an independent property owner, Mary Rauh sold Adolph properties she owned in Denver, Idaho Springs, and Fort Collins, including the marble works and Rauh Terrace, for $1.00. What motivated this transfer we may never know. For the first time, Adolph Rauh legally owned the marble works at 36th and Blake that he had been managing for so long. He

was the oldest living monument maker in Denver and people began to think of him as Denver's first sepulchral carver. Mary had always been a silent and invisible partner, and after this sale, only her initial in the firm name and on hundreds of monuments remained to suggest her presence.[37]

Mary Rauh contributed substantial financial assets at a critical juncture in Adolph's development of the monument business, and she may have actively participated in behind-the-scenes business decisions. Whatever the exact nature of their collaboration, Mary and Adolph Rauh succeeded in providing a lot of the most interesting sculpture to one of the most carefully planned and elaborately filled sculpture garden cemeteries in the Rockies. From the time Mary entered the business, it grew in size, stature, and the production of unique and unusual monuments. Mary Rauh's Riverside Marble Works produced some of the most visually appealing and regionally distinctive monuments in the southern Rockies. Yet the public face of the business remained masculine.

As we have seen, men made the sculpture and they landscaped and maintained the garden cemetery. On the rare occasion when a woman became involved, her sex was disguised or her roles minimized, so that she fit as many gender expectations as possible: dutiful Latter-Day Saint daughter or devoted wife and mother who placed her financial resources at her husband's disposal. At this point, we might reasonably conclude that cemeteries were masculine constructs and that if they represented civilization, then the civilizing force was not female. A closer look at one of M. Rauh's figural monuments and similar statues throughout the Rockies provides a different perspective.

The Image of Woman in the Sepulchral Garden

The George Stille monument (fig. 48) may be one of the first produced by and signed "M. Rauh Denver." After a period of prospecting and work as a mining agent, George

48. Mary Rauh's Riverside Marble Works produced this marble sculpture at the request of Mrs. George Stille about the time that Colorado Territory achieved statehood. The neoclassical style— contraposto pose, classical draperies, stoic expression, classical hair and features— made such sepulchral statues symbols of Western civilization and high artistic culture in frontier towns. Riverside Cemetery, Denver.

Stille had become a reasonably successful commissioning merchant in Denver, dealing in staple produce of the American West. He died in May 1876 at the age of fifty-six, and his widow, Mary J. Stille, erected this memorial to him about two years later. It portrays a classically draped woman with her arms folded across her middle, holding a small memorial wreath. She stands atop an imaginative variety of ornamental bases peering down at the grave of George Stille with a look of deep contemplation on her face. This figure does not immediately bring to mind any particular mythological or allegorical subject. One might read grief into her posture, given the cemetery context and the wreath, but the carver has not represented any emotion on her face. Her features are those of classical beauty, and the white marble, so prized in the nineteenth-century cemetery, also conveyed notions of purity. The Stille monument was carved by one of the male carvers at M. Rauh to represent an idealized female figure whose meaning relates to the loss of a loved one but remains rather ambiguous.

Like Riverside Cemetery where the Stille monument stands, extant fair mount sculpture gardens throughout the Rocky Mountains most often date from the late 1870s and the 1880s. They may include tombstones and monuments moved there from earlier cemeteries in the area, but the stamp of the 1880s is strong upon them. In this era, the image of woman dominated American fine art as an aesthetic ideal. Scholars have long recognized the aesthetic movement's preoccupation with beautiful women, predominantly but not exclusively white women, from the Pre-Raphaelites to Art Nouveau and from William Blake and James Abbott McNeil Whistler to art pottery. The art historian Bailey Van Hook has written more specifically about the American image of women in *Angels of Art: Women and Art in American Society, 1876–1914,* stating that the trend in painting female images moved

49. Each of the four sides of the large monument that Alexander Ross erected in Fairmount Cemetery, Denver, holds a white marble relief portrait of one of his family members, creating a strong contrast against the dark red granite. Rocky Mountain men, more often than women, found form in mortuary portraiture.

away from narrative to nonspecific, poetic renditions of feminine beauty where mood superseded action. Many interpretations of these images of women were possible, encouraging the audience to contemplate the meanings of the figures that often assume contemplative poses. Whether representations of angels or virgins or Madonnas or allegories of various virtues, images of women in fine art were expected to elevate the viewer's thoughts and intentions to a higher, more spiritual plane. Van Hook concludes that "images of ideal American womanhood would function on a pedestal: as icons of culture, embodiments of refinement and taste and evocations of aesthetic, not sensual, beauty."[38]

These ideas about the female image as symbol of a high spiritual and aesthetic ideal are even more apparent in the cemetery than in paintings. Marble and granite women looked down from their pedestals upon a diverse, rough-

and-ready population who settled a rugged, often danger-ous environment. Very few of these cemetery sculptures represent real women, and those that do are more apt to be relief portrait busts than full-length portraits in the round (fig. 49). The vast majority represent ideals in fe-male form, especially allegories of various ideas related to the belief in life after death. Van Hook points out that American painters often placed the female form in a land-scape to associate her with nature and to increase the po-etic mood of their art. The same effect was achieved by placing sepulchral female sculptures in the rural cemetery, where the landscape was carefully managed to set the statues off to best effect.

Faith, Hope, and the Woman at the Cross are three of the most common sepulchral allegories. With one hand these allegorical women gesture to head, heart, or heaven, while the other clasps a symbolic attribute. Hope rests one hand over her heart and in the other she holds a small an-chor, or she rests her hand upon a large anchor at her side (fig. 50). The anchor of faith had been Hope's attribute in art for many centuries, based on Hebrews 6:19: "Which hope we have as an anchor of the soul."[39] Faith, on the other hand, usually holds a Bible or a cross and with her other hand points toward the heavens. Often, she lifts her eyes to heaven, but the version sold as Faith #43 in the Italian marble import catalogue *Excelsior Statuary De-signs* casts her eyes downward toward the grave at her feet. The viewer naturally follows Faith's gaze to the place where the earthly body lies, and then looks up, follow-ing her pointing finger, to the place where the soul was thought to reside. This composition makes the sculpture's message evident.

Both Hope and Faith are recognizable as allegories, not only by their attributes, but by the classical drapery that covers them from neck to toe. American artists reveled in the human figure and they painted and modeled images of

50. Hope, with her anchor of faith, was one of the most popular allegorical sculptures in late nineteenth-century cemeteries. This sandstone figure stands on the top of the Soper mausoleum in Fairmount Cemetery, Denver.

nude and seminude classical or literary females, including occasional sepulchral figures in the East such as Daniel Chester French's *Melvin Memorial* in Sleepy Hollow Cemetery, Concord, Massachusetts. No matter what the classical reference, though, nude or overly exposed figures did not find favor in the Rocky Mountain cemetery. The modesty and virginal purity that characterized the American

51. Variations on the ever popular Woman at the Cross can be found throughout the Rockies. The type originated with classical images of female mourners and Christian images of the three Marys at the cross. This marble example, in memory of John Frederick Johnson, looks down at a grave in Greenhill Cemetery, Laramie, Wyoming.

artist's image of American womanhood and that better suited Americans' slightly Puritanical taste reigned supreme here. For the sepulchral sculpture garden to function as an embodiment of "refinement and taste," of high culture and civilization in the frontier West, the statuary had to evoke "aesthetic, not sensual, beauty." The early Rocky Mountain audience does not seem to have shared the artists' attitude toward the nude as the epitome of high art, and Rocky Mountain monument makers appear to have been equally reluctant to introduce her to sepulchral sculpture gardens. Marble sepulchral women of the West stand in stark contrast, ideologically, to the dance

hall girls, barmaids, and prostitutes whose presence in early mining communities is well documented.[40]

The woman draping a laurel or floral wreath or a garland of flowers over the cross was one of the most popular full-round sculptures in the late nineteenth-century Rocky Mountain cemetery (fig. 51). Virtually every cemetery large enough to have standing figurative sculpture has one of these. The laurel wreath had been placed on the heads of victors in athletic games in ancient Greece, and in the nineteenth-century cemetery it represented victory over death. Floral tributes have long been associated with death and are often found in sepulchral sculpture, wrapping crosses, anchors, urns, and people. The cross in the Woman-at-the-Cross composition is usually rustic in style and may be larger or smaller than the figure, with the woman draped around it or leaning against it. In each case the image intimates that the woman is supported by her faith in the promise that Jesus' crucifixion and resurrection brings victory over death to those who believe.

The Woman at the Cross was sometimes entitled Faith by monument companies, and the Christian iconography is so strong that one would expect to find it only in Protestant and Catholic cemeteries or on the graves of Christians. Yet this image seems to have reached a state of popularity that allowed it to be modified for non-Christian use. On the grave of nineteen-year-old Jesse Salomon, daughter of a pioneering Jewish family of Colorado, the woman drapes her floral tribute over a tree trunk, the same height and shape as rustic crosses in similar Woman at the Cross compositions, but with a thicker trunk and a branch too short to turn the tree into a cross. It is certainly possible that Jesse converted to Christianity and that her Jewish family recognized her faith with this monument but would not go so far as to have a cross on their plot.[41] It is more likely that the identification of an ideal woman with spirituality and purity had become so strong in American

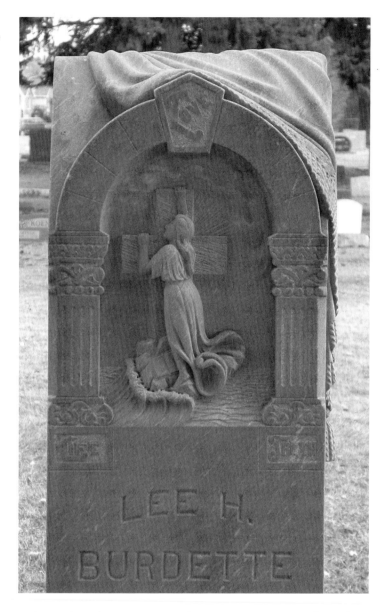

52. Dark marble monuments with the Rock of Ages vignette in relief, like this one for Lee H. Burdette in Loveland's Lakeside Cemetery, were carved by many different hands and reveal subtle technical differences yet remain faithful to the prototype in each detail.

culture that the Woman at the Cross image overflowed its original Christian boundaries.

As can be seen, allegories of Faith, Hope and the Woman at the Cross were primarily about Christian faith and the promise of salvation. The ultimate representation of this idea was a vignette called Rock of Ages in which a woman clings to the two bars of the cross on a rocky isle (or cairn) in the midst of a stormy sea (fig. 52). This image

originated with an eighteenth-century poem, altered in the early nineteenth century and set to music by Thomas Hasting in 1830, that became extremely popular as the Christian hymn "Rock of Ages."[42] The hymn begins and ends, "Rock of ages, cleft for me, Let me hide myself in Thee," and evokes a mental image that does not correspond at all to the scene we know as Rock of Ages. It may have been the painter Johannes Adam Simon Oertel who gave the image its visual form in an oil painting of 1876, now in the Fogg Museum at Harvard, that was much copied. Rather than choose the obvious, an image of a person hiding in a cleft rock, he was inspired by a line in the third verse, "Simply to Thy Cross I Cling." There is no reference to the sea or storms in the hymn. Oertel seems to have added this setting to convey the troubles of the world, sin, and death, forces against which the Christian clings to the cross for salvation. Its mood correlates rather well with the savage weather and rugged wilderness of the mountains described by early pioneers.

In the Rocky Mountain cemetery, Rock of Ages appears most often as a relief carving on a tall, square, dark blue or gray marble pedimented shaft monument with a framing arch carrying the words "Love," "Life," and "Truth." The manufacturers of white bronze monuments chose Rock of Ages and Hope as samples to be used by their salesmen to sell more monuments, another indication of the popularity of these figures in American funerary art of the 1880s and 1890s. Their three-dimensional version of this monument included the phrase "Simply to Thy Cross I Cling" on the back of the cross, but it was the relief vignette that mountain dwellers sometimes purchased to adorn their white bronze memorials. In 1914 a granite monument producer in Barre, Vermont, adopted the name Rock of Ages and went on to become the biggest monument concern in the country.

Female mourning figures fashioned from marble, gran-

ite, and zinc also abound in the late nineteenth-century cemetery sculpture garden (see fig. 3 and the statues in the background of fig. 11). More secular than Hope and Faith or the Woman at the Cross, they served a wider audience. The George Stille monument (fig. 48) is a good example. Another typical mourning figure scatters flowers on the grave at her feet. She usually wears classical garments and holds the flowers in one hand or a fold of her draperies, with the other outstretched to drop a blossom. Often she appears to be striding downhill and Christian iconography is sometimes added. A marble example in Laramie's Greenhill Cemetery "in memory of John R. Johnson 1815–1878 . . . his wife Sarah 1816–1888," and other family members combines her with a small scroll and cross monument at her feet, a monument within a monument. A late granite variation on the Daly plot in Butte shows her carrying a resurrection lily in one hand, stepping down from the large rock-face cross at her back, about to drop a single lily blossom upon the grave at her feet. Like most allegories and ideal figures in the cemetery, the woman scattering flowers usually wears her hair parted in the center and curling away from her face in long rolls that may cascade down her back or be caught together at the nape, a type familiar from Pre-Raphaelite paintings. Euro-American artists equated beauty with purity and strove to express the beauty of the soul in the delicate features of the romantic or classical feminine face. A barefoot young woman in a nightgown with lace neckline and slit sleeves, seated at the head of the Conroy graves in a Catholic cemetery in Trinidad, Colorado, exemplifies the most Romantic and modern of these types. With half-closed eyelids, she seems to have drifted into a trance or daydream while reading her little book of poetry, Bible, or Psalter. At one time, a Latin cross stood at her back, and in this context she might be compared to Bernini's *Ecstasy of Saint Theresa*.

Other mourning figures assume a seated or kneeling pose, with head bowed and sometimes with hands clasped over their breast or tears visible on their cheeks. A common variation has hands clasped in prayer and eyes lifted to heaven as if pleading for the soul of the person buried at the foot of the statue. These sepulchral figures have antecedents in English church monuments that the art historian Nicholas Penny has described as ideal portraits and devotional figures.[43] In the late nineteenth-century American West, they usually served as generic mourners rather than portraits. Statuary and monument producers gave them titles of Grief, Submission, Sorrow, Memory, Remembrance, and Resignation. They functioned as allegories of these notions, most of which had strong feminine gender associations.

Art historians have long recognized that western (European and North American) artists more often give abstract ideas the physical form of women than men. Marina Warner suggests that this practice has its source in linguistic gender, where "it can be said that one of the consequences of gender has been the seemingly animate and female character of numerous abstract nouns."[44] The use of female forms to express abstract ideas in the cemetery, a borderland between the known physical world and the unknown abstract hereafter, may seem especially appropriate. Yet these statues of grief and mourning also played a more traditional feminine role in publicly expressing the sorrow of those left behind when someone dies.

Tony Walter has summarized the historical transition in the late eighteenth century from an ungendered understanding of grief and tears as the natural expressions of men and women alike to an expectation in the nineteenth century that men would suppress their tears, as "grief came to be seen as particularly associated with women's frail, emotional nature."[45] At the same time, grief moved into the private realm of the home and women were bound

by strict rules of mourning. Retirement from social events and public view, wearing black or gray for a predetermined period of time, giving jewelry made from the hair of the deceased, and sending black-bordered letters and cards were among the customs practiced during most of the nineteenth century.

By the 1880s, women had entered the public sphere by taking up more and more professions previously considered appropriate only for men, by speaking out publicly on issues that concerned them, by fighting for legal rights, and by agitating for the vote. How women mourned, and the social expectations surrounding grief, also began changing in the 1880s and 1890s. Scholars have shown that in the western territories and states Victorian social mores and customs often bound women even less strictly than in the East. Women could and did homestead and run ranches on their own, set up businesses throughout the frontier, wear unconventional attire, pursue higher education, and choose a single life or life with other women. Pioneers in the Rockies developed their social structures and institutions in an era when the understanding of women's proper roles and natural abilities was rapidly changing. Wyoming granted women the vote in 1869, while it was still a territory. The Utah territorial legislature followed suit the next year. When Wyoming entered the Union in 1890, it became the first state to enfranchise women. Colorado was the second in 1893, with Utah and Idaho following in 1896. Thus the first four states to enfranchise women were Rocky Mountain states. As real women shed their mourning dress and ignored the old prohibitions against public activity while in mourning, cemeteries began to fill with stone images of ideal women perpetually weeping and scattering rose petals on the grave. A role that many women could no longer accept in life was admirably filled by marble and granite statuary in the city of the dead. Thus grief moved back to the public realm from

the domestic, but continued to be an activity associated with the feminine. By transferring this obligation to inanimate sepulchral statues, society moved a step toward dissociating the business of death from daily life in a process that has been called the dying of death.[46]

One of the most common images of mourning is a seated or standing woman holding a wreath at her side. A relatively early version can be seen in Salt Lake City's Mt. Olivet Cemetery on the graves of Edward and Eva Forney. Edward Forney died in the spring of 1879 when he was only thirty-seven. Presumably Eva, who lived to be eighty-three before she was buried beside him, chose the full-length marble woman standing beside a funerary urn holding a memorial wreath to adorn his grave. It harks back to antebellum mourning images of families clustered under a weeping willow in postures of grief around an urn monument. More common in the Rocky Mountain cemetery is the less explicit representation of a woman with her finger to her chin or cheek in an attitude of melancholy meditation. These solemn figures seem to be considering the great question of what happens after death. Only the people beneath the surface of the cemetery know, and many of these contemplative sculpted women look down on them as if seeking the answers. Contemplation of the grave can just as well be interpreted as memory of the deceased. Sometimes a laurel wreath or palm frond suggests victory over death, a book alludes to faith, or an olive branch says "Rest in Peace." More often, these images partake of the nonnarrative and unspecific idealism seen widely in American fine art at this time. Even when they were not designed for the cemetery, many neoclassical female statues incorporated qualities of meditation and grief. For example, the sculptor Thomas Crawford said of his *Hebe and Ganymede* (1841), "At the moment Hebe is leaving the service of the gods. . . . She stands in a pensive attitude which is also expressive of deep grief." American

sculptors and their patrons were attracted to what one writer calls "the tragic, brooding female personalities from antiquity."[47] It was expected that viewers would recognize the "pensive attitude expressive of deep grief" in the many generic classical female mourning figures in the cemetery, such as the George Stille monument, without referencing a specific goddess or antique subject. As Bridget Heneghan has pointed out, the white marble from which these sepulchral mourning statues were usually carved before 1890 also presented unexamined notions of whiteness and privilege.[48] The white marble mourner on a Rocky Mountain grave easily invoked "high culture," social elitism, and civilization for the majority of viewers.

Most of the three-dimensional statues of sepulchral women discussed so far also exist in a form with wings. For example, white bronze companies sold a kneeling figure with clasped hands called Grief, and they marketed the exact same figure with the addition of wings under the title Angel. The Woman at the Cross composition can be seen in Denver's Fairmount Cemetery as a winged angel leaning on a tree trunk with her finger to her cheek. The figure of Hope with her anchor takes the form of an angel of hope in Mt. Olivet Cemetery in Salt Lake City. On the other hand, one importer of Italian statuary entitled two designs that show wingless women dropping flowers on the grave Angel with Flowers.[49] It is partly the close identification of the female figure in American art with the type of an angel that allows these transpositions. The interchangeable woman-angel compositions reinforced the notion of woman as spiritual perfection and guide to heaven, an idea already well established in the notion of the "angel of the home."

Whereas generic angels were most often associated with the feminine in late Victorian American culture, when a specific angel named in the Bible or other religious literature was carved for the cemetery, it was male.[50]

For example, the Angel of the Resurrection was associated with two incidents involving an archangel. In one he meets Mary at Jesus' tomb and announces that Jesus has risen from the dead; in the other, he blows his trumpet to announce Judgment Day. Neither archangel is identified by name in the Bible, but both Michael and Gabriel became identified with the Angel of the Resurrection, who was depicted in masculine form in late nineteenth-century cemeteries.[51] The Angel of the Resurrection is almost certainly intended in the granite wingless robed figure with masculine features and torso on the Albert and Mary Walker plot in Salt Lake City. He holds his long trumpet across his body as if waiting for the signal to bring it to his lips, as related in I Corinthians 15:52: "The trumpet shall sound, and the dead shall be raised incorruptible, and we shall be changed." This angel looks very much like Randolph Rogers's bronze Angel of the Resurrection on his monument for the inventor of the colt revolver, Samuel Colt, in Hartford, Connecticut.[52] Rogers designed his angel in 1863 with a more active posture, holding the trumpet bell out to the side and the other arm held out from the body in counterbalance, but otherwise the figures are similar. In 1877, the New England Granite Works provided a "marble statue representing the Angel of the Resurrection" for the Lamson Sessions canopy monument in Cleveland, Ohio.[53] It appears that they had exhibited this design in their display at the Centennial Exposition in Philadelphia, where it must have been seen by many. It resembles the Walker angel in all but the specific pose. The male angel Moroni may be found on the graves of some Latter-Day Saints and visually resembles the Angel of the Resurrection. A relief profile view of Moroni is usually depicted in flight, blowing his trumpet.

Unlike the Angel of the Resurrection, the recording angel took both male and female forms, depending on the company marketing it. Sometimes it appeared as an adult

53. In Cheyenne, a white marble putto rests against an overturned torch, signifying the extinguished flame of life. Neither male nor female, it represents a popular type of Victorian-era decoration that conveys the Woodmansees' grief at the loss of their daughter and their hope for consolation: "Our darling Eva is but asleep. Her spirit rests not neath this covering sod. O why should we bow our heads and weep, She is waiting for us by the throne of God."

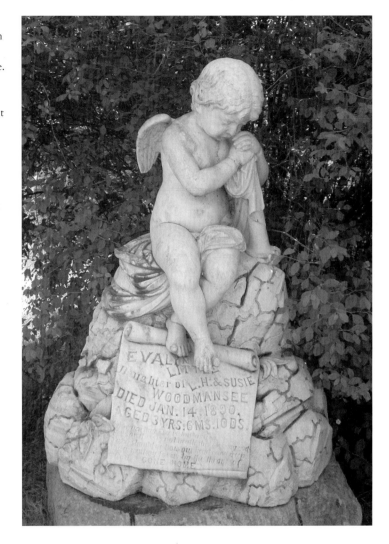

angel and more often as a youth or a child. The marble recording angel on the Green brothers' tribute to their mother in Riverside Cemetery, Denver, is a youthful winged and classically draped male who holds his quill pen to his chest as he stops to consult God with upraised eyes before writing a name in the book of the elect. A female version a few blocks away sits on a rock cairn writing on a scroll. This smaller, younger female recording angel monument can be found in several Rocky Mountain cemeteries.

Of course, some artists attempted to render their angels

androgynous. There are also multiple examples of Renaissance-style putti, the angels' secular counterparts (fig. 53). These chubby cherubs had become popular in many aspects of Victorian American decoration. In mountain cemeteries, they are seen astride globes, extinguishing torches, unveiling a monument, and rising from a sarcophagus.

The most common artistic representation of men in the cemeteries were not angels, however, but portraits. A few men took their place as full-length bronze statues in modern dress, such as those of James Archer (Riverside Cemetery, Denver) and Frederick Falkenburg (Fairmount Cemetery, Denver). Many more appeared in the form of relief busts, such as those of the Ross family (fig. 49) and John J. O'Farrell (St. Patrick's Cemetery, Butte). Each statue of a man was intended to help remember a specific person. This contrasts rather sharply with the majority of female statues. In turn-of-the-century Rocky Mountain mortuary sculpture, male figures almost always stood for real men or named angels and female figures almost always stood for abstract ideas.

In many ways, the cemetery was a place dedicated to the past. It recorded past lives and the history of the community through monument inscriptions and portraits. The female images made it also a place of the present and the future. Allegories of grief and statues of mourners spoke to the living about their present feelings of loss, while Faith, Hope, and angels asked them to consider life in the future, beyond their earthly existence.

In addition to the figurative sculpture already mentioned, images of Jesus and Mary sometimes found a place in Catholic cemeteries, although they were less common in the pioneer era than one might expect. A relief image of Jesus surrounded by children occurs on a number of white bronze memorials on Protestant as well as Catholic graves, and crucifixes commonly appear as finials on shaft monuments in St. Patrick's Cemetery in Butte. Mary was a frequent occupant of sections of cemeteries dedicated to

nuns, and there are a few unusual statues such as the zinc Virgin Mary standing on a serpent and crescent moon in Mt. Olivet Catholic Cemetery, Denver, to mark the grave of Mary Hogan.

Of particular interest is a nonfigurative, gendered representation that occurred in at least two Catholic cemeteries in Montana just after the turn of the twentieth century. In each case, nuns and priests were buried in or around a cemetery's central circle in strict segregation from one another. Abstract stone monuments differentiated the priests from the nuns. Priests received tall, dark granite shafts. Nuns had lower, rounded white marble headstones. The classic division between phallic sharp-edged shaft (black for priests' robes) and virginal white rounded headstones (a tombstone shape often considered to represent a gate or entrance) must have seemed so natural as hardly to have been noticed at the time. Both priests and nuns took vows of chastity, but nuns were also commonly described as brides of Christ and the white marble memorials conveyed the idea of a spiritual marriage that was presumably fulfilled in death.

Many basic types of figurative cemetery sculpture have been described here, including some variations and combinations of those types. Almost any combination of pose and attributes can be found, but a few traits stand out. Full-round sepulchral sculpture most often took the form of a classically draped female ideal statue that encouraged contemplation and denied a quick read. She is best understood in the physical context of being placed at the head of the grave, for her gestures and meanings always related to the deceased's body or soul. Male statues more often depicted the forms of once living men in heroic poses, just as real men most often made, sold, and set sculpture of all forms in the cemetery, designed its landscapes, and maintained its grounds. It would appear that in the cemetery, the female sex was not the "gentle tamer" of a wild land,

but that a particular gendered notion of woman did convey the idea of a civilizing, and morally uplifting, force. Real women played minimal roles in creating the sculpture garden, but idealized female images suggestive of faith, beauty, grief, hope, culture, and victory over death marked the landscape.

Patronage

Patronage is an area in which both men and women influenced the appearance of the cemetery. Many women became patrons of cemetery art when a wealthy husband died. It was expected of the upper echelon of Rocky Mountain society that widows would mark the passing of their pioneer husbands with substantial visual tributes. Late nineteenth-century historians considered these men to have built the West, and the cemetery became a record of their deeds through the monuments erected to their memory.

Rocky Mountain society distinguished class status not only by wealth and manner, but also by how early one established oneself in the region. Arrival in Colorado before 1860 entitled men and women to membership in the exclusive Society of Colorado Pioneers, and the inscription "Pioneer," with or without the year of arrival, appears on many mausolea and monuments as a testimonial to the deceased's pioneer status. A tree stump monument in Leadville inscribed "my husband . . . one of the first settlers of Colo. in 1858," informs the viewer that William Campbell played an important role before he died there in 1863. People who had become residents of Montana Territory before the year 1864 organized the Association of Montana Pioneers in 1884. Such pioneer associations served to set early residents apart as they held annual picnics and accumulated evidence of their contributions to history. Adolph Rauh understood the significance of proclaiming one's pioneering activities when he chose

the names Pioneer Steam Stone Mill and Pioneer Marble Works for his early monument-making ventures. Statements of pioneer status and dates of arrival on sepulchral monuments constituted statements about social standing and historical value that helped the cemetery publicly proclaim a town's place in the "civilizing" enterprise of Manifest Destiny.

Social competition sometimes raised the stakes among women contemplating tributes to their husbands. The relatively early examples of Mrs. Iliff and Mrs. Eckhart, who turned to the New England Granite Co. in their search for suitably impressive monuments for their husbands, are discussed elsewhere in this volume. Susan Soper commissioned the first mausoleum built at Fairmount Cemetery for her husband, Roger. It is a massive sandstone structure with a life-size figure of Hope on the rooftop (fig. 50).

By the beginning of the twentieth century, with inherited fortunes from cattle, silver, gold, coal, real estate, and the provisioning of miners and settlers, Rocky Mountain widows outdid themselves. Lena Stoiber commissioned a mausoleum for her husband, Edward G. Stoiber, who had owned mines in Silverton, Colorado, that he eventually sold to the Guggenheims for $1.5 million. He was fifty-one when he died in Paris of typhoid pneumonia. Lena had his mausoleum built of Vermont granite with an interior of Parian marble. It measures twenty-six by sixteen feet and cost about $30,000. Edward Stoiber was entombed here in 1906.

More unusual in design is the Smails mausoleum (fig. 54). The R. A. Swanson Monumental Co. of Denver built it on commission from Mrs. Eva Lowe Smails, a socialite devoted to charity work. Her husband, John, had fought throughout the Civil War, except when he was a prisoner of war after the battle of Bull Run. He came to Colorado after the war, worked as an agent for eastern powder companies, and remained active in the military order of the

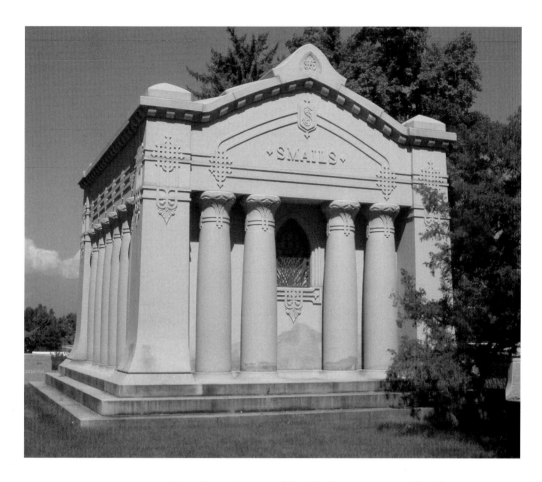

54. Socialite Eva Smails erected an impressive granite mausoleum of original design to the memory of her husband, just one of many Rocky Mountain widows whose patronage helped build the sculpture gardens of the West. 1912–1915, Fairmount Cemetery, Denver.

Loyal Legion until he died in 1912. Richard A. Swanson designed the mausoleum to be one of the largest in the region, about twenty-six by thirty feet. It stands twenty-one feet tall with a Gothic-inspired doorway, Egyptianesque columns, and prominent geometric relief ornament surrounding the architrave. Marr & Gordon cut all of the pieces to design in Barre, Vermont, and shipped them to Denver by railroad in an estimated twenty-two carloads. Ninety pieces of Barre granite form the exterior. Each column and capitol was cut in a single piece to simplify construction and create a more modern appearance. An additional forty-one pieces of stone make up the interior, including six more columns. Marr & Gordon also cut two free-standing sarcophagi for the interior, each from a single block of granite. The Swanson Monumental Co.

assembled the mausoleum in Fairmount Cemetery on a foundation of Colorado granite, with an art glass window that carried the Smails's coat of arms and a record of John Smails's army service. The mausoleum was finished in 1915 at a reported cost of $45,000. Mrs. Smails died the next year, the tribute to her husband complete.[54]

Slightly less well placed widows commissioned slightly more modest monuments for their husbands. We have already seen the statue that Mary Stille purchased for her husband's grave. The women's rights activist Amelia J. Cherot took over the Cherots' grocery business upon her husband Charles's death in 1886. She commissioned a tall granite obelisk from the local monument maker Thomas M. Carrigan that now stands in Riverside Cemetery in Denver.[55] Augusta Chouinard ordered a substantial granite monument and grave fence from Paul & Welch of Butte, Montana, for her husband, Maxime, who died in 1890 and was buried in Mt. Moriah Cemetery. Elizabeth J. Nicholls engaged the sculptor Almond Ernest Pascoe to fashion a monument for her "dearly beloved husband," Edward Nicholls, also in Mt. Moriah. He had died at age fifty-four of cirrhosis of the liver. Social standing and wealth occasioned these impressive monuments, but even a simple, finely lettered, polished marker conveyed the idea of cultural refinement associated with the civilizing process. Emanuel Gerber's wife placed a small marble scroll monument in Laramie's Greenhill Cemetery after her husband passed away in 1882. An open book on the unsigned monument identifies Emanuel as "My Husband" and the Masonic and Odd Fellows symbols on the base identify him as a fraternalist. A small gothic-style marble headstone with a trefoil cutout produced by William Brown's Marble Works for a grave in Salt Lake City's Mt. Olivet Cemetery says only "My Husband A.C.L.P." As patrons, women made choices that helped shape the sepulchral sculpture garden and the market for cemetery art.

Conclusion

With a few exceptions, such as Mary Rauh, who lent her property and her initial to the monument-carving enterprise, and the Bott daughters, who polished the carvers' work and ran errands for their father, women rarely appeared as makers of the sculpture in the garden. Instead, male sculptors immortalized notions of the feminine in ideal Neoclassical and Romantic statues and portrayed modern women only occasionally. Everywhere one looked in the cemetery, the image of woman looked back. She was marble, granite, zinc, or limestone angel, allegorical virtue, or mourner. In a way, marble and granite women freed flesh and blood women to participate in the action of building up western communities, economies, and culture by taking the place of real women on the tall pedestal of Victorian gender expectations. The image of man found its place in the cemetery in portraits of the recently deceased and in the living workforce that tended the garden.

Women's contributions in transforming the burial ground to an ever more visually impressive sculpture garden most often took the form of choosing and purchasing markers, monuments, and mausolea that covered the gamut from elaborate and impressive to simple and modest. Such patronage was another way of publicly revealing one's sorrow and esteem for a spouse, along with wearing black and limiting public activities, as well as a way of asserting one's own social standing.

Monuments to both men and women pioneers recorded the early history of Rocky Mountain communities. The civilizing influence of the Rocky Mountain mortuary sculpture garden can be understood as a collaboration among men and women to express certain ideas and values in visual form: faith in one's God, hope for salvation, returning the body to the earth while releasing the soul to heaven, expressing the sorrow of those left behind, being a pioneer in life, gaining victory over death, reuniting

families, and valuing innocence, purity, and beauty. Mary and Adolph Rauh provide one case study of a man and woman who formed a partnership that contributed to making Riverside Cemetery a premier sculpture garden. In general, the Rocky Mountain sculpture garden assumed a feminine aspect as a site of culture filled with idealizations of female beauty. Fashioned by men, but financed and occupied by both men and women, it projected an image of woman as spiritual guide, emotional compass, and aesthetic ideal.

Mail-Order Monuments and Other Imports

Rocky Mountain Cemeteries in a National Context

For established monument firms east of the Missouri River, the western territories represented an unlimited new market. Eastern sales goals were well served by the attitude of many westerners who felt that monuments made in Italy, Vermont, New Hampshire, Massachusetts, and Rhode Island, and even those produced in the newly settled "middle west," carried more cultural weight than anything carved locally. Add to this the economic reality that until after 1900 it was often cheaper to import a marble statue from Italy than to quarry marble in the Rockies and carve it locally, and the large number of imported monuments in Rocky Mountain cemeteries is easily explained. Imported monuments played an important role by ensuring that the cultural message of the Rocky Mountain cemetery was cast in the visual language of civilization as the pioneers understood it.

Within a year of founding, most towns had a regular freighting service that provided the goods needed to survive on the frontier. Long trains of oxen or mule teams pulled wagons of freight through the mountains. Very small monuments might conceivably have come by way of

stagecoach, but generally the weight and bulk of marble, whether raw or finished, suggests that ox freighters were the most common way of bringing such materials into town before the arrival of the railroads. In Butte, Montana, Alonzo K. Prescott set up a monument business in 1883 and, according to his son, "his marble was shipped to the end of the railroad in the Dakotas and then hauled by bull train to Butte."[1]

The arrival of the railroads increased the availability and decreased the cost of imported monuments. An early newspaper, the *Frontier Index*, carried ads for the Union Pacific in 1868, boasting, "The shortest and quickest route between the mountains and the east is via the Union Pacific Rail Road, now open from Omaha to Cheyenne, 580 miles west of the Missouri River, and 300 miles nearer Denver and Salt Lake than any other Rail Road Line."[2] Not surprisingly, monuments came straight down the Union Pacific line from Illinois, Iowa, and Nebraska into Wyoming. The Omaha monument maker M. J. Feenan provided a rounded marble shaft with a relief lily and rose on top to commemorate twenty-four-year-old James Hunton, who was killed by Indians near Cheyenne in 1876 (fig. 55). Next to it, a draped marble pillar for Emeline Slaughter carries the signature of the Lincoln Marble Works of Lincoln, Nebraska. The railroad reached Laramie in May 1868 and there, too, we find monuments from Omaha and Lincoln. The parents of one-year-old Lillie M. Isaac had her tombstone carved with a sleeping lamb by the Lincoln Marble Co. M. J. Feenan also supplied early monuments to the more difficult to reach Virginia City Cemetery in Montana Territory. His signature on an upright marble slab for Dr. Jabez Robinson, who died in 1866, and one for Charles W. Vincent a decade later document the geographic reach of this marble works.

Towns that the railroads platted enjoyed the advantage of readily available marble monuments from their

55. The Omaha monument maker M. J. Feenan signed this marble monument for James Hunton, who rests in Lakeview Cemetery in Cheyenne. Freight rates made it economical to ship even large monuments across country by rail.

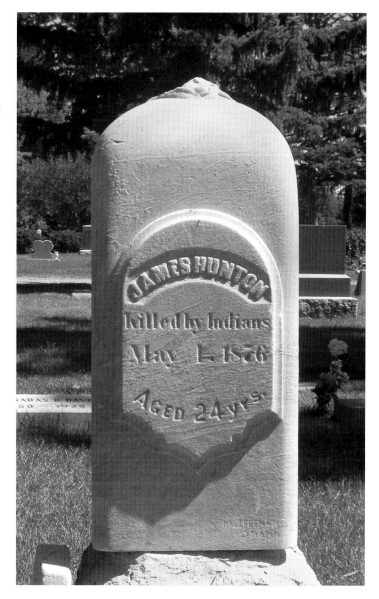

inception. As a result, the percentage of imported monuments may have been higher than in places such as Salt Lake City and Denver, where carvers settled and advertised tombstones before the railroads arrived. Because the Union Pacific Railroad could flood the market along their line with cheap imports, it is likely that merchants, rather than stone carvers, supplied the towns' major sepulchral needs with finished monuments they shipped in, just like

their other merchandise. Perhaps dry goods merchants or furniture dealers such as Laramie's Vine and Boise, who advertised not only all kinds of furniture and upholstering but also metallic coffins and undertaking services, provided Laramie's citizens with monuments. Although their advertisements in the *Laramie Daily Independent* do not specifically mention tombstones, these types of businesses seem most likely to have handled them. While railroad routes eventually determined where a town's imported monuments were most likely to come from, other factors also played a role.

Midwestern Monuments

Many early emigrants to the southern Rockies, especially to Colorado, came by way of St. Louis, the great jumping-off point for wagon trains. Some spent a year or more in St. Louis or Kansas City before setting out farther west. They became familiar with Missouri businesses, which they continued to patronize from frontier towns in the mountains. It is not surprising, then, to find many monuments from Missouri and other midwestern points of origin in the pioneer cemeteries of Colorado. Memorials for people who died in Denver in the 1860s include a stylized rustic cross by J. Pfeiffer & Son of St. Joseph, Missouri; a marble tablet by W. Meyer & Co. of Kansas City, Missouri; an obelisk signed by Wickens & Co. of Council Bluffs, Iowa; and a variety of St. Louis monuments. F. Adolph Brocker emigrated from St. Louis to Leavenworth, Kansas, and then by wagon train to the Cherry Creek settlements between 1858 and 1860. He married Amelia L. Brocker and they had two children who were only three and four years old when Adolph died suddenly while on a return trip to St. Louis in 1870. His remains and an upright marble headstone produced by the St. Louis tombstone maker Reinhold H. Follenius were shipped back to his family in Denver and placed in the

56. The relief carving of a weeping willow, a monument, and mourners with which the St. Louis monument maker R. H. Follenius decorated a marble headstone for Adolph Brocker had been popular in the late eighteenth and early nineteenth centuries on watercolor and stitched mourning pictures. It lost favor after the Civil War and might have been considered old-fashioned by the time it appeared on Brocker's grave in Denver.

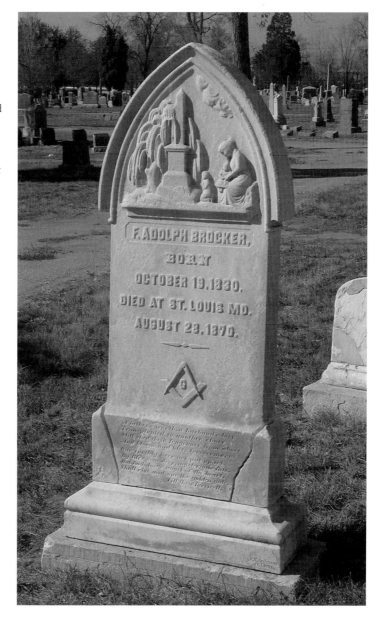

Masonic Cemetery for eight years, when Amelia relocated them to the fashionable new Riverside Cemetery (fig. 56). Follenius owned one of fifteen marble works in St. Louis at that time, making St. Louis a monument center in comparison with Denver, which had only three.

By the 1870s and 1880s a network of railroads and stage and wagon services linked shipping centers like Denver

57. A leader in an early Jewish community in southern Colorado, Alexander Levy and his wife, Lillie, placed a statue of a sleeping baby in a seashell on their daughter's grave. The same image appears on Christian children's graves throughout the mountains and suggests the flexibility of mortuary sculpture to satisfy diverse needs. H. Marquardt of St. Louis produced this marble monument, which remains in excellent condition in the Masonic Cemetery, Walsenburg, Colorado.

with remote towns throughout the mountain territories. The Sporleder family left St. Louis in the early 1870s and settled in Walsenburg, a small settlement at the foot of the mountains in southern Colorado. German-born August Sporleder established a hotel in Walsenburg, in addition to his activities as a merchant and tailor. After his wife died in 1878 he obtained a marble tombstone, elaborately carved with ivy and ferns against a raised tablet, from the firm of Douglas and Fausek in St. Louis. Four years later, Sporleder's twenty-three-year-old son George died, and once again Douglas and Fausek supplied a marble tombstone. In the meantime, Sporleder's daughter Lillie

married the local merchant Alexander Levy. On July 20, 1883, she bore him a daughter, Sevilla Levy, who died the same day (fig. 57). According to family tradition, Alexander had traveled through St. Louis on his way west around 1870 and may have met his future wife there.[3] Perhaps he had his own contacts in St. Louis to turn to. In any case, Alexander and Lillie Levy procured their daughter's monument from a different St. Louis monument maker, H. Marquardt, and set it up on her grave next to the Sporleder monuments for Lillie's mother and brother.

Marquardt provided Sevilla Levy's grave with a baby-in-a-half-shell monument, a type that first appeared in the 1870s and can be found in a dozen or so cemeteries in the mountains. It utilized an ancient sepulchral symbol, the portrait soul in a shell, to suggest transformation from body to spirit and a journey from earth to heaven.[4] It employed the popular simile of sleep as a reference to death, from which the child was expected to awaken to a new heavenly life. Alexander and Lillie Levy suffered another loss a few years later, when their five-month-old son Sidney died. This time Marquardt sent an upright marble slab, on top of which a little boy sleeps in a nightshirt and stocking feet, holding a spray of lily of the valley. Both of the children's monuments are signed not only with Marquardt's name, but also his street address, to make it easier for other Walsenburg residents to write to him for tombstones. Some of the same impulses probably account for Eliza Eldred's marble obelisk in Sheridan, Montana, which is clearly marked "Bedwell & Abbott, Chillicothe, Livingston Co. Missouri" on its base. The lengthy signature, including the county to help prospective buyers locate the town of Chillicothe, was an obvious bid for more business. Bedwell & Abbott also made this obelisk a sampler of their carvers' skills in patterned lettering. Sporleder, Levy, and probably Eldred all turned to previous places of residence to fill their monumental needs, in the process

introducing high-quality sepulchral art to places not yet equipped to produce their own.

Perhaps the biggest exporter of marble and granite monuments from Missouri to the southern Rockies was Kansas City–based H. E. Barker. Harry Barker (1856–1924) grew up in Quebec and at the age of sixteen apprenticed to the Canadian marble cutter G. Z. Hill.[5] After a short period of professional stonecutting in Montreal, he moved to Kansas City, where he worked as a cutter, polisher, and foreman for J. P. Daly & Co. from about 1878 to 1880. He then opened his own monument business, Eastern Marble Works, which soon became the Eastern Marble and Granite Works. His reference to eastern marble in the company name probably indicated a Vermont source for his stone, as well as a desire to emulate standards of mortuary art as they existed on the eastern seaboard. He kept the name long after he began advertising "foreign marble and granite" for sale.

Under Barker's management, Eastern Marble and Granite rapidly outpaced his former employer's firm, J. P. Daly & Co. Barker invested in advertising, often having the only large boldface advertisements among monument companies in the Kansas City directories and taking out full-page advertisements as his business prospered. He was an excellent designer and carver by reputation, and won various awards, but as his business grew he employed many additional carvers. In the 1890s he added a branch location and advertised tiling, wainscoting, and plumbers' supplies in addition to the cemetery work that remained his specialty.[6] His business was a fixture of East Twelfth Street throughout the 1880s and 1890s, easily found and revisited by those passing through the city to the West. Whether they learned about Barker from their travels, his advertising campaigns, or his work with the Knights of Pythias, Odd Fellows, and the temperance cause, westerners from Denver to Cheyenne purchased examples of

his work. Albert and Minnie Rouleau remembered their seven-and-a-half-year-old daughter Florine with a Barker lamb (Cheyenne, Wyoming), and James and Gertrude Tallmadge marked their infant son's grave with a basket of flowers tipped over (Leadville, Colorado).

One of Barker's most famous monuments in the Rocky Mountain region was the marble statue of a Union soldier commissioned by Custer Post Number One of the Grand Army of the Republic "In Memory of our Dead Comrades." This is an example of the new, post–Civil War memorial to the "common soldier" that Kirk Savage has analyzed so thoroughly.[7] It stands on a tall granite base in Greenhill Cemetery in Laramie, Wyoming, one of dozens of H. E. Barker monuments in this cemetery.

The variety of styles produced by Barker's firm is clear from just these few examples. The volume of his production grew throughout the 1880s and 1890s. At the turn of the century, an article in a national magazine touted Barker's modern machinery and the capacity of his large facilities, noting that he had on hand twenty-five carloads of rough granite, six loads of marble, 188 finished granite monuments, one hundred finished marble monuments, and one hundred granite tablets and markers, in addition to a large stock of finished marble markers.[8] Barker was then only forty-eight years old, but had been in business for twenty-nine years and had built it into a substantial industry.

Eastern Marble

Harry Barker was not the only businessman to capitalize on the cultural cachet of eastern marble. More and more monument retail dealers set up shops in the mountains, ordering directly from eastern wholesalers. Some, like the Bills brothers, brought their eastern contacts to the Rocky Mountains with them. Around midcentury, Carroll Bills got his start in the marble business as a salesman

for General Ripley, a marble quarrier and monument maker in Rutland, Vermont, whose sons continued the business during the 1880s and 1890s as Ripley Sons.[9] In 1883 Ripley Sons joined four other Vermont companies—Dorset Marble Co., Redmond Proctor's Vermont Marble Co., Sheldon and Sons, and Gilson & Woodfin—to create Producers' Marble Co., which sold all their monuments under a set of common design numbers and agreed upon prices. Their catalogues, preserved in the Vermont Historical Society, include literally thousands of designs. This scheme enabled them collectively to produce and sell carved marble monuments to retailers anywhere in the country.

For a time in the early 1880s Carroll Bills ran a monument business in Kansas City with his brother Neal, called Bills Brothers. In 1885 they moved Bills Brothers to Denver, where their brother Willis had already been selling monuments for five years, and expanded the firm to include him. Carroll's knowledge of the Vermont marble industry, Ripley Sons, and the products of Producers' Marble Co. put him in an ideal position to provide their Rocky Mountain clients with East Coast marble monuments. Bills Brothers became one of the biggest Rocky Mountain dealers and importers of monuments from the eastern states and abroad.

The existence of volume producers such as H. E. Barker, Producers' Marble Co., its biggest Vermont competitor Rutland Marble Works, and many others in the last quarter of the century made it easier for people in the mountains to become established in the monument retail business. They could simply order what they needed from a variety of sources and handle the sales, lettering, and setting themselves. William H. Mullins in Salem, Ohio, produced huge quantities of statues from sheet metal. A promotional photograph of the Mullins statue plant in the 1890s shows angels and allegories of Victory and

Hope as well as soldiers and other less sepulchral statues lined up in rows in front of the plant. F. O. Cross became a large producer of rustic limestone sculpture.[10] He considered himself the inventor of this branch of monumental art. Around 1890, after a decade or more in Chicago, he moved to the source of some of the best sculpture-grade limestone: Bedford, Indiana. Rustic, or natural tree-branch-based motifs, were extremely popular in mid-nineteenth-century cemeteries throughout the country and a lot of examples of rustic limestone monuments by various carvers are found in the Rockies. The miniature tree stump with a broken flower pot at its base for two-year-old Ralph Maucham in Pueblo's Pioneer Cemetery is a good example of F. O. Cross's work.

Italian Marble Statuary

Rocky Mountain dealers ordered not only from American producers but also from importers of Italian marble. Statue "factories" in Carrara, Italy, advertised in American publications the product of their famous quarries and skilled carvers. With sculptors lined up in their workshops to produce sepulchral art in quantity, they supplied the United States with work that was often unique to a cemetery, and perhaps even to a county, but was rarely actually unique. Nevertheless, Carrara marble statuary remained popular after other monument forms converted to granite. The *Monumental News* reported that five thousand men worked the Carrara quarries and at least sixty thousand people in Carrara and the neighboring villages depended on the marble industry for their livelihood, exporting thousands of tons of marble sculpture annually. Carrara sculptors, who worked for lower wages than American carvers, were reportedly required to spend from eight to ten years in the academy of fine arts. This combination meant that Carrara produced some of the highest quality and lowest priced marble sculpture in the world.[11]

National tariffs and trade agreements affected importation of marble sculpture. Before the tariff act of March 1883, "manufactured" marble cost 50 percent *ad valorem*. After 1883, it cost 45 percent, with an exclusion for fine art. The tariff law exempted statuary from the duty as long as it was "cut, carved or otherwise wrought by hand from a solid block or mass of marble" and was "the professional production of a statuary or sculptor only." To prove that a Carrara export met the criteria, each "bona fide" sculptor signed a declaration authenticating his work in the presence of the consular agent at Carrara before it was shipped. According to at least one source, the majority of statuary shipped to the United States was bound for cemeteries. This trade could be crippled by a change in the tariffs. Rocky Mountain dealers who imported Carrara statues wanted the duty as low as possible, while carvers and businesses hoping to develop Rocky Mountain marble sources preferred a high duty tax in order to lessen the Italians' competitive edge. In 1897 when American port officials again began to require the 50 percent manufactured marble tax on certified Italian sculpture for monumental purposes, there was a brief panic, one of numerous such scares for importers over the years. It was smoothed out so that the distribution of Italian marble sculpture to American cemeteries continued uninterrupted into the twentieth century.[12]

Not all, but the majority of life-size marble figurative sculpture in Rocky Mountain cemeteries is unsigned. Much of it originated in Carrara. Excellent preservation provides evidence of the high quality of Carrara marble, which resists erosion better than most Vermont marbles. The female figures on the graves of Lillian Stoakes Cullen and Katherine Sinclaire Sligh, who died in Helena at the ages of seventeen and twenty, respectively, provide excellent examples of this type of memorial.[13] The grieving families had the financial means to provide impressive

memorials. Lillian's father, William E. Cullen, came to Helena from Minnesota in 1866 to practice law and soon found himself on the seven-person legislature of Montana Territory.[14] Over the years he served as a legislator in the territory and the state, attorney for the Northern Pacific Railroad, attorney-general for the territory, chairman of the Democratic Party's territorial committee, and a partner in various law firms. He married Caroline Stoakes in Helena and they had four daughters and a son. Lillian was the first to die, while only seventeen, and the unexpected loss hit her family very hard. Her burial permit states that she died of "abcess," but an obituary explains that she was stricken with appendicitis and did not seem to be recovering very rapidly from the operation.[15] Hoping to speed her progress with a vacation by the sea, her mother and sister took her to British Columbia, where a tumor was discovered. She did not survive this second operation. The Cullens were a close-knit family, to judge by the inscription her parents had carved on her monument: "We mourn dear Lilly thy untimely end, Thy mother's darling and thy father's friend."

Less than a year later, Katherine Sligh's family laid her to rest not far from Lilly in Forestvale Cemetery (fig. 58). She was engaged to marry the president of the Montana National Bank but died of rheumatic heart disease after a two-day illness.[16] Her father, James M. Sligh, served as company physician for one of the largest mines in the territory as well as a state senator. Like the Cullens, the Slighs were devastated by their unexpected loss, made more difficult for her father by his inability to save her with his medical skills. The tragic deaths of these young women inspired their parents to erect impressive marble sculptures of beautiful women over their graves. Neither is signed, but both appear to be Carrara marble and are carved in detail. The Cullen memorial represents a standing cloaked woman writing in a book, probably intended

58. Katherine Sligh's parents chose a marble Melancholia to mourn perpetually at their daughter's grave in Forestvale Cemetery, Helena, Montana. The exact maker is unknown, but similar figures originated in the numerous sculpture studios of Carrara, Italy, such as McFarland's and Dempster's, as well as some Vermont studios.

to represent a wingless recording angel, while the Sligh memorial depicts a contemplative woman seated in the traditional pose of melancholy, perhaps best known from Dürer's engravings of *Melancholia*. She rests her cheek lightly against the fingers of one hand, while the other holds a memorial wreath near her knee. Very similar statues, carved by different hands, can be seen in the Salt Lake City Cemetery for Joseph and Eliza Smith and for George Morris, as well as in other cemeteries. These were types found in the repertoire of many of the large monumental marble statuary firms in Italy.

Even unsigned monuments can sometimes be traced to

59. A schoolboy with his open book looks up to his mother in this marble group chosen for the Bethell plot in Fairmount Cemetery, Denver. Most likely imported by H. T. Dempster from Carrara, Italy, it emphasizes generational continuity in the face of the child mortality that inspired its erection.

their likely source through catalogues and other records. William Decatur Bethell and Cynthia Saunders Pillow Bethell created a memorial to two of their sons, J. Pillow Bethell and Pinckney C. Bethell, by having a marble statue of a boy at his mother's knee placed on a substantial granite base (fig. 59). A wealthy and influential man in Memphis, Tennessee, William Bethell moved his family to Denver in 1891 in hopes of improving his health in the mountain air. He purchased land at Sloan's Lake to build a resort called Manhattan Beach that became a landmark of metropolitan Denver. He also built a palatial mansion in the fashionable Capital Hill area for his family, and he and his wife entered Denver society. By the time of his

death, Captain Bethell was estimated to be worth $2 million.[17] In December of their first year in Denver, their son Pillow died. Just over a year later Pinckney joined him in the fashionable new Fairmount Cemetery. It was not surprising that Captain Bethell and his wife chose to erect on their sons' graves one of the most impressive monuments yet seen in Fairmount.

The statue of a mother and child that graces the Bethell monument appears in a catalogue from the well-known Carrara firm of H. T. Dempster, under the title *Soar*.[18] Renamed *Mother and Son* by an American importer, it could be obtained in 1895 for $350 in marble or $918 in Westerly granite. The Bethells chose the more traditional marble. A Denver monument company probably contracted to move the statue from the railroad to the cemetery, to provide the granite base, and to set them both up in Fairmount Cemetery, an additional substantial expense. At four feet, six inches, the seated figure is approximately life size. Its choice seems to express the pride in family heritage that characterized the Bethells. Pillow went by his mother's maiden name, and Pinckney bore his paternal grandfather's name. William had been devoted to his own father, and a glance at the family tree elicits the information that family members constantly named their children after ancestors. The little boy learning to read at his mother's knee illustrates that family continuity. It also bears a visual relationship to earlier work, such as the British monument for Harriet Susan Fitzharris in Christchurch by John Flaxman. Nicholas Penny describes this composition of a seated woman reading a book to three children as a representation of *Caritas*.[19] Charity is not one of the allegories commonly found in Rocky Mountain cemeteries, although her companions, Faith and Hope, are prevalent.[20] The same Italian monument catalogue that sold *Mother and Son* also provided one design called *Charity*, representing a seated woman with a

60. The Italian firm of Fratelli Lapini [Lapini Brothers] carved this large marble monument in 1892 for the grave of John J. O'Farrell. It stands near the central circle of St. Patrick's Cemetery in Butte, Montana.

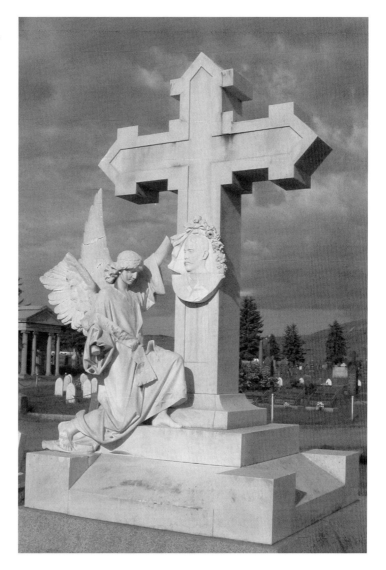

drapery over her head, an open book in her hand, and a child leaning against her knee with its head in her lap. No example of this statue has been found in the mountains. The catalogue titles for the statue on the Bethell plot make it unlikely that it was intended to represent Charity; nevertheless, compositionally it is one of numerous descendants of Flaxman's *Caritas*.

One of the most elaborate and unique marble monuments in the nineteenth-century Rockies came from Florence, Italy. Near the center circle of St. Patrick's Cemetery

in Butte, an over-life-size marble angel kneels at the base of an impressive marble cross, against which she holds up a relief portrait bust of John J. O'Farrell (fig. 60). The angel and cross are signed with the name of the studio that produced them: "Fratelli Lapini, Firenze 1892." That twenty-seven-year-old John J. O'Farrell should have the most imposing monument in Butte's Catholic cemetery is at first surprising. But his positions, as his father's namesake and firstborn child, as the nephew of the most important mining man in Butte, Marcus Daly, and as the popular superintendent of the Chambers Syndicate of Mines, made John an unusual young man. He had been engaged in mining all his life, beginning as a tool boy with his father in the famous Comstock Mines of Virginia City, Nevada, and then moving to Butte to work in his uncle's mines in 1880. Daly built up the Anaconda copper mines in Butte, so the family relationship undoubtedly helped John move steadily up to the position of superintendent. Yet John had a magnetic personality of his own, and according to his lengthy and laudatory obituary, "was greatly esteemed by the miners who worked under him, and they would do anything for him on account of his impartiality and hearty disposition. . . . He was very efficient in the discharge of his duties; faithful and competent. In fact, he was a universal favorite with all classes."[21] The truth of this was demonstrated when, upon John's unexpected and premature death in 1888 from complications brought on by typhoid fever, the Anaconda, St. Lawrence, and Chambers Syndicate mines and the Anaconda smelter all shut down and numerous social functions in town were postponed. Although Marcus Daly was unable to return for the funeral, it is said that he paid for the memorial that dominates the O'Farrell family plot.[22] The magnificence of that imported Italian monument made a suitable tribute to one so well liked and well placed in Butte society.

Scottish and American Granite

Granite slowly gained popularity for monumental purposes in the Rockies throughout the 1880s and 1890s, a bit later than in the eastern United States and in the Midwest. Except for statuary and mausolea, granite almost completely displaced marble in the cemetery monument trade by the early twentieth century. From an artistic point of view, figurative statues rarely looked as naturalistic in granite as in marble. The stone's gray color absorbed the light evenly instead of creating highlights on the high surfaces and deep shadows in the grooves to provide the defining contrasts on which carved marble relied. Granite was also harder to carve. Even with pneumatic and then electric-powered cutting tools, most statues and carved ornaments were no longer as deeply defined as they had been in marble. For example, the Forestvale Cemetery in Helena contains a granite example of the type of seated melancholy mourning woman seen in marble on Katherine Sligh's grave. The granite model is dedicated to William and Margare (*sic*) Nicholas. Comparison of the Sligh and Nicholas figures demonstrates the greater workability of marble. The Sligh figure has delicate features, a slender neck, and an elegant pose and her deeply carved hair flows naturally down her back, while the granite Nicholas figure has a thick neck, a blocky head, and stiffer posture. Recognizing that such traits were common to granite sculpture, one granite statue producer in Vermont quoted an observer of their studio: "We saw four men working on statues; and by statues we mean statues that are works of art, not the stiff, straight, staring images we often see."[23]

Whatever producers said about the artistic quality of granite statues, people more often purchased this stone for a different trait. The same hardness that made some granite figures appear lifeless also caused granite to resist erosion far better than even the best marbles. Importers looked to Scotland in the late 1870s and early 1880s for

finished granite monuments. The best known American granite for monuments in this early period may have been Westerly granite from Rhode Island.

Carvers at the Hartford, Connecticut, New England Granite Works mass-produced sculptures, pedestals, and monuments of all kinds from their quarries in Westerly. After John Wesley Iliff's granite monument with its statue of Memory (fig. 14) was erected as the centerpiece of the Riverside sculpture collection in Denver, others began to order from this firm as well. In fact, the very next order accepted by the firm came from Denverite John Hindry for a fifteen-foot obelisk to mark the graves of a grown son and a daughter who had died as a toddler ten years earlier.[24] This constituted a far more modest memorial than the Iliff monument, and was shipped with it on March 22, 1880, to save costs. The next year, Mary Eckhart erected a tall granite obelisk with etched ornamental designs for her late husband, John, a dry goods merchant who had come to Denver in 1864. An acknowledged alcoholic, he died early in 1880 from an overdose of sleep medication prescribed for insomnia on top of an excess of whiskey that stopped his heart.[25] As the administrator of an estate estimated by the newspaper to be worth $70,000, Mary Eckhart had the means to rival Lizzie Iliff. She buried her husband on the ring just outside the Iliff circle at Riverside and marked his grave with a tall granite obelisk. Mrs. Iliff had worked directly with the New England Granite Works, receiving personal attention from its secretary, H. A. Batterson, and from the company director, George T. Batterson, who traveled to Denver to oversee the monument's erection.[26] Mrs. Eckhart probably met with George Batterson while he was in Denver. Although the height and polish of the Eckhart monument rivaled the Iliff monument, it cost Mary Eckhart only $1,500, compared to the $7,500 that Lizzie Iliff paid for her husband's memorial. Within a month of Mary Ekhart's order, yet

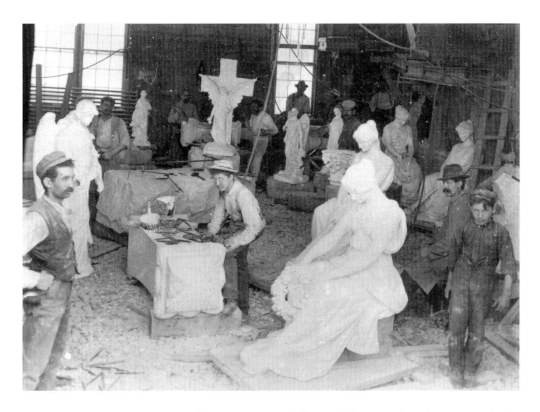

61. Carvers in the stone studio of Corti & Novelli in Barre, Vermont, created multiple examples of popular female allegories and angels for cemeteries around the country. Courtesy of the Aldrich Public Library, Barre, Vermont.

another Denverite followed the trend and contacted the New England Granite Works for a large urn monument to his twelve-year-old daughter, Susie Knox. It took only seven and a half months from the order date until it was shipped, together with the Eckhart obelisk, to Denver. All of the monuments supplied to the Rocky Mountain region by this firm before 1910 went to Denver, except one for Pueblo, Colorado. After the first four orders from individuals, New England Granite Works began dealing exclusively with Denver's Greenlee & Co. Many other carvers and monument firms quarried and processed Westerly granite, and Westerly granite also had many competitors by the late 1880s and 1890s.

Fred Barnicoat and John Horrigan both ran large studios in Quincy, Massachusetts, specializing in granite statuary of their own designs carved from Quincy granite. Barnicoat had worked as a carver for the New England Granite Works in the early 1880s before opening his own

62. Wholesalers jealously guarded their price systems from customers but shared information with each other. The 1902 *Barre Granite Manufacturer's Association Price List* offered statue no. 11 (Memory) to the trade for fifty dollars a linear foot. Courtesy Vermont Historical Society, VHS-3637.

No. 11, $50 per foot.

studio in Quincy, where he is said to have cut the first statues from Quincy granite.[27] By 1900 his studio made about fifty statues a year. Horrigan billed himself as a monumental sculptor and offered to send a free catalogue of his designs upon receipt of ten cents postage. Both advertised nationally. Many other sculptors specialized in granite statuary for cemeteries and quite a few settled around quarries in Barre, Vermont (fig. 61).

Barre granite has a fine grain and consistent composition throughout, with few flaws, producing a very even

gray color in statues and other monuments. Barre monument producers joined forces in the Barre Granite Manufacturer's Association, which produced a price list for the aid of its members and their agents. From this source we learn that by the end of the nineteenth century, wholesalers were selling granite statuary at anything from $48 to $80 per linear foot depending on the complexity, or perceived popularity, of the design (fig. 62).[28]

The very idea of purchasing the Virgin Mary by the foot goes against most notions of fine art. For the wholesale and retail monument dealers this was, indeed, all business. But for the purchaser of a monument to the memory of a loved one choosing between an angel or a figure of Hope, the purchase was a work of art to beautify the family plot and the community cemetery. Understanding this, monument firms stressed the artistic quality of their work in their advertising. For example, Ryegate Granite Works, another Vermont producer, titled their 1888 catalogue *Artistic Cemetery Improvements*. They wrote about their granite, "The finest monuments and the most prefect statuary are cut from it, and people of the most artistic taste unite in their preference for this material. . . . It is admitted by artists and sculptors to be unrivaled." They even hired the director of their statue cutting room from Carrara and reported that he claimed that Ryegate granite produced better effects than any stone with which he had ever worked, inferring that it surpassed Carrara marble.[29]

By the 1890s, Rocky Mountain firms often functioned as middlemen between local patrons and eastern firms. To return to the Bills Brothers, for example, an article about the company's show room in 1912 noted, "There is an especially good representation of marble statuary, imported direct from Carrara and a good selection of granite and marble from every section of the world."[30] When the Wohl family of Denver purchased a monument

from the Bills Brothers, they may have considered it a local transaction, but the Bills Brothers then turned around and contracted with the Barclay Brothers, famous granite producers in Barre, to provide the twelve-foot-long exedra from Barre granite. They paired this exedra with a marble statue of a woman scattering flowers that they imported from Carrara. Bills Brothers wrote the contract, designed the monument, corresponded with the various providers, transported the parts to Emanuel Cemetery, and assembled them. Stone carvers in Vermont and Italy actually made the memorial.[31]

The practice of subcontracting became especially prevalent with the architectural monuments that gained popularity in the largest Rocky Mountain cemeteries during the 1890s. For example, Denver Marble and Granite took the Davis family's order for a granite canopy monument, a short colonnade twelve feet long and over sixteen feet tall, and then contracted with the Jones Brothers, one of the first exclusive granite wholesalers in Barre, Vermont, to cut all the parts in Barre granite and send them to Denver. Likewise, Bayha and Bohm, a Denver firm whose German-born proprietors preferred German-inspired mortuary architecture, designed and erected an exedra for the Deutsch-Andersson families. They sent their drawings to the Cross Brothers in Northfield, Vermont, to have the exedra cut in Barre granite and sent the three sculptured panels to be cast in Düsseldorf, Germany. As the parts arrived in Denver, Bayha and Bohm assembled them, with urns containing the ashes of the deceased hidden behind the outside panels. Gottlob (Charles) Bayha and Paul Bohm had both worked as stonecutters for the well-known Denver stone contractor and builders Geddis & Seerie before opening their monument firm about 1896, but to be competitive, they had to specialize and subcontract.

Similarly, Butte Tombstone Co. sent drawings to mon-

ument companies from Minnesota to Georgia, requesting bids on work of all sizes. For each job, they chose the best subcontractor they could find. It is unclear why they used their own carvers for some jobs and imported work for others, unless the type of stone requested by the customer made the determination. This contracting and subcontracting procedure led to an even more cohesive national monument market and further unified the appearance of cemeteries from coast to coast after the turn of the century. It also reflected the national trend toward the separation of retail and wholesale operations and the professionalization of monument selling.

In 1898 a meeting of marble and granite monument dealers at Council Bluffs, Iowa, resulted in the formation of the National Retail Marble and Granite Dealers Association, which became the National Retail Monument Dealers Association and began holding annual conventions throughout the country. When Denver hosted the NRMDA convention in 1915, firms nationwide took the opportunity to highlight their past work in Denver's cemeteries. The April and June issues of *Monumental News* carried full-page advertisements by companies outside the Rocky Mountains that featured monuments they had made for Denver firms.

Marketing with Photographs

Another innovation in monument marketing also promoted the importation of monuments to the Rocky Mountain region near the end of the century: the introduction of national monument photography businesses. Harry Augustus Bliss of Buffalo, New York, may have been one of the first photographers to specialize in sepulchral art. Born in 1867 to the successful Buffalo photographer Horace Lathrop Bliss, Harry learned portrait and landscape photography from his father, with whom he worked in Bliss & Son. When Horace Bliss retired around 1889, Harry

joined his brothers Frank and Alfred in Bliss Brothers, where portraiture took second place to "views and landscapes and photographs of machinery and manufactured goods."[32] Harry developed an interest in cemetery art and traveled the United States photographing examples of monuments. Advertising in *Monumental News* in 1910, he described himself as a "specialist in monument, mausoleum and headstone photography" for whom "originality and exclusiveness of design" determined which markers to photograph.[33] He sold them as individual photographs or bound into books, and in 1918, when the brothers sold their business, he became the publisher of a new magazine, *Monument and Cemetery Review*, and began writing and publishing books about memorial art.

Another person who developed a specialization in memorial photography, the monumental draftsman and designer Charles H. Gall, based his business in Chicago. Gall found that photographic prints quickly and inexpensively conveyed design ideas to larger audiences than the blueprints and drawings normally produced by designers on commission. In an undated circular to the trade for his second series of twenty-three designs, each printed on a fourteen-by–twenty-one-inch sheet of heavy paper, Gall noted that this photographic collection of his original designs cost only $5, instead of $150 that he would have charged for the original hand-drawn designs.[34] He continued to issue sets of his own designs, but like Bliss, Gall also photographed every type of monument, from the most mundane to the most unique. His 1897 *Book of Monumental Designs* carries eighteen thumbnail photographs per page of what sometimes appear to be nearly identical monuments; closer examination reveals subtle differences. The purpose of this book was to sell photographs, not monuments. From the fifty pages of thumbnails, customers ordered photographs on cards or cloth in sizes ranging from eight by ten inches to eleven by fourteen inches. The photographs

could be ordered bound in cloth or leather with the name and address of the monument company or salesman on the cover. Orders of fifty or more earned a discount, suggesting that Gall's goal was to furnish monument dealers with personalized catalogues of the designs that they would then manufacture or sell. Gall followed his original book, issued May 1, 1897, with a supplement in December, a second edition in May 1898, and a second supplement in May 1899. These monument photograph books form a compendium of the popular designs of the day.

Armed with a customized book of Bliss or Gall photographs, independent salesmen could represent to consumers a wide variety of potential monuments. When customers placed orders, the salesmen ordered them from whatever manufacturer they desired. The *Monument Dealers' Manual* alluded to this practice in a section entitled "Changing Names on a Photograph," which explained how to white out the family name and draw in a prospective customer's name to elicit a sale without destroying the original photograph. After cleaning the photograph, the process could be repeated for another customer.[35] The use of photographs in the 1880s and 1890s revolutionized monument marketing. Even Producer's Marble Co. of Vermont, which in the mid-1880s published an extensive catalogue illustrated with simple line drawings, offered to provide photographs of any of the designs to retailers and salesmen, explaining, "We have secured the services of a first-class photographer and shall be able to furnish very fine photographs which will assist you greatly in your trade . . . either mounted on fine tinted card board or bound in book form."[36] In this case, Producer's Marble expected the resulting monument orders to come back to its component companies.

The extensive use of monument photographs as design models and for marketing and sales increased the likelihood of any given monument, marker, or mausoleum

being found in multiple parts of the country. American monumental forms had always tended more toward the communal than the individual or unique, and the introduction of monumental photographers in the 1890s built on that foundation. Local and regional preferences can be identified, but truly unique monuments are rare in late nineteenth-century American cemeteries.

Zinc and Bronze

Zinc monuments began to appear in Rocky Mountain cemeteries in the 1880s. Unlike stone, which was manufactured locally as well as imported, most zinc monuments were cast outside of the region and freighted in. The majority arrived by rail from the Western White Bronze Co. of Des Moines, Iowa. A related firm, the Detroit Bronze Co., supplied similar monuments throughout the region for a brief period in the early 1880s, and the American Bronze Foundry Co. of Chicago placed monuments in Montana in the 1890s. A small independent monument plant in Warsaw, Missouri, w.z.w., shipped a number of zinc monuments of its own design to the Rocky Mountain states around 1900. At least one zinc statue of the Virgin Mary standing on a crescent moon came from M. J. Seelig & Co. Art Zinc Foundry of Brooklyn, New York (Mary Hogan grave, Mt. Olivet Cemetery, Denver). There are undoubtedly other manufacturers represented in the region, but the majority of zinc sepulchral sculpture is of the Western White Bronze type.

Western White Bronze began business in 1884 with capital of $100,000 and prominent local businessmen as stockholders, according to the Iowa Board of Trade.[37] It had a foundry with twelve hundred square feet of space and a separate building, over seven times that size, with offices and a plant for assembling, finishing, packing, and shipping monuments.[38] Twenty people were reported to be at work in the plant a few years after it began, and it

was producing a large volume of work for a seven-state area west of Iowa.

In her pioneering history of the white bronze industry, Barbara Rotundo explains that Western White Bronze was part of a larger enterprise that had begun in Bridgeport, Connecticut, with the Monumental Bronze Co. in the mid-1870s.[39] This company marketed its zinc monuments under the trade name "white bronze," thereby associating them with an ancient medium of fine art rather than the material commonly used for industrial purposes. "White bronze" provided a more artistic connotation for customers than the utilitarian-sounding "zinc." The Monumental Bronze Co. expanded in 1881 with a subsidiary in Detroit, and over the next few years other plants were established in Chicago (American White Bronze), Ontario (St. Thomas White Bronze), and Des Moines (Western White Bronze Co. until 1904, when its name changed to the White Bronze Monument Co.).[40] All of the plants shared designs, techniques, and the trade name white bronze. Rotundo's theory that the Bridgeport plant actually did the casting for all the others is not borne out in Des Moines, where the facilities were constructed for full production. The articles of incorporation for the Western White Bronze Co. make no mention of any other company, but treat it as a wholly independent business. Each white bronze plant claimed a different geographic region. When it began in 1884, Western White Bronze made the monuments for Iowa, Missouri, Kansas, Colorado, Nebraska, Wyoming, and Dakota. Four years later, it was no longer the sole producer for Missouri or Wyoming, but continued to supply the other states. Although Western White Bronze made no claims about Utah, its product is also found in the Salt Lake City Cemetery. In fact, white bronze monuments can be found in all the Rocky Mountain states covered by this study, but a large number give no indication of which plant fabricated them.

Like the other white bronze companies, Western White Bronze produced custom-made cemetery monuments and civic sculpture from stock components, and it also designed new monuments or parts of monuments on commission. The company employed a full-time artist as well as foundry workers but also fabricated works of art designed by independent artists. For example, the Chicago sculptor Charles J. Mulligan modeled a statue of Richard Bland that was cast by Western White Bronze for the town of Lebanon, Missouri, at a cost of $5,000.[41] He also created a life-size figure of two-time acting territorial governor Thomas Francis Meagher for the Montana state capitol in Helena that was cast by the American Bronze foundry in Chicago. Neither of these examples is sepulchral, but the publicized use of fine artists combined with the white bronze trade name to suggest a high artistic quality to potential buyers of white bronze monuments.

As Rotundo has pointed out, white bronze monuments imitated stone monuments in many respects. They assumed well-established sepulchral forms, such as the obelisk, draped urn, shaft, and rounded and shaped headboards, and the familiar complement of cemetery statues: Hope, Faith, Jesus, lamb, cross, Mary, angel, Grief, and soldier. Some even imitated rock face, the roughly chipped surface peculiar to granite, which Western White Bronze called ashlar. Yet the white bronze companies marketed their product on its supposed improvements over stone, often listing the positive qualities of zinc in one column and the opposite, negative qualities of stone in another. Even as its advertising attempted to convince consumers of the superiority of zinc, the management recognized that purchasers of grave markers had strong visual expectations already well established by stone monuments. To be competitive, zinc had to look like traditional stone but cost less and last longer. A white bronze lamb statue on a simple base with lettering cost only $30 and plainer markers

could be acquired for even less, making them extremely competitive with marble and granite. At one point, the parent company claimed to offer monuments ranging in price from $5 to $5,000, something for everyone.[42]

Among the qualities that white bronze touted, first and foremost was the claim that pure zinc would resist the effects of weather and erosion far better than any carved stone surface, or even traditional bronze. When inscriptions were cast in this material, they were expected to remain easily legible for centuries and the oxidized metal surface produced a silvery-white color that was much less susceptible to chemical change than bronze. Second, the medium-size and large monuments were designed with removable dies. Zinc plates with an inscription or with a stock low-relief motif—flying dove, sheaf of wheat and sickle, angel, floral wreath—were attached to the die areas, and sometimes to bases, of each monument. Over the years as family members died, the image plates could be exchanged for additional inscription plates at little expense, making these particularly flexible monuments. New plates were easily bolted on by the owner. White bronze advertisements also noted that any mistake in an inscription would be corrected with a replacement plate, an advantage that stone monuments could not match.

Riverside Cemetery in Denver, Colorado, has a significant concentration of Western White Bronze monuments. By looking more closely at this cemetery we can gain some insight into possible patterns of use in the region. A word of caution is in order, though. Even though zinc is less susceptible to erosion than other materials, it can be brittle and is not proof against vandalism, theft, lightning, errant lawn mowers, and falling objects. Over the course of a century the original number and types of white bronze markers at Riverside has changed to a degree that cannot be judged precisely. While documenting a story about the deterioration of the cemetery in 1967, for example, a

photographer for the *Denver Post* happened to catch on film the broken white bronze monument of L. K. Lusner, who died December 15, 1882. It no longer marks Lusner's grave and we cannot know how many other damaged monuments have been discarded in the past. Therefore, the statistics below should be used only as an indication of trends.

There are one hundred extant zinc monuments in Riverside, and seventy-five of them bear the raised inscription "Western White Bronze, Des Moines, Iowa" on their bases. Twenty-four have no marking to identify the manufacturer but look just like the Western White Bronze products. To date, scholars have assumed that unmarked monuments originated at the same plants as the marked ones, but no one has advanced a theory to explain why. The possibility that unmarked white bronze monuments were produced by counterfeit companies cannot be dismissed without more research and opens the small possibility that some white bronze originated in the Rocky Mountain region. The final monument out of one hundred at Riverside is marked "Detroit Bronze Company, Detroit Mich."

Together, obelisks and cottage monuments account for half of the extant zinc monuments in Riverside Cemetery. Twenty-six are obelisks, many with relief drapery on the sides and/or an urn on top, and twenty-four are cottage style, also frequently finished with an urn. The Body monument (fig. 63) is an example of the cottage style, about which Western White Bronze claimed in 1888, "The style of monument termed 'Cottage' has for several years been more popular than any other. The style known as 'Sarcophagus' also meets with great favor."[43] The Riverside survey seems to support the first of these claims, although cottage and obelisk may have been equal in popularity. The second claim was probably not true for Denver, where only three white bronze sarcophagi remain.

63. Western White Bronze Co. of Des Moines, Iowa, cast this zinc monument in the popular cottage style and finished it with a kneeling angel for Minnie Body, who died in Denver in 1887. The date of the monument's creation, 1888, is also cast into it. Another cottage-style white bronze monument with a square urn on top stands in the background. Riverside Cemetery, Denver.

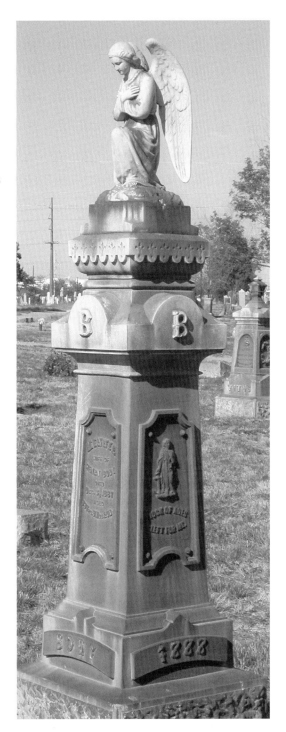

Instead, the less expensive double-fronted monument makes up the next most popular category, with eighteen examples surviving. Double front was a term used for the traditional headstone shape made in two parts for front and back, fused together with an almost invisible seam. Three other types are equally simple: low-lying head markers with the inscriptions facing the sky, upright slabs that look like double fronted but are actually made like a box, and a single-thickness marker in the same traditional headstone shapes, known as a single front. In aggregate, these four simple, relatively inexpensive types account for almost 40 percent of the zinc monuments at Riverside. This suggests that simplicity and low cost were almost as attractive to white bronze buyers in this community as the elaborate effects that could be achieved with the larger monuments.

Seventeen extant white bronze monuments have full, three-dimensional statues, including six lambs and two Young Saint Johns carrying lambs. There are examples of white bronze's foremost allegories, Faith and Hope, as well as a kneeling angel, a praying child, and Grief. Statues can be found surmounting obelisks, cottage-style monuments, and a sarcophagus, as well as standing on very simple low bases of their own, as do the two crosses and six lambs.

By 1888, the Western White Bronze Co. advertised the availability of three thousand designs; in a catalogue accompanying their exhibit at the 1893 World's Columbian Exposition, they raised that number to twenty-five thousand. Despite such a large number, the overall impression one receives in Riverside Cemetery is of a more limited variety of shapes and motifs. A closer look at the components of the Western White Bronze monument purchased by the cigar and tobacco dealer Henry Body to commemorate his wife, Minnie, helps explain the apparent discrepancy. The base has ashlar panels to imitate

stone, and customers could choose designs with single- or multiple-tiered bases and different textures, including smooth, corrugated, and ashlar. On this base, the main shaft of the Body monument rests on its own pedimented base with the family name and the date of manufacture in the base pediments, one of many available options. Four different inscription and image panels adorn the shaft, one for each side. Customers could choose from a large selection of bas-relief motifs for this purpose at no additional cost. Henry chose the Rock of Ages motif for one die, an allegory of Hope for another, and a panel with the inscription "Minnie, wife of Henry Body, Died Dec. 8, 1887 Aged 33 Yrs 9 Ms 20 Ds" on a third. Several years later the fourth panel, of unknown design, was replaced with an inscription for Henry, who died March 22, 1892. The shaft is also capped with a pediment, which came in many different shapes, plain or decorated. The Body monument has a capital B in the rounded pediment on all four sides. Another assemblage of decorative bands and the base for the statue provide several more areas where a variety of options existed. Finally, Henry Body chose the kneeling angel sculpture to complete his wife's monument. He could have chosen a model with a square urn, a round one, a draped urn, a cross, or any number of other statues, each available in a variety of different sizes. It was through the amazing number of different combinations of all these parts that Western White Bronze arrived at three thousand and then twenty-five thousand as the number of available designs.

A broken monument in Central City, Colorado, reveals on its interior that each part was marked on its back side with the family name, order number, and component part number, presumably to keep them together during the assembly process until they were fused with molten zinc. Because each monument was made to order, customers felt they were receiving a memorial personal to their loved

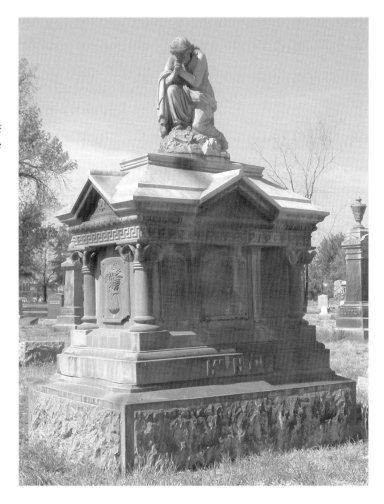

64. Like most large Western White Bronze monuments, this one for John Sr. and Janet McNeil is hollow. The sarcophagus style simply provided a large and visible marker for the grave site in front of it. A relief portrait of Janet McNeil is barely visible beneath the shadows of the central pediment. 1889, Riverside Cemetery, Denver.

one. Because the system relied on standard components, the cost stayed low and the overall visual effect in the cemetery suggested unity.

The McNeil monument (fig. 64), a white bronze sarcophagus, takes advantage of other options available from Western White Bronze. State mine inspector John McNeil Jr. ordered this monument in 1889, a date that forms part of the monument's decoration. His father had died in December 1887 at the age of sixty-nine, followed the next year by his wife, Janet, who was thirty-three. John Jr. expressed his sentiments by surmounting the 73-by-71.5-by-41.75-inch sarcophagus with an allegorical figure of Grief. Standard bas-reliefs of the all-seeing eye, harvested

wheat, Hope, Faith, and a wreathed cross decorate the sarcophagus. What individualizes this monument is a bas-relief portrait bust of Janet McNeil. The white bronze companies all advertised portrait services. In the words of the American Bronze Co. of Chicago, "In no way can we so satisfactorily retain the features of departed friends as in enduring bronze."[44] According to a report that probably originated in the Western White Bronze offices, the Des Moines company offered to "produce correct likenesses of individuals in the shape of life size busts modeled from photographs or the living subject. This has become a leading feature of their business."[45] Janet McNeil's relief portrait appears on a panel between an inscription plate memorializing her and one for her father-in-law. The verse chosen to describe her conforms to an early nineteenth-century ideal of the "true woman":

> She was gentle, patient, meek and mild
> and as guileless as a little child;
> was zealous, brave, true and good,
> the highest type of womanhood.[46]

Western White Bronze Co. also produced statues of Civil War soldiers for town squares and cemeteries, as well as the graves of individual soldiers. Riverside Cemetery has two examples with different faces. The Western White Bronze Co. chose the one that has a custom portrait for a short list of superior examples of their work: "that of Major Wise, at Denver, Colorado, which is 16 feet high, and reared in the 'Cottage' design with a cadet on top."[47] The list also included the Homestake Mine Monument in Leadville, mentioned in chapter 1 (fig. 3).

The majority of white bronzes at Riverside were apparently sold between 1887 and 1900 by Henry H. Helmbrecht, who acted as the principal agent for the Western White Bronze Co. in the Denver area.[48] Helmbrecht got his start in the monument business by partnering with a

local undertaker, Henry Behymer. Together they sold both white bronze and stone monuments until Behymer decided to concentrate on the undertaking business again. For the next couple of years, Helmbrecht worked on his own, undoubtedly still benefiting from his association with an active undertaker. He may have traveled throughout the region, selling Western White Bronze monuments with the catalogues produced by the company for its salesmen. The Monumental Bronze Co. advised sales agents to purchase stock white bronze bas-reliefs made specially as samples to show prospective buyers, with the normal finish but framed in walnut. Agents could also invest in a miniature headstone or a twenty-six-inch replica of a square zinc monument, each with its own carrying case. These samples would give prospective customers a good idea of the silver-gray matte finish of the monuments, as well as the overall effect of two popular models. This type of "agents' outfit" was expensive, however. The scale models and two of the relief panels would have cost the agent $46, a considerable up-front investment. We do not know how much Helmbrecht invested in this enterprise, but as he made his first sales and Western White Bronze monuments began to appear at Riverside Cemetery, he undoubtedly sent prospective buyers there to see the real thing.

In 1890, Helmbrecht began working with a series of local partners who were already involved in the production and sale of stone monuments. Presumably, he brought each of these establishments the added business of white bronze. In turn, the partnerships allowed him to invest in print advertising in such regional publications as the *Western Architect and Building News*. Until 1893 Henry Helmbrecht partnered with William R. Farrington in Helmbrecht & Farrington. The next year, the firm's name changed to Helmbrecht, Olinger & Co. and then simply David B. Olinger, for whom Helmbrecht continued to work.

Like many Coloradans, Helmbrecht may have suffered financial losses during the Panic of 1893, which hit the western silver-producing states especially hard. Soon after his marriage to the widow Kate M. Bailey on May 24, 1895, the city directory listed her as a partner in the new firm of Olinger & Helmbrecht, which suggests that she brought additional financial resources to the marriage that gained the entrée to a renewed partnership with David Olinger. Still, the Helmbrecht name no longer had first billing and Henry continued to work as an employee of the firm in 1896. Kate dropped out of the city directory in 1897, apparently to stay at home, and she bore Henry a daughter the next year. At the same time that Kate left the firm, Henry became the secretary-treasurer of Olinger & Helmbrecht, whose yard the national trade journal *Monumental News* reported to be filled mostly with "home material."[49] In other words, Olinger & Helmbrecht dealt more with locally carved stone monuments than imported white bronze. By 1899, Henry had all but abandoned the monument business to become a clerk and bill collector in a real estate office. It is possible that the added financial responsibilities of a wife and stepson, plus the birth of their daughter in 1898, caused him to seek a different line of work. This was an era when the white bronze market was falling off nationally, and Henry's role in selling stone monuments may not have been enough to support his family.

Not surprisingly, the dates of greatest popularity for zinc monuments in Denver correspond to the years that Helmbrecht actively sought customers for Western White Bronze. The Des Moines company stopped advertising in 1906 and disappeared from Iowa and Des Moines business directories around 1908, when the struggling business failed, but the last white bronze monument purchased for Riverside appeared in 1900. In that year, Riverside Cemetery came under new management and the Fairmount Cemetery Association instituted a rule prohibiting all

metal monuments other than real bronze. This rule had already been in force at Fairmount Cemetery, where few zinc monuments exist today. The zinc prohibition reflects the increasing resistance of cemetery superintendents and consumers to zinc sculpture nationwide. For reasons that are still not entirely clear, zinc's relatively low cost became equated with cheapness of a different sort. The quality of the products remained high, but they were no longer understood as high-class or artistic.

The single white bronze at Riverside from the Detroit Bronze Co. was an exception in several ways. One name-plate on the base of this obelisk tells us that Juliann Smith is buried there and cemetery records indicate that James G. Smith, a person of color, purchased the plot where Mrs. Julia Ann Smith, a white woman, was buried in December 1883 at the age of seventy. James joined her nearly twelve years later at the age of ninety-two. Historical research has not yet revealed what promises to be the fascinating story of James G. and Julia Ann Smith. Since the Detroit Bronze Co. appears to have gone out of business by 1885, James probably ordered this monument early in 1884, before the Des Moines plant went into operation, making it the oldest white bronze in this cemetery. Although the white bronze companies claimed that their inscriptions could not be destroyed because the letters were cast as a single unit with the backing, the raised letters for the inscriptions on two sides of the Smith obelisk's shaft are missing. The white bronze casting technique was described in detail in technical journals, as well as more generally in various advertisements, and their claims about inscriptions appear to be borne out by the removable inscription plates on monuments from both Western White Bronze and Detroit Bronze.[50] However, the Detroit Bronze Co. chose to also put unique inscriptions on the obelisk's sides rather than limit them to the removable plates. To do this they apparently cast each letter separately and then attached them to

this monument with an adhesive cement or by heating the surfaces. Whatever the method, this process allowed the letters to either fall off or to be scraped off the monument, leaving behind a faint, illegible stain.

Rotundo notes that the Detroit Bronze Co. had a "figurehead" management, not knowledgeable about casting zinc.[51] Perhaps an unorthodox manufacturing process was one of the reasons for its early exit from the white bronze business. It should be noted that not all Detroit Bronze monuments exhibited this problem, however. Very similar examples in Rose Hill Cemetery in Idaho Falls, Idaho, and in Lakeview Cemetery in Cheyenne, Wyoming, still have the letters on their shafts. Given the unusual loss of letters from the Smith obelisk, we must consider the possibility of vandalism aimed at a biracial couple after their deaths. Only James's information seems to be missing (and this is an assumption that the inscription was for him), while Juliann's base tablet information remains. At the same time, the obelisks in Idaho and Wyoming provide evidence of more irregularities at the Detroit Bronze plant. Their foundry marks appear to be stamped into the metal from the interior, rather than cast, and the letters are of uneven depths and sizes. They are not even arranged in a straight line.

With the exception of the Detroit Bronze obelisk, the number of white bronze monuments in Riverside Cemetery and the relatively short period in which they were sold is a testament to Henry Helmbrecht's sales acumen. Surprisingly, Riverside has no other type of zinc monument, despite Denver's connection to w.z.w. monuments. The name apparently stood for Warsaw Zinc Works, but even the owner-operators of this unincorporated business referred to it variously as the Warsaw Monument Works, the Warsaw Zinc Monument Works, and most often as the monumental works. Here it will be known by the initials that marked each monument.

65. The Warsaw Zinc Works of Warsaw, Missouri, also provided zinc monuments, whose decorative trapdoors concealed paper memorial tributes and photographs of the deceased. The Zella Green marker, 1905, Greenwood Cemetery, Canon City, Colorado, is one of three identical markers on this plot.

Unlike the white bronze producers, Missouri-based w.z.w. named its monuments zinc and intended them to look like nothing other than zinc. Most utilize one of the most popular late nineteenth-century monument forms, the four-sided upright shaft. Many terminate with a pyramidal cap or a rounded cap supporting an urn, and they are ornamented with one or more raised, low-relief designs that include a hand holding a bouquet of roses, a flying dove, a wreath, emblems of various fraternal orders, and a sheaf of wheat at harvest. They do not have imitation

rock-face textures, statues, or other features typical of white bronze monuments. Instead, the sides are smooth, matte-finished metal with soldered corner joints, and the flat inscription plates are usually cemented on. Unlike the white bronze process, which used only pure zinc, w.z.w. fastened its monuments with aluminum and brass at the corners.[52] Their most interesting feature is a tight-fitting trapdoor that opens upward to reveal a printed obituary behind a glass panel. This molded trapdoor with its small metal knob and decorative edging further negates any imitative resemblance to a stone monument (fig. 65).

There are w.z.w. monuments in Canon City and Salida, Colorado; the Salt Lake City and Provo cemeteries in Utah; and private cemeteries in Sweetwater County, Wyoming, among other places.[53] They were manufactured in Warsaw, Missouri, from the late 1890s to the early 1910s, the very era when the white bronze companies were going out of business. That w.z.w. may also have struggled in a lagging market is evident from lengthy and often repeated newspaper notices in the Warsaw paper warning people not to believe the traveling marble salesmen who claimed that w.z.w. monuments were made of iron and would rust. The notices asserted that "no iron monuments or other than those made of zinc have been made or sold at the Warsaw Zinc works." They quoted scientific and other testimonials borrowed from the Bridgeport Monumental Bronze Co.'s earlier literature to promote the notion of zinc's invincibility.[54] The company also claimed that zinc was actually becoming more popular nationally, citing as evidence that in 1890, 250,000 pounds of zinc was used in making monuments, and that in 1898 that amount had multiplied fourteen times to nearly two thousand tons.[55] According to Clyde Sutherland, whose father managed the business around 1905, w.z.w. was a relatively small operation. Sutherland's memoir says only that the plant "manufactured monuments or tombstones from

66. Despite some water damage, the paper insert under the trapdoor of Zella Green's marker still reveals the lengthy inscription over one hundred years later: "In loving remembrance of Zella, Infant daughter of Mr. & Mrs. J. H. Green. Born February 17, 1883, Died May 2, 1883, Age 2 months and 15 days. She leaves father, mother, one brother, Alonzo J. and two sisters, Alice A. and Laura G. to mourn her loss. [verse] Monument erected July, 1905, by Brother, Alonzo."

zinc and finished in a dull satin finish by sandblasting the smooth metal. In each monument was a receptical [*sic*] built in to display a picture and biographical sketch of the person buried by the monument."[56] Yet the advertising tactics cited above, not to mention the company's use of local ministers to sell their product, must have worked for a while. In January 1900 W.Z.W. claimed to have monuments in seventeen cemeteries, and only a month later they raised that figure to twenty-three, noting that monuments were being shipped that month to Iowa and Arkansas, in addition to places throughout Missouri.[57] Soon they were also shipping monuments to the Rockies.

In 1905, a farmer in Fremont County, Colorado, named Alonzo Green purchased three identical w.z.w. monuments. He and his wife, Mary, had recently lost their two-week-old daughter, Doris Amy. One of the monuments memorialized Doris, while another was for an earlier child, Alice Ann, who had died in 1898. The third monument commemorated Alonzo's sister Zella, who died at two and a half months of age in 1883. Formed as rectangular boxes on bases, all three monuments are about eighteen inches tall and have simple slanted tops. Zinc plates attached to the front of each monument gave the girls' names, dates of death, and ages, in addition to the information on the printed inscriptions behind the monument doors (fig. 66). The black-bordered inserts combined the traits of a newspaper obituary with those of a monument inscription. They listed the surviving members of the family and provided standard mourning poetry. Alice's quoted the popular verse

> This lovely bud so young and fair,
> Called hence by early doom;
> Just came to show how sweet a flower
> In paradise would bloom.

Zella's included the information that her brother Alonzo erected the monument in July 1905.

It is not clear how Alonzo and Mary Green learned about the zinc monuments from Warsaw, Missouri, but they may have chosen them over other models because the w.z.w. monuments could preserve the likeness of the deceased at much less expense than the porcelain photographs typically attached to stone monuments. The Greens possessed photographs of all three babies. Alice Ann's printed insert states that her photograph was taken after her death; Doris Amy's was taken just before she died. Visitors to the cemetery who discovered the trap-doors in these monuments would learn more about the

children they commemorated than was typically the case with other types of memorials.

Each monument also carried a small zinc plate cemented to the back identifying it as a w.z.w. monument from Warsaw, Missouri, and noting its patents. The company's signature plates changed over time. An early one in the old Warsaw cemetery in Missouri for Lizzie Miller, who died in May 1896, says "Pat. Appl'd for," while a later example in the mountain town of Salida, Colorado, states "Pat. Jan. 9, 1894, Other Pat. Pending." All three of the Green monuments and most others in the Rocky Mountains date from the era when the signature plates read "Patented Dec. 3, 1901 and March 18, 1902."

The patents from 1901 and 1902 are instructive. Both were obtained by Thomas Benton White, a Civil War veteran who was wounded in the bloody Vicksburg campaign.[58] According to the National Cemetery Administration, in 1865, with the war at an end, the government was preparing to recover the rest of an estimated three hundred thousand bodies from battlefields and other temporary resting places for reburial. The overwhelming numbers of casualties and mutilating injuries in this war, and White's close-range view of the carnage, may have inspired him to fashion a metal monument whose object was to preserve people's likenesses. His 1901 patent defined the structure of the monument to be composed of an outer and inner casing, "which may be either cast or formed from heavy sheet metal, such as zinc," with "an interposed composite filling and means for permitting a circulation of air for the purpose of equalizing the temperature and for allowing for expansion or contraction of the metallic parts without danger of fracture."[59] The 1902 patent dealt more specifically with the inscription frame, "the object in view being to provide an incasing frame for inscriptions, photographs, memoranda, etc., which frame is so constructed as to hermetically seal the contents and is provided with

means whereby it may be applied to monuments and the like whether constructed of stone or a metallic casing."[60]

White's motivation for this second patent may be found in his career as a newspaperman. He had moved to Warsaw in 1883 and purchased the *Missouri Weekly Enterprise*, which he published and edited under the name *Benton County Enterprise* until he retired and left it in his son Edwin Mahlon White's hands in 1915. The monument company appears to have been a relatively small sideline for White. In fact, it is not clear how he was involved with w.z.w., other than being the monument's designer and patent holder. Clyde Sutherland remembered the son, Mahlon White, as the owner and said the plant was located in back of Mahlon's furniture shop. In any case, both father and son devoted their lives to publishing. Obituaries formed just a small part of the paper, but in thinking about preserving the memory of those who die, a newspaperman's thoughts might naturally turn to a paper obituary. Thomas Benton White was in a position to print the paper inserts at the newspaper in quantities that could have been distributed as death notices and memorials, thus doing double duty in the community and on the monuments w.z.w. produced.

Preserving paper in a cemetery in such a way that it could still be read years later presented a major challenge. Time has shown White's "hermetically sealed" inscription frame to have been unequal to the task. Many of these monuments lost their paper inserts when the glass was broken. Those that survive have suffered some water damage and often severe cockling. Yet White's desire to preserve paper in the monuments made sense. Printing inscriptions was cheaper than carving them in stone or creating molds to cast them in metal. Paper obituaries could use much smaller lettering and remain legible, so more could be said about the deceased on a small monument.

Although he lived for thirty-two years in Missouri, White did have a Colorado connection that might help explain the

presence of w.z.w. monuments in the Rockies. Sometime after his discharge from military service in 1864, White had come to Denver to practice his trade, working on the *Denver Herald*. He married Lois Alice Walker on New Year's Day 1872 and they lived in Denver for two more years before moving on. White's sister, Mrs. E. M. Ford, lived in Denver and two of his daughters became schoolteachers there in the early 1900s. Most of the Wyoming w.z.w. monuments seem to memorialize people who died between 1881 and 1891, while the Colorado monuments date to the period between 1900 and 1905. It is possible that Thomas or Mahlon sold them on one or more trips to visit family in Colorado. Or w.z.w. may have sent advertising circulars to this region through Thomas White's connections with printers or through his brother-in-law. When White retired from editing the *Enterprise*, he and his wife moved back to Denver to be closer to their children. They are buried in the family plot at Crown Hill Cemetery in Wheatridge, Colorado, together with their son and daughters. A granite monument and headstones grace the plot, suggesting that w.z.w. monuments were no longer being produced in 1922, when White and his wife died. Although w.z.w. monuments are not found in Denver, their infrequent appearance in cemeteries elsewhere in the Rockies, with their secret compartments full of information about the deceased, still give observant visitors a delightful surprise.

Far more rare in nineteenth-century Rocky Mountain cemeteries than zinc or white bronze was real bronze. The white bronze monumental companies sometimes also produced bronze monuments and called them antique or yellow bronze to distinguish them from white bronze, but cast bronze was expensive and not particularly successful with western patrons. Full-scale bronze monuments before 1900 were imported from established sculptors and art bronze foundries farther east. One of the earliest was a larger-than-life standing portrait of James Archer

modeled by the St. Louis sculptor Wellington W. Gard-
ner and cast at the Bureau Brothers Foundry in Philadel-
phia.[61] The Irish-born Archer had already made his for-
tune as a government supplier during the Civil War while
he was based in St. Louis. He migrated west in 1869 after
his first wife's death and became involved in Denver real
estate, helped establish the Denver waterworks, and was
president of the gasworks that first lit Denver's streets and
residences. When he died of rheumatic heart disease in
1882, his body was shipped back to St. Louis for burial
at Belfontaine Cemetery. His second wife, Catherine Ar-
cher, purchased six lots at Riverside Cemetery in Denver
and placed the sculpture there in 1887 as a cenotaph. Riv-
erside record books indicate that she intended the large
plot to be bordered by flower beds as a memorial park. A
daughter and son-in-law were later buried there.

Fairmount Cemetery in Denver also has one larger-
than-life standing bronze portrait depicting Fred Falken-
burg, the cofounder of the fraternal organization Wood-
men of the World and the leader of its Pacific Jurisdiction,
headquartered in Denver. The Texas sculptor Pompeo
Coppini modeled the statue and members of the Wood-
men paid a reported $6,500 for it through subscription.[62]
Falkenburg assumes a more active pose than Archer, hold-
ing out his hand as if addressing a crowd. The sculptor
explained that he chose "that very instantaneous attitude
by which he was known and beloved and admired" "since
it certainly was in his emotional speeches that he won
power and greatness."[63] The granite base was originally
decorated by a relief sculpture of a woodman chopping
down a tree, since lost.

Mail-Order Monuments

The final wrinkle in the saga of imported monuments oc-
curred in the late 1890s when the large Chicago discount
department stores applied their mail-order catalogue

principles to the monument business. At first this caused consternation among monument makers and dealers nationally. When the secretary of the Ohio Marble and Granite Dealers Association saw an advertisement in his local paper "showing that a large Chicago clothing and department firm is offering to sell tombstones to the general public," he wrote to the national trade journal, *Monumental News*, in great indignation.[64] Other retailers specializing in cemetery art were equally concerned, and suggestions for dealing with this new type of competition ranged from boycotting the department stores to boycotting the wholesalers who supplied them with monuments. Because the sources of Sears, Roebuck and Co., Montgomery Ward & Company, and Kresge Company monuments were unknown to retailers, letter writing and worrying took the place of action.

Monument firms feared that they would be undersold because mail-order companies could buy in large quantities at discount prices and did not have the additional overhead of keeping a yard, show room, or sales force. At first, mail-order companies sold monuments with other goods through their regular catalogues, but they soon issued separate monument catalogues. A 1902 Sears, Roebuck and Co. monument catalogue has survived, and from it we can see that all the most popular styles of small monuments were on offer at prices ranging from $4.88 for a simple dark blue marble tombstone on a base with a total height of one and a half feet to $39.74 for a rustic cross in white marble with morning glory vines and a base, three feet, eight inches tall. Inscriptions cost an additional six cents per letter for plain sunk letters on the die and fifteen cents for each raised two-inch letter on a base.[65] Shipping added even more expense.

After a few years, the *Monumental News* canvassed monument dealers in the West to learn what impact the mail-order business was having on their trade. A response

from Lewiston Marble and Granite Works in Idaho was fairly typical: "Sears, Roebuck & Co. and Montgomery Ward & Co., of Chicago, are the only two mail order houses doing any business in this part of the country. They have sold a few monuments here, but the work was very unsatisfactory. They use a very poor grade of marble and do not furnish any bottom base. After the freight is paid and they pay for the base, the job costs the purchaser about 10 per cent more than we can furnish the same work in Rutland dark blue stock."[66] The Colorado Monumental Works of Colorado Springs agreed, writing, "Quite often my salesmen are shown their catalogues, but in almost every case secured their orders without cutting price."[67] These letters provide the best evidence for the extent of monument business by mail-order houses in the Rocky Mountains at the turn of the century. It is not possible to identify mail-order monuments by appearance, for they were soon found to be supplied by "two Rutland, Vt., firms, who for years past have been and still are engaged in the retail monument business."[68] In other words, the same stock monuments purchased from Rutland by dealers in the Rockies and lettered by them were sold direct by Sears with lettering done in Rutland. Neither Sears nor Montgomery Ward inscribed their own names on monuments.

By 1910, any need for secrecy to protect the suppliers of mail-order firms from angry monument dealers was past and the *Monumental News* matter-of-factly reported that the Goodell Marble and Granite Co. of Burlington, Vermont, and their new owners, the Temple brothers, had contracts to furnish all the monumental work for both Sears and Montgomery Ward for the next ten years.[69] Almost certainly, mail-order monument catalogues attracted customers in the smaller mountain towns and remote regions that did not have their own monument carvers or dealers. Because mail-order houses dealt only in relatively small, inexpensive work, real advantages

came to consumers who could see work before purchasing it, established monument makers in larger towns suffered little from this competition. Mail-order concerns introduced no innovations by way of design, sculpting techniques, or inscriptions. Their only contribution was a new way of selling monuments. The impact on the by then well-developed sculpture collections in Rocky Mountain cemeteries was minimal.

Conclusion

Imported metal and stone monuments stamped mountain cemeteries with a national and international flavor. They helped the cemeteries to stand for civilization and culture as the pioneers understood it. A red sandstone monument quarried in the foothills might produce local pride, but an Italian marble allegory of Faith revealed the cultural aspirations of the fledgling mountain societies. Therefore, monuments were shipped to the Rockies from all the major monument-producing centers and many smaller ones in the East, Midwest, and Europe. The Rocky Mountain region became an integral part of a national system of designing, marketing, wholesaling and retailing monuments that developed during the second half of the nineteenth century, just as mountain towns were becoming established and growing. Although individuals in the mountain region could write away for monuments in the 1860s and 1870s, and Rocky Mountain dealers and salesmen imported monuments from the states to the territories throughout the 1870s and 1880s, large-scale wholesaling of monuments to the Rocky Mountains really picked up in the 1890s and after. The monument business had been an early, although small part of developing economies along the Front Range and continued to contribute to the economic vitality of the region. Only by staying in tune with national trends could mountain communities use cemeteries as invokers of civilization and cultural taste.

The Cemetery in Western Life

The boot hill burial grounds formed by Rocky Mountain pioneers as a place to bury their known and unknown dead usually attracted living members of the community for that purpose only. An undertaker or responsible citizen buried the strangers, while family members buried their own, often with little ceremony. The anonymous reporter who paid so much attention to the graveyard in Leadville while it was still a rough mining camp described such a scene:

> Last evening, just as the sun was setting behind Capitol Hill, a hearse and single carriage drove hurriedly in the city cemetery enclosure, at the foot of Chestnut street. The cortege stopped beside an open grave. The grave digger and an assistant with a business air hurriedly opened the carriage for the dead. At the same time a middle aged, plainly dressed gentleman and three small children alighted from the hack. . . . As the coffin was lowered into the grave the children shouted for their mamma. There was no minister; no friendly mourners. . . . The miner, alone in a strange land, far from friends, trying to read the funeral service

over the grave of his dead wife, three motherless children clinging to him and wailing with grief. The two grave diggers, the hearse driver, the coachman, and a reporter, the only witness of the sad, sad scene.[1]

His observations emphasize the haste with which the burial was accomplished and the lack of ritual or audience. The presence of outlaws in unmarked graves and the general air of neglect that typified these utilitarian graveyards discouraged family and leisure visits. Boot hill was an uninviting place for return visits to mourn.

Fair Mount as a Public Park

As towns rehabilitated their boot hills into fair mounts, the cemetery gained new purpose and took on new life within the community. As mentioned earlier, the park-like ideal for which some communities strove had been established in New England and on the mid-Atlantic seaboard earlier in the century. At Mt. Auburn and Laurel Hill Cemeteries, shady paths, green hills, ponds, and neoclassical pavilions invited picnickers and strollers to enjoy the surroundings. Blanche Linden-Ward has described some of the leisure uses of rural cemeteries in the antebellum East and Midwest:

> These new institutions served as popular "resorts" or "asylums," frequently termed that by the genteel who favored their use for meditative promenades, considered acceptable and even desirable by the staunchest moralists or advocates of well-spent, edifying leisure time. In their mid-century heyday, before the creation of public parks, these green, pastoral places also functioned as "pleasure grounds" for the general public, often to the dismay of their founders. They became major tourist attractions, touted by guidebooks and travelers' accounts as musts to be seen.[2]

These are the settings and activities some western cemetery

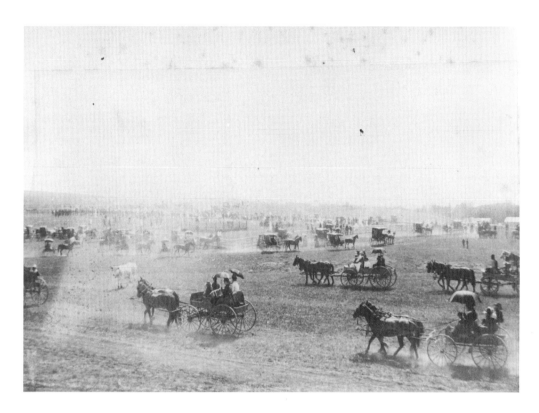

67. Numerous marble obelisks and a few fenced plots in the background mark the unidentified cemetery in Montana Territory on which many buggies and wagons are converging for one of the ceremonies that brought communities together frequently in the nineteenth century. A steer wanders through the left foreground. Gallatin Historical Society, Bozeman, Montana.

makers set out to replicate, but their situation was vastly different.

With only a few years of development behind them and an uncertain future, western towns frequently lacked the institutional base for the pleasure park described by Linden-Ward. If they attempted to create the park-like setting of an eastern rural cemetery, they had to start from scratch, and the terrain often worked against them. Arid, rocky, rough ground, steep mountain slopes, and treeless plains could most readily be sacrificed to the purpose of burial grounds. Even when trees were planted, it took years for them to mature. Therefore, westerners gathered at whatever spot the town had designated for a cemetery and used it as a public meeting space for a variety of funerary and community purposes. The purpose and place of the assembly depicted in an old photograph of Montana Territory have been forgotten (fig. 67). Whole families are crowded into wagons and buggies, some wearing

dark colors, possibly mourning dress, and others wearing light colors. The women carry umbrellas or parasols to ward off the sun, and the rising dust gives the impression of a hot dry summer. Only the marble obelisks and headstones provide visual interest in this cemetery. These people could be assembling for the funeral of a prominent citizen, for the unveiling and dedication of a new monument, or for a community celebration such as Memorial Day ceremonies, all rituals that commonly brought pioneers to mountain cemeteries.

Far from the saloons, gambling halls, and prostitutes' quarters that provided the majority of entertainment in the early years of many western towns, the rural park cemetery with its emphasis on nature and artistic beauty offered a moral alternative for families, courting couples, and others. Even before nature yielded to the pioneers' efforts and produced green spaces, in many places the cemetery represented the only constant cultural experience. Traveling theatrical groups, temporary art exhibits, even local musical groups came and went. The cemetery existed as a permanent site of public sculpture from the erection of the first carved wood and stone monuments.

In a few rapidly growing towns, such as Denver, the public park ideal eventually came to fruition. Riverside Cemetery planted nearly a thousand trees in its first two years and watered them from the Platte River that flowed beside it. In its first published prospectus in 1878, Riverside explained, "There is neither wisdom nor good taste in making the place of the dead abhorrent to the living. . . . As best calculated to promote this result, the landscape or park plan . . . is being very generally adopted; the governing idea being to preserve to the grounds a natural aspect so far as possible, and to beautify them by a system of ornamentation . . . [so that] the cemetery is a much frequented and delightful park where bright and beautiful birds make their dwelling."[3] Although they are rarely still

visible, many cemeteries, including Riverside, originally had walking paths as well as carriage drives. Strategically placed hitching posts allowed the visitor to leave horse or buggy and stroll along these paths among the monuments and plants.

When the Fairmount Cemetery Association began planning a new cemetery for Denver in 1890, it hired a landscape architect from Germany, Reinhard Schuetze. Two years into the project, the local newspaper pronounced it "a cemetery that is a park." Noting that Denver's citizens had been calling for more parks and boulevards, this article, which was probably planted by the cemetery, further encouraged Denver's citizens to take a carriage ride to Fairmount, which it implied was a park first and a cemetery second. "In a measure the requirements for more parks and good driveways are already satisfied by Fairmount cemetery and the route to it. . . . The Fairmount Cemetery association is repairing the road to the gates of its grounds and there it is establishing a 560-acre park— a cemetery, too."[4] After four years of planting trees and planning paths and vistas, Schuetze went on to design most of Denver's early city parks.

For cemeteries to function as parks, they had to be accessible to the general public. Riverside took advantage of the railway that bordered it, advertising that four railroad lines ran cars from Union Station downtown to the cemetery. Special funeral cars could be engaged as needed, but people took the tramway for leisure outings. Situated even farther from the city center than Riverside, Fairmount began hiring hacks to meet every Sunday train at the end of the nearest electric trolley line, one and a half miles distant. In 1891 an average of two hundred people availed themselves of this free ride each Sunday to visit the cemetery. The historian David Halaas has documented Fairmount's tortuous path to accessibility. In 1893, the cemetery incorporated a new company, the Fairmount Railway

Co., to build and operate a cemetery tramway in order to encourage more visitors and, consequently, lot sales. On its first day of operation, one thousand visitors were reported to have traveled on the Fairmount steam train to the cemetery. About this same time, the new Catholic cemetery, Mt. Olivet, announced that by special arrangement with the Union Pacific Railroad, a spur would be built to the cemetery on the far west side of town.[5]

Once the railways and tram companies had invested in special transportation to the cemeteries, they had a strong interest in encouraging cemetery traffic. In addition to funerals and special celebrations, these transportation companies advertised the cemeteries as picnic parks and the tram ride as a leisure activity. A carefully placed newspaper article announced:

> Fairmount cemetery, a delightful seven-mile ride from the center of the city is attracting many visitors this fine weather, particularly on Sunday. . . . From here a fine view of the Rockies can be had, which will well repay the visitor for his trip. The grounds are well kept, regularly laid out and profusely stocked with shade trees and shrubbery. A great number of substantial and expensive monuments, among which are many of unique design, are scattered throughout, and the cemetery is becoming one of the visiting spots in Denver. . . . The fact that electric street cars run right into the cemetery grounds, making the place easy of access, accounts in a large measure for the popularity of the ride.[6]

As this typical advertisement demonstrates, the plants, the view, and the monuments constituted the major attractions of the cemetery sculpture park. Articles and advertisements usually called attention to the uniqueness of the monuments in an attempt to endow them with additional artistic merit and interest.

In the East, cemeteries played an important role in several sculptors' emerging careers, as Elise Ciregna has

explained.[7] Sculptors met patrons and accepted important commissions for sepulchral art, and as visitors to the park cemeteries of the East saw the work of these sculptors, additional commissions came their way. In the Rocky Mountain West, this happened in a somewhat different way. Rather than look for a few beautiful sculptures by recognized sculptors, the citizens of western towns seem to have valued the simplest of carved memorials. Some were made by their own hands and others by "local mechanics," giving them personal meaning. Still others, imported from the nearest large city or a national monument firm, might excite interest as an example of something new. It did not matter whether the carver was known or the same image existed in the next town's cemetery. Each work of art, however simple, also carried meaning because it represented a person who had belonged to the fledgling community. As it accumulated monuments that recorded the town's history through the lives of its founders and pioneers, the cemetery became an ever more inviting and well-used public space.

Lot owners contributed to the park-like environment of the cemetery by composing landscape designs to frame their monuments with flower beds, benches, and urns in well-tended and ornamented family plots (fig. 68). The Green brothers planted a hedge around their plot, enclosing a tall marble angel. Urns filled with plants stood on stone bases at either side of the entrance inscribed "Loved Ones" and "Remember." The Barths' more modest headstones received similar treatment, with century plants in tall cast iron vases marking the front corners of the plot. In an old photograph of this plot, a bed of flowers unites the two graves with a floral blanket over the bodies, and a fan-shaped trellis behind the double headstones will create a visual wall or endpoint for the composition when it becomes covered with foliage. A bentwood chair to one side invokes the presence of visitors to this plot. Period

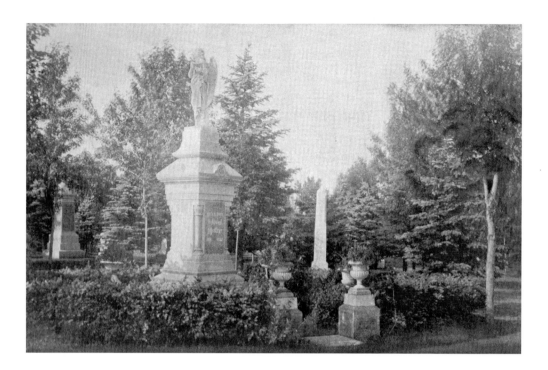

68. The Green family set off their marble recording angel with shrubs and planters to create a garden spot to which they and their neighbors would want to return often. Fairmount Cemetery Co. Archives, Fairmount Heritage Foundation, Denver, Colorado.

photographs of other plots reveal grave mounds artfully planted with concentric rectangles of different-colored flowers, a means of replicating colorful quilts and adding to the bedstead effect created by matched headstones and footstones. Potted floral arrangements often decorated the stones. Cemeteries relied on each family's aesthetic sense and financial means to punctuate the park with these plant-and-monument tableaux. Cemetery authorities sometimes set aside lots, strategically placed in the landscape, to be sold only to families who could afford visually impressive monuments. The public could then enjoy a vista where the end point included sculpture framed by trees and silhouetted against the sky. The family might not even be aware of that larger concern on the part of the cemetery operators, but in this way their private property served the public good.

The intense sun, low rainfall, and high altitude of the Rockies necessitated frequent trips to the cemetery to water plants, whether they were planted directly in the

ground or in the stone and metal urns and planters that were popular nationally. Near the end of the century a few large cemeteries began offering perpetual care or provided these services for a fee, but earlier and smaller cemeteries did not. Numerous companies advertised reservoir vases, cast iron planters, usually in the shape of a round urn, with a double outer wall that could be filled with water to help keep plants alive through hot, sunny weather. The Boston vase, introduced in the early 1890s by M. D. Jones & Co. of Boston, claimed to keep potted plants moist for several weeks. One of the best known mortuary vase manufacturers, Walbridge & Co. of Buffalo, New York, sold numerous designs by mail order. Walbridge reservoir vases sold for as little as $3 and as much as $100. All types of iron vases required regular painting and even then they tended to rust from the inside out. Few remain today, but historic photographs demonstrate their popularity in the late nineteenth century. Examples of cast iron vases by Walbridge and by Kramer Brothers of Dayton, Ohio, still stood in Denver's Fairmount Cemetery as recently as 1999.

In the battle to keep cemetery properties looking park-like, another innovation, similar to the reservoir vase in concept, caught on in many small Rocky Mountain cemeteries. Patented by Jesse Kinney as "an Improvement in Iron Fences," it consisted of a grave guard formed from water pipe or gas pipe with its corner posts flaring open into vases. The vases contained dirt and plants, while the corner posts and side rails held water. Kinney expected the plants to draw the water up out of the pipes through holes in the bottom of the vases, thereby keeping the plants green throughout the hot summers. This concept was the primary innovation that Kinney protected with his patent, since pipe grave fences already existed (fig. 10). During the winter months, Kinney's vases unscrewed from their posts for transport into the home. This migratory part of

the grave monument brought the spirit of the deceased into the parlor for a season. Kinney declared his fence to be equally useful around an entire cemetery lot or a single grave and provided for a sliding section of rail to serve as a gateway in the former instance. He first applied for the patent on July 30, 1877, and received patent number 199,651 on January 29, 1878, a date that is cast into the lip of the vases on all his subsequent monuments.

By 1880 Kinney had applied for an additional patent, and this improved version matches surviving examples throughout the Rockies. He added a drain to prevent winter freezes, abandoned the notion of removable vases, and added a canopy frame. The Freddie Schneider memorial illustrates Kinney's concept as applied to a child's grave (fig. 69). By comparing it with drawings from Kinney's second patent, 237,024 obtained January 25, 1881, the flexibility of the design becomes evident. Information about the deceased child is inscribed on a circular marble tablet bolted to the top rail with a bracket, as described in Kinney's patent. We learn that Freddie was just a month shy of his third birthday on September 20, 1887, when he left his parents' home for this final resting place. The monument looks appropriately like a child's bed, with its four corner posts, side rails, dangling cast iron tassels, and marble pillow at the head. The tight configuration of the fence components to create this child bed appearance was certainly intentional. What is no longer apparent is whether Freddie's parents, C. E. and A. Schneider, also used the fence to create the garden effect that Jesse Kinney had perfected with his second patent. Did they charge the pipes with water and fill the vases with dirt and plants? Or did they take advantage of Kinney's improved post design with its flaring open foot buried beneath the ground and fill the corner posts with dirt to wick moisture up directly from the ground below? Did they plant a flower bed inside the fence as Kinney suggested?

69. Freddie Schneider died in 1887 before his third birthday and was laid to rest in the Crystal Valley Cemetery, Manitou Springs, Colorado, beneath a Kinney cast iron grave fence designed to look like a child's bed. The round marble "pillow" inscribed with Freddie's identification, and the cast iron tassels hanging from draped chains to suggest bed hangings provide additional visual interest.

Freddie Schneider's monument does not have the crossed canopy supports that Kinney recommended covering with an awning to protect the flower bed beneath. But this grave is found in a steep narrow mountain valley where the hours of direct sun are less severe. Kinney also recommended increasing the plant life by suspending a basket of hanging flowers from the center point of the canopy frame, especially appropriate, he said, for a child's grave. If the Schneiders purchased the cast metal bouquets of painted flowers that Kinney invented to fill the vases during the winter months, they have been lost. The Schneiders appear not to have taken advantage of Kinney's introduction of an array of pendant symbols: flying angel, dangling cross, and anchor. They did use the heart symbol that hangs from the center of the upper side rails and to which are attached dangling chains and metal tassels.

Jesse Kinney stated that "the object of this invention is to produce, in a compact, cheap, and highly-ornamental form, a complete outfit for a cemetery-lot or for a single grave."[8] He envisioned the underlying metal structure

249

supporting a natural feast of plants and flowers to memorialize the dead with a living monument that every visitor to the cemetery could enjoy.[9] Today, these monuments are devoid of plants and stark in their rusted, often sagging condition. In the absence of historic photographs, we must imagine what they might once have looked like with trailing plants and flower beds.

Fair Mount as a Classroom

In varying degrees, town cemeteries also functioned as open-air classrooms. Some monuments conveyed spiritual lessons, others moral lessons, and still others served to preserve local history and legend. Most monuments combined an image (sometimes simply the form of the monument) with multiple inscriptions in native tongues or Hebrew. Text and image worked together to communicate the message. Some grave markers carried no more meaning than the implicit message "this person lived and died." But statues of Hope and Faith, Christian crosses, and ascending souls were meant to direct the minds of viewers toward spiritual self-examination. The Star of David served as a reminder of identity within the Jewish community. Statues of contemplative women provided visual cues to the proper seriousness and engaged intellect appropriate to this environment. Art was expected to uplift society in the nineteenth century, and nowhere is this more evident than in the cemetery. A walk through the sepulchral park, past one angel after another gazing upward as if about to rise to the heavens, was certainly inclined to turn the attention of the living away from earthly concerns. The fact that cemeteries attracted the largest crowds of visitors on Sundays contributed to the anticipated atmosphere of moral enlightenment for Christians. For them, a Sunday stroll in the cemetery could become an extension of church and Sunday school.

Some people chose their monument with the idea that

70. Carved entirely of granite by the New England Granite Co. in 1895–1897, the Good Samaritan composition dominates the graves of Vincent and Mary Markham. A walkway led nineteenth-century visitors past this sculpture in Fairmount Cemetery, Denver.

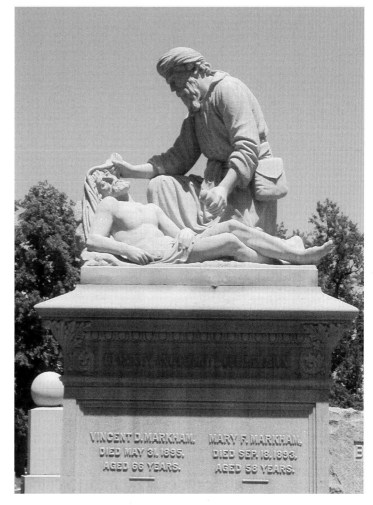

VINCENT D. MARKHAM.
DIED MAY 31, 1895.
AGED 66 YEARS.

MARY F. MARKHAM.
DIED SEP. 13, 1893.
AGED 58 YEARS.

it gave them one last opportunity to have an impact on society through a work of art that might teach future generations. For example, Judge Vincent Markham purchased a cemetery plot at the time of his wife's demise and planned to be buried beside her. In his will, he wrote that if he had not yet erected a monument by the time of his death, his executor should do so. He specified "a joint granite monument at a cost of not less than $5,000 nor more than $7,000, with our names upon the same, dates of our deaths; and the inscription 'Humanity and Charity our Religion'" (fig. 70). This was the creed by which he and his wife had lived and the philosophy underpinning

his judgeship. He wanted to keep sending that message forth after his death and entrusted his attorney friends to find the appropriate visual imagery with which to do so. He cautioned only that it should not take the form of a shaft.[10]

Markham's friends published an announcement of a contest to design the judge's monument and received almost thirty proposals. From these, they chose a design submitted by Greenlee's Denver Marble and Granite Co. that originated with Albert Fehmer and Charles Conrads, the principal designer and sculptor of the New England Granite Works. Once Greenlee received the commission, he contracted with New England Granite Works to produce the monument and Greenlee set it up once it arrived in Denver. The composition depicted the biblical tale of the Good Samaritan aiding the Israelite who had been attacked by thieves and left to die beside the road. The British scholar Nicholas Penny has traced this motif to mid-eighteenth-century English church monuments, where relief panels of the Good Samaritan were intended "to illustrate the virtues of the deceased" and "to stir the public to go and do likewise."[11] By the nineteenth century, this sepulchral subject had developed into full-round sculptures, of which Markham's is a rare example in the Rocky Mountain region. By connecting the image of the Good Samaritan with the motto "Humanity and Charity our Religion" and with the family name Markham, this monument conveys not only that Vincent Markham lived and died, but that he lived by the values of this motto and wished all who saw the monument to do the same. It became a way of extending his life's work in public service beyond death. Markham made the monument provision the second item in his will, after paying his debts, and wrote that money for the monument "is to be taken from my estate in priority of any other bequest or legacy provided for in this will." This monument

was obviously of great importance to him and he set aside $1,000 as an endowment to ensure its perpetual care. He instructed that "flowers, flower beds and shrubery [sic]" be planted and maintained on the plot, creating a pleasant environment in which others could contemplate his message.

Even more instructional are those monuments whose image and message were constantly reused and widely understood. The fraternal group Woodmen of the World, with its Pacific Jurisdiction headquarters in Denver and a particularly large membership in the Rocky Mountain West, promised its insured members a monument worth $100 upon their death. The Woodmen became the largest corporate patron of sepulchral art in the Rocky Mountain region, erecting thousands of monuments over the graves of its members.[12] They chose the popular tree trunk motif as one of their standard monuments (fig. 32). Carved of stone that was intended to endure through time, the Woodmen tree stump memorial included either a raised relief still life of the order's insignia—ax, wedge, and mallet—or the same symbols incised in a seal. The image was intended to suggest the tenets of woodcraft: charity for neighbors and support of widows and orphans. Woodmen lived by these values, which were symbolically encompassed in the image of the tree or log. Each monument also bore the title "Woodmen of the World" or "Women of Woodcraft" and the Latin inscription *Dum Tacet Clamat*, meaning "Although Silent I Speak." It was not just a grave marker, but a voice delivering a message. Although silenced by death, the Woodman continued to proclaim Woodcraft values through his monument, hoping that "the passer-by will pause and read the name of a good man and a true Neighbor. It will be an inspiration to emulate his life."[13]

As we walk through these old cemeteries today we glean only a fraction of the messages left for us to read

by those who have passed on. But in the late nineteenth century, when it was far more common for people to walk among the tombstones, remembering deceased friends and neighbors, many of the monuments and their familiar inscriptions taught lessons intended to further the public good.

Cemetery Rituals

The burials that had constituted the entire life of a boot hill often became elaborate spectacles in a fair mount. These and other rituals provided the living entertainment of the sculpture park, performed according to strict protocols. Funerals for prominent citizens and those organized by the Masons, Odd Fellows, Woodmen, Elks, or other societies usually started in town with a service at the lodge headquarters or a church or at the home of the deceased. They then paraded in a cortege through the town to the cemetery, often gathering more people on the way. Bands almost always formed part of the ceremonies, playing funeral hymns, marches, and society songs. At the graveside, additional rituals were performed as the coffin was lowered into the ground. Participants might stay for refreshments and music or return to town (fig. 71).

The *Rocky Mountain News* published the order of procession for the military funeral of Capt. Silas Soule in 1865. It started with a band, proceeded with a cavalry escort, then the hearse, followed by military officers, officiating clergy and two generals, the governor and civil officers of the United States, and finally citizens. The announcement also invited the public to attend the funeral at St. John's Church and participate in the procession that would form immediately afterward to go to the cemetery.

Twenty years later in Laramie, Wyoming, Charles A. Trabing's funeral included an unusually large cortege to the relatively new Greenhill Cemetery in May 1885. A popular rancher and merchant, Trabing died from blood

71. A funeral band and friends from Rugby, Colorado, pose with the deceased before finishing their march to the cemetery in the background. Courtesy Colorado Historical Society (Ault 4571 CNS.A748),

poisoning and his neighbors turned out in force to honor his position in the community. To some extent, these funerary spectacles were a means by which the community began to repair the rift in its social fabric caused by the death of a prominent person. They involved speeches recognizing the deceased's good qualities and songs, recitations, and other means of fixing that person's memory within the community. At burial time, the deceased was held up as an example to the community, an opportunity for all others to perpetuate that person's good works or avoid his or her mistakes. Every community had numerous long funeral corteges, and the claim that a person's funeral was the largest ever seen in the community became a standard refrain in many newspapers. The size of the cortege reflected the prestige of the deceased and the social standing of the survivors.

Funeral and burial ceremonies for Chinese westerners followed a similar pattern with many of the same elements (fig. 72). The historian Liping Zhu describes funerals of the Chinese in Idaho City as proceeding through town to the cemetery in a large procession led by a band.

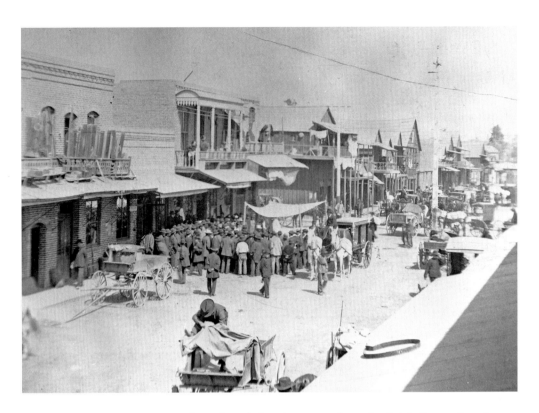

72. At a Chinese funeral a crowd gathers in the street, while women look on from the balcony and a hearse drawn by two white horses stands at the ready, in this unidentified town believed to be somewhere in Montana Territory. Courtesy Montana Historical Society Archives, 940-904, Helena.

At first the Idaho City Band or the Irish Brass Band was sometimes hired to lead the procession and provide music at the cemetery, just as they did for other funerals. Later Chinese residents formed bands with Chinese instruments to play more traditional funeral music. Firecrackers were also sometimes employed as part of the funeral procession and helped attract the attention of a wider public. Feasting constituted an important part of the community event, with one significant difference from most Euro-American funeral feasts: food was left on the grave to ensure that the deceased would enter the spirit world well provisioned. According to Liping Zhu, Euro-American citizens in Idaho City often participated in these funeral parades, as well as the feasting and gift-giving afterward. Funerals, cemetery processions, and graveside ceremonies provided an occasion for bringing the community together and furthering intercultural understanding.[14]

A Butte, Montana, newspaper described the funeral

and burial of Quong Tuck Wung, "a wealthy Celestial," tan gambler, and partner in a Chinese store: "His funeral was a large and peculiarly attractive one. First came Orton's band in a large wagon, drawn by four black horses; then the dead body in a hearse, with guards of honor on either side, and followed by Tuck's friends in a dozen carriages, and finally a wagon filled with the funeral baked meats, to be placed on the grave of the deceased." A child on top of the hearse threw bits of white tissue paper into the air, "propitiation to Joss, the celestial devil, to keep aloof." Other scholars have described these same features of Chinese funerals throughout the American West, saying the white paper had holes in it to confuse evil spirits, which was also the purpose of the loud firecrackers. This reporter was especially taken with the fact that the clothing of the deceased was ceremonially burned, including a gown worth $150.[15] The very public nature of Chinese and other funeral processions brought them to the attention of residents who either observed the proceedings as an entertainment or participated by going to the cemetery. In 1871 the *Helena Daily Herald* reported that white men surrounded a mass Chinese funeral ceremony on Water Street to observe eleven Chinese coffins with burning tapers around them, a table of food in a nearby house for the later feast, and a wagon of roasted meats to be taken to the cemetery.[16]

Jacob Schaetzel described a typical German pioneer funeral in Colorado.[17] By the 1880s, burial services were held on Sunday afternoons, the only day people were not at work and everyone could attend. The head officer of each fraternal organization in attendance distributed funeral badges, and the men pinned armbands or black bows on their left arms. Schaetzel continued: "When the service was about to begin, the group of fraternal members entered the parlor, lined up, each with his own group. The flag of the various groups was unfurled and the flag

bearer led the members. When the service was over, they were the first to leave. The band assembled, the hearse followed and then the pall bearers and the family came in carriages, each drawn by two black horses. The band played a dirge while the remaining people walked in slow processional order." In Denver, while the family carriages and hearse drove to Riverside Cemetery, everyone else got on tramway cars and arrived at the cemetery thirty minutes before the family. At the appropriate time they re-formed their processional order to meet the hearse and family carriages, accompanying them to the grave with the band playing a dirge. After the burial rites, the participants returned to town the same way. Exiting the trams together, they walked behind the band to a lively tune until they arrived at the German Society's headquarters, Turn-verein Hall, where beer, sausages, and sandwiches were served. Everyone sang German folk songs and enjoyed a community social event. Schaetzel was particularly impressed at the age of twelve by a funeral procession for the brewmaster Philip Zang. "I stood by my father's cigar store and watched it all go by. It was the largest and most impressive funeral that I had ever seen."[18]

Funeral processions through town to the cemetery served the purposes of alerting the community to the loss of one of its members, of advertising the benefits of joining a fraternal order, religious group, or ethnic society that would care for one's last needs and for one's dependents, and of providing a community event. Because of the widespread participation in fraternal societies, women's auxiliaries, workers associations, and immigrants' national societies, as well as a variety of religious organizations, middle-class people often received elaborate, well-attended burials. These brought large portions of the community to the cemetery on a regular basis. Before and after the burial, people wandered among the monuments, revisiting the sites of previous fraternal or society burials

and the graves of friends and relatives. It was familiar territory.

As the century progressed and the populations of western towns grew, the function of the cortege and burial as a public spectacle and an entertainment increased, especially in large cities. The public, both those who knew the deceased and perfect strangers, could count on numerous funeral parades each week. Near the turn of the century, a Denver paper reported that fifteen burial ceremonies took place at Riverside and Fairmount Cemeteries on a single day.[19] More and more people visited the cemeteries to view the funeral corteges and burial rites. Under the strain of such large crowds, cemetery societies no longer encouraged townspeople to think of the cemetery as a picnic park. "Undertakers of Denver will protest against the mobs that make the cemeteries of Denver pleasure resorts," announced a newspaper in 1904.[20] Denver's cemetery authorities blamed the fraternal rituals for attracting such large crowds.

One man, an Elk and a Mason who attended many fraternal burials in Denver's cemeteries, defended the societies against such attacks. He had the ability to make his views known through newspaper articles and began a regular campaign to get the cemeteries to hire policemen for crowd control. He coined the term "funeral maniac" to describe those people whom he believed spent time at the cemeteries as spectators at first one burial and then another: "These people include men and women and children. They spend their Sundays . . . in the cemeteries of the city. They go there early in the morning, take their lunches with them and remain all day. When a funeral appears they follow the cortege, either scrambling behind or alongside the carriages and when the grave is reached they crowd around. . . . A funeral is a circus to them and they always strive to get a front place at the show."[21] Incensed at what he considered an abuse of the cemetery,

73. A large crowd gathered for the Woodmen unveiling ritual at Fairmount Cemetery when Pompeo Coppini's bronze statue of Woodmen leader Frederick A. Falkenburg was revealed in 1907. The same derrick that had earlier set the statue in place was now used to raise the large flags that hid it from view. Another photograph of the event reveals a Woodmen officer gently tapping the granite pedestal with a ceremonial wooden ax. Denver Public Library, Western History Collection, McClure, Mcc3703.

this reporter accused: "It is not the quiet beauty of the trees and flowers that attracts them. It is not the exquisite symbolism of storied monument that lures them."[22] These attractions would have been acceptable, we are led to believe, as nature and art made the cemetery into a proper park for citizens on Sundays. But the funeral maniac came to the cemetery out of morbid curiosity and an unnatural attraction to death, according to this source. One hopes that his stories of maniacs racing the family to the grave, crowding out the mourners, climbing trees for a better view, drowning out the minister with their noise, and even falling into the grave as they elbowed other gawkers out

of the way are as exaggerated as the hyperbolic language he employed. Still, reports from the cemetery associations and staff show that theft of flowers, damage to monuments as people climbed on them, trampling of lawns and fresh grave plots, and trash left behind from lunches had become serious problems by the turn of the century.

Burials were not the only rituals that brought crowds to the cemetery. Any time from a few months to several years after a burial, a monument was likely to be placed on the grave. If it was the grave of a Woodmen of the World or of a prominent person, it would become the center of an unveiling or dedication service (fig. 73). The Woodmen of the World developed a special ritual to introduce the grave monument to the community, and that ceremony was carried out in the cemetery by the local Camp of Woodmen to which the deceased had belonged. Jonathan Schaeffer followed the Woodmen's precepts by preparing for his death and the support of his widow well in advance. He purchased the very first lot when Fairmount Cemetery opened in 1890. Upon his death twelve years later, this popular foreman of the Hallack & Howard lumberyard in Denver was buried by the Woodmen of the World and the Brotherhood of American Yeomen.[23] Greenlee & Co. provided a unique granite monument in the form of a sarcophagus with a relief scene depicting the interior of a carpenter's workroom, a reference to Schaeffer's profession (fig. 74). Shields on the back wall of the room represented his two fraternal societies, further imprinting the monument with his identity. Before its unveiling, it would have been draped in either a U.S. flag or a black cloth. When the members of the camp and family and friends of the deceased arrived at the cemetery, the uniformed Woodmen formed a V with its point just beyond the monument. The widow and children were placed in the center of this wedge of brothers, which, like two symbolically extended arms, embraced them in Woodmen support.

74. Lumberman Jonathan Schaeffer's monument depicts a carpenter's shop with emblems of his fraternal orders, Woodmen of the World and the Brotherhood of American Yeomen, the groups who dedicated the monument and returned annually to decorate it. The Denver Marble and Granite Co. provided this imposing granite memorial.

The prescribed ceremony included ritual songs by a band and a quartet, set speeches by the officers of the camp, and a eulogy by an invited orator. All present were reminded of the tenets of Woodcraft, what we would now call family values: providing for your dependents, living an upright life, helping your neighbors in need. In fact, the highest ranking Woodmen officer was required to remind everyone present that "[this] cold stone which shall mark his last resting-place stands like a faithful sentinel to guard his dust and indicate to the world his devotion to those he loved and to his chosen craft. It tells a story, though mute and motionless. It glorifies life; it idealizes death."[24] That the monument was to address "the world"

75. This granite pulpit with book and scroll, designed by N. M. Parsons, became the site of a large dedication ceremony for Socialist leader and Christian minister Myron Reed in 1900, Fairmount Cemetery, Denver.

suggests a very broad audience; the underlying purpose was to recruit that audience to the values of this fraternal community. After unveiling the monument with solemn ceremony, the Woodmen anointed it with salt, oil, and water and struck it lightly with wooden axes. This granite stone, like most Woodmen monuments, memorialized a common citizen, a working man with a small circle of friends, yet the ritual called the larger community's attention to the monument, and the individual for which it stood, in a very public way.

Notwithstanding all the pomp attending Woodmen unveiling rituals, dedications for community leaders' gravestones often became even larger and more public affairs. On May 30, 1900, the monument for Rev. Myron Reed was unveiled at Fairmount Cemetery (fig. 75). The

newspaper described Reed as "Denver's most popular pastor."[25] Born in Vermont in 1836, he spent part of his boyhood on a Chippewa Indian Reservation in Wisconsin and studied law as well as religion before enlisting to fight for the Union in the Civil War. Afterward he began serving Congregational churches around the country, arriving at the First Congregational Church of Denver in 1884. He was an activist for human rights and civil liberties, recognizing no distinctions of class, creed, or race. A popular and effective speaker, he advised politicians and worked closely with many social groups.

After Reed's death on January 30, 1899, the *Denver Post* urged the community to erect a monument for this man who was "identified with every public movement which had for its object the improvement of the condition of the masses" and offered to help finance and publicize it.[26] Similarly, speakers at the massive funeral service suggested the need for a monument. Although these public calls for memorialization focused on a civic sculpture, the monument that resulted was placed in the cemetery upon Reed's grave. In March 1899 the *Monumental News* reported that the Denver Typographical Union had taken charge of the project to erect a memorial to the late Rev. Myron Reed. Not until a year later was it announced that a design by N. M. Parsons had been accepted. The monument would represent a pulpit on a platform accessed by three steps symbolizing the three ages of man: childhood, youth, and manhood. Parsons intended an open scroll on the pulpit to suggest Reed's life work and a closed book to symbolize the close of his labors.[27] These associations were undoubtedly explained at the unveiling ceremony and taken away by the public in attendance, who would pass along such explanations on return visits.

Ultimately all the local labor organizations became involved in financing the Reed monument. They attended the unveiling, as did delegates from the unions and the

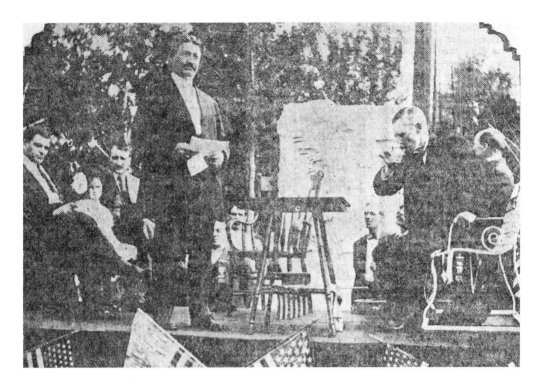

Trades Assembly, members of his congregations, and
many others. The four speakers, Father O'Ryan, Rabbi
Friedman, President J. D. Faulkner of the Trades Assem-
bly, and Joseph Evans for the Stone Cutters Union, sug-
gest the breadth of Reed's influence. The first two had
helped officiate at Reverend Reed's funeral a year earlier.
Faulkner and Evans were added to ensure adequate repre-
sentation of the monument makers and patrons. A report
of the ceremony—which focused on the monument while
making reference to the man it commemorated—noted
that special tramcars had been engaged to deal with the
large number of attendees and that the audience partici-
pated in the singing.[28]

The dual unveiling of monuments at Fairmount Cem-
etery for George Pettibone and John Murphy a few years
later expanded the typical public ceremony into a rally for
political action (fig. 76). George Pettibone was the "silent
leader" of the Western Federation of Miners, and John
Murphy served as its attorney, as well as attorney to the

national Brotherhood of Locomotive Firemen and Engineers. These two men died a few months apart, in March and August 1908. The labor organizations deliberately chose the seventeenth annual convention of the Western Federation of Miners, which took place in Denver the next year, as the occasion for a public unveiling and dedication of the monuments they raised over Pettibone's and Murphy's graves. Over five hundred delegates to the convention and representatives of many other labor groups gathered in Fairmount Cemetery. The crowd represented organizations ranging from radical and violent to conservative, but they all used this opportunity to lift up the working man and the cause of the labor unions in a very public way. As one of the speakers on the stage set up in front of the Pettibone monument proclaimed, "Let it be carried to the business interests of the land by this unveiling that labor appreciates what is done for it and pays honor to whom honor is due, and that these stones show how two labor organizations paid tribute to their hero dead."[29] The unveiling became a platform from which to challenge corporate authority and rally the workers.

John Murphy had fought in court for the eight-hour workday and was proudly referred to as "Eight-hour Murphy." New York–born George Pettibone became famous after his retirement from mining when he was arrested for the murder of Idaho's Governor Steunenberg, who had been active in suppressing labor uprisings. Although Pettibone was eventually acquitted, his long imprisonment was held to have destroyed his health, and he died seven months after his release. Miners considered him a martyr, the victim of a government conspiracy. A large crowd gathered to see these memorial tributes unveiled and many others saw and read about them in the newspaper. Although many in the crowd never knew the deceased, these carved blocks of stone also stood for the values of the labor movement and served as touchstones for them.

The papers spoke of the monuments as works of art, even recording the names of the designers. Emphasizing their artistic merit was a way of endowing them with still more social value. The size of the stones made a visual statement about their importance, and that of the deceased as well. The Pettibone is a 6,100-pound block of rock-faced granite designed by William Higman of Denver Marble and Granite, a company that made many of this style of monument. A highly finished temple façade in the Corinthian order emerges from one corner of the rough rock, bearing Pettibone's name on its base. The face of the rock also holds a huge palm frond signifying victory over death, symbols of the Western Federation of Miners, and the motto "It isn't the fact that you're dead that counts, but only how did you die?" The fourteen-foot Murphy monument was designed by Richard Swanson and carved by the firm of Bayha and Bohm with a parchment scroll and law book on which is carved "A Seeker for the Truth." Members of the two labor organizations purchased the monuments through subscriptions for $2,000 each. The contracts required that union men carve them, and the granite cutters union was well represented at the unveilings.[30]

Monuments such as this could become the focus of a series of events even before reaching the cemetery. For example, in Westerly, Rhode Island, where the granite was quarried and sometimes finished for monuments sent throughout the country, it was customary to hold a weekend open house upon completion of a major carving. Everyone from town, including the various stone workers and their families, would come see the finished work before it was crated and shipped out. One worker reminisced, "Crowds would flock up Granite Street in gay attire gathering around to gaze in admiration as the miraculous production towered above them."[31] Celebrations at the completion of major monuments in Denver monument

77. Taken in 1881, this photograph reveals the Colorado Springs Opera House decorated for a patriotic memorial service with an obelisk monument on stage. Denver Public Library, Western History Collection, x14870.

works also occurred, if not as regularly. A correspondent for the *Monumental News* noted that Greenlee & Co. had treated all the stonecutters and laborers to a beer party upon the completion of a particularly important commission and hoped that other firms in the Rockies would take up the practice.

A photograph taken in the Colorado Springs Opera

House in 1881 hints at still another type of public display of a monument before its erection in the cemetery (fig. 77). On a stage decorated with many floral tributes and a flower-embowered lectern stands a tall memorial obelisk with an inscription that, unfortunately, is illegible in the photograph. This could be the site of a funeral or memorial service for an important person, perhaps a veteran. However, the presence of a huge American flag above the speakers' chairs, a smaller flag on the stage, and two cannons suggest Fourth of July or Decoration Day celebrations instead. Certainly a large crowd was anticipated at this event, and speakers probably focused on patriotism, sacrifice, and remembrance, referring to the objects on the stage around them.

When a particularly large monument arrived at the local train station or was ready to be transported from a local monumental firm to the cemetery, it often created its own parade. It took twenty horses to pull the Good Samaritan statue and the pedestal and bases for the Markham monument over roads and bridges that had to be inspected beforehand for their capacity to carry the load.[32] Extremely heavy stone sculptures could require as many as sixteen teams of horses to pull each section on a wagon through the streets to the cemetery. Photographs published in old newspapers demonstrate the newsworthiness of such events, once again turning public attention toward cemetery art. All of these rituals and spectacles brought attention to the cemetery as a sepulchral sculpture garden and a place for the living as much as the dead.

Memorial and Decoration Days

In addition to sporadic monument parades, weekly funeral corteges, burial ceremonies of all types, and numerous monument unveilings and dedications, several annual events also brought the community of the living into the city of the dead. One of the most national of these

was Memorial Day, made an official holiday in 1868 by John Logan, commander in chief of the Grand Army of the Republic. Many towns held a parade and decorated the graves of both Union and Confederate soldiers on this day. Some also sponsored picnics and speeches. The 1885 Memorial Day ceremonies in Denver began with a morning parade from the city center to the City Cemetery, led by the grand marshal and his staff, followed by the Grand Army of the Republic Drum Corps and seven local posts of the GAR. The Colorado Sons of Veterans and Garfield Cadets also marched, and the Women's Relief Corps followed in carriages. At the cemetery, the Cadets fired a salute and the women presented a floral tribute to the unknown soldiers and scattered flowers on the graves. A detachment sent to Riverside Cemetery decorated those soldiers' graves as well. After the ceremonies in the cemeteries concluded, everyone regrouped for an even bigger parade in the afternoon, with the addition of mounted police, several bands, the Colorado National Guard, high school cadets, the Denver Turnverein, the Patriotic Order of the Sons of America, the Odd Fellows, Veterans of the Mexican War, and many politicians from every level of government. Citizens were invited to join the end of the parade in their carriages for a grand promenade to the Denver rink, where speeches and songs concluded the day's events.[33]

Two years later, the focus had shifted to decorating the graves at Riverside, with detachments going to the Hebrew Cemetery and Mt. Calvary. A set of orders published the day before requested all citizens to participate in the exercises at Riverside, for which purpose both the Union Pacific and the Burlington Railroads ran special trains at a cost of twenty-five cents roundtrip.[34] Four years after that, in 1891, the ranks of the marching veterans were noticeably depleted and the numbers of both the living and the dead at the cemetery had increased. The newspaper

reported on its front page that the graves of two hundred veterans, representing every state in the Union, were to be decorated. In addition, "thousands took private conveyance for the cemetery, many families spending the entire day under the cool shade of the trees. Others planted flowers on the graves of loved ones and passed the hours in dreamy remembrance of the shadowy past."[35] While these thousands waited at the cemetery, an estimated seven thousand more thronged the parade route and gathered at the high school, where the children presented the veterans with floral wreaths and garlands to take to the cemetery. The amount of flowers caused the reporter to run out of superlatives, but the effect in the cemeteries was to create a flower garden around the monuments.

Even as the Memorial Day celebrations continued to grow, a new Decoration Day entered the scene in the 1890s. The Woodmen of the World celebrated their own annual Memorial Day on the Sunday nearest June 6, the day the order was founded. In addition to decorating the graves and monuments of all their fallen members, it was customary on this day in some cities to hold the unveiling ceremonies for each of the monuments newly erected in the past year. In no city in the region was this event more impressive than in Denver, the headquarters of the Pacific Jurisdiction Woodmen.

In 1899, a short article in the *Rocky Mountain News* described the strength of the Woodmen of the World with a report on the annual Woodmen Memorial Day parade. Ten camps, three with drill teams, marched down Sixteenth Street to the tramcars that would carry them to four different cemeteries to decorate graves and unveil monuments for departed Woodmen. Led by the Colorado State Camp band, each camp marched by the officers of the Woodmen for a review, carrying its camp banner. The article described the uniforms of each camp, in variations of red and white, some of them wielding wooden axes

in synchronized routines. By the next year, the event had grown much stronger and newspapers devoted even more column space to it. Because of the parade, the city woke up to an awareness of this fraternal group and its emphasis on supporting widows and orphans, just as the Grand Army of the Republic Memorial Day parade began to suffer from a serious shortage of veterans. "Every person in Denver knew that yesterday was Memorial Sunday for the Woodmen of the World. Four thousand followers of woodcraft marched through the business streets in the afternoon, accompanied by bands and flags and flowers and later the cemeteries were thronged," reported the *Rocky Mountain News*.[36]

The Woodmen identified the purpose of their parade as a means "to create a favorable impression in the minds of the public."[37] This was the reason for a route through the middle of downtown and for holding a parade, rather than simply assembling at the cemeteries where the memorial and unveiling rituals would take place. With the public in mind, members of the order and of affiliated circles of Women of Woodcraft went all out to create a grand spectacle. Since the previous year, the number of camps had grown to fourteen, with camps arriving from throughout the state. Rather than just Woodmen officers, the governor of the state and the mayor of the city helped review the parading men and women in their distinctive uniforms. This time the parade included a platoon of police, the Denver City Camp band, armloads and carloads of floral wreaths and memorials, a second band midway in the line of march, and numerous brightly clad drill teams, in addition to thousands of Woodmen and Women of Woodcraft. It took an hour for everyone to get on the trams taking them to various cemeteries. According to the reporter, the city streets were crowded with spectators who often broke into applause.

In addition to the memorial days already mentioned,

78. Families such as the Lubys of Leadville typically decorated graves and monuments with flowers and mementos on important occasions, including memorial days. Denver Public Library, Western History Collection, X229.

some towns and Catholic churches, especially in the southern Rockies, emphasized a more religious decoration day on All Souls Day. The Chinese in many places visited the graves of the dead at Qingming, a spring festival; at Yulapen, the autumn Hungry Ghosts Festival; and at the Chinese New Year, when a variety of rituals were carried out, from cleaning graves and markers to providing food and drink for the spirits of the dead.[38] On April 8, 1869, the *Helena Herald* reported that Chinese residents visited burial places until two in the afternoon, burning incense and candles around the grave markers and reverencing the ancestors as part of the "annual Josh Day."[39]

Many Memorial Day and Decoration Day ceremonies featured the decoration of graves and monuments with flowers and bunting. Turn-of-the-century photographs of decorated graves in the mountains provide an indication of the seriousness with which citizens approached this annual duty (fig. 78). The only other time a grave was so

richly decorated was immediately after the burial, when the funeral wreaths and bouquets were usually placed upon the fresh grave mound and no monument was yet present. Memorial Days and Decoration Days provided opportunities for families to pay tribute to their dead by enrobing the graves in flowers, pulling weeds, and cleaning monuments. Although each family tended its own plot, it was a community event. In sharing these activities, lot owners came together in a public celebration of their continued reverence for and memory of departed ancestors, friends, and neighbors.[40]

The Cemetery as a Place for Private Grief and Mourning

The visibility and blatant visuality of funeral corteges, burial rituals, and unveiling ceremonies often turned even private events into public spectacles, and use of the cemetery as a leisure park increased the available audience. However, fair mount cemeteries also played important, less visible roles in the private lives of individuals. For many people, selecting and making return trips to a grave marker or monument helped with the grieving process. For them the cemetery was a place of mourning, contemplation, and remembering, a place for healing the spirit. Cemetery and garden furniture companies sold many types of chairs and benches to be placed on plots so that mourners could sit with their memories in a peaceful environment. Cemetery officials recognized the importance of the cemetery space and its monuments to lot owners who came there to mourn. An article placed in a local paper by the Fairmount Cemetery Association explained, "Reasonable rules have been made governing the care of the grounds and the erection of monuments and memorials; the aim of the management being to provide a place, which by its beauty and brightness gives the mind suffering from bereavement, a spot in keeping with the hallowed memories of the departed."[41] Apart from burials

and other group rituals, cemetery etiquette prohibited visitors from intruding on the private grief of individuals mourning at a grave site.

Purchasing a monument and visiting it became an intensely personal and often emotional experience about which little has been written with regard to the late nineteenth century.[42] Undoubtedly, some individuals created their own private rituals inspired by memories of the deceased whose grave they visited. Typically, Jewish mourners left a pebble or some other token on the monument at each visit. Jewish tradition encouraged visits to the graves, not only of one's relatives, but also of rabbis and other spiritual people in order to ask the dead to pray for mercy on behalf of the living. This might happen at times of personal tribulation or on fast days and at Rosh Hashana, depending on the traditions of each community. For some people, tending the flower beds and shrubs on the family plot proved therapeutic. It was a way of continuing to care for, or to demonstrate one's love for, a deceased family member. Private grief could also be shared by friends. Not long after Judge Markham's monument was erected in Fairmount Cemetery, a group of his friends assembled at the grave to view the monument and reminisce informally.[43] Because of their prominence—a senator, the governor, judges, and doctors—this private activity was remarked by a reporter, but such gatherings among friends and families to mourn or reminisce at grave sites usually took place without public notice on special occasions, such as the birth or death anniversary of the deceased.

The role of the memorial in what sociologists and psychologists now call "grief work" was intensified by the fact that markers and monuments functioned as replacement objects for the lost body of the loved one, both marking the spot where that body last existed in this world and standing in for the body by taking its name and dates and often other personal information. The Thomas

Bower monument takes the familiar form of a tree stump. This is an unusually solid tree, with a broad base that includes a symbolic sheaf of wheat and the sickle that cut it, mushrooms, a cut shoot, and a slab of stone with a relief depiction of a monumental stone yard. Thomas Bower spent his adult life as a stone carver, working for a monument firm in St. Paul, Minnesota. He died in Denver while visiting his uncle and was buried in Riverside Cemetery. Like many men who were memorialized with limestone tree trunks, Bower is being described symbolically as an upright citizen, solid as an oak tree, well rooted, and gainfully employed. The tree stump monument stands for Thomas Bower, stonecutter, in a very corporeal manner.

It may be easiest to understand a monument or marker as a stand-in for the lost body buried at its base when that monument takes the shape of a figure, such as a tree trunk or a soldier. Nigel Llewellyn has discussed British historical attempts to replace the natural body with an effigy— life masks, casts of hands, carved stone and modeled wax statues, embalmed bodies—as a means of preserving the social body.[44] Unlike the flesh-and-blood body, the social body is the idea of the person and the position in society that person filled.[45] It forms the memory of the person. Llewllyn sees the British monumental body—effigy plus inscription, heraldry, and architecture—as a permanent replacement for the social body. In the United States, most monuments and markers came to play this role of the body substitute, and abstract forms had the advantage of more easily symbolizing the social body than figurative monuments.

Markers for Margaret and James Shields stand side by side in Lakeside Cemetery in Loveland, Colorado. The identical, cylindrical obelisks, his larger and hers smaller, abstractly visualize a long-married couple who were born in the 1820s and lived out the era of separate spheres for men and women. His roles as head of the household and

79. Identical marble monuments by Ketchin & Tuite for Bridget (ca. 1889) and Patrick (ca. 1893) O'Neill in St. Patrick's Cemetery, Butte, visually signal their family bond and Catholic faith, while the inscriptions tell of their origins in County Tipperary and County Cork, Ireland. Many of Butte's miners came from Ireland, and that identification remained important to the community even after death.

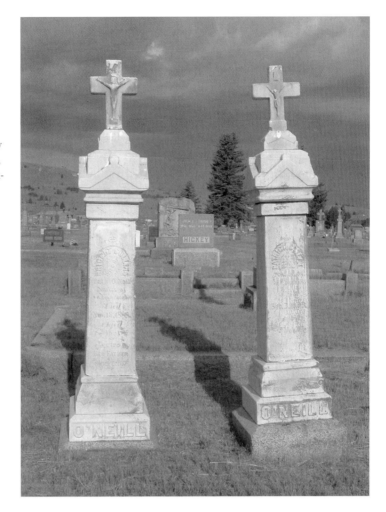

breadwinner are suggested in the larger size of his monument. The choice of the same style for both monuments, even though Margaret died seventeen years before James, represents the understanding in late nineteenth-century American society that marriage made them a single unit. Some couples, such as the Weltys of Colorado Springs, chose to depict this more graphically with entwined tree trunk monuments.

When Bridget O'Neill died, it was not her husband but her father who erected her tombstone, and he made sure everyone knew it by having it inscribed "Erected by her father Patrick Collins" (fig. 79) The seven-foot-tall shaft

form surmounted by a crucifix was quite popular among Butte's Irish Catholics. When Bridget's husband, the superintendent of the Amy and Silversmith Mine, died five years later, an identical monument marked his grave beside hers. It, too, was probably purchased by Bridget's father, who had a strong sense of the sacredness of the marriage bond. Both monuments, and another like it just a few lots away for Bridget's mother, Bridget Collins, came from the same local stonecutter, Ketchin & Tuite.[46]

Occasionally, double headstones were carved for a married couple. The inscription might carry both names, even though only one had died; the inscription for the other would be completed at death. This practice became much more frequent in the twentieth century than it was in the nineteenth. With the increased commercialization of death, the argument could be made that purchasing a "couples" monument would save money. But whether motivated by economics or as a means to ensure togetherness, it suggests that when one half of a married couple died, the social unit died, and this was acknowledged with a joint memorial. Often, verses on monuments express the desire for reunification in heaven, and the couples monument might be understood as an expression of the determination that the marriage bond will defy death. But it can also be interpreted as a commemoration, not of the death of an individual nor as preparation for the death of the one left behind, but as an acknowledgment that the social body represented by that marriage union had been sundered by death ('til death do us part). In other words, it stands in memory of the marriage as much as of the individuals who formed that marriage. As a fundamental institution of late nineteenth-century American society, marriage was important to the public well-being. Recognizing the gap left in society with a monumental replacement became a statement of healing.

Not every pair of identical headstones denoted a family

relationship, of course. Alonzo K. Prescott provided identical marble headstones for Daniel O'Brien and Timothy Lynch, unrelated miners who died in an explosion October 29, 1887. According to a detailed news story, they had gone to get blasting powder from the fifty-pound store of giant powder used for distribution on the two-hundred-foot level of the Lawrence mine when the other miners on that level felt a terrible explosion. Hurrying to the scene, they found that O'Brien and Lynch "were literally blown to atoms, and where they had been there was only some blackened debris, among which a few fragments of the men were found." A bit of dark hair was identified as Lynch and a bit of sandy-colored scalp as O'Brien. "As it was impossible to identify any of the remains except the scalps, it was decided to put one scalp in each coffin, and divide the other fragments equally."[47] O'Brien lived in Centerville, Montana, with his wife of a year and their baby, only a few weeks old. Lynch had two daughters and four sons, two of whom worked in the mine with him, and his burial took place from his home in Dublin Gulch. The Hibernians took charge of Lynch's funeral, while the Miners' Union arranged O'Brien's, and the two separate funeral processions met in Butte at St. Patrick's Cemetery. They were buried side by side, most likely at the mining company's expense, and their identical headstones show them united (literally) in death.

Monument makers typically marked the graves of siblings with a common base holding separate headstones. The horseshoe was another popular form for two children or for a married couple, as it consisted of two separate dies joined below by a common base and above by an arch (fig. 2). Each die carried the information for one individual and the base usually gave the family name. There are also many examples of identical monuments in graduated sizes representing a parent and children. In the 1880s and 1890s it became increasingly popular throughout

the country to erect a single stone for the family name and smaller headstones for the individual members of the family. An example by C. F. Middleton in Ogden, Utah, commemorates all six family members twice, once on the family monument and again on a headstone. The relationships are also carefully designated, with the word "Father" on Israel Canfield's headstone, "Mother" on Annis Canfield's and Charlotte Canfield's headstones, "Sister" for Rosalthe and Aurora, and Willie is designated "Our Baby."

One can easily see all these markers and monuments as abstract bodies, even postmortem family portraits because of the way they visualize social and power relationships. Strengthened by the late nineteenth-century preference for vertical monuments, this symbolic—sometimes even anthropomorphic—quality emphasizes the personal nature of the monuments as replacements for individuals, even when the form may be indistinguishable from many others. Some people personalized standard monuments by attaching photographic portraits, in the process emphasizing the extent to which a monument represented a person. The earliest attempts took the form of a daguerreotype, ambrotype, or tintype placed in a sunken niche in the stone and covered with glass. One of the few surviving examples depicts Auguste and his sister Lillie Hermsmeyer, who both died in December 1876 and were buried in the Nevada City cemetery in Montana. The photograph has deteriorated badly, but part of a little girl is still visible and the heavy beveled glass cover remains intact. Soon the German process of burning a photograph onto a piece of porcelain came into vogue as the quickest method of fixing a visage to a monument. Monument makers all over the country sent patrons' photographs to companies in Berlin, Chicago, and Detroit to have the porcelain photograph created. Several American patents for affixing these photographs also exist, and one of the

80. The features of Viola Natalie Holmquist, captured in a photograph on porcelain, individualize her diamond-shaped granite memorial in Fairmount Cemetery, Denver.

best preserved examples is the hand-colored photograph of Viola Natalie Holmquist on a late nineteenth-century granite memorial of modern design (fig. 80). Monument portrait photographs helped to individualize and personalize mass-produced monuments and contributed to their ability to serve as an aide-de-mémoire for mourners by countering the natural tendency for a loved one's features to fade from memory over time.

In the case of Woodmen, ritual helped make the transition from living body to monumental body visible. The funeral and burial ritual ushered the physical body out of sight, and the unveiling and dedication rituals ushered its stand-in into sight. During the course of the unveiling, living Woodmen literally stood shoulder to shoulder with the monument, the symbol of their departed comrade. One cannot but think that this anthropomorphic quality facilitated the use of monuments in grief work.

81. Thomas and Augusta Woodward visited the well-decorated grave and marble tombstone of their son Willie in Alvarado Cemetery, Georgetown, Colorado, while a photographer took their picture. Such photographs decorated parlors and photo albums. Denver Public Library, Western History Collection, x1102.

Some mourners also had photographs made of themselves beside the monuments of loved ones (fig. 81). These could be sent to distant friends and family members unable to visit the memorials and tend the graves. They also served as testimonials to one's ongoing memory of the departed. Some hung in the parlor, a way of bringing dead parents, for instance, back into the home of the living. They became new family portraits, ones that continued to include the dead by means of the grave monument.

Privatization of Cemetery Life

Beginning near the end of the century, the national movement toward replacing cemeteries with city parks as leisure and tourist destinations encouraged some changes in cemetery usage. Where old fair mount cemeteries had become surrounded by a city and burial had been discontinued, cities now began the process of removing the bodies and monuments to the newer rural cemeteries to convert former cemeteries into real city parks. Such parks can be found in Denver, Salt Lake City, and Helena.

Superintendents in large Rocky Mountain rural cemeteries were further motivated by the damage done when huge, sometimes unruly crowds held burial and unveiling rituals in spaces that were increasingly crowded with monuments, benches, urns, and flower beds. As alternative leisure spaces emerged in the city, superintendents organized to take back the cemetery as a purely sepulchral space.

At its inception in 1890, Denver's Fairmount Cemetery imposed only ten rules. Rule 3 announced, "Persons with refreshments will not be permitted to pass the gate," and Rule 10 explained, "The grounds of the Cemetery are sacredly devoted to the interment and repose of the dead, and . . . a strict observance of the decorum due to such a place will be required of all."[48] These rules were calculated to reduce nonfunerary and day-long excursions, and Riverside soon instituted similar measures: "Rule #4 Persons with refreshments will not be admitted. Lunching on the grounds is prohibited. . . . Rule #8 All persons are prohibited from plucking any flower . . . or entering any individual's lot without leave, lying down or lounging on the same. . . . Rule #9 Loud, boisterous and profane language is prohibited. No person will be permitted to disturb the quiet or good order of the place in any way."[49] With its longer experience, Riverside apparently felt the need for more and better defined rules, each of which addressed a common practice in the cemeteries.

To change patterns of social conduct takes time, and the shift from recreational park behavior to exclusively funerary behavior was not complete in Denver's cemeteries until well after the turn of the century. The activities that Riverside had welcomed in the 1870s and 1880s and had begun to discourage in the 1890s became truly undesirable to cemetery authorities after 1900. In 1904, the secretary of Riverside Cemetery Association became incensed upon reading an article in the newspaper that he took to be an invitation by a tramway company for Denverites

to come to "Riverside for a grand picnic tomorrow and without as much as asking the leave of the association." He reportedly engaged police to meet potential picnickers at the gates, declaring that "the scenes of last year would not be repeated tomorrow. Then it was desecration day and not Decoration day. Picnickers camped on the gravestones, made lunch tables of tombstones, stole flowers, hose and wheels and left behind them all sorts of refuse and any number of empty beer bottles. There will be no lunching allowed in the cemetery this year and no beer drinking."[50]

The era of treating the cemetery as the town park was drawing to a close. The cemetery board met for several consecutive years to discuss bans on Sunday funerals, bans on brass bands in the cemetery, and bans on fraternal funerals and unveilings. Each time, they decided that they had no authority to enforce such changes. Even though they were responsible to private lot owners, they recognized that public sentiment was still too great in favor of the cemetery as a community space. Over time, that sentiment began to change. Ministers found it difficult to fit in all the funerals after Sunday services, and undertakers were unhappy at not having any Sundays free. Some lot owners expressed displeasure at the state of their property after funerals. Families may have been disturbed at the graveside presence of strangers in a time when death rituals were becoming more private. Undertakers and funeral homes had increasingly taken over functions previously performed by families, and cemeteries also had stricter procedures that left the family few roles to play but that of private mourner. A number of twentieth-century historians have explored this shift in American attitudes toward death quite thoroughly, including Charles Jackson, David Stannard, and James Farrell. As Americans began to distance themselves from death, dissociating death rites from everyday life activities, the public parks in the city began

to look like good alternatives for recreational space. Many cultural opportunities existed in the city, more attractive than the history and art in the cemetery. That the Denver City Council sent a representative to Fairmount Cemetery to learn how to keep a park looking beautiful says a lot about the position that Denver's cemeteries had attained as parks before the end of the century, but the first decade of the twentieth century saw an almost complete reversal in the balance of public and private roles that the cemetery played in western life.

As one of the largest cities in the Rocky Mountain region and a center for monument production, Denver cannot be considered representative. It presents an interesting case study, important because of its position in the region. But other large cities also used their rural cemeteries as public spaces, decorating graves, unveiling monuments, picnicking on Sundays, and riding among the trees and monuments for excursions. Smaller towns throughout the region often continued their community cemetery traditions longer than the cities, but the national trend toward denying death rather than embracing it in community celebrations eventually caused changes there as well.

Conclusion

Mountain cemeteries, like other rural cemeteries of their time, combined public with private functions in a unique way. Some communities established their cemeteries on publicly owned land, with use rights granted to individuals. Other community cemeteries were privately owned by all the individuals who purchased lots or were held by a body of private investors. No matter the legal arrangement, cemetery lands became community property and public space by virtue of their use. On the other hand, most monuments were purchased by family or friends and remained private property. A significant minority of monuments, having been purchased by subscription, fraternal funds, or other public entities, could be said to belong to the whole community, as in the example of the firefighters' monuments that became popular around 1900 (fig. 82). Private and public monuments together formed one of the main visual attractions of the cemetery, providing a material substitute for the disintegrating bodies and invisible souls of the departed. This situation caused the work of sepulchral carvers to become a form of public sculpture that integrated deep

82. The volunteer fire department of Fort Collins, Colorado, erected this $1,500 granite memorial by the local firm of Salladin & Campbell, to their fallen comrades in 1909. Grandview Cemetery, Fort Collins.

private meaning with widely shared values. It is worth looking more closely at the public nature of these sculpture parks.

Twentieth-century theorists have postulated that the amorphous entity known as "the public" actually consists of multiple publics and counterpublics, each formed around a set of ideas. Jürgen Habermas identified the eighteenth and nineteenth centuries as the time in Europe when a bourgeois democratic public first emerged, aided by salons, coffeehouses, diarists, and journals. Other sociologists and political theorists have contributed to our understanding of publics and the roles that fine art and popular culture play in their formation. Michael Warner, for example, describes publics as entities created

through discourse among people (many of them strangers) surrounding particular cultural texts or practices. This way of thinking can help explain how western sepulchral sculpture gardens contributed to shaping the public within developing mountain communities and how these publics viewed death, memory, individuality, and community good.[1]

Late nineteenth-century cemeteries combined fine art with popular culture through the juxtaposition of original, high-quality sculptures and mausolea commissioned by wealthy citizens and mass-produced markers purchased by the middle classes. The shared experiences of choosing and siting these memorials during times of great personal loss, of cleaning and decorating graves year after year, and of taking leisurely strolls or recreational drives among "storied monuments" molded a diverse population of neighbors and strangers into a public that cared passionately about how the deceased were memorialized through visual culture. This audience rarely reacted against innovation or protested any of the art in the cemetery, for change occurred very slowly in the monument industry and overall visual unity was the order of the day. Subtle differences in the details of a mass-produced monument made it sufficiently unique from its neighbors to represent the individual whose memory it preserved, and families embraced the idea of sharing visual forms with one another to the extent that they often chose a monument design based on whose grave or plot it had previously decorated. Thus, twenty-five thousand Western White Bronze designs could look like no more than a hundred different monuments, satisfying the simultaneous desires for individuality and community.

Much sepulchral imagery proclaimed widely accepted values that ranged from specific religious references to universal concerns with death and life. This was a public art that successfully invested the visual object with

meanings that its audiences could grasp and accept. At a time when the public roles of private monuments were especially pronounced, public unveiling rituals, memorial parades, and annual decoration rites joined private rituals of mourning and viewing to shape people's relationships with sepulchral art, while also inscribing it with multiple levels of meaning. To some extent, then, private and public rituals constitute the discourse surrounding the object that formed a public in the Old West.

This public did not object to new additions to the community sculpture garden, but it did jealously guard the collection from perceived trespasses against the values it represented. So, for example, when a local paper reported that the Fairmount Cemetery Association would require all lot owners in two Denver cemeteries to substitute marble for wooden headboards, an outraged public protested. According to the first, inflammatory report on May 24, 1904, lot owners had been given until June 1 to remove the wooden headboards or else the cemeteries would dispose of them, marking the graves with very small numbered posts instead. The given reason for the order was that "headboards disfigured the looks of the cemeteries" and "it would add to the beauty of the two burying grounds to have the boards replaced by neat stone markers, tombstones or monuments."[2] Lot owners and reporters protested that the action targeted "the poorer class" who often chose wood as the only affordable option. An additional concern might be summed up in the words of a man who suspected the cemetery of removing a marble slab from his wife's grave because he had carved it himself: "I lettered this little marble with my own hands, that my grandchildren and great-grandchildren might see my handiwork. I am a mechanic, and could do it, and when I pass off they could look at it and say that was done by grandpa."[3] This controversy pitted the right of individuals to choose their own monuments against the corporate

authority of the cemetery and its newly adopted curatorial role. The cemetery offered overall aesthetic quality and the unspoken but anticipated improvement in their business as reasons for the change to a higher class of artwork, while the public upheld as a greater good the principles of individual choice and personal emotional investment. In other words, the private function of the wooden marker as a family memorial inscribed with personal meaning by a family member was deemed by the public to represent a higher good than the public function of the marble sculpture as a work of art for the whole community. In this instance, public opinion prevailed and the cemetery board rapidly backpedaled, calling the substitution of marble monument for wooden marker simply a "suggestion."

At other times the private and public aspects of a memorial came into direct conflict with different results. The bronze statue of the Woodmen leader Frederick A. Falkenburg in Denver's Fairmount Cemetery is actually a cenotaph, the erection of which Falkenburg's daughter reportedly attempted to prevent (fig. 73). When she learned that she could not be buried next to her parents if their bodies were moved to the lot chosen by the Woodmen of the World for this memorial sculpture, she chose instead to leave their remains in the family plot and erected her own private monument over the graves. She did not attend the unveiling of the Woodmen's monument to her father, although it did serve as the principal public statue of Falkenburg and the site of future public celebrations of this man.[4] In this case, public and private roles could not be reconciled in a single memorial, so two monuments became necessary. The more imposing of the two, Coppini's bronze statue of Falkenburg making a public address, had been purchased through general subscription in the western states and for thousands of westerners it stood as the image of a virtuous public servant.

In the nineteenth-century cemetery, the public good was

a common underlying theme for monument makers, purchasers, and audiences, beyond private concerns with immortality. Vincent Markham extended his civic influence as a judge beyond his lifetime with the large Good Samaritan monument that proclaimed the benefits to society of individual acts of charity and humanity (fig. 70). Lawman Frank Beck's monument features a portrait of his "faithful dog"; the retriever is depicted pointing at the grave as a symbol of fidelity, his to Frank and Frank's to the community he served (fig. 34). Thousands of Woodmen made their silent proclamations about the importance of forming a community to support widows and orphans, using the visual symbol of the tree stump and the inscriptions, "Woodmen of the World" and "Dum Tacit Clamat" (fig. 32). Masons displayed the concept of brotherhood and Odd Fellows promoted neighborliness in the symbolism of their monuments. Labor groups erected monuments to Socialist leaders, implicitly upholding the laboring classes and affirming the value of manual labor and a strong work ethic. Christians erected angels and allegories of faith and hope, as well as thousands of smaller monuments whose popular and sacred inscriptions promoted spiritual purity and moral rectitude. Jews announced their commitment to religious community with Stars of David, lambs, and Hebrew inscriptions. Latter-Day Saints emphasized genealogy with detailed biographical inscriptions in a quest to save the souls of everyone, including ancestors. All of these people and organizations placed the sepulchral sculpture that memorialized beloved individuals in the service of a larger community's broad-based values and ideals.

Even the grave markers of criminals could be made to serve the public good. When part of the Plummer Gang was caught and hanged in Montana Territory in 1864, the town of Virginia City buried them in unmarked graves. By letting nature claim the bodies without a permanent marker, the townspeople may have hoped to erase these

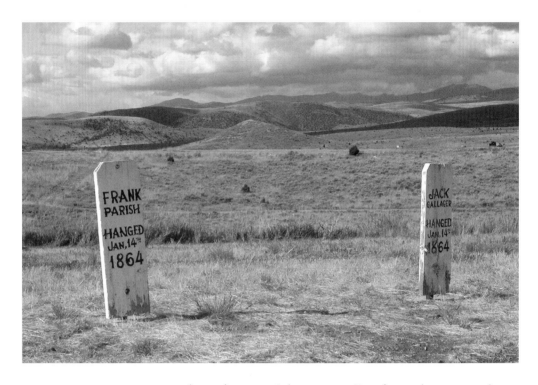

83. Outlaws generally went to unmarked graves in the early years, but Virginia City, Montana, decided to mark the graves of its most famous outlaws around 1900 to capitalize on them as a tourist attraction. These painted boards for Frank Parish and Jack Gallager in Boot Hill Cemetery date from the twentieth century.

outlaws from social memory. But forty-three years later, when mining had played out and the presence of notorious outlaws in the local graveyard had become a tourist attraction and a much needed economic and historical asset to the community, the town erected an old-fashioned wooden headboard for each outlaw, painted with his name and the inscription "Hanged January 14, 1864" (fig. 83) Emphasizing the method of execution attracted tourists and underlined the triumph of law and order over the wild west. Those markers have been renewed over the years and they are now, ironically, almost the only marked graves in Virginia City's Boot Hill Cemetery.[5]

While the cemetery-viewing public might embrace outlaw monuments under certain circumstances, one group of people almost universally excluded from pioneer community cemeteries and the public that enjoyed them were the Native peoples of the mountains. This absence occurred not only because of the pronounced racial tensions that often excluded Native Americans from the

communities themselves, but also because of dissimilar cultural practices and beliefs with regard to death. Even when Native peoples adopted Christianity and typical nineteenth-century American memorial practices, their monuments can more often be found in the cemeteries of forts, reservations, and missions, where they frequently occupied burial ground segregated from that of the non-Native residents of these institutions. References to Native Americans in pioneer community cemeteries most often appear on monuments to people whom they killed or on markers for military personnel engaged in the Indian Wars. However unpalatable it may be today, the fact remains that the typical pioneer community's notion of the public good embraced genocide, or at the very least, the targeted killing of "hostile" Indians. Thus memorials paid tribute to soldiers and officers who killed Indians as heroes who made pioneer settlements possible, and they commemorated those who were killed by Indians as martyrs. Only on rare occasions did they memorialize Native peoples, and only rarely might one find Indians, usually Christians, participating in the public rituals of the pioneer cemetery. This remained true in the 1890s and even later, when eastern artists were engaged in romanticizing the Plains and Mountain Indians. The Remington bronze of an Indian on his pony and similar types of western art found no place among sepulchral sculptures in the West. These cemeteries and their sculpture collections remained fairly exclusive to the white, black, Hispanic, and Asian peoples who invaded and settled the mountains.

Some of these individuals ignored the opportunity for public work and instead expressed very private goals for their own monuments. Through a period of mortal illness, the author and champion of Native American rights Helen Hunt Jackson wrote notes to her husband communicating her wishes. She was too ill to carry out any arrangements and she allowed for the possibility that circumstances or

his own wishes might cause him to alter her instructions, but she has left a record of one woman's thoughts in the summer of 1885 about her own death and the disposition of her body. She hoped to avoid the community cemetery and to have a modest natural stone mark her grave.

> Dearest, If it is not too much trouble, I would like very much to be buried up on Cheyenne Mt.—You know I told you this once before. . . . The place I would choose of all others is behind the big rock where we used to camp in the winter, in the olden days—near where the blacksmith's tent was. That will be out of sight of the road. . . . Put a rough stone wall and the grave–nature will take care of the rest!— on the grave I would like a plain slab of our red granite rock rough hewn & only this inscription on it
>
>> Helen,
>> Wife of Wm S. Jackson
>> EMIGRAVIT
>
> with the date of my death below. Not another word.[6]

Jackson was inspired by an old tomb she said she saw in Rome, which in turn had inspired the sonnet "Emigravit" meaning "one who emigrated," at the end of her novel, *Mercy Philbrick's Choice.* The rough-hewn red Colorado granite that she requested expressed her own appreciation for raw nature and the Rocky Mountains. Her husband, the banker and officer of the Denver and Rio Grande Railway Co., William Sharpless Jackson, shared her appreciation for the Rockies' natural grandeur, but he also loved nature in the forms that art could shape. Seven years after his wife's death, he wrote to William R. Pierce to order a sarcophagus or grave stones (headstone and foot stone) with a base of Gunnison granite "very finely hammer Dressed, not less than number ten hammer," and on top of that the best quality granite from Quincy, Massachusetts, also highly polished and perfectly fitted together. Only the

lettering was to be exactly as his wife had specified, with the date of her death, August 12, 1885. Although Helen Hunt Jackson had written that she did not want to be buried in the "parched thirsty cemetery at the Springs," the monument her husband ordered was placed in Evergreen Cemetery in Colorado Springs. Because she was so well known for her books and reform activities, many people visited this memorial and it became far more public than she had envisioned.

There are also those in every age who do not wish for any tangible evidence of their passing or prefer a different type of memorial than a monument in a cemetery. Living plants were a common substitute in the nineteenth century. Samuel Parsons, a strong advocate of living memorials, wrote that "the excessive and tasteless use of stonework in our cemeteries has been unnaturally fostered by love of display and by the fact that cut stone is more permanent and needs less care than shrubs and flowers. . . . Plants, however, have long been employed, entirely independent of what the fashion might be, and in their use, therefore, lies the really heart-felt offering to the memory of the departed."[7] With the passing of Marcus Daly, one of the most influential men in Butte, the *Butte Reveille* suggested that "a Daly Institute, consisting of labor halls, reading and lecture rooms, gymnasium . . . would be of more value than all the marble shafts or any other useless monuments that all the money of the world could produce."[8] This sentiment can even be found on some monuments. Although George Albert Smith's monument was obviously important to those who erected it in the Salt Lake City cemetery, a quote from J. F. Smith on its base suggests that the carved marble is not necessary to ensure fame: "He will never die; he lives in the hearts of God's people and will survive all books or monuments of stone." Those who eschewed grave memorials formed a minority in a society that more often celebrated individual

lives with private grave markers and then appropriated them for public visual consumption.

The peculiar nature of the early western cemetery as a public sculpture garden stands out even more clearly when compared with public sculpture a century later. The private roles of late twentieth-century sepulchral art remained as vital as in the past, but many of the public aspects of nineteenth-century cemeteries disappeared when public sculpture moved from the cemetery to the city park and square at the turn of the century. In this transition, the private and public functions that had been melded in each work of sepulchral art became separated again. Whereas nineteenth-century cemetery art held very strong personal meaning in addition to its broadly accepted social iconology and religious or historical iconography, late twentieth-century public art often meant more to the artist than it did to a distanced public. The pioneer public that observed community cemetery art went out of its way to see it, whereas the late twentieth-century public more often viewed community art because it stood in a physical space between people and their daily destinations. Divorced from a common unifying concept such as the mystery surrounding inevitable death and alienated from personal identifications and meanings, modern public art frequently became the center of public controversy. Richard Serra's *Tilted Arc* ignited controversy in ways that Ole Rustad's Lester Drake monument never did, and not only because one was nonobjective abstraction and the other representational realism. The public's personal and collective investment in sepulchral sculpture in the old West greatly exceeded that of the public's investment in most modern or postmodern civic sculpture. Only at the turn of the twenty-first century do more artists seem to have discovered the means to form an appreciative public through community input at every step of the process from conception to dedication. This may be especially true of

contemporary public sculpture that has a memorial function. The result often bridges the gap between popular and fine art forms.

Rocky Mountain pioneer community cemeteries and their sepulchral art took the forms they did because a non-Native, but otherwise ethnically diverse, mostly middle-class, largely Christian public believed the death of a good person should be marked with a monument that would make a statement of positive value in the community. That value was enhanced by applying the aesthetic qualities and social cachet of fine art to what was essentially a popular art form. Pioneer cemeteries in the Rockies accumulated memorials to all sorts of individuals and surrounded them with visual spectacles that drew the attention of the living to the dead. These collections of memorial art objects joined private with public functions, forming important cultural centers for pioneer communities on the frontier. Community cemeteries became the sculpture gardens of the Rocky Mountains, active witnesses to and agents in the performance of Manifest Destiny. Ultimately, the American public established a mountain society near the end of the nineteenth century that valued the individual, even after death, as one who could affect the public good through monumental commemoration.

Notes

Chapter 1. From Boot Hill to Fair Mount

1. Horace Greeley, *An Overland Journey from New York to San Francisco, in the Summer of 1859*, ed. Charles T. Duncan (1860; New York: Knopf, 1964), 133. Many of the barely habitable huts Greeley described had been abandoned as discouraged gold seekers and settlers returned home or moved farther into the mountains. Before another full year had passed, there were frame buildings and one brick one.

2. "Early Impressions of Cheyenne," section of *Cheyenne Photos from Wyoming Tales and Trails*, http://www.wyomingtalesandtrails.com.

3. Thomas Josiah Dimsdale, *The Vigilantes of Montana* (Virginia City MT, 1866), 5; March of America Facsimile Series No. 95 (Ann Arbor: University Microfilms, 1966).

4. James McClellan Hamilton, *History of Montana: From Wilderness to Statehood* (Portland OR: Binfords & Mort, 1970), 258.

5. *Denver Rocky Mountain News,* October 20, 1859.

6. Linda Wommack, *From the Grave: A Roadside Guide to Colorado's Pioneer Cemeteries* (Caldwell ID: Caxton Press, 1998), 346. Idaho quote is from Dimsdale, *The Vigilantes*, 227. He writes of several instances when the townspeople prepared the coffins and buried the outlaws hanged by vigilantes, but nowhere mentions the marking of graves.

7. Early Rocky Mountain town promoters made efforts to counter the widespread belief that mortality rates were higher in mountain towns than in the East, sometimes quoting statistics and always talking about healthful mountain air. Whether mortality rates were really higher or not, the perception of widespread death and media attention to that fear created its own reality. National mortality rates were also relatively high, especially for children.

8. "The National Park Massacre," and "Sixteen Men Killed and One Man and two Women Prisoners," *Helena Daily Independent*, August 28, 1877, p. 3, cols. 2, 3, gave the first local accounts of the disaster. Many more items followed, which were summarized by Robert E. Miller in the *Montana Record Herald* of July 31, 1929. Miller's report was reprinted in the *Helena Independent Record*, December 10, 1961, p. 8 cols. 1–3. Kenck's son located the original burial place at the site of the shooting in Yellowstone by an inscription carved in a tree trunk, but he also had the body exhumed from its place in Helena's Catholic cemetery, examined to determine whether it was really Charles Kenck, and moved to the newer Forestvale Cemetery on July 30, 1929.

9. Clark, Root & Co., *Leadville City Directory (1st annual)* (Denver: Daily Times Steam Printing, 1879), 7.

10. Don L. Griswold and Jean Harvey Griswold, *History of Leadville and Lake County, Colorado: From Mountain Solitude to Metropolis*, 2 vols. (Denver: Colorado Historical Society and University Press of Colorado, 1996), 2:1564–65.

11. "An Old Graveyard Discovered," *Leadville Daily Chronicle*, July 12, 1879, p. 2, col. 3.

12. "Early Timer's Body," *Helena Herald*, April 14, 1893, 1, copy in vertical file, "Helena—Cemeteries," Montana State Historical Society, Helena.

13. Wommack, *From the Grave*, 414.

14. Wommack, *From the Grave*, 197. Silver Plume is in Colorado, directly west of Denver.

15. A diligent search in extant newspapers and early histories finds no mention of the exact location of the earliest boot hill cemetery in the Denver area. Junius E. Wharton's *History of the City of Denver from Its Earliest Settlement to the Present* (Denver: Byers and Dailey, printers, 1866) describes these and many other deaths in 1859, taken in large part from the weekly *Rocky Mountain News*. "Early Days in Jefferson," *Rocky Mountain News*, February 1, 1860, p. 2, col. 1 gives the account of Thomas Biencroff's

murder on April 7, 1859, and the subsequent trial and hanging of John Stofel on a cottonwood tree near the intersection of Third and St. Louis Streets; "Fatal Affray," *Rocky Mountain News,* October 27, 1859, p. 2, col. 4 recounts in detail the affair between Davis and the blacksmith William J. Pain. Their burial locations are not noted.

16. Cemeteries associated with forts are a different matter, as are mission cemeteries. These are not included in this study, but it is fair to say that many Native Americans are interred and memorialized in both types of cemetery.

17. I am indebted to the Catholic Cemeteries sexton Pat Mulcahey for bringing this to my attention and to the author Zena Beth McGlashan for sharing her research about it. She discusses the people who were so noted in chapter 4, "The People's Friend," of her forthcoming book, *Buried in Butte: A Business and Social History.*

18. "Boulder Pioneer Cemetery," handwritten manuscript, BHS 301, box 2, folio 15, Boulder Public Library, Boulder, Colorado. It probably refers to a cemetery once located on Sunset Hill in Boulder.

19. City directories sometimes exaggerated the positive qualities of western towns to lure more settlers, but the brief history of Leadville published by Clark, Root & Co., in *Leadville City Directory* (1879), 5–9, from which this summary of the town's first two years of growth is taken, has the advantage of being contemporaneous with the events. The rapid growth may also be seen in the writer's reference to those residents of only two years as "the pioneers." The contemporary historians Don L. Griswold and Jean Harvey Griswold have accepted this early account in their *History of Leadville.*

20. "City of the Dead: A Search through Leadville's Cemetery by a Chronicle Reporter and What He Saw There," *Leadville Daily Chronicle,* May 26, 1879, p. 1, cols. 1–4.

21. "Evergreen Cemetery," *Leadville Daily Chronicle,* November 8, 1879, p. 3, col. 6.

22. "City of the Dead," p. 1, col. 1.

23. "A New Cemetery," *Leadville Daily Chronicle,* June 6, 1879, p. 1, col. 2, called the old cemetery "that disgrace to a semi-civilized community."

24. "Communicated. Our Dead," *Boulder County News,* November 23, 1869, p. 2, col. 2. Phyllis Smith's brief, unpublished "Historic Overview" of Columbia Cemetery was helpful in locating

this source; the author received a photocopy of Smith's overview from Mary McMillan of Boulder Park Service.

25. "The Dead," *Leadville Daily Chronicle*, January 1, 1882, p. 10, col. 2.

26. "Bills Bros.," in *American Journal of Progress, Special Extra Number Descriptive of and Illustrating Denver* (New York: American Journal of Progress, ca. 1898), 17.

27. "Evergreen Cemetery," p. 3, col. 6.

28. Elise Ciregna discusses Mt. Auburn as an opportunity for young sculptors to learn more about sculpture, meet patrons, and gain commissions. In the West, it would appear that cemeteries played a smaller role in individual sculptors' lives. See Ciregna, "Museum in the Garden: Mount Auburn Cemetery and American Sculpture, 1840–1860," *Markers* 21 (2004): 101–47.

29. "The Dead," p. 10, col. 2. Hebrew Cemetery was established in 1880 when the local Jewish community purchased a section of Evergreen. In 1888 St. Joseph's Catholic Cemetery opened, and in 1919 Mt. Holy Cross began taking internments adjacent to it. At some point, sections were also designated for the Grand Army of the Republic, babies, and paupers.

30. Wommack, *From the Grave*, 187.

31. Forestvale Cemetery Association, Lot Ownership Book, 200–203 and 207–8, Mss Collection 240, Forestvale Cemetery Association Records, Montana State Historical Society, Helena.

32. "A Proposition Made to the Council for the Establishment of a New Cemetery," *Helena Weekly Herald*, July 19, 1888, p. 7.

33. St. Patrick's Church was founded in 1881 and the cemetery was listed in the 1884–85 city directory. Zena Beth McGlashan has established the founding dates of Mt. Moriah and the Jewish Cemetery as 1877 and notes that an earlier burial ground closer to the town center had begun in 1866.

34. Scholars of the Chinese in the American West debate this point among themselves, with Liping Zhu emphasizing self-determinacy and some writers in Chung and Wegars seeing the Chinese as victims of racism that enforced their segregation. See Liping Zhu, *A Chinaman's Chance: The Chinese on the Rocky Mountain Mining Frontier* (Boulder: University Press of Colorado, 1997), and Sue Fawn Chung and Priscilla Wegars, eds., *Chinese American Death Rituals: Respecting the Ancestors* (New York: Altamira Press, 2005).

35. For an excellent account of the creation of Mt. Auburn and

the philosophies that supported it, see Blanche Linden-Ward, *Silent City on a Hill: Landscapes of Memory and Boston's Mount Auburn Cemetery* (Columbus: Ohio State University Press, 1989).

36. "A Proposition Made to the Council," p. 7.

37. *Butte Evening News*, Sunday ed., May 1, 1910, sect. 2, p. 11, cols. 6–7.

38. Remnants of this practice may be seen in the cemetery at Nevada City, Montana, but it is not clear whether the practice dates back to the nineteenth century.

39. For an extensive article about these sandstone quarries, see "Larimer County Stone," *Denver Republican*, May 25, 1890, p. 11, cols. 1–2.

40. The signature at the bottom front center of the stone appears to say R[?]OOILACOTT and may refer to John Roolia, who was buried in the Salt Lake City Cemetery in 1892. No other documentation has yet emerged to help identify the carver or firm.

41. Richens & Co. Advertisement, *Rocky Mountain News*, June 7, 1874, p. 2, col. 3.

42. "Things at the Exposition," *Denver Tribune-Republican*, October 19, 1886, p. 8, col. 1.

43. "Quarry Notes," *Monumental News* 6 (June 1889): 98.

44. "The State House Stone," *Denver Republican*, April 16, 1883, p. 4, cols. 4–5; "Silver Plume" *Central City Daily Register Call*, January 25, 1886, p. 1, col. 3. See also "Riches Are in Rock," *Denver Rocky Mountain News*, January 1, 1891, p. 11, cols. 5–7, and John H. Murray, "The Stone Industry of Colorado," *Denver Times Friday Magazine*, February 2, 1906, pp. 10–11, for surveys of rock quarries throughout Colorado.

45. These included gray Gunnison, which had a medium grain; Cotopaxi, with its fine grain; pink and dark Arkins granite from the John D. McGilvray & Co. quarries; a granite discovered by the Denver monument maker F. Clifton Gray on the Crystal River in Pitkin County; "Colorado Barre granite," discovered near Leadville and worked since 1886 on a modest scale; Silver Plume; Platte Canyon; and Salida granites.

46. With headquarters and financing in Denver, it sent monument-grade stone to its Denver plant until 1907, when a new cutting and finishing plant was built in Salida on more modern lines. When I saw it in 1999, the Salida plant housed the Hylton Lumber Co., but granite chips were still evident the length of the straight shed. The *Monumental News* regularly carried notices of the progress of

this firm: "Granite Notes," 16 (April 1904): 266; "Among the Retail Dealers," 19 (May 1907): 382; and "Granite," 19 (July 1907): 550.

47. "The Granite Industry of Colorado," *Monumental News* 1 (January 1897): 50.

48. "Denver, Col." *Granite Cutters' Journal* 30 (April 1906): 5.

49. The history of marble is told in Duane Vandenbusche and Rex Myers, *Marble, Colorado, City of Stone* (Denver CO: Golden Bell Press, 1970). In 1910 a large-scale monumental department was set up under the management of M. E. Granger. Some of its monument designs were reproduced in *Monumental News* 21 (August 1910): 602.

50. The process is described in many places, but a good contemporaneous source is Prof. Lakes, "Quarrying and Working Marble," reprinted from the *Denver News* in *Monumental News* 5 (July 1893): 333.

51. "Obituaries," *Monumental News* 24 (September 1912): 736.

52. "Kountze's Fortune Is Unknown; May Be $20,000,000," *Denver Rocky Mountain News*, November 19, 1911, sect. 1, p. 3, col. 1.

53. Junius E. Wharton, *History of the City of Denver* (Denver, 1866), reprinted in *Colorado Gazateer and Directory of 1866*, reproduced by D. O. Wilhelm, May 1909.

54. Herman S. Davis, compiler, *Reminiscences of General William Larimer and His Son William H. H. Larimer* (Lancaster PA: Press of the New Era Printing Co, 1918). This account is somewhat suspect. Over the next few months, letters to the newspaper, quoted below, suggest that the spot had long been used for burials, and one writer even accused a local undertaker, John J. Walley, of claiming the public graveyard as his own by writing to the Territorial Government of Kansas for legal title to something to which he had no right. Walley was also accused of having long charged exorbitant fees for burials. Larimer, Walley, and several others were involved in the cemetery together, but Walley was the person most citizens dealt with. "He it was, who disregarding the sacredness to which the ground had long been consecrated and set apart, lacking even the veneration and respect which the savage of the Plains always manifests for the resting place of the dead, for base and selfish purposes 'jumped' this land, and is now endeavoring to secure a patent for it from the United States." Citizen, "The City Cemetery," *Denver Rocky Mountain News*, February 23, 1860, p. 2, col. 1.

55. David Fridtjof Halaas, *Fairmount and Historic Denver* (Denver CO: Fairmount Cemetery Association, 1976), 17.

56. "Mount Prospect Cemetery," *Denver Rocky Mountain News*, February 29, 1860, p. 2, cols. 2–3.

57. "Died," *Denver Rocky Mountain News*, November 17, 1859, p. 3 col. 3.

58. Citizen, "The City Cemetery," p. 2, col. 1. Halaas attributed citizens' dislike of Mt. Prospect to Jack O'Neil, the victim of a shoot-out whom he said the Mt. Prospect Burial Association offered to bury for free when the miners and merchants, whose impromptu "court" had determined it a fair shooting, could not agree on what to do with the victim's body. He reports that this incident, followed by many other criminal burials, created an unsavory reputation for Mt. Prospect, which locals were apt to call Jack O'Neil's Ranch. Halaas, *Fairmount*, 17–19. Halaas does not note the source of this information and incorrectly cites O'Neil, who died March 30, 1860, as the first burial in Mt. Prospect. It should be noted that most of the town's deceased citizens, not just criminals, were buried there, and the published complaints, which predate the O'Neil affair by over a month, had to do with the cemetery's appearance, not its residents. The murder of Jack O'Neil was reported in detail in the *Rocky Mountain News* the week after it took place.

59. "The McClure Fund," *Denver Rocky Mountain News*, February 20, 1866, p. 4, col. 3.

60. William Larimer Jr., president, and J. J. Walley, secretary, treasurer, and undertaker, "Mount Prospect Cemetery," advertisement, *Denver Rocky Mountain News*, April 12, 1862, p. 2, col. 5, and April 25, 1862, p. 1, col. 1.

61. *Denver Rocky Mountain News*, January 8, 1863, p. 1 col. 2.

62. *Denver Rocky Mountain News*, January 8, 1863, p. 1 col. 2.

63. For example, "New Advertisements," *Denver Rocky Mountain News*, February 22, 1862, p. 3, col. 2.

64. "Acacia Cemetery," *Denver Rocky Mountain News*, May 3, 1867, p. 1, col. 2.

65. The burial society was not a congregation, but an association of Jews.

66. Riverside Cemetery Association, *Prospectus. Riverside Cemetery* (Denver CO: Denver Tribune Steam Book and Job Printing Establishment, 1878).

67. Riverside Cemetery Association, *Prospectus*, 5. The following two quotes are from the same source, 6–7.

68. "Decoration Day," *Denver Rocky Mountain News*, May 29, 1887, p. 8, col. 2.

69. "Riverside Cemetery," *Denver Weekly Times*, July 12, 1876, p. 1, col. 5.

70. In spring 2007, Professor Larry Conyers and his anthropology students at the University of Denver used ground-penetrating radar to survey the areas beneath the floor and beyond the walls of the mausoleum, confirming that no body is buried there. The radar revealed only one body immediately behind the building, that of Mary E. Jones, whose marble monument marks her last resting place. Jessica Gabriel, "Riverside Cemetery, H. F. Jones Burial," GPR report, spring 2007. I am grateful to Caitlin Schwartz, an art history graduate student at the University of Denver, who discovered new biographical information about Jones, including the existence of a fourth wife, Caroline S. Jones.

71. Jill Overlie, "Nineteenth-Century Sepulchral Architecture in Denver: The Martha T. Evans Mausoleum" (MA thesis, University of Denver, 2000). For more information about Evans, Jones, and Hollister, see Annette L. Student, *Denver's Riverside Cemetery: Where History Lies* (San Diego CA: Printed on demand by Christian Network Services, 2001), 137–38, 163–64, 171–72.

72. "Gov. Otero's Mother, Whose Daughter Lives in Denver, Dies in Santa Fe," obituary for Mrs. Mary J. Otero, widow of Miguel Antonio Otero, *Denver Republican*, May 21, 1900, p. 5, cols. 2–3. New England Granite Works Order Book, vol. 2, order #1842 placed by Greenlee & Co. of Denver for Miguel A. Otero monument, July 6, 1882, New England Granite Works Papers, Westerly Public Library, Westerly RI.

73. "Walk through Historical Riverside Cemetery," a pamphlet produced by Riverside Cemetery, Denver, provides brief biographies of these and others buried at Riverside.

74. This is Rule 7 of the first eighteen rules instituted by the association in its *Prospectus* of 1878. Many more would follow.

75. William B. Vickers, *History of the City of Denver, Arapahoe County, and Colorado* (Chicago: O. L. Baskin, 1880), 291.

76. I am indebted to my former student Keri Bradford, whose research on the Iliff monument first uncovered the original contract and correspondence between Elizabeth Iliff and New England Granite Works. These documents are found in the collection of Iliff Family Papers, Rocky Mountain Conference Archives, Taylor Library, Iliff School of Theology, Denver, Colorado. See also Keri

Bradford, "The Monument to John Wesley Iliff," research paper, November 23, 1998, copy in the author's possession.

77. William F. Havemeyer died November 30, 1874, and was buried in Green-Wood Cemetery in Brooklyn. Less than a year later, on October 15, 1875, he was reinterred at Woodlawn Cemetery in the Bronx; this is where the monument is found. The change of cemeteries may have something to do with choosing the best site for this very tall monument, which was ordered on October 4, 1876, at a cost of $10,000. New England Granite Works, Order Book, vol. 1, order #319, Westerly Public Library, Westerly RI.

78. Elizabeth Iliff paid $600 for the center circle, fifty feet in diameter, where her husband was buried and the monument was erected. Only a year and three months later, John Wesley Iliff Jr. died and was buried beside his father. Lizzie had just ordered the monument and headstone, so she added an inscription for her son to the headstone order.

79. New England Granite Works, Order Book, vol. 1, order #905, April 3, 1879, Westerly Public Library, Westerly RI.

80. "Amusements," *Denver Rocky Mountain News,* March 6, 1887, p. 5, col. 6. The next year this congregation built a synagogue on the east side of Cherry Creek at Blake Street. They do not appear to have succeeded in building a cemetery.

81. The Riverside purchase was made in February 1896. Several other Jewish congregations in the area developed their own cemeteries, including the United Hebrew Cemetery Association, which opened Rose Hill Cemetery in 1882. The present site of Emanuel Cemetery was acquired in 1909, when the Congregation purchased land in Fairmount Cemetery. Between 1911 and 1923, a large number of burials were removed from the old Hebrew Cemetery to the new Emanuel Cemetery. Marjorie Hornbein, *Temple Emanuel of Denver: A Centennial History* (Denver CO: A. B. Hirschfeld Press, 1974); Alan Breck, *The Centennial History of the Jews of Colorado, 1859–1959* (Denver CO: Hirschfeld Press, 1960), 85.

82. Riverside Cemetery Association, *Riverside Cemetery, Denver Colorado* (Denver CO, ca. 1890–91). See Rule 12 regarding foundations, 13 on the prohibition of inappropriate monuments, 14 on removal of objectionable features, and 15 on the size of headstones for the quotes in this paragraph.

83. *Prospectus of the Fairmount Cemetery Association, together with its Rules, Regulations, Maps and Plans and General Information* (Denver CO: Press of C. J. Kelly, 1891), 13.

84. Fairmount Cemetery Association, *Rules and Suggestions for Monument Builders and Lot Owners* (Denver CO: Fairmount Cemetery Association, ca. 1890s), 4.

85. Fairmount Cemetery Association, *Rules and Regulations Governing the Cemeteries of Fairmount and Riverside and Suggestions to Lot Owners* (Denver CO: Fairmount Cemetery Association, 1900).

86. *Denver Rocky Mountain News*, August 22, 1891, p. 2, col. 6.

87. Marlene Chambers, ed., *The First Hundred Years: The Denver Art Museum* (Denver CO: Denver Art Museum, 1996).

88. Of course, the cemetery was not the only effort to demonstrate and instill culture. Many western towns established an opera house quite early in their history, including Central City, Colorado, which built its opera house in 1878. There were numerous, usually short-lived, museums and collections of curiosities. Most towns had at least one photographic studio, and often several, within their first year or two. Photographers made not only portraits, but scenic views that were displayed in the studio as a form of art gallery in the hope of selling on speculation. And yet only the cemeteries had the quality of a permanent place of public art in the early years, when theater often consisted of roving troops of actors whose artistic and class standing were assumed to be suspect and whose acts sometimes contributed to the wild image of the western town.

89. Even before the move to Utah, then named Deseret, the Church had recruited stonemasons and stone carvers from England to work on its temples. The temple builders in Illinois and in Utah often carved and lettered tombstones during the winter months, work that could be done indoors.

Chapter 2. Tombstone Carvers and Monument Makers

1. Carol Edison, "Custom-made Gravestones in Early Salt Lake City: The Work of Four English Stonecarvers," *Utah Historical Quarterly* 56 (Fall 1988): 310–30. For the symbolic relationship between temple building and monument making, see George H. Schoemaker, "Acculturation and Transformation of Salt Lake Temple Symbols in Mormon Tombstone Art," *Markers* 9 (1992): 197–216.

2. Charles Lambert Journal, transcribed from the original handwritten, paper-bound book in the possession of Lambert's son Alma Cannon Lambert in October 1940 by Lucile Richens and

Cornelia Spaans as part of a WPA project, transcription, Utah State Historical Society, Salt Lake City.

3. Lambert Journal, part 3, entry of May 13, 1860.

4. Edison, "Custom-made Gravestones," 320, describes a joint project of Lambert and Player in 1865 for the Governor James Doty obelisk, for which they received $375.

5. Andrew Jenson, *Biographical Encyclopaedia or Condensed Biographical Sketches of Presiding Officers . . . in the Salt Lake Stake of Zion* (Salt Lake City, UT, 1888), 93; Salt Lake City directories; 1874 Gazetteer of Utah; 1879 Utah Directory and Gazetteer.

6. See Barbara Welter, "The Cult of True Womanhood, 1820–1860," *American Quarterly* 18 (Summer 1966): 151–74, for an analysis of the importance of this phrase.

7. Morris's autobiography appears in his obituary, "Bishop Morris Dead," *Salt Lake City Deseret Evening News*, March 17, 1898, p. 1, col. 7, p. 2, col. 1. Additional information was obtained from "Elias Morris," *Salt Lake City Deseret Evening News*, June 30, 1900, sect. 2, p. 22; Elias Morris & Sons Co., *Integrity, Craftsmanship, Quality: The Story of Elias Morris & Sons Company* (Salt Lake City UT: Elias Morris & Sons Co, n.d.).

8. The most relevant of many writings about Mormon beliefs is Mary Ann Meyers, "Gates Ajar: Death in Mormon Thought and Practice," in *Death in America*, ed. David E. Stannard (Philadelphia: University of Pennsylvania Press, 1975), 112–33, especially 120–21.

9. B. H. Roberts, *A Comprehensive History of the Church of Jesus Christ of Latter-Day Saints,* 6 vols. (Salt Lake City UT: LDS Church, 1930), 3:482 confirms data on the monument.

10. Esther Bott Freeman, "The Life Story of John Henry Bott," in *The Generations of Cecelia Rasmusson Peterson Bott*, comp. Glen R. Freeman (Provo UT: Privately published, 1997), 55–59, quote on 58.

11. George H. Schoemaker discusses another such monument-making family, the Childs of Springville, Utah, with an emphasis on twentieth-century developments, in "The Shift from Artist to Consumer: Changes in Mormon Tombstone Art in Utah," in *The Old Traditional Way of Life: Essays in Honor of Warren E. Roberts*, ed. Robert E. Walls and George H. Schoemaker (Bloomington: Indiana University Folklore Institute and Trickster Press, 1989), 130–45. The Childs apparently shifted to granite and pneumatic tools very late compared with the rest of the Rocky Mountain and national monument industry; see 133.

12. See, for example, Nancy-Lou Patterson, "United Above Though Parted Below: The Hand as Symbol on Nineteenth-Century Southwest Ontario Gravestones," *Markers* 6 (1989): 180–206.

13. Richard C. Poulsen, *The Pure Experience of Order: Essays on the Symbolic in the Folk Material Culture of Western America* (Albuquerque: University of New Mexico Press, 1982), 45–55.

14. Schoemaker, "Acculturation," 197–214.

15. Meyers, "Gates Ajar," 132–33.

16. Richard H. Jackson, "Mormon Cemeteries: History in Stone," in *Nearly Everything Imaginable: The Everyday Life of Utah's Mormon Pioneers*, ed. Ronald W. Walker and Doris R. Dant (Provo UT: Brigham Young University Press, 1999), 407–12. See also Allen D. Roberts, "Where Are the All-Seeing Eyes? The Origin, Use, and Decline of Early Mormon Symbolism," *Sunstone* 4 (May–June 1879): 22–37; Richard G. Oman and Susan S. Oman, "Mormon Iconography," in *Utah Folk Art: A Catalog of Material Culture*, ed. Hal Cannon (Provo UT: Brigham Young University Press, 1980).

17. Carl Oscar Johnson, obituary, *Salt Lake City Deseret News*, July 31, 1936, p. 4, col. 1.

18. "Monument of Native Marble," *Denver Weekly Rocky Mountain News*, December 28, 1861, 4, accessed at http://www.coloradohistoricnewspapers.org. Another article, "Colorado Marble," *Denver Rocky Mountain News*, June 22, 1866, p. 1, col. 1, stated, "Mr. E. Gaffney has shown us a specimen of what appears to be a fine quality of marble. It is found in large quanties [*sic*] some fifty miles from here, and if it proves to be what it is thought to be, it is a good thing."

19. Mt. Vernon Towne no longer exists, but was once located at the mouth of Mt. Vernon Canyon and was the territorial capitol in 1859. Today Interstate 70 runs through the site just south of Golden.

20. The first advertisement quoted here is found in many issues of the *Denver Rocky Mountain News*, including, for example, September 11, 1860, p. 3, col. 3. The second is from the same paper, January 21, 1864, p. 3, col. 4, and continued throughout the year. Additional information about the stone appeared in a short article, "Fine Building Stone," *Denver Rocky Mountain News*, February 1, 1860, p. 3, col. 1.

21. A representative example of his advertisement can be seen in the *Denver Rocky Mountain News*, January 6, 1864, p. 1, col. 1.

22. "The Homicide Last Night," *Denver Rocky Mountain News,* April 25, 1865, p. 3 col. 1; "Lieut. Canove Arrests Squires," *Denver Rocky Mountain News,* July 12, 1865, p. 2, col. 1; "Squires Escapes," *Denver Rocky Mountain News,* October 10, 1865, p. 4, col. 2.

23. *Denver Rocky Mountain News,* November 29, 1865, p. 4, col. 1.

24. "The Soule Monument," *Denver Rocky Mountain News,* January 19, 1866, p. 4, col. 1.

25. "A Card of Thanks," *Denver Rocky Mountain News,* June 19, 1866, p. 4, col. 1.

26. "Denver City Marble Works," advertisement, *Denver Rocky Mountain News,* April 25, 1867, p. 1, col. 5; "Mr. Eli Daugherty," *Denver Rocky Mountain News,* May 8, 1867, p. 4, col. 1.

27. Arapahoe County Assessment Rolls for 1865–76, Colorado State Archives. Denver and U.S. Census for Denver, 1870, which shows forty-nine-year-old stonecutter Thomas Buchanan and twenty-two-year-old laborer William Hellingsly living with the thirty-one-year-old Eli Daugherty. Usually in such cases they were also working together.

28. The only L. M. Koons in Denver was the pastor of a Lutheran church, a publisher, and the owner of $14,000's worth of real estate, $7,500 of capital invested in manufacturing of some sort, and other assets (1867 Arapahoe County Assessment Rolls, Colorado State Archives) in the 1860s before he partnered with Rounds, who had only $500 of real estate and $500 capital in merchandise at the time of their monument partnership (1873 Arapahoe County Assessment Rolls, Colorado State Archives). Probably Rounds was the businessman and Koons the investor-financier.

29. William B. Vickers, *History of Denver, Arapahoe County, and Colorado* (Chicago: O. L. Baskin, 1880), 403.

30. Denver Board of Trade, *The Manufacturing and Commercial Industries of Denver, Colorado* (Denver: Journal of Commerce Printing House, 1882), 26.

31. J. H. Triggs, *History and Directory of Laramie City, Wyoming Territory* (Laramie City WY: Daily Sentinel Printers, 1875), 28.

32. "Burials and Memorials—History of Government Furnished Headstones and Markers," Veterans Administration website, http://www.cem.va.gov/hmhist.htm, accessed August 30, 2005.

33. James Milmoe, "Colorado Wooden Markers," *Markers* 1 (1979–80): 56–61. In a telephone conversation with James Milmoe, July 14, 2006, he indicated that to his knowledge no tests had been

done, nor had he found documentation related to this theory, but his own background as a chemist working with wood preservation led him to conclude that most of the marker inscriptions he saw had become raised through erosion of unpainted surfaces.

34. By contrast, a now very short headboard that remains in the Salt Lake City Cemetery and was also formed from hardwood about two inches thick for Edward Jonie [?], who died in 1858, is barely legible. It has probably rotted through at ground level and been reburied several times.

35. My thanks to staff who showed me the marker and to the curator George Oberst for additional information, including a copy of the newspaper account "Grave Marker Given to State," *Philipsburg* (Montana) *Mail*, January 13, 1928, which documents this marker's provenance.

36. I compiled Peel's biography from newspaper accounts of the time: "Fatal Shooting Affray—Farmer Peel Killed," *Virginia City Montana Post*, July 27, 1867, p. 8 cols. 4–5; "A Tragedy—One Man Killed," *Helena Herald*, July 24, 1867, p. 3, col. 3. The whole story was rehashed with additional information added in "The Tale of a Bad Man," *Helena Daily Independent*, March 19, 1892, p. 2, cols. 1–2; "He Went Back Heeled," *Helena Independent*, March 20, 1892, p. 8, col. 1.

37. "He Went Back Heeled," meaning armed.

38. Advertisement for John How, *Virginia City Montana Post*, January 20, 1867, p. 7, col. 5.

39. Quoted in Robert R. Swartout Jr., "Kwangtung to Big Sky: The Chinese in Montana, 1864–1900," in *Chinese on the American Frontier*, ed. Arif Dirlik (Lanham MD: Rowman & Littlefield, 2001), 375.

40. The most thorough and recent source on Chinese death rituals in the United States is Sue Fawn Chung and Priscilla Wegars, eds., *Chinese American Death Rituals: Respecting the Ancestors* (Lanham MD: Altamira Press, 2005). See also Sue Fawn Chung, "Between Two Worlds: The Zhigongtang and Chinese American Funerary Rituals," in *The Chinese in America: A History from Gold Mountain to the New Millennium*, ed. Susie Lan Cassel (Lanham MD: Altamira Press, 2002), 217–38.

41. Advertisement for Reitze & Gregory, *Denver Rocky Mountain News*, February 23, 1866, p. 1, col. 7.

42. Triggs, *History*, 37, quoting Joseph Richardson, a director of the Union Pacific Railroad, letter of April 1, 1875, regarding an iron foundry.

43. John B. Robinson, *Trade Secrets: A Collection of Practical Receipts for the use of Sculptors, Modellers, Stone Masons, Builders, Marble Masons, Polishers, etc.* (Derby, England: Self-published, 1862), 51. This author drew on many sources, including American ones, but the source of this artificial marble recipe is not given.

44. E. L. Blackburne, ed., *The Mason's, Bricklayer's, Plasterer's, and Decorator's Practical Guide* (London: James Haggue, [186-]), 15–19.

45. "Books and Trade Publications Reviewed," book review, *Monumental News* 21 (August 1910): 601, describes both A. A. Houghton's *Ornamental Concrete without Moulds* and the same author's *Concrete from Sand Molds*.

46. "Denver's Monument Plants. I—Bills Brothers." *Monumental News* 27 (February 1915): 101.

47. A. K. Prescott obituary, *Montana Record-Herald*, February 3, 1930, p. 1, cols. 3–4, p. 2, col. 1. Several biographies and memoirs by Prescott's children are found in vertical files, "A. K. Prescott," Montana State Historical Society, Helena. For Leland F. Prescott and Robert A. Ketchin, see A. W. Bowen and Co., *Progressive Men of the State of Montana* (Chicago: A. W. Bowen, ca. 1902), 809–10, 700–701.

48. Colorado State Business Directories, 1889–1905; Corbett, Hoye & Co.'s *Annual City Directory* for Leadville, succeeded by Corbett & Ballenger's *Leadville City Directory*, 1880–1905; articles about Judson are found in Don L. Griswold and Jean Harvey Griswold, *History of Leadville and Lake County, Colorado: From Mountain Solitude to Metropolis*, 2 vols. (Boulder: Colorado Historical Society and University Press of Colorado, 1996), 1:1220, 2:1383; *Lake County Administrator's Record Book B*, p. 32, for Herbert H. Judson probate, clerk of common courts, Lake County Courthouse; *Index to Divorces in Lake County, 1879–1938* gives case 4284 Nancy Bull vs. Ansel Bull; and Leadville Marble Works was featured in the monthly publication *The Leading Industries of the West* (Chicago: H. S. Reed, November 1883), 59.

49. Information about Malpuss is found in the Leadville city directories, U.S. Census records for 1900 and 1910, Leadville; and the 1900 Census for Denver, which shows Charles E. Malpuss, marble carver, is a patient at the Arapahoe County Hospital in Denver.

50. "Letters and Lettering," in *Monument Dealer's Manual*, ed. O. H. Sample (Chicago: Allied Arts, 1919), 62–63.

51. *Monumental News* 25 (June 1913): 435.

52. See, for example, the series of letters and essays "Rock-Faced Work—Its Use and Abuse," *Monumental News* 16 (January 1, 1904): 33–36. As late as 1914, this journal was still publishing such letters. Perry & Rockwood's new book of rock-faced designs was advertised in *Monumental News* 2 (November 11, 1890): 354, and in 1919 Harry A. Bliss published a book of "the best examples of rock-faced memorials," *Rock-Faced Monuments* (Buffalo NY: Harry Bliss, 1919). These books frame the period of rock-face popularity.

53. Michele Bogart, *Public Sculpture and the Civic Ideal in New York City, 1890–1930* (Chicago: University of Chicago Press, 1989), chap. 2. The National Sculpture Society that plays such a large role in the story of New York public sculpture is not a factor in Rocky Mountain sepulchral sculpture.

54. *Monumental News* 3 (May 1891): 178. It would be 1900 before western cutters and carvers won the eight-hour day.

55. "A letter from Judge Slough to E. Gaffney," *Denver Rocky Mountain News,* March 9, 1867, p. 4, col. 1.

56. C. M. Bills, "Forty-Seven Years of Trade Progress," *Monumental News* 24 (October 1912): 829.

57. Peggy McDowell and Richard E. Meyer, *The Revival Styles in American Memorial Art* (Bowling Green OH: Bowling Green State University Popular Press, 1994).

58. "Art Education for Marble and Granite Workers," *Monumental News* (January 1906): 50–54, quote on 54.

59. "Personal," *Monumental News* 24 (September 1912): 735. The 1911 and 1912 Barre City Directories show Donald Harold was an employee of Barclay Brothers, granite sculptors of Barre, Vermont.

60. *Granite Cutters' Journal* 27 (January 1904): 4.

61. "Dissolution Notice," *Denver Rocky Mountain News,* May 3, 1882, p. 4, col. 6, states that Ernest Kuster is retiring from the firm of Byrne & Kuster. City directories provided information about Byrne's employers and changing titles.

62. "His Favorite Horse Stands as Guard over His Grave," *Denver Post,* June 3, 1901, p. 5, cols. 1–2. The reporter based this article on an interview with Lily Baker Wood Snell but made an error that the *Post* would repeat throughout the twentieth century in giving the name of the horse lover for whom Lily erected this monument as Nathan A. Baker. Nathan Addison Baker was Lily's

brother, whom she said took no interest in the monument project. He died in 1934, not 1884, and was buried in a different cemetery. The horse stands on the grave of Lily and Nathan's father, Addison E. Baker.

63. When the Denver historian Nolie Mumey went through the papers of Nathan A. Baker, he found an undated newspaper clipping about the monument that he quoted at length in note 49 of Baker's published diaries: Nolie Mumey, *Nathan Addison Baker (1843–1934) . . . His Diary of 1865, 1866, 1867 . . .* (Denver CO: Old West, 1965), 43. It provides the information, repeated here, about price, size of marble block, and length of time to carve it.

64. (Mrs.) Beatrice Purcell, "Horse Helps in Decision," *Denver Rocky Mountain News*, February 12, 1956, p. 53, cols. 1–2.

65. "Some Peculiar Monuments," *Monumental News* 8 (November 1896): 711.

66. *Denver Daily News*, October 19, 1886, p. 8., col. 3. *Monumental News*, 8 (June 1896): 381 indicated that the Woodbury bust would be given to the Denver Public Library, but there is no record that it ever was.

67. All quotes in this paragraph are from "It Has Caused a Clash," *Denver Colorado Sun*, February 7, 1892, p. 3, cols. 3–4. I am indebted to Doyle Buhler for bringing this article to my attention.

68. "A Colorado Artist," *Denver Times*, November 13, 1893, p. 2, col. 2. "Sculpture," *Monumental News* 5 (June 1893): 274; "Sculpture," *Monumental News* 5 (August 1893): 364.

69. "A Valuable Suggestion," *Monumental News* 7 (March 1895): 188.

70. "James A. Byrne, Sculptor, Is Dead," obituary, *Denver Post*, March 24, 1908, p. 9. col. 2.

71. "Denver News," *Granite Cutters' Journal* 34 (August 1910): 11.

72. The attribution to Oreste Gariboldi is based on an unidentified 1911 newspaper interview with G. W. Pell Jr. in which he supposedly stated that his father designed the monument and brought Gariboldi from Italy to carve it. David Fridtjof Halaas, *Walk into Historic Colorado: A Self-Guided Walking Tour of Fairmount Cemetery*, 3rd ed. (Denver CO: Fairmount Cemetery, 1994), n.p. Three Gariboldis worked in Denver after 1900: brothers Angelo and Oreste, and Gaetano, who was almost always listed as simply a cutter. Angelo moved to California years before Pell died, but Oreste had a reputation as a skilled carver and sculptor in Denver.

The claim that the Pells brought Gariboldi to Denver could be true only if the monument was designed and carved around 1901, the year Oreste arrived in Denver, which was ten years before Pell Sr. died. This attribution is complicated by the fact that Oreste worked for Denver Marble and Granite until 1910 and again after 1911, but *Monumental News* 25 (June 1913): 434 stated that Fairmount Monumental Works produced the Pell monument. If it was carved while Oreste was on his own or in partnership with Bonicalzi, then it is possible that the Fairmount Monumental Works received the commission and engaged Oreste as a subcontractor to do the carving.

73. Obituaries, *Denver Rocky Mountain News*, December 25, 1911, p. 4, cols. 2–3; *Denver Post*, December 25, 1911, p. 4, col. 4; *Denver Times*, December 25, 1911, p. 4, col. 1.

74. I am indebted to Alisa Zahller of the Colorado Historical Society for finding an advertisement that identified the carver: Giovanni Perilli, *Colorado and the Italians in Colorado* (Denver CO: N.p., 1922), 185. The monument itself carries the signature "Denver Marble Granite Co.," the company for which Oreste Gariboldi worked in 1913–14, when this was probably carved.

75. 1881 British Census, accessed at http://www.FamilySearch .org. Butte city directories 1904–6 list Almond. The 1906 directory gives William Pascoe as a marble cutter with the Butte Tombstone Co., and the 1908 directory lists Alfred Pascoe as a stonecutter there. These may be relatives. The Butte Tombstone Co. records, Mss. Collection 247, Montana State Historical Society, Helena, do not include employee information. The process of "Leaded Lettering for Monumental Work" was described by the Scottish monument maker Archie S. Hill in *Monument Dealer's Manual*, ed. O. H. Sample (Chicago: Allied Arts, 1919), 68–70, who notes that it is unusual in the United States.

76. Pompeo Coppini, address to the Texas Retail Marble and Granite Dealers' Association, "The Sculptor and the Monument Maker," *Monumental News* 25 (December 1913): 854–56.

77. The obituary for Willie did not even name the child: *Salida* (Colorado) *Semi-Weekly Mail*, July 22, 1887, p. 7, col. 1. "Death of Roy Campbell," *Salida Semi-Weekly Mail*, January 31, 1896, p. 3 col. 6. No documentation has yet emerged for the source of the monument, but it is in the path of the Pueblo Marble Co.'s distribution route and is not inconsistent with other monuments signed by that company.

78. Gary Brown, *Soul in the Stone: Cemetery Art from America's Heartland* (Lawrence: University Press of Kansas, 1994), photo and caption on 158.

79. Ellen Marie Snyder, "Innocents in a Worldly World: Victorian Children's Grave Markers," in *Cemeteries and Gravemarkers: Voices of American Culture*, ed. Richard E. Meyer (Logan: Utah State University Press, 1992), 11–29. See also Deborah Ackroyd Smith, "'A Floweret Snatched from Earth to Bloom in Heaven': Perceptions of Childhood and Death on Delaware Tombstones, 1840–1899" (MA thesis, University of Delaware, 1981).

80. Snyder, "Innocents," 11–12.

81. "Death of Georgie Marsh," *Butte Daily Miner*, September 11, 1883, p. 4, col. 1.

82. For example, see David Lubin, "Guys and Dolls: Framing Femininity in Post–Civil War America," in *Picturing a Nation: Art and Social Change in Nineteenth-Century America* (New Haven CT: Yale University Press, 1994), 205–71.

83. Obituary, *Bozeman Weekly Avant Courier*, January 23, 1890, p. 3, col. 6, and follow-up February 6, 1890, p. 3, col. 3.

84. See Zena Beth McGlashan's *Buried in Butte: A Business and Social History* (unpublished manuscript) for a substantial discussion of Gen. Charles S. Warren and Mittie. I am grateful to Zena Beth for generously sharing her manuscript. Charley's obituary is in the *Butte Daily Miner*, October 13, 1886, p. 3, col. 2.

85. James Heddle Harold, obituary, *Pueblo Daily Chieftain*, March 15, 1891, p. 4, col. 4.

Chapter 3. M. Rauh and the Gendered Cemetery

1. In order of appearance, quotations in this paragraph come from Joan M. Jensen and Darlis A. Miller, "The Gentle Tamers Revisited: New Approaches to the History of Women in the American West," in *Women and Gender in the American West*, ed. Mary Ann Irwin and James F. Brooks (Albuquerque: University of New Mexico Press, 2004), 9, 12, 15. See also Dee Brown, *The Gentle Tamers: Women of the Old Wild West* (Lincoln: University of Nebraska Press, 1958).

2. Some argue that sex, like gender, exists on a continuum. This may become true in the future, since our means of defining sex is changing. Anatomy was the only determinant in the nineteenth century. Now chromosomes and hormones complicate the process of iden-

tification, and there is no telling what additional biological factors will arise in the future. A percentage of the population has always been born with mixed male and female sex traits.

3. Jensen and Miller, "The Gentle Tamers Revisited," 19. I am speaking of numbers of men and women who died and were buried, not mortality rates or life expectancy.

4. "Some Women Marble Cutters," *Monumental News* 14 (February 1902): 120.

5. "Some Women Marble Cutters," 120.

6. "The Stratton Monument, Colorado Springs, Colo.," *Monumental News* 18 (November 1906): 760.

7. See Ann Douglas's classic study, *The Feminization of American Culture* (New York: Knopf, 1977).

8. Unless otherwise noted, all biographical information in this paragraph is from William B. Vickers, *History of the City of Denver, Arapahoe County, and Colorado* (Chicago: O. L. Baskin, 1880), 562. Rauh did not appear in either the 1860 or the 1870 U.S. census.

9. "Assessment Rolls of Arapahoe County 1865–1876," Colorado State Archives, Denver. A. Rauh and Tim Ryan appear on the rolls for 1871, 161. Ryan is listed again in 1872 and 1873, but there is no other reference to Rauh through 1876. Frotzscher & Co. appears in 1872, 102.

10. "Colorado Artists," *Denver Rocky Mountain News*, April 13, 1871, p. 1, col. 5, describes the Case monument and Rauh and Ryan's business. Their ad appears in column 6 on the same page.

11. "Rauh and Frotzscher," *Daily Rocky Mountain News*, February 4, 1872, p. 1, col. 6.

12. Accounts of the boating accident on July 13, 1871, are found in *Denver Rocky Mountain News*, July 15, 1871, p. 1, col. 6 and July 18, 1871, p. 1, col. 6. See also "C. J. Estabrook's Funeral," *Denver Rocky Mountain News*, July 20, 1871, p. 1, col. 4. "Riverside Cemetery Association Certificate of Lot Ownership," Fairmount Cemetery Association Archives, Denver, shows purchase of the lot on June 20, 1879, and the monument would have been moved there soon after.

13. Vickers, *History*, 562. Vickers's source for such a detailed biography was almost certainly Rauh himself, despite some incorrect dates.

14. *Denver Rocky Mountain News*, April 19, 1873, p. 4, col. 1.

15. "Dissolution," *Denver Rocky Mountain News*, January 1, 1874, p. 1, col. 5.

16. "Dissolution Notice," *Denver Rocky Mountain News,* June 18, 1874, p. 1, col. 2, reported co-partnership dissolution between Alvord and Rauh at the same time that it announced the sale of the entire interest of the two men in the Pioneer Stone Steam Mill Works to E. W. Chittenden. On p. 4, col. 3 of the same paper, Adolph Raugh's (*sic*) sale of property to Ed. W. Chittenden is also recorded. Rauh was involved in quite a few real estate transactions at this time, both buying and selling.

17. Bishop Winfield Scott of the First Baptist Church married Emma Brooks to Adolph Rauh on February 6, 1873, in Denver. "Marriages of Arapahoe County," book 17, p. 151, Colorado State Archives, Denver. Their daughter Tillie was born in 1875 and Mary G. in 1876.

18. Mary DeVille and Adolph Rauh were united by a minister of the Methodist Church. "Marriages of Arapahoe County," book 65, p. 266, Colorado State Archives, Denver.

19. Mary DeVille's early life is recorded only in the 1860 U.S. Census for Washington Township in Whitly County, Indiana, schedule 1, p. 231, and in the 1870 U.S. Census for Iowa City, Iowa, schedule 1, p. 4. Information about the Rices comes from the Iowa City directory for 1875–76; U.S. Census records of 1860 and 1870; Oakland Cemetery records, Johnson County, Iowa; and the probate record for L. M. Rice, Iowa State Historical Society. I am grateful to Chiara Hamilton for her successful research on Mary Rauh's early life and the discovery of her marriage to Herman Bock.

20. "Marriages of Arapahoe County," book 17, p. 104, Colorado State Archives, Denver. German Church Society notice, *Denver Rocky Mountain News,* October 25, 1871, p. 1, col. 5; court records, *Rocky Mountain News,* October 22. 1872, p. 4, col. 2. See also Arapahoe County Court records, Colorado State Archives, Denver. The 1873 Denver City directory shows H. Bock had a bakery and saloon on the northwest corner of L Street and Larimer, where he and Mary also lived.

21. Probate Record #367 for Herman Bock, Arapahoe County, Colorado State Archives, Denver.

22. Block and Lot Index for Baldwin's Addition to Denver, vol. 1, p. 141, Colorado State Archives, Denver.

23. Case #6473, *M. Rauh vs. The Burlington and Colorado Railroad Company,* filed December 11, 1882, in Arapahoe District Court, Colorado State Archives, Denver. Chiara Hamilton's research uncovered this episode.

24. "Steam Marble Works," *Denver Rocky Mountain News*, January 1, 1880, p. 26, col. 2.

25. "Beautiful Monuments," *Denver Rocky Mountain News*, July 11, 1879, p. 8, col. 4.

26. *Denver Rocky Mountain News*, October 21, 1881, p. 8, col. 3. The 1880 U.S. Census for Denver says that Edmund F. Wright made his living as a marble agent.

27. Building Permit #1414, October 3, 1892, M. Rauh, for Lots 15 and 16 of Block 25 in Baldwin's Addition to Denver, Denver Buildings Permit File, vol. 3, Denver Public Library. Block and Lot Index for Denver, vol. 5, p. 144, vol. 6, p. 212, Colorado State Archives; Baist's 1905 Survey Maps of Denver, and Sandborne Insurance Maps.

28. "Obituary," *Denver Rocky Mountain News*, September 6, 1879, p. 5, col. 2.

29. Harley's gravestone was described by a reporter while it was still in the Rauh marble yard: "A Beautiful Monument," *Denver Rocky Mountain News*, January 6, 1882, p. 5, col. 2.

30. "A Good Man Gone," *Denver Rocky Mountain News*, May 9, 1882, p. 8, col. 2. See also Vickers, *History*, 618. For a typical Treat advertisement, see *Denver Rocky Mountain News*, January 24, 1865, p. 1, col. 3.

31. The 1885 data are from Schedule 3 Manufactures-Products of Industry, Arapaho County, Colorado State Census, 1885, p. 1, line 13. Prices are from advertisements for Riverside Marble Works in the *Denver Rocky Mountain News*, such as May 24, 1886, p. 7 col. 3.

32. Advertisement for Riverside Marble Works, *Denver Rocky Mountain News*, January 27, 1888, p. 2, col. 6

33. Lester Drake died March 17, 1889. His obituaries appeared on the front page of the March 18 *Rocky Mountain News* and in the *Central City Weekly Register Call*, 22 March 1889, p. 6, col. 3. Although most remembered him as a miner and his tombstone reinforces that identity, the 1870 and 1880 U.S. Census records for Colorado list his profession as farmer, and numerous newspaper references bear that out. Most of the biography in this paragraph was put together from small articles in the *Rocky Mountain Sunday School Casket*, *Rocky Mountain News*, *Daily Register Call*, *Evening Call*, *Colorado Banner*, and *Boulder County News* published between June 1865 and July 1883.

34. I am grateful to Bob and David Baerresen, Ole's grand-neph-

ews, for information about their family. Their aunt Bertha Baerresen also provided a short summary of her Uncle Ole's work on the cabin and a photograph of herself standing near it to the Denver Public Library's Western History Collection. Rustad's very brief obituary is found in *Denver Republican,* July 2, 1893, p. 3, col. 5, and *Denver Rocky Mountain News,* July 2, 1893, p. 6, col. 4, with the misspelled name Busbad or Rusbad.

35. Cemetery records indicate that after Lester Drake was buried there in March 1889, his three-year-old grandson Lester E. Drake Jr. was buried in February 1906, followed by Lester Drake's son Lester Eugene (Gene) Drake, who was the father of Lester E. Drake Jr., in February 1918. Other family members are also buried here.

36. A letter from another family branch, Lisa Jennings to Cliff Dougal of Riverside Cemetery, March 1, 2003, states that Gene Drake paid for the monument with money provided by his brother-in-law, Francis (Frank) Channing. This oral history makes no mention of Lester Drake Sr. or of Gene's brother Alonzo and attributes the carving to a whiskey-drinking spiritualist with whom Gene is supposed to have negotiated directly. Existing documentation supports the attribution to M. Rauh Marble Works and Ole Rustad, but it is possible that Channing provided the funds. The deed for the lot where the monument rests was purchased on February 12, 1885, by Lester Drake (most likely Gene Drake's father) but bears no signature, according to information from Nancy Niro, Fairmount Heritage Foundation, who looked up the deed for me in the cemetery records.

37. In December 1909, when he was about seventy-three, Adolph bought a plot at Crown Hill Cemetery just west of Denver, and when he died five years later he was buried at this site. Mary inherited all her property back, which she promptly divided between their daughters. "First Tombstone Maker in Denver Dies at Age of 78," *Denver Post,* February 22, 1914, sect. 2, p. 10, col. 2. Mary died of pneumonia in 1922, leaving an estate of over $24,000. Probate Case #29522, Mary Rauh, Arapahoe County Courthouse, Denver, Colorado. "Mrs. Mary Rauh, Pioneer Resident of Denver, Is Dead," *Denver Post,* January 24, 1922, p. 2, col. 3.

38. Bailey Van Hook, *Angels of Art: Women and Art in American Society, 1876–1914* (University Park: Pennsylvania State University Press, 1996), 56.

39. Douglas Keister, *Stories in Stone: A Field Guide to Cemetery Symbolism and Iconography* (Salt Lake City UT: Gibbs Smith,

2004), 111. Iconographic dictionaries of art tend to agree on allegorical attributes, but special attention should be paid to Barbara G. Walker, *The Women's Encyclopedia of Myths and Secrets* (San Francisco: Harper & Row, 1983), which emphasizes a feminist interpretation.

40. For example, see Michael Rutter, *Upstairs Girls: Prostitution in the American West* (Helena MT: Farcountry Press, 2005); Anne Seagraves, *Soiled Doves: Prostitution in the Early West* (Hayden ID: Wesaane, 1994); Anne M. Butler, *Daughters of Joy, Sisters of Misery: Prostitutes in the American West, 1865–1890* (Urbana: University of Illinois Press, 1985).

41. Among other things, Jennifer Porter's research for a graduate paper on the Jesse Salomon monument indicated that only Jesse's immediate family are in Fairmount Cemetery, while the rest of the Salomons lie several sections away in the Jewish Temple Emanuel Cemetery.

42. Colleen McDannell, *Material Christianity: Religion and Popular Culture in America* (New Haven CT: Yale University Press, 1995), 123–25. See also June Hadden Hobbs, "A Woman Clinging to the Cross: Toward a Rhetoric of Tombstones," *Studies in the Literary Imagination* 39 (Spring 2006): 55–74.

43. Nicholas Penny, *Church Monuments in Romantic England* (New Haven CT: Yale University Press, 1977), 65–74.

44. Marina Warner, *Monuments and Maidens: The Allegory of the Female Form* (London: Weidenfeld & Nicolson, 1985), 70. On p. 54 she begins a discussion of Victory, which has implications for references to victory over death found in cemetery statuary.

45. Tony Walter, *On Bereavement: The Culture of Grief* (Buckingham, England: Open University Press, 1999), 134.

46. James J. Farrell, *Inventing the American Way of Death, 1830–1920* (Philadelphia: Temple University Press, 1980).

47. Crawford quote is from an 1842 letter to Charles Sumner quoted in Boston Museum of Fine Arts, *American Figurative Sculpture in the Museum of Fine Arts, Boston* (Boston: Museum of Fine Arts, 1986), 64. J. S. R. catalogue entry for William Wetmore Story, *Sappho*, 1863, in *American Figurative Sculpture*, 115.

48. Bridget Heneghan, "The Pot Calling the Kettle: White Goods and the Construction of Race in Antebellum America," *Nineteenth Century Studies* 17 (2003): 119.

49. Cook & Wilkins, *Excelsior Statuary Designs* (Boston, 1895), copy in the Winterthur Library, Winterthur DE.

50. Only three angels are named in the Bible and Apocrypha: Michael, Gabriel, and Raphael. Moroni is named in the *Book of Mormon*. The sex and gender of angels were debated in the nineteenth century. Elizabeth Roark has found that in fourteen cemeteries in the East, South, and Midwest, angels between 1850 and 1870 were androgynous, while at the end of the century they were more often female. She divides them into eight types, most of which are found in the Rockies, although with less clear boundaries between them. Elizabeth L. Roark, "Embodying Immortality: Angels in America's Rural Garden Cemeteries, 1850–1900," *Markers* 24 (2007): 73–74.

51. Louis Comfort Tiffany depicted the Angel of the Resurrection as Archangel Michael wearing his armor and holding a trumpet (1904, Indianapolis Museum of Art). William Morris depicted a winged Angel of the Resurrection sitting on the sepulcher holding a palm frond, a symbol associated with Gabriel (1862, Tate). Angel iconography and identifications were entwined in the nineteenth century. In the twentieth century, the identification between the Angel of the Resurrection and Gabriel became stronger, in part through the work of Cole Porter, who wrote the song "Blow Gabriel Blow" in 1934. Negro spirituals also associate Gabriel with the biblical trumpet blower.

52. It is pictured and described in Millard F. Rogers Jr., *Randolph Rogers: American Sculptor in Rome* (Amherst: University of Massachusetts Press, 1971), 89.

53. New England Granite Works order book, vol. 1, order #339, Westerly Public Library, Westerly RI. This record includes a drawing of the Lamson Sessions Co. monument and statue.

54. "A Mausoleum of Rarely Original Design," *Monumental News* 27 (January 1915): 21. "Mrs. Smails Died on Coast and Body will rest beside husband in splendid tomb," and "Decimating Commandery of the Loyal Legion," obituary, March 24, 1912, unidentified newspaper clippings, Fairmount Cemetery archives, Denver.

55. Charles A. Cherot, obituary, *Denver Tribune-Republican,* December 30, 1886, p. 5, col. 2; Denver City Directories.

Chapter 4. Mail-Order Monuments and Other Imports

1. Harold B. Prescott, "A. K. Prescott," mimeographed biography, ca. 1968, p. 1, in vertical file "A. K. Prescott," Montana State Historical Society, Helena, Montana.

2. Advertisement, *Fort Sanders* (Dakota Territory) *Frontier Index*, March 6, 1868, 1.

3. I am grateful to Sevilla "Sally" Cannady and Suellen Levy, great-granddaughters of Alexander and Lillie Levy, for their letters explaining more about this family's history. Note that the tombstones spell Lilly Levy's name differently than other sources, which cite Lillie. It was not unusual for monuments to be mislettered, especially when they were ordered by mail.

4. Annette Stott, "The Baby in a Half Shell: A Case Study in Child Memorial Art of the Late Nineteenth Century," *Nineteenth-Century Art Worldwide* 7 (Autumn 2008), http://www.19thc-art worldwide.org.

5. *The History of Jackson County, Missouri,* indexed ed. (1881; Cape Cicardeau MO: Ramfre Press, 1966), 788–89; "Harry E. Barker," obituary, *Kansas City News Press,* January 10, 1924, 68, of microfilmed newspaper scrapbook in the Kansas City Public Library; Ballenger and Hoyes, *Kansas City Directories,* 1878 (first year he appears) through 1894, 1898, 1900. Katherine Conti first brought my attention to Barker in her research paper "The Vivian Draped Urn and Obelisk," 1998, copy in author's possession.

6. See, for example, the full-page ad in the 1894 Kansas City directory, 17.

7. Kirk Savage, "Common Soldiers," in *Standing Soldiers, Kneeling Slaves: Race, War, and Monument in Nineteenth-Century America* (Princeton NJ: Princeton University Press, 1997).

8. "Missouri," *Monumental News* 16 (November 1904): 688, 690.

9. Mortimer R. Proctor, *Proctor: The Story of a Marble Town* (Brattleboro VT: Vermont Printing Co, 1922), 95–117, explains much of the tangled history of the Vermont marble industry and Ripley's place in it. "Personal," *Monumental News* 19 (January 1907): 90 mentions Carroll Bills's early work with "old Gen. Ripley" and the fact that he was still well known among the Vermont marble men of earlier days.

10. For a thorough survey and statistical analysis of rustic monuments in Indiana, see Susanne S. Ridlen, *Tree-Stump Tombstones: A Field Guide to Rustic Funerary Art in Indiana* (Kokomo IN: Old Richardville Publications, 1999).

11. "Carrara," *Monumental News* 4 (March–April 1892): 123–25.

12. H. T. Dempster, "A Protest against Increased Duty," *Monumental News* 10 (January 1898): 49; "The Many Sided Tariff on Marble and Statuary," *Monumental News* 21 (February 1909): 145–46.

13. For a fictionalized account of these two women, see Ann Cullen, *Lilly Cullen: Helena, Montana 1894* (Helena: Book Montana, 1999).

14. "William E. Cullen," in *Progressive Men of the State of Montana* (Chicago: A. W. Bowen & Co., ca. 1902), 117–19.

15. The Helena Cemetery Association, vol. 2, "Record of Burial Permits," in "Forestvale Cemetery Association Records," manuscript collection 240, Montana State Historical Society, Helena. "Died in Victoria," *Helena Independent*, July 24, 1895, p. 5, col. 4.

16. "Death Claims Miss Katherine Sinclair Sligh as Its Own," *Helena Daily Independent*, March 18, 1896, p. 8, col. 3; Helena Cemetery Association, vol. 2, "Record of Burial Permits." Biographical information about her father comes from *Progressive Men of Montana*, 845–46.

17. "Capt. Bethell Succumbs to Long Illness," *Denver Republican*, August 20, 1906, p. 1, col. 7; census records; Pinckney C. and William D. Bethell papers, State Historical Society of Colorado, Denver, provide the biographical information.

18. #17 *Soar*, in *Excelsior Statuary Designs* (Boston, 1895). This book in the Winterthur Library, Winterthur DE, has been personalized by pasting the business card of L. W. Frink, granite and marble dealer of Norwich, Connecticut, on the cover. Frink also pasted "Dempster, Carrara, Italy" on the title page as an indication of the source of his marble statuary, hiding the original publisher, "Cook & Wilkins, Importers and Manufacturers of Italian Marble and Granite Statuary," a firm based in Boston with offices in Quincy, Massachusetts, Aberdeen, Scotland, and Carrara, Italy. This suggests that H. T. Dempster and Cook & Wilkins offered the same designs.

19. Nicholas Penny, *Church Monuments in Romantic England* (New Haven CT: Yale University Press, 1977), 159.

20. Charity appears to have been less popular nationally. Significantly, the white bronze companies sold statues of Faith and Hope, but not Charity. *Excelsior Statuary Designs* included nineteen angels, ten Faiths, and two Hopes, but only one Charity.

21. "John J. O'Farrell Dead," *Butte Daily Miner*, December 28, 1888, p. 4, col. 2.

22. Zena Beth McGlashan provides the information that Daly was the patron of this marble sculpture in her forthcoming book.

23. Ryegate Granite Works, *Specialties. Artistic Cemetery Improvements* (South Ryegate VT: Ryegate Granite Works, 1888), 4.

24. New England Granite Works, order book vol. 1, Hindry order #906 (April 1879), Eckhart order #1244 (May 1880), and John Knox order #1267 (8 June 1880); vol. 3, Moore order #2123 (September 3, 1883) by Greenlee, Drake & Co. of Pueblo, Colorado, New England Granite Works Papers, Westerly Public Library, Westerly RI.

25. "The Silent Sleep: John M. Eckhart Found Dead in His Room," *Denver Rocky Mountain News,* January 24, 1880, p. 8, col. 4. Frank Hall, *History of the State of Colorado* (Chicago: Blakely Printing Co., 1890), 4:433, and Probate Case #451, "John M. Eckhart," Arapahoe County, Colorado State Archives, shows that $20,000 cash was divided among Mary Eckhardt, administratrix of the estate, and her three children, and she continued to live in their mansion in Denver's Highlands valued at $75,000 in 1890.

26. H. A. Batterson to Mrs. L. S. Iliff, Denver, Colorado, April 10, 1880, letter introducing George T. Batterson, Iliff Family Papers, Taylor Library, Iliff School of Theology, Denver.

27. Arthur W. Brayley, *History of the Granite Industry of New England* (Boston: National Association of Granite Industries of the U.S., 1913), 1:107.

28. *Barre Granite Manufacturer's Association Price List* (Barre VT: Granite Manufacturers Association, 1902).

29. Ryegate Granite Works, *Specialties*, 2–3.

30. "Denver's Model Monument Display Room," *Monumental News* 24 (February 1912): 150.

31. "Denver's Best Cemetery Monuments. II—Bills Brothers," *Monumental News* 27 (May 1915): 294. The Wohl monument is pictured and described.

32. Transcription of 1890 article from *Illustrated Buffalo*, accessed July 29, 2004, at http://www.bflohistory.com.

33. "What Our Advertisers Are Doing," *Monumental News* 22 (September 1910): 708.

34. Chas. H. Gall, "Chas. H. Gall Series No. 2 . . . 23 Original and Practical Designs for $5.00," Chicago Historical Society Library.

35. "Changing Names on a Photograph," in *The Monument Dealer's Manual,* ed. O. H. Sample (Chicago: Allied Arts Publishing Co., 1919), 133, reprinted from earlier edition of *Monumental News*.

36. Producers' Marble Co., monument catalogue bound for Ripley Sons, 1886, University of Vermont Library, special collections.

37. J.P. Bushnell, compiler, *Resources & Industries of Des Moines*

& Polk County, Iowa showing the Trade & Commerce . . . Fifth Annual Report of the Board of Trade for the year ending Dec. 31, 1884 (Des Moines IA: J. P. Bushnell & Co, 1885), 80–81; "Articles of Incorporation of the Western White Bronze Company," March 7, 1884, Office of the Polk County Recorder, Polk County Courthouse, Des Moines IA. Article 5 states that the business will begin to function on April 1, 1884.

38. *The Leading Industries of Des Moines, Iowa* (Des Moines: People's Publishing & Adv. Co., 1888), 71.

39. Barbara Rotundo, "Monumental Bronze: A Representative American Company," in *Cemeteries and Gravemarkers: Voices of American Culture*, ed. Richard E. Meyer (Logan: Utah State University Press, 1992), 263–91.

40. *Des Moines City Directories* and *Iowa State Gazateer and Business Directories* from 1886 through 1910 provide a history of names and addresses.

41. "Monumental Notes," *Monumental News* 13 (November 1901): 631.

42. Monumental Bronze Co., *White Bronze Monuments, Statuary, Portrait Medallions, Busts, Statues, and Ornamental Art Work for Cemeteries, Public and Private Grounds and Buildings*, trade catalogue (Bridgeport CT, 1882).

43. *Leading Industries of Des Moines*, 71.

44. American Bronze Co., *White and Antique Bronze Monumental Work* (Chicago: American Bronze, n.d.), 27, Winterthur Library DE. An illustration on p. 24 is almost identical to the McNeil Monument, but with a different surname and date and without the portrait bust.

45. *Leading Industries of Des Moines*, 71.

46. Barbara Welter, "The Cult of True Womanhood: 1820–1860," *American Quarterly* 18 (Summer 1966): 151–74.

47. *Leading Industries of Des Moines*, 71. I am grateful to Nancy Niro of Fairmount Cemetery Foundation for the information that descendants of George Wise have photographs of him that prove this is a portrait.

48. *Denver City Directories*, 1887–1900. Western White Bronze opened a show room in Des Moines in 1887 under the auspices of real estate dealers Horning and Madden, who became the general agents for Western White Bronze. They apparently covered only Iowa, so other people were engaged as salesmen in major cities throughout the Western White Bronze territory.

49. *Monumental News*, 9 (October 1897): 604.

50. The most complete technical description is A. B. Saw, "Ornamental White Bronze Castings," *The Foundry* 35 (January 1910): 191–95. Monumental Bronze Co., *White Bronze Monuments* claimed, "The inscriptions, without additional expense, are all in raised letters which cannot be broken off." "White Bronze," *Scientific American*, November 14, 1885, p. 309, noted "the positive assurance of the raised lettering or inscriptions remaining legible for ages."

51. Rotundo, "Monumental Bronze," 270.

52. "Zinc Monuments," *Benton County Enterprise*, February 23, 1900, p. 4, col. 7.

53. Photographs of some w.z.w. monuments are posted on the Web at http://www.mckinnonwyoming.com/cemeteries.htm under the Burntfork Cemetery and McGinnis/Bullock Cemetery entries for Sweetwater County, Wyoming. The author was unable to see the monuments, which are on private land, due to flooding at the time of her visit.

54. "Zinc Monuments," *Benton County Enterprise* September 21, 1900, p. 4, cols. 6–7.

55. "Metallic Monuments," *Benton County Enterprise*, March 16, 1900, p. 4, col. 6; "Monument Shipments," *Benton County Enterprise*, February 23, 1900, p. 5, cols. 5–6.

56. Clyde Sutherland, "Turn of the Century Memories," in *The History of Benton County, Missouri*, ed. Kathleen Kelly White and Kathleen "Kay" White Miles (Clinton MO: White & Miles, 1971), 3:459–60. In a phone conversation August 10, 2005, Kay White Miles, great-granddaughter of T. B. White, indicated that a brief history of the monument works exists, but she was unable to locate it.

57. "Zinc Monuments," *Benton County Enterprise*, January 19, 1900, p. 4, col. 7; February 23, 1900, p. 4, col. 7. The Reverend D. M. Hudson of Calhoun, Missouri, explains how he sells the monuments and the Iowa and Arkansas sales are mentioned in "Monument Shipments," p. 5, cols. 5–6.

58. Biographical information in this chapter is from his Thomas Benton White's obituary in the *Enterprise*, reprinted in White & Miles, *History*, vol. 2, 91n; *The History of Cole, Moniteau, Morgan, Benton, Miller, Maries and Osage Counties, Missouri* (Chicago: Goodspeed, 1889), 741; Denver city directories and U.S. Census records.

59. U.S. Patent No. 688,043, dated December 3, 1901; application filed December 28, 1900, Serial No. 41,343, U.S. Patent Office.

60. U.S. Patent No. 695,744, dated March 18, 1902, application filed April 4, 1901, Serial No. 54,276, U.S. Patent Office.

61. Minsoo Song, "Archer Monument in Riverside Cemetery," unpublished research paper, 1999, copy in the author's possession.

62. Leland A. Larson and James R. Cook, *The Woodmen Story: "Our First 100 Years,"* 2nd revised ed. (Omaha NE: Woodmen of the World Life Insurance Society, 1991), 24.

63. Pompeo Coppini, "Conventionality in Sculpture," *Monumental News* 19 (October 1907): 775. This is a letter defending his sculpture of Falkenburg against criticism that it lacked repose.

64. "Department Store in the Monumental Business," *Monumental News* 11 (December 1899): 697.

65. *Special Catalogue of Tombstones, Monuments, Tablets and Markers* (Chicago: Sears, Roebuck and Co., 1902).

66. "Selling Monuments by Mail," *Monumental News* 17 (September 1905): 620.

67. "Selling Monuments by Mail," 620.

68. *Monumental News* 18 (January 1906): 98.

69. "Granite," *Monumental News* 22 (April 1910): 314.

Chapter 5. The Cemetery in Western Life

1. "A Sad Sight," *Leadville Daily Chronicle*, May 24, 1879, p. 3, col. 1.

2. Blanche Linden-Ward, "Strange but Genteel Pleasure Grounds: Tourist and Leisure Uses of Nineteenth-Century Rural Cemeteries," in *Cemeteries and Gravemarkers: Voices of American Culture*, ed. Richard E. Meyer (Logan: Utah State University Press, 1992), 293.

3. Riverside Cemetery Association, *Prospectus. Riverside Cemetery, Denver, Col* (Denver CO: Denver Tribune Steam Book and Job Printing Establishment, 1878).

4. "A Cemetery That Is a Park," unidentified Denver newspaper (March 27, 1892) in the scrapbook "Fairmount History 1890 to . . . ," Fairmount Cemetery Archives, Fairmount Heritage Association, Denver CO.

5. David Fridtjof Halaas, *Fairmount and Historic Denver* (Denver CO: Fairmount Cemetery Association, 1976). See all of chapter 3, "The Way South—The Fairmount Railway," for a detailed account of attempts to transport the public to the cemetery.

6. "Fine Tramway Trip," unidentified newspaper clipping in the scrapbook "Fairmount History 1890 . . . ," Fairmount Cemetery, Denver CO.

7. Linden-Ward, "Strange but Genteel," 293–328. Elise Ciregna, "Museum in the Garden: Mount Auburn Cemetery and American Sculpture, 1840–1860," *Markers* 21 (2004): 101–47.

8. U.S. Patent Number 237,024, U.S. Patent Office, lines 35–38.

9. Kinney was not the first to combine plants and fence as a method of defining a grave. As early as 1869, the Philadelphia horticulturalist Elizabeth Mary Stigale had patented a cemetery lot fence, the rails of which were flower boxes. She placed floral "caskets" of preserved flowers or urns filled with live plants on the corner posts. See patent numbers 97,984 and 84,445. The caskets were glass domes hermetically sealed to preserve flowers and other mementos.

10. Vincent D. Markham Probate Case #3948 includes his handwritten will dated May 1895; the contract between Denver Marble & Granite Co. and Charles D. Cobb, Markham estate Executor, dated March 29, 1899; a petition to accept that contract; and cemetery deeds, Colorado State Archives, Denver. The probate record shows a $5,000 payment to Denver Marble & Granite Co. New England Granite Works. order book, vol. 5, order #4598 (April 1899), contains a sketch of the pedestal and an order by Denver Marble & Granite Co. for Design 4063A in Concord Granite with the name Markham, for which they are to be paid $2,965. Westerly Public Library, Westerly RI. See also "A Beautiful Monument Marks the Last Resting Place of Judge and Mrs. V. D. Markham," *Denver Republican*, August 10, 1900, p. 12, cols. 1–3; "Among the Dealers," *Monumental News* 11 (February 1899): 129.

11. Nicholas Penny, *Church Monuments in Romantic England* (New Haven CT: Yale University Press, 1977), 136.

12. Annette Stott, "The Woodmen of the World Monument Program," *Markers* 20 (2003): 1–29.

13. "Unveiling Ritual," in *Ritual of the Pacific Jurisdiction Woodmen of the World* (Omaha NE: Beacon Press Print, 1897), 63–72.

14. Liping Zhu, *A Chinaman's Chance: The Chinese on the Rocky Mountain Mining Frontier* (Boulder: University Press of Colorado, 1997), 161–62. Similar funerals are described in California and Nevada, with additional explanations in Sue Fawn Chung and Priscilla Wegars, *Chinese American Death Rituals: Respecting the Ancestors* (New York: Altamira Press, 2005).

15. Photographic reproduction of an unidentified newspaper article exhibited at the Mai Wah Museum in Butte MT, Summer 2005. Attempts to locate the source of this article have failed, so the date is also unknown.

16. "Chinese Pow wow," *Helena Daily Herald*, July 24, 1871, p. 3, col. 2.

17. Jacob V. Schaetzel, *German Pioneers in Colorado, 1850–1900's* (Denver CO: H. W. Marsh, 1975), 43–44; the long quote in this paragraph is from p. 44.

18. Schaetzel, *German Pioneers*, 145.

19. "Sunday Funerals to Be Barred in Denver," unidentified Denver newspaper, January 9, 1905, and "Cannot Prevent Sunday Funerals," unidentified newspaper, January 17, 1905, clippings in the scrapbook "Fairmount History 1890 to . . . ," Fairmount Cemetery Archives, Fairmount Heritage Association, Denver CO.

20. "Rowdies Rush to Funerals," unidentified Denver newspaper, May 17, 1904 in "Fairmount History 1890. . . ."

21. "Funeral Maniacs: The Cemetery Authorities Should Take Steps to Suppress Them," in "Fairmount History 1890. . . ."

22. "The Funeral Maniac and How to Deal with Him," in "Fairmount History 1890. . . ."

23. "Death of Jonathan Schaeffer," *Denver Rocky Mountain News*, February 4, 1902, p. 5, col. 3; "Will Be Buried at Fairmount Where He Bought the First Lot," *Denver Daily News*, February 9, 1902, p. 6, col. 1.

24. "Unveiling Ritual," 63–72.

25. "Denver's Most Popular Pastor Passes Away," *Denver Rocky Mountain News*, January 31, 1899, p. 1, cols. 1–3; p. 10, cols. 2–3. See also "Funeral of Rev. Myron Reed," *Denver Post*, January 31, 1899, p. 3, cols. 2–3; "Thousands View Remains," *Denver Times*, February 1, 1899, p. 8, cols. 1–2; "Funeral Fit for the Father of His Country," *Denver Rocky Mountain News*, February 2, 1899, p. 1, cols. 1–2, p. 10.

26. "So the People May Know," *Denver Post*, January 31, 1899, p. 1, cols. 3–4.

27. "Proposed Monuments," *Monumental News* 11 (March 1899): 177; "Monumental Notes," *Monumental News* 12 (April 1900): 242.

28. "Unveiling of the Monument to Myron Reed at Fairmount," *Denver Times*, May 30, 1900, p. 2, col. 3.

29. A. H. Hawley, quoted in "Two National Labor Bodies Pay

Homage to Former Leaders," *Denver Post,* July 25, 1909, p. 6, cols. 1–3.

30. "Pettibone Monument Will Be Unveiled Tomorrow," *Denver Post,* July 23, 1909, p. 12, cols. 2–4; Alf. M. Henry, "Denver," *Granite Cutters' Journal* 32 (March 1909): 5; Robert Broon, "Denver," *Granite Cutters' Journal* 33 (August 1909): 4–5.

31. Stephen W. Macomber, *The Story of Westerly Granite* (Westerly RI: Utter Co. and Westerly Historical Society, 1958), 7.

32. "A Beautiful Monument," 12.

33. "Honoring Heroes," *Denver Rocky Mountain News,* May 31, 1885, p. 3, cols. 1–4.

34. "Memorial Day," *Denver Rocky Mountain News,* May 29, 1887, p. 8, cols. 1–2.

35. "Veterans," *Denver Rocky Mountain News,* May 31, 1891, p. 1, col. 1–2.

36. "Woodmen Live in Memory If Not in the Flesh," *Denver Rocky Mountain News,* June 5, 1899, p. 8, cols. 2–3; "Woodmen Have Memorial Day," *Denver Rocky Mountain News,* June 4, 1900, p. 2, col. 1.

37. "Anniversary and Memorial Celebration," in *Ritual of the Pacific Jurisdiction Woodmen of the World* (Omaha NE: Beacon Press, 1897), 88–93.

38. These rites are described as they occurred in China and some parts of the West, but insufficient evidence has yet been found to make any conclusions about their practice in the Rocky Mountains. See Chung and Wegars, *Chinese American Death Rituals,* 29–30.

39. Robert R. Swartout Jr., "Kwangtung to Big Sky: The Chinese in Montana, 1864–1900," in *Chinese on the American Frontier,* ed. Arif Dirlik (Lanham MD: Rowman & Littlefield, 2001), 375. See all of part 4, "Chinese in the Rocky Mountains," for additional information about the life of Chinese Americans in this region during the nineteenth century.

40. This community attention to individual graves shares some similarities, in terms of its purpose and the combination of public and private activities, with the turn-of-the-century community cleaning days that Terry Jordan describes in *Texas Graveyards: A Cultural Legacy* (Austin: University of Texas Press, 1982), 25–28. However, an interesting regional contrast appears in terms of forms, aesthetic, and the surrounding celebrations.

41. "Beautiful Fairmount Cemetery," in "Fairmount History 1890...."

42. In his study of late nineteenth-century diaries, Paul Rosenblatt

found evidence that people at the turn of the twentieth century experienced grief in much the same way as people today. Paul C. Rosenblatt, *Bitter, Bitter Tears: Nineteenth-Century Diarists and Twentieth-Century Grief Theories* (Minneapolis: University of Minnesota Press, 1983). A few contemporary grief counselors speak of commemoration as a step in the mourning process. S. S. Fox, "Helping Children Deal with Death Teaches Valuable Skills," *Psychiatric Times* (1988): 10–11, as described and enlarged upon by Susan Nolen-Hoeksema and Judith Larson, *Coping with Loss* (Mahwah NJ: Lawrence Erlbaum, 1999), 127, 132–33; Geraldine M. Humphrey and David G. Zimpfer, *Counseling for Grief and Bereavement* (London: Sage, 1996), 113. For a review of grief theory, see Dorothy Stroh Becvar, *In the Presence of Grief* (New York: Guilford Press, 2001).

43. "A Beautiful Monument," 12.

44. Nigel Llewellyn, *The Art of Death: Visual Culture in the English Death Ritual, ca. 1500–ca. 1800* (London: Victoria and Albert Museum and Reaktion Books, 1991), see especially chapters 9 and 16.

45. For a brief discussion of the natural body that decays after death and the social body that continues, see Joachim Whaley, ed., *Mirrors of Mortality: Studies in the Social History of Death* (New York: St. Martin's Press, 1982).

46. Bridget's monument is inscribed "Ketchin & Tuite, Butte," but five years later, when Patrick's stone was made and inscribed, Robert A. Ketchin had moved on and James E. Tuite was in business for himself. Bridget's obituary stressed her youth (twenty-two) and short marriage (thirteen months) as being especially sad for her popular husband. "Peace to Her Ashes," *Butte Daily Miner*, November 16, 1888, p. 4, col. 2.

47. "Frightful Accident," *Butte Daily Miner*, October 30, 1887, p. 3, col. 3.

48. *Prospectus of the Fairmount Cemetery Association* (Denver CO: Fairmount Cemetery, 1891), 16–17.

49. *Riverside Cemetery Denver Colorado* (Denver CO: Riverside Cemetery Association, ca. 1891–93).

50. "Tramway Invites the Public to Picnic at Riverside," unidentified Denver newspaper (May 30, 1904), in the scrapbook "Fairmount History 1890. . . ." The article that inspired the secretary's wrath was substantially the same as the one published earlier about Fairmount Cemetery. Part of the problem was the timing. Published

the day before Memorial Day with a reference to how beautifully lot owners had decorated with flowers in preparation for the day, it was likely to add more crowds to the busiest day of the year at the cemetery.

Conclusion

1. Jürgen Habermas, *The Structural Transformation of the Public Sphere: An Inquiry into a Category of Bourgeois Society* (Cambridge MA: MIT Press, 1991); Michael Warner, *Publics and Counterpublics* (New York: Zone Books, 2002).
2. "Relatives of the Dead Angry," *Denver Times,* May 24, 1904; "Denies Order Will Be Issued," *Rocky Mountain News,* May 25, 1904, clippings in the scrapbook, "Fairmount History 1890 to . . . ," Fairmount Cemetery Archives, Fairmount Cemetery, Denver, Colorado.
3. E. W., Georgetown CO, letter to unidentified newspaper, clipping in the scrapbook, "Fairmount History 1890 to. . . ."
4. "Two Rival Monuments to Founder of Woodmen," *Monumental News* 19 (August 1907): 581.
5. The grave of one pioneer couple who died in 1864 was marked by their granddaughter many years later and that is the only other marker among the many pioneer graves. A historical marker at the cemetery in September 2005 provides this history. A photograph in the Montana Historical Society with an original label indicating that it is of a local man standing by the unmarked grave of Clubfoot George, around 1900, provides additional evidence that only oral history kept the burial locations alive.
6. Helen Hunt Jackson Papers, part 4, Ms 0348; letters from HHJ to her husband, William S. Jackson, transcribed by Nancy Knipe in 2002 and placed online by Tutt Library, Colorado College, Colorado Springs. All references in this paragraph to the Jacksons and their correspondence are from this source. Accessed December 2005 at www.coloradocollege.edu/library/SpecialCollections/ Manuscript/HHJ4-1-4.html.
7. Samuel Parsons Jr., *Landscape Gardening*: *Notes and Suggestions on Lawns and Lawn Planning, Laying Out . . . Cemetery Plots . . .* (New York: G. P. Putnam's Sons, 1900), 303.
8. "Suggestion for the Daly Monument," *Butte Reveille,* December 18, 1900, p. 8, col. 1.

Bibliography

Manuscript Collections

Boulder Public Library, Boulder, Colorado
 BHS 301 Mss Collection

Clerk of Common Courts, Lake County Courthouse, Leadville,
 Colorado
 Lake County Administrator's Record Books: divorces, marriages,
 probate

Colorado Historical Society, Denver
 James Henry Whitehouse Manuscript Collection 672
 Pinckney C. and William D. Bethell Papers

Colorado State Archives, Denver
 Arapahoe County Assessment Rolls, Colorado Territory,
 1865–1876
 Arapahoe County Deeds and Property Records
 Arapahoe County Marriage Books
 Arapahoe County Probate Records
 Arapahoe District Court Records
 Denver Plats and Maps

Denver County Courthouse
 Probate Records

Denver Public Library
 Western History Department, Photographic Collections

Fairmount Cemetery, Denver, Colorado

Fairmount Cemetery Records: scrapbooks, photographs, publications, and business records

Fairmount Heritage Association and Fairmount Cemetery, Denver
Riverside Cemetery Records: plans, pamphlets, and business records

Gallatin Historical Society, Bozeman, Montana
Vertical Files, Historic Photographs

Missoula Cemetery, Missoula, Montana
Missoula Cemetery Archives

Montana Historical Society, Helena
Butte Tombstone County Records, Mss Collection 247
Forestvale Cemetery Association Records, Mss Collection 240
Photographic Archives
Vertical File

Montana's Museum, Helena
Curatorial File: Langford Peel grave marker, x1928.27.01

Office of the Polk County Recorder, Polk County Courthouse,
Des Moines, Iowa
Western White Bronze Co. articles of incorporation

Rocky Mountain Conference Archives, Taylor Library,
Iliff School of Theology, Denver
Iliff Family Papers

Tutt Library, Colorado College, Colorado Springs
Helen Hunt Jackson Papers

U.S. Patent and Trademark Office
Patent Records, http://www.uspto.gov/patft/index.html

Utah State Historical Society, Salt Lake City
Charles Lambert Journal, 1844–1892. Transcription by Lucile Richens and Cornelia Spaans, 1940, Mss A 194–1

Westerly Public Library, Westerly, Rhode Island
New England Granite Works Papers, business records

Woodmen of the World Insurance Co., Littleton, Colorado
Woodmen of the World Publications and Records

Monument Catalogues

American Bronze Co. *White and Antique Bronze Monumental Work.* Chicago: American Bronze, n.d. Winterthur Museum Library, Wilmington DE.

Badger Wire and Iron Works. *Catalog No. 10.* Milwaukee WI: Badger Wire and Iron Works, n.d.

Charles G. Blake Co. *The Selection of a Monument.* Chicago: Chas. G. Blake Co., 1919. Chicago Historical Society Library.

Colorado-Yule Marble Co., *Monumental Designs*. Marble CO: Colorado-Yule Marble Co., ca. 1915. Colorado Historical Society Library, Denver.

Cook & Wilkins. *Excelsior Statuary Designs*. Boston, 1895. Winterthur Museum Library, Wilmington DE.

Delahunty, Thomas. *Plain and Ornamental Granite and Marble Works*. Philadelphia: Thos. Delahunty, ca. 1905.

Forsyth, James. *A Book of Designs for Headstones, Murals, and Other Monuments*. Philadelphia: Henry Carey Baird, 1871.

Franke, William B. *Designs for Monuments*. New York: W. B. Franke, ca. 1875.

Gall, Charles H. *Book of Monumental Designs*. Chicago: Chas. H. Gall, May 1897.

———. *Chas. H. Gall Series No. 2 . . . 23 Original and Practical Designs for $5.00*. Chicago Historical Society Library.

———. *Chas. H. Gall Series No. 5 . . . 23 Original and Practical Designs for $5.00*. Chicago Historical Society Library.

———. *Supplement No. 1 Monumental Designs*. December 1897.

———. *Supplement No. 2 Monumental Designs*. May 1899.

Geo. Holt & Son. Untitled leather-bound book of photographs of marble tombstones. Dixfeld ME: George Holt & Son, ca. 1900. University of Delaware Library.

Hoffmann & Prochazka. *Public and Private Monuments and Memorials*. New York: Hoffmann & Prochazka, 1896. Library of Congress.

Louis Prang & Co. *Collections of Monuments and Headstones*. New York: Prang & Co., 1866.

Lyndon, William. *Sixteen Original Practical Designs for Tablets*. Boston: Monumental Works, 1881.

Monumental Bronze Co. *Catalog A*. Bridgeport CT: Monumental Bronze Co., ca. 1904. University of Delaware.

———. *White Bronze Monuments, Statuary, Portrait Medallions, Busts, Statues, and Ornamental Art Work for Cemeteries, Public and Private Grounds and Buildings*. Bridgeport CT: Monumental Bronze Co., 1882. Winterthur Museum Library DE.

Nichols and Co. *Monumental Designs #6*. Chicago: Nichols & Co., ca. 1908. Winterthur Museum Library DE.

Ogden, William Sharp. *Designs for Christian Grave-Stones*. London: John Heywood, 1888.

Palliser, Palliser & Co., Architects. *Palliser's Memorials and Headstones . . . for Designers, Cutters, Carvers and the General Public*. New York: J. S. Ogilvie, 1891.

Ripley Sons. *Producers' Marble Company Illustrated Price List for the Trade*. Rutland VT: Producer's Marble, 1886.

———. *Producers' Marble Company Illustrated Price List for the Trade*. Rutland VT: Producer's Marble, 1887.

———. *Producers' Marble Company Illustrated Price List for the Trade*. Rutland VT: Producer's Marble, 1889.

Ryegate Granite Works. *Specialties: Artistic Cemetery Improvements*. South Ryegate VT: Ryegate Granite Works, 1888. Vermont Historical Society.

Schulze, Paul. *Original Designs in Monumental Art*. Boston: Paul Schulze, 1851.

Sears, Roebuck and Co. *Special Catalogue of Tombstones, Monuments, Tablets and Markers*. Chicago: Sears, Roebuck and Co., ca. 1902. Winterthur Museum Library DE.

Smith Granite Co. *Memorials*. Westerly RI: Smith Granite, 1910.

Tiffany Glass and Decorating Co. *Out-of-Door Memorials: Mausoleums, Tombs, Headstones, and All Forms of Mortuary Monuments*. New York: Tiffany, 1898.

Tiffany Studios. *Memorials in Glass and Stone*. New York: Tiffany, 1913.

Troup Studio. *Troup Studio Producers of Monumental Photographs Folio No. 1*. Barre VT: n.p., n.d. Copy in Vermont Historical Society.

Vermont Marble Co. *Children's Designs and Markers*. Proctor VT: n.p, n.d.

———. *1891 Price List*. Rutland VT: Press of Pelton Printing Co., 1891.

———. *Vermont Marble Company's Designs*. Proctor VT: n.p., ca. 1910. Copy at Hagley Library, Wilmington DE.

W. A. Gault & Son. *W. A. Gault & Son, Baltimore*. Cambridge MA: University Press, ca. 1911. Hagley Library DE.

Wathan, Richard. *Monumental and Head Stone Designs*. New York: Mayer, Merkel & Ottmann Lithographers, 1875.

Western White Bronze Co. *White Bronze Monuments and Statuary*. Des Moines: Iowa Printing Co., 1893. Cataloged as No. 6 in a series of brochures produced by exhibitors at the World's Columbian Exposition in Chicago, Winterthur Museum Library DE.

W. H. Mullins Co. *The Blue and the Grey: Statues in Stamped Copper and Bronze*. Cleveland: The Caxton Co., 1913. Copy in Perkins Library, Duke University.

Willard, O. J. *White Bronze Monuments, No. 3-Fortieth Edition Circular*. Mayville NY: n.p., 1882. Copy in University of Delaware library.

Willison, E. C. *Marble, Granite and Statuary*. Gardner MA: Press of Lithotype Publishing Co., ca. 1890. Copy in Winterthur Library DE.

Wilson, Henry. *Portfolio of Monumental Designs*. St. Louis: Jno. McKittrick & Co. Lith., 1874. Library of Congress.

Published Works

American Journal of Progress, Special Extra Number Descriptive of and Illustrating Denver. New York: American Journal of Progress, ca. 1898.

Ames, Kenneth L. "Ideologies in Stone: Meanings in Victorian Gravestones." *Journal of Popular Culture* 14 (Spring 1981): 641–56.

A. W. Bowen and Co. *Progressive Men of the State of Montana*. Chicago: A. W. Bowen, ca. 1902.

Barre Granite Manufacturer's Association Price List. Barre VT: Granite Manufacturers Association, 1902.

Becvar, Dorothy Stroh. *In the Presence of Grief*. New York: Guilford, 2001.

Berresford, Sandra. *Italian Memorial Sculpture, 1820–1940: A Legacy of Love*. London: Frances Lincoln, 2004.

Blackburne, E. L., ed. *The Mason's, Bricklayer's, Plasterer's, and Decorator's Practical Guide*. London: James Haggue, [186-].

Bliss, Harry A. *Memorial Art, Ancient and Modern*. Buffalo NY: Harry A. Bliss Monument Photographer, 1912.

———. *Rock-Faced Monuments*. Buffalo NY: Harry Bliss, 1919.

Bogart, Michele H. *Public Sculpture and the Civic Ideal in New York City, 1890–1930*. Chicago: University of Chicago Press, 1989.

Boston Museum of Fine Arts. *American Figurative Sculpture in the Museum of Fine Arts, Boston*. Boston: Boston Museum of Fine Arts, 1986.

Brayley, Arthur W. *History of the Granite Industry of New England*. 2 vols. Boston: National Association of Granite Industries of the U.S., 1913.

Breck, Alan. *The Centennial History of the Jews of Colorado, 1859–1959*. Denver: Hirschfeld, 1960.

Brown, Dee. *The Gentle Tamers: Women of the Old Wild West*. Lincoln: University of Nebraska Press, 1958.

Brown, John Gary. *Soul in the Stone: Cemetery Art from America's Heartland*. Lawrence: University Press of Kansas, 1994.

Bunnen, Lucinda. *Scoring in Heaven: Gravestone and Cemetery Art of the American Sunbelt States*. New York: Aperture, 1991.

Bushnell, J. P., compiler. *Resources & Industries of Des Moines & Polk County, Iowa showing the Trade & Commerce . . . Fifth Annual Report of the Board of Trade for the year ending Dec. 31, 1884*. Des Moines IA: J. P. Bushnell, 1885.

Cassel, Susie Lan, ed. *The Chinese in America: A History from Gold Mountain to the New Millennium*. Lanham MD: AltaMira, 2002.

Chambers, Marlene, ed. *The First Hundred Years: The Denver Art Museum*. Denver CO: Denver Art Museum, 1996.

Chung, Sue Fawn, and Priscilla Wegars, eds. *Chinese American Death Rituals: Respecting the Ancestors*. New York: Altamira, 2005.

Ciregna, Elise. "Museum in the Garden: Mount Auburn Cemetery and American Sculpture, 1840–1860." *Markers* 21 (2004): 101–47.

Clark, William J., Jr. *Great American Sculptures*. 1878. Reprint with Introduction by H. Barbara Weinberg. New York: Garland, 1977.

Clarke, Rod. *Carved in Stone: A History of the Barre Granite Industry*. Barre VT: Rock of Ages, 1989.

Craven, Wayne. *Sculpture in America*. New and revised ed. Newark: University of Delaware Press, 1984.

Curl, James Stevens. *A Celebration of Death*. New York: Charles Scribner's Sons, 1980.

Denver Board of Trade. *The Manufacturing and Commercial Industries of Denver, Colorado*. Denver: Journal of Commerce, 1882.

Dimsdale, Thomas Josiah. *The Vigilantes of Montana*. Virginia City MT, 1866.

Dirlik, Arif, ed. *Chinese on the American Frontier*. Lanham MD: Rowman & Littlefield, 2001.

Douglas, Ann. *The Feminization of American Culture*. New York: Knopf, 1977.

Edison, Carol. "Custom-made Gravestones in Early Salt Lake City: The Work of Four English Stonecarvers." *Utah Historical Quarterly* 56 (Fall 1988): 310–30.

Elias Morris & Sons Co. *Integrity, Craftsmanship, Quality: The Story of Elias Morris & Sons Company*. Salt Lake City UT: Elias Morris & Sons, n.d.

Elkins, James. *The Domain of Images*. Ithaca NY: Cornell University Press, 1999.

Farrell, James J. *Inventing the American Way of Death, 1830–1920*. Philadelphia: Temple University Press, 1980.

Freeman, Glen R., compiler. *The Generations of Cecelia Rasmusson Peterson Bott*. Provo UT: Privately published, 1997.

Gale, David C. *Proctor: the Story of a Marble Town*. Brattleboro VT: Vermont Printing, 1922.

Gerdts, William H. *American Neo-Classic Sculpture: The Marble Resurrection*. New York: Viking, 1973.

Granite Manufacturers' Association. *Granite Manufacturer's Association Handy Reference Book B.* Barre VT: K. W. Cumings, 1903.

Greeley, Horace. *An Overland Journey from New York to San Francisco, in the Summer of 1859.* Ed. Charles T. Duncan. 1860; rpt. New York: Knopf, 1964.

Griswold, Don L., and Jean Harvey Griswold. *History of Leadville and Lake County, Colorado: From Mountain Solitude to Metropolis.* 2 vols. Denver: Colorado Historical Society and University Press of Colorado, 1996.

Habermas, Jürgen. *The Structural Transformation of the Public Sphere: An Inquiry into a Category of Bourgeois Society.* Cambridge MA: MIT Press, 1991.

Halaas, David Fridtjof. *Fairmount and Historic Denver.* Denver CO: Fairmount Cemetery Association, 1976.

Hall, Frank. *History of the State of Colorado.* 4 vols. Chicago: Blakely, 1890.

Hallam, Elizabeth, and Jenny Hockey. *Death, Memory, and Material Culture.* New York: Berg, 2001.

Hamilton, James McClellan. *History of Montana: From Wilderness to Statehood.* Portland OR: Binfords & Mort, 1970.

Heneghan, Bridget. "The Pot Calling the Kettle: White Goods and the Construction of Race in Antebellum America." *Nineteenth Century Studies* 17 (2003): 107–32.

The History of Cole, Moniteau, Morgan, Benton, Miller, Maries and Osage Counties, Missouri. Chicago: Goodspeed, 1889.

The History of Jackson County, Missouri. 1881. Indexed ed. Cape Girardeau MO: Ramfre, 1966.

Hook, Bailey Van. *Angels of Art: Women and Art in American Society, 1876–1914.* University Park: Pennsylvania State University Press, 1996.

Hornbein, Marjorie. *Temple Emanuel of Denver: A Centennial History.* Denver CO: A. B. Hirschfeld, 1974.

Houghton, A. A. *Concrete Monuments, Mausoleums and Burial Vaults: A Practical Treatise.* New York: Norman W. Henley, 1911.

Humphrey, Geraldine M., and David G. Zimpfer. *Counseling for Grief and Bereavement.* London: Sage, 1996.

Jackson, Kenneth T., and Camilo Jose Vergara. *Silent Cities: The Evolution of the American Cemetery.* New York: Princeton Architectural Press, 1989.

Jackson, William H. "Mormon Cemeteries: History in Stone." In *Nearly Everything Imaginable: The Everyday Life of Utah's Mormon Pioneers,*

edited by Ronald W. Walker and Doris R. Dant, 407–12. Provo UT: Brigham Young University Press, 1999.

Jeffrey, William H. *The Granite City, Barre, Vermont: Early Settlement, History, Resources, Development, and Progress.* Concord NH: Rumford, 1903.

Jensen, Joan M., and Darlis A. Miller. "The Gentle Tamers Revisited: New Approaches to the History of Women in the American West." In *Women and Gender in the American West*, edited by Mary Ann Irwin and James F. Brooks, 9–36. Albuquerque: University of New Mexico Press, 2004.

Jenson, Andrew. *Biographical Encyclopaedia or Condensed Biographical Sketches of Presiding Officers . . . in the Salt Lake Stake of Zion.* Salt Lake City UT, 1888.

Johnsen, Norma. "'Our Children Who Are in Heaven': Consolation Themes in A Nineteenth-Century Connecticut Journal." *Connecticut Historical Society Bulletin* 51 (Spring 1986): 76–101.

Jones Brothers Co. *Four Brothers: Their Contribution to the Memorial Industry of the United States.* Boston MA: Privately published, 1942.

Jordan, Terry G. *Texas Graveyards: A Cultural Legacy.* Austin: University of Texas Press, 1982.

Keister, Douglas. *Stories in Stone: A Field Guide to Cemetery Symbolism and Iconography.* Salt Lake City UT: Gibbs Smith, 2004.

Larson, Leland A., and James R. Cook. *The Woodmen Story: "Our First 100 Years."* 2nd revised ed. Omaha NE: Woodmen of the World Life Insurance Society, 1991.

Leading Industries of Des Moines, Iowa. Des Moines: People's Publishing & Adv., 1888.

Leading Industries of the West. Chicago: H. S. Read, 1883.

Linden-Ward, Blanche. "'The Fencing Mania': The Rise and Fall of Nineteenth-Century Funerary Enclosures." *Markers* 7 (1990): 35–58.

———. *Silent City on a Hill: Landscapes of Memory and Boston's Mount Auburn Cemetery.* Columbus: Ohio State University Press, 1989.

Llewellyn, Nigel. *The Art of Death: Visual Culture in the English Death Ritual, ca. 1500–ca. 1800.* London: Victoria and Albert Museum and Reaktion, 1991.

Macomber, Stephen W. *The Story of Westerly Granite.* Westerly RI: Utter Co. and Westerly Historical Society, 1958.

Manual of Monumental Lettering. Chicago: Monumental News, 1920.

McDannell, Colleen. *Material Christianity: Religion and Popular Culture in America.* New Haven CT: Yale University Press, 1995.

McDowell, Peggy, and Richard E. Meyer. *The Revival Styles in American*

Memorial Art. Bowling Green OH: Bowling Green State University Popular Press, 1994.

Meyer, Richard E., ed. *Cemeteries and Gravemarkers: Voices of American Culture.* Logan: Utah State University Press, 1992.

Mills, Cynthia, and Pamela H. Simpson. *Monuments to the Lost Cause: Women, Art, and the Landscapes of Southern Memory.* Knoxville: University of Tennessee Press, 2003.

Milmoe, James. "Colorado Wooden Markers." *Markers* 1 (1979–80): 56–61.

Mumey, Nolie. *Nathan Addison Baker (1843–1934) . . . His Diary of 1865, 1866, 1867. . . .* Denver CO: Old West, 1965.

Mytum, Harold. *Mortuary Monuments and Burial Grounds of the Historic Period.* New York: Kluwer Academic/Plenum, 2004.

Nolen-Hoeksema, Susan, and Judith Larson. *Coping with Loss.* Mahwah NJ: Lawrence Erlbaum, 1999.

Oman, Richard G., and Susan S. Oman. "Mormon Iconography." In *Utah Folk Art: A Catalog of Material Culture*, edited by Hal Cannon. Provo UT: Brigham Young University Press, 1980.

Overlie, Jill Ann. "Nineteenth-Century Sepulchral Architecture in Denver: The Martha T. Evans Mausoleum." MA thesis, University of Denver, 2000.

Parsons, Samuel, Jr. *Landscape Gardening: Notes and Suggestions on Lawns and Lawn Planting, Laying out . . . Cemetery Plots . . .* New York: G. P. Putnam's Sons, 1900.

Patterson, Nancy-Lou. "United Above Though Parted Below: The Hand as Symbol on Nineteenth-Century Southwest Ontario Gravestones." *Markers* 6 (1989): 180–206.

Penny, Nicholas. *Church Monuments in Romantic England.* New Haven CT: Yale University Press, 1977.

Perilli, Giovanni. *Colorado and the Italians in Colorado.* Denver CO: N.p., 1922.

Poulsen, Richard C. *The Pure Experience of Order: Essays on the Symbolic in the Folk Material Culture of Western America.* Albuquerque: University of New Mexico Press, 1982.

Proctor, Mortimer R. *Proctor: The Story of a Marble Town.* Brattleboro VT: Vermont Printing, 1922.

Ridlen, Susanne S. *Tree-Stump Tombstones: A Field Guide to Rustic Funerary Art in Indiana.* Kokomo IN: Old Richardville, 1999.

Roark, Elizabeth L. "Embodying Immortality: Angels in America's Rural Garden Cemeteries, 1850–1900," *Markers* 24 (2007): 57–111.

Roberts, Allen D. "Where Are the All-Seeing Eyes? The Origin, Use, and

Decline of Early Mormon Symbolism." *Sunstone* 4 (May–June 1879): 22–37.

Roberts, B. H. *A Comprehensive History of the Church of Jesus Christ of Latter-Day Saints.* 6 vols. Salt Lake City UT: LDS Church, 1930.

Robinson, John B. *Trade Secrets: A Collection of Practical Receipts for the use of Sculptors, Modellers, Stone Masons, Builders, Marble Masons, Polishers, etc.* Derby, England: Self-published, 1862.

Rogers, Millard F., Jr. *Randolph Rogers: American Sculptor in Rome.* Amherst: University of Massachusetts Press, 1971.

Rosenblatt, Paul C. *Bitter, Bitter Tears: Nineteenth-Century Diarists and Twentieth-Century Grief Theories.* Minneapolis: University of Minnesota Press, 1983.

Sample, O. H., ed. *Monument Dealer's Manual.* Chicago: Allied Arts, 1919.

Savage, Kirk. *Standing Soldiers, Kneeling Slaves: Race, War, and Monument in Nineteenth-Century America.* Princeton NJ: Princeton University Press, 1997.

Saw, A. B. "Ornamental White Bronze Castings." *The Foundry* 35 (January 1910): 191–95.

Schaetzel, Jacob V. *German Pioneers in Colorado 1850–1900's.* Denver CO: H. W. Marsh, 1975.

Schoemaker, George H. "Acculturation and Transformation of Salt Lake Temple Symbols in Mormon Tombstone Art." *Markers* 9 (1992): 197–216.

———. "The Shift from Artist to Consumer: Changes in Mormon Tombstone Art in Utah." In *The Old Traditional Way of Life: Essays in Honor of Warren E. Roberts*, edited by Robert E. Walls and George H. Schoemaker, 130–45. Bloomington: Indiana University Folklore Institute and Trickster Press, 1989.

Sloane, David Charles. *The Last Great Necessity: Cemeteries in American History.* Baltimore: Johns Hopkins University Press, 1991.

Smith, Deborah Ackroyd. "'A Floweret Snatched from Earth to Bloom in Heaven': Perceptions of Childhood and Death on Delaware Tombstones, 1840–1899." MA thesis, University of Delaware, 1981.

Stannard, David E., ed. *Death in America.* Philadelphia: University of Pennsylvania Press, 1975.

Stott, Annette. "The Woodmen of the World Monument Program." *Markers* 20 (2003): 1–29.

Student, Annette L. *Denver's Riverside Cemetery: Where History Lies.* San Diego CA: Printed on demand by Christian Network Services, 2001.

Triggs, J. H. *History and Directory of Laramie City, Wyoming Territory* (Laramie City WY: Daily Sentinel, 1875).

Vandenbusche, Duane, and Rex Myers. *Marble, Colorado, City of Stone*. Denver CO: Golden Bell, 1970.

Vermont Marble Co. *Keeping Up with Marble: Sketching the Growth of a Great Industry and Telling Why Marble Has Kept in the Lead*. Proctor VT: Vermont Marble Co., ca. 1913.

Vickers, William B. *History of the City of Denver, Arapahoe County, and Colorado*. Chicago: O. L. Baskin, 1880.

Walter, Tony. *On Bereavement, the Culture of Grief*. Buckingham, England: Open University Press, 1999.

Warner, Marina. *Monuments and Maidens: The Allegory of the Female Form*. London: Weidenfeld & Nicolson, 1985.

Warner, Michael. *Publics and Counterpublics*. New York: Zone Books, 2002.

Welter, Barbara. "The Cult of True Womanhood, 1820–1860." *American Quarterly* 18 (Summer 1966): 151–74.

Whaley, Joachim, ed. *Mirrors of Mortality: Studies in the Social History of Death*. New York: St. Martin's, 1982.

Wharton, Junius E. *History of the City of Denver from Its Earliest Settlement to the Present*. Denver CO: Byers and Dailey, 1866.

White, Kathleen Kelly, and Kathleen White Miles. *The History of Benton County, Missouri*. 3 vols. Clinton MO: White & Miles, 1971.

"White Bronze." *Scientific American*, November 14, 1885, 309.

Wommack, Linda. *From the Grave: A Roadside Guide to Colorado's Pioneer Cemeteries*. Caldwell ID: Caxton, 1998.

Woodmen of the World. *Ritual of the Pacific Jurisdiction Woodmen of the World*. Omaha NE: Beacon, 1897.

World's Columbian Exposition Exhibit of Barre Granite. Barre VT, 1893. Copy in Vermont Historical Society.

Zhu, Liping. *A Chinaman's Chance: The Chinese on the Rocky Mountain Mining Frontier*. Boulder: University Press of Colorado, 1997.

Index

Cotopaxi granite, 303n45

cottage monuments, 218, *219*, 220, 223

Council Bluffs IA, 190, 211

Crawford, Thomas, 129, 175–76

Creede CO, 9

criminals, 2–4, 9, 46, 291–92, *292*, 305n58

Cross, F. O., 197

Cross Brothers, 210

crosses: in boot hill cemeteries, 10; in Byrne's work, 121–22, *122*; in Case monument, 147; in children's monuments, *135*; in Denver Catholic cemeteries, 53; on fences, 249; in Gariboldi's work, 125; imported, 190, *203*, 204, 236; on Irish Catholic monuments, 277–78; of iron, 94; on Kountze-Best monument, 36; popularity of, 179; white bronze, 216, 220–21, 223; and women's images, 169–72, *170*

Crown Hill Cemetery (Wheatridge CO), 54, 125, 234, 321n37

Crystal River (CO), 303n45

Crystal Valley Cemetery (Manitou Springs CO), 249

Cullen, Caroline Stoakes, 199

Cullen, Lillian Stoakes, 198–200

Cullen, William E., 199

culture: and imported monuments, 187, 238; role of cemeteries in, xi–xii, 9, 15–17, 54–55, 140, 287–88, 297, 308n88; and styles of monuments, 184; and women's images, *163*, 168, 176

Daily Mining Journal, 45

Dakota, 215

Daly, Marcus, 204, 295

Daly plot, 172

Daniel, Lucy, 142

Daugherty, Eli, 76–77, 147, 311n27

Daughters of the American Revolution, 122–23

Davis, Oliver, 11, 301n15

Davis family monument, 210

Dayton OH, 247

death: attitudes toward, xi, 7, 9–10, 15, 70, 173–76, 181, 185–86, 278, 284–85, 297; causes of, 1–7, 10, 46; symbols of, 117, *128*, 130, 169, *192*, 193, 267

death rituals, 254–69; for children, 129; Chinese, 88–89, 255–57, 256, 330n14; German, 257–58; rules and regulations for, 283–84, 330n50; and social context, xiii–xiv; for Treat, 155–56; Western, 239–42, *241*, 288–89

decoration days. *See* memorial days

Dempster, H. T., *201*, 202, 325n18

Denver and Rio Grande Railway Co., 128–29, 294

Denver Artificial Stone Co., 94

Denver Art Museum, 54

Denver Board of Trade, 78

Denver City CO, 2–3, 37, 272. *See also* Denver CO

Denver City Marble Works, 76

Denver CO, 36–54; Bethell family in, 201–2; boot hill cemeteries, 11, 36–42, 55, 300n15; Byrne's work in, 121–23, *122*; ceremonies in, 258–59, 261–69; children's monuments in, 130–31; fair mount cemeteries in, 15–16, 36–42, 53–55; granite monuments in, 206–7, 209–10; imports to, 189–92; location of first cemetery in, 37–38; Manufacturer's Exposition (1886) in, 118; memorial days in, 270–72; monument makers in, 32–34, 59, 72–79, 98, 100–101, 103–4, 111–12, 116–19, 133, 137, 146–49, 156, 159, 191, 196; parks, 282–85; patronage in, 182–84; population, 48; Rauhs in, 77–78, 146–47, 150–51, 153, 161; scholarship about cemeteries in, viii; sculptors in, 116–26, 144; sign painters in, 90; violence in, 1; White family in, 234; Woodmen of the World in, 253. *See also* Fairmount Cemetery (Denver CO); Mt. Olivet Cemetery (Denver CO); Riverside Cemetery (Denver CO)

Denver Marble and Granite Co., 78,

Greenlee, Drake & Co., 98
Greenlee, William E., 78
Green, Mary, 231
Greenough, Horatio, 52
Green River WY, 27, 99, 107
Green-Wood Cemetery (Brooklyn), 307n77
Greenwood Cemetery (Canon City CO), 228
Greenwood Cemetery (Helena MT), 29
Green, Zella, 228, 230, 231
Grief allegory, 6, 173–76, 179, 185, 216, 220, 222. *See also* mourners
grief work, 275, 281–82, 333n42. *See also Melancholia* (Dürer); mourners
Griswold, Don L., 301n19
Griswold, Jean Harvey, 301n19
Grove City Cemetery (ID), 136
Guggenheims, 182
Gunnison granite, 294, 303n45

Habermas, Jürgen, 287
Halaas, David, 38, 243–44, 305n58
Hallack & Howard lumberyard, 261
handclasp, 69–70, 149, 173
Hanna mine explosion, 4
Hanover OH, 150
Hansen, P. O., 134
Harold, Donald, 114, 132–33, 314n59
Harold, Donald, Jr., 114
Harold, Hedley, 132–33, *133*
Hartford CT, 177
Hastings, Thomas, 171
Havemeyer, William F., 46, 307n77
headstones: and landscaping, 245; market for marble, 98–109, 156; in Montana Territory, 242; regulations on, 49–52; styles of, 220; white bronze, 216, 220. *See also* monuments; wooden headboards
hearse, horse-drawn, 148
heaven, images of, 70
Hebe and Ganymede (Crawford), 175–76
Heberle, Lawrence, 88

Hebrew Burial and Prayer Society, 42, 305n65
Hebrew Cemetery (Denver CO), 42, 48, 53, 270, 308n81
Hebrew Cemetery (Leadville CO), 302n29
Helena Herald, 88–89, 257, 273
Helena Independent, xvii, 99, 300n8
Helena MT: capitol, 216; Carrara marble in, 198–99; children's monuments in, 130, 132; deterioration of cemeteries in, xvii; fair mount cemeteries in, 20–21, 26–27; grave guards in, 29; Kenck marker in, 3, 4, 300n8; monument makers in, 59, 98–100; parks, 282; Peel in, 85–86; sign painters in, 88–90, 89; unmarked graves in, 7. *See also* Forestvale Cemetery (Helena MT)
Hellingsly, William, 311n27
Helmbrecht, Henry H., 223–25, 227
Helmbrecht, Olinger & Co., 224
Helmbrecht & Farrington, 224
Henderson, Nancy, 149
Heneghan, Bridget, 176
Hermsmeyer, Auguste and Lillie, 280
Hibernians, 279
Higman, William, 267
Hill, G. Z., 194
Hillside Cemetery (Silverton CO), 29
Hindry, John, 206
Hispanics, xiv, 45, 293
History of Leadville (Griswold and Griswold), 301n19
History of the City of Denver from Its Earliest Settlement to the Present (Wharton), 300n15
Hoeckel Hutchinson Monument, 52
Hoenes, Frank, 111
Hogan, Mary, 180, 214
Hollister, Ovander J., 45
Holmquist, Viola Natalie, 281, *281*
Holy Spirit, 136
Homestake Mine monument, 6, 6–7, 223
Hope allegory: description of, 176; Mullins's, 197; popularity of, 166, 202, 325n20; significance of, 179, 250, 291; on Soper mausolea, *167*,

182; and white bronze, 216, 220–21, 223. *See also* allegorical figures; Rock of Ages (design)

Horn children, 129

Horne family monument, *18*

Horning and Madden (real estate dealers), 327n48

Horrigan, John, 207–8

horses, 51, *115*, 116, 137, 148

horseshoe form, 279

Hosmer, Harriet, 142

Houghton, Robert, 79

How, John, 86–87

Howard, Ernest E., 78

Howland, John, 118–19

Huddart, John James, 45

Hudson, Rev. D. M., 328n57

human figure. *See* allegorical figures; children; portraits; women

Hungry Ghosts Festival, 273

Hunton, James, 188, *189*

Hylton Lumber Co., 303n46

Idaho: Bott family in, 67, 69; burials in, 4, 299n6; fair mount cemeteries in, 22; Latter-Day Saints in, 56; monuments in, 69, 100, 227, 237; population, 141; scholarship about cemeteries in, viii; women in, 174

Idaho City Band, 256

Idaho City (ID), 255–56

Idaho Falls ID, 227

Idaho Springs Cemetery (Idaho Springs CO), 26, *26*

Idaho Springs CO, 26, *26*, 159, 161

Iliff, Elizabeth, 46, 182, 206, 306n76, 307n78

Iliff, John W., Jr., 307n78

Iliff, John W., Jr., 307n78; cost of monument of, 156; maker of monument of, 45–47, 206, 306n76, 307n78; placement of monument of, 47, 53

Illinois, 129, 188

imports: from eastern states, 195–97, 238; granite, 205–11; from Italy, 187, 197–204, 238; by mail-order, 235–38; and marketing, 211–14; from

Midwest, 17, 190–95, 205, 238; transport of, 187–90; zinc, 214–26

Independent Record (Helena MT), xvii

Indiana, 150–52

Indian Row, 37. *See also* Native Americans

inscriptions: of Bedwell & Abbott, 193; on cabin monuments, 156–57, *157*, 159; for children, *120*, 126, 131; on Drake monument, 156–58, *157*; errors in, 324n3; on headboards, 83–85, 88–90, 311n33; on iron markers, 93–94; languages of, 107–9; of Latter-Day Saints, 65, 66–67, 69–72; on mail-order monuments, 236; significance of, 179, 250–54, 276, 278, 291; techniques and tools for, 76, *104*, 125, 137; by women, 143; on Woodmen monuments, 102, *102*, 253, 291; on zinc monuments, 217, 220–21, 223, 226–27, 229, 230, 231–33, 328n50

Iowa, 188, 215, 230, 327n48

Iowa Board of Trade, 214

Iowa City IA, 150

Irish, 277, 277–79

Irish Brass Band, 256

iron, xi, xvi, 51, 92, 92–94, 229, 247–49, *249*

Isaac, Lillie M., 188

Italians, 20, 107, 123–26, 197–98. *See also* Carrara marble

Italy, 187, 197–204, 238. *See also* Carrara marble

Ivers, William H., 79

Jackson, "Brother," 61

Jackson, Charles, 284

Jackson, Helen Hunt, 293–95

Jackson, Richard H., 70

Jackson, William Sharpless, 294–95

Japanese, 22–23, *23*, 46, 108–9

Japanese Memorial and Burial Association, 109

Jensen, Joan M., 139

Jesus statues, 53, 179, 216

Jews: in Butte, 131, 302n33; in fair mount cemeteries, 20–21, 46, 48, 307n81; inscriptions for, 94,

Marquardt, H., *192*, 193
Marr & Gordon, 183
married couples, 276–80
Marsh, George and Lizzie, 130
Marsh, Georgie, 130
Martin, E. J., 94
Maryland Institute (Baltimore), 113
Mary Miller mine, 158
Mary statues, 53, 179–80, 209,
 214, 216
Masons: and burial services, 7, 254,
 259; children's monuments in
 cemeteries of, *192*; in Denver, 37,
 40–41, 148, 191; in fair mount
 cemeteries, 20; symbolism of, 94,
 184, 291; in Trinidad, 129
Massachusetts, 17, 187
Maucham, Ralph, 197
mausolea: commissioning of, xiii,
 182–84, *183*, 288; in Fairmount
 Cemetery, *167*; materials for,
 205; in Mt. Olivet Cemetery,
 53; photographs of, 212–14;
 regulations on, 54; in Riverside
 Cemetery, 44–45, 70
McClure, Louis C., *35*
McClure, W. P., 3
McCormick, I. L., 76
McDonald, John D., 126
McDowell, Peggy, 112
McGilvray, J. D. (construction
 firm), 123
McGilvray Stone Co., 79
McGinnis/Bullock Cemetery
 (Sweetwater County WY), 328n53
McGlashan, Zena Beth, 301n17,
 302n33
McKenzie & Strobel, 71
McMillan, Mary, 302n24
McNeil, John and Janet, 222,
 222–23
M.D. Jones & Co., 247
Meaderville MT, 91
Meagher, Thomas Francis, 216
Meek, Channing, 35–36
Melancholia (Dürer), *200*, 200
Melvin memorial, 167
memorial days, 269–74, 334n50
Memory (statue), 206, *208*. *See also*
 Iliff (John W.) monument

men, 179–85. *See also* gender
Mercy Philbrick's Choice (Jackson),
 294
Merrill, Adelbert, *57*
Meyer, Richard E., 112
Meyers, Mary Ann, 70
Michael (angel), 177, 323n50,
 323n51
Michigan, 32
Middleton, C. F., 280
Midwest, 17, 190–95, 205, 238, 240
Miles, Kay White, 328n56
military, 82, 195, 197, 216, 223, 232,
 254, 270–71, 293
Miller, Darlis A., 139
Miller, J. H., 76
Miller, Leslie, 113
Miller, Lizzie, 232
Miller, Robert E., 300n8
Milmoe, James, 83–85, 311n33
miners: in boot hill cemeteries,
 9–13; burials of, 239–40, 265–67,
 279; and causes of death, 4–7; in
 Denver, 36–37, 55–56; imported
 monument for, 204; and iron
 markers, 93; mausolea for, 182;
 monument styles for, 277, *277*–79;
 M. Rauh monuments for, 156–61,
 157. See also gold seekers
Miners' Union, 279
Minneapolis School of Fine Arts, 113
mission cemeteries, 301n16
Missoula Marble Works, 109
Missoula MT, 108–9
Missouri, 190–94, 214–15, 227–34
Missouri Weekly Enterprise, 233
Mitchell Brothers, 60–62
M. J. Seelig & Co. Art Zinc Foundry,
 214
Montana: boot hill cemeteries, 2,
 9, 291–92, *292*; burial rituals
 in, 241, *241*–42; capitol of, 216;
 Catholic cemeteries in, 180; causes
 of death in, 4–5; Chinese death
 rituals in, 256, *256*–57, 273;
 fair mount cemeteries in, 20–22;
 imports to, 188, 198–99, 214;
 Marsh family in, 130; monument
 makers in, 99–100, 137; pioneer
 society in, 181; population of, 141;

Morris & Whifenbach, 64

Morrison, George, 73–74, 77

Morrison CO, 73

Morrison Stone Lime and Town
Co., 73

mortality rates, 4, 300n7

Mother and Son (monument), *201*,
202

Mountain View Cemetery (Butte
MT), 27

Mountain View Cemetery
(Longmont CO), 27

Mountain View Cemetery (Pocatello
ID), 27

Mountain View Cemetery (Pueblo
CO), *133*

Mountain View Cemetery (Rock
Springs WY), 27

mourners, 166–76, *168*, 185, *191*,
200, 205, 274–82. *See also* grief
images; grief work

M. Rauh Marble Works, xiii,
145–62; advertising by, 156;
competition of, 78; and Drake
monument, 321n36; employees
of, 153, 156–59; origin of,
146–47; success of, 156; suing
of railroad, 152. *See also* Pioneer
Marble Works; Riverside Marble
Works

Mt. Auburn Cemetery, viii, 9, 17,
24, 52, 240, 302n28

Mt. Calvary, 41–42, 48, 53, 270

Mt. Holy Cross Cemetery (Leadville
CO), 302n29

Mt. Hope (Sheridan WY), 17

Mt. Moriah (Butte MT), 21, *105*,
130, 132, 184, 302n33

Mt. Moriah (Pocatello ID), 17

Mt. Olivet Cemetery (Buena Vista
CO), 25

Mt. Olivet Cemetery (Denver CO),
53–54, 121–22, *122*, 180, 214,
244

Mt. Olivet Cemetery (Salt Lake City
UT), 22, 64, *134*, 175–76, 184

Mt. Prospect Burial Association,
305n58

Mt. Prospect Cemetery: and Acacia
Cemetery, 40–41; establishment

and description of, 38–39, 53–54,
304n54; reputation of, 39, 305n58;
shell-encrusted obelisk in, 97;
Soule monument in, 75; transfer
of burials from, 48. *See also* City
Cemetery (Denver CO)

Mt. Prospect Cemetery Association,
38

Mt. Vernon CO, 73, 310n19

Mulcahey, Pat, 301n17

Mulligan, Charles J., 114, 216

Mullins, William H., 196–97

Mumey, Nolie, 315n63

Murphy, John, 265–67

Murray UT, 69

museums, 308n88

Myers, Rex, 304n49

National Cemetery Administration,
232

National Retail Marble and Granite
Dealers Association, 211. *See also*
National Retail Monument Dealers
Association

National Retail Monument Dealers
Association, 125, 211

Native Americans: burial practices of,
11–12, 292–93, 301n16; in Denver,
36–38; as monument subjects,
137; and reservations, 264; and
violence, 4, 10, 19, 74, 188, 300n8

Nauvoo IL, 59

Nebraska, 98, 188, 215

neoclassical style, *163*, 175, 185. *See
also* Greek sculpture

Nevada, 204, 330n14

Nevada City MT, 27, 280, 303n38

New England Granite Works, 46–47,
156, 177, 182, 206–7, 251, 252,
306n76, 330n76

New Hampshire, 17, 187

New Mexico, viii, 45, 98, 110

New York City, 109, 110, 111

Nez Perce Indians, 3, 4

Nicholas monument, 205

Nicholls, Edward, 125, 184

Nicholls, Elizabeth J., 184

N. M. Parsons marble works, 78

Northern Pacific Railroad, 108, 199

Northfield VT, 210

North Platte NE, 160
nuns, 179–80

obelisks: as body substitutes, 276–77; by Carrigan, 184; at Colorado Springs Opera House, 268, 269; imported, 190, 193, 206; in Montana Territory, 241, 242; in Mt. Olivet Cemetery, 64; preference for, xv; by Rauh, 153; in Riverside Cemetery, 45; shell-encrusted, 97, 98; white bronze, 216, 218, 220, 226–27
Oberst, George, 312n35
obituaries, 19, 129, 229, 231, 233
O'Brien, Daniel, 279
Odd Fellows, 20–21, 24, 184, 194, 254, 270, 291
Odd Fellows Cemetery (Central City CO), 149
Oertel, Johannes Adam Simon, 171
O'Farrell, John J., 179, 203, 204
Ogden UT, 30, 60, 62–63, 71, 95, 280
Ohio Marble and Granite Dealers Association, 236
Old Carbon WY, 27, 28
Old Pioneer Cemetery (Montana), 8
Olinger, David B., 78, 103, 224–25
Olinger & Helmbrecht, 225
Omaha NE, 188, 189
IOOF cemetery (Central City CO), 160
O'Neil, Jack, 305n58
O'Neill, Bridget Collins, 277, 277–78, 333n46
O'Neill, Patrick, 277, 278, 333n46
Ontario, Canada, 215
opera houses, 268, 268–69, 308n88
Ornamental Concrete without Moulds, 95
Orthodox populations, 22, 46
O'Ryan, Father, 265
Otero, Mary J., 306n72
Otero, Miguel Antonio, 45, 306n72
Otero CO, 45
Ouray CO, 99, 127, 127–28

Pain, William J., 301n15

Panic of 1893, 225
paper, 229, 231, 233, 257
parades, 270–72. See also corteges
Parish, Frank, 2, 292
park settings, 240–50, 254, 259–61, 282–85, 296. See also gardens, sepulchral; landscapes
Parsons, N. M., 263, 264
Parsons, Paul, 78
Parsons, Samuel, 295
Pascoe, Alfred, 316n75
Pascoe, Almond Ernest, 125, 316n75
Pascoe, John, 125
Pascoe, William, 316n75
Patriotic Order of the Sons of America, 270
patronage, xiii, 181–86, 206–7, 288
Paul & Welch, 184
pauper sections, 21, 45, 55, 302n29
Pedersen, Leona A., 92
Peel, Langford, 84, 85–87
Pell, George Washington, 124, 124–25, 316n72
Pell, George Washington, Jr., 124, 315n72
Pell Fish and Oyster House, 124
Pena, Earnest. See Pera, Earnest
Pennsylvania Academy of Fine Arts, 113
Penny, Nicholas, 173, 202, 252
Pera, Earnest, 91, 91–92
Perkins family plot, 52
perpetual care, 247, 253
Peterson, I. Aldrich, 107
Pettibone, George, 265–67
Philadelphia PA, 9, 177, 235
photographic studios, 308n88
photographs, 18, 211–14, 280–82, 281, 282, 328n53
Pierce, William R., 98, 294
Pike's Peak gold rush, 37
Pioneer Cemetery (Pueblo CO), 197
Pioneer Marble and Stone Steam Mill, 147–48, 182, 319n16
Pioneer Marble Works: advertising, 150; name, 154, 182; origin, 149–50; success of, 152–54. See also M. Rauh Marble Works
pioneers: German, 257–58; and Native Americans, 292–93;

stone cutters: advertising by, 73–74, 310n20; as artists, 16, 123–26; as distinct from carvers, 114–15, 119–20; and gender, 143–44; at Leadville Marble Works, 101; monuments for, 276; techniques used by, 110–11; training of, 109–13, 125, 138; in Wyoming, 80–81. *See also* monument makers

Stone Cutters' Association of Denver, 111

Stone Cutters' Union, 111, 265

St. Patrick's Cathedral (New York City), 111

St. Patrick's Cemetery (Butte MT), 70, 91, 179, *203*, 203–4, 277, 279

St. Patrick's Church (Butte MT), 21, 302n33

St. Paul MN, 276

Stratton, Winfield Scott, 143–44

St. Thomas White Bronze, 215

Sunnyside (Creede CO), 9

Sunset Hill (Boulder CO), 301n18

Sunset Hills Cemetery (Bozeman MT), 131

Sutherland, Clyde, 229–30, 233

Swanson, Richard A., *104*, 183, 267

Sweden, 32, 107

Sweetwater County WY, 229, 328n53

Taft, Lorado, 120

Tallmadge, James and Gertrude, 195

Tanner, John, Jr., 30

Tanner, John, Sr., 30

Tanner, Sarah, 30, 56

tariff, 198

Temple brothers, 237

Tenney, Henry J., *135*

Thatcher, G. S., 61

theater, 308n88

Thompson, Annie and William, 112, *113*

Thompson, Arthur, *113*

Thorvaldsen, Albert Bertel, 112

Tiffany, Louis Comfort, 323n51

Tilted Arc (Serra), 296

tools, 103–5, *104*, 110, 137, 205

Trabing, Charles A., 254–55

Trades Assembly, 265

tramway, 258, 265, 271–72, 283–84, 333n50. *See also* railroads

trapdoors, 228, 229, *230*, 231–32

Treat, Salmon W., 155–56

tree monuments: as body substitutes, 277; for children, 130, 134, *135*; inscriptions on, *102*, 102, 253, 291; for Leadville pioneer, 181; limestone, 101–3, *102*, 197, 276; in Mt. Olivet Cemetery, 22; by Rauh, 155; sandstone, 30, 34; weeping willow, *191*; and women's images, 169, 176; and Woodmen of the World, 23–24, 101–3, *102*, 253

trees: in fair mount cemeteries, 15, 43–44, 55, 241; and Latter-Day Saints, 57; planting of, 25–26, 242. *See also* landscapes

Trinidad CO, 98, 129, 172

Tuite, James E., 333n46. *See also* Ketchin & Tuite

Turkey Creek quarries, 75

Turnverein Hall, 258, 270

Turret mountain quarry, 34

undertakers, 16, 141, 223–24, 239, 284

Union Pacific Railroad, 4, 79–80, 93, 154, 188–89, 244, 270

Union Station (Denver), 243

United Circle, 157

United Hebrew Cemetery Association, 307n81

University of Denver, 118

unmarked graves, 7, 291–92, *292*, 334n5

urns: and floral images, 169; imported, 207, 210; and landscaping, 245–47, *246*; in Mt. Olivet Cemetery, 22, 175; sandstone, 30; zinc, 216, 218, *219*, 221, 228

U.S. Congress, 23

U.S. Mint (Denver), 123

Utah: iron markers in, 93–94;

Williams, Albina and Cyrene, 57
Williams, Albina Merrill, 57
Williams, Francis, 57
Williams, Thomas Steven, 56–57, *57*
Windsor, Ontario, 143
wings, 176
Winterthur DE, 325n18
Wirgler, August J., 79
Wise, Major, 223
Wohl family, 209–10
Wolle, Muriel Sibell, 29
Woman at the Cross, 166, *168*, 169–70, 176. *See also* allegorical figures; Rock of Ages (design)
women: as monument makers, 142–45, 185–86; as monument subjects, 19, 141–42, 145, 162–81, *163*, 185–86, 198–200, *200*, *207*, 250; as patrons, 181–86; in Western culture, 139–40. *See also* allegorical figures; gender
Women of Woodcraft, 272
Women's Relief Corps, 270
Woodbury, Roger W., 118, 122, 315n66
wooden headboards, 82–92; banning of, 49, 289; in boot hill cemeteries, 10, 13, 40, 292, *292*; deterioration of, xvi, 83–85, 312n34; and history of use, xi, 55, 79, 136–37; and Latter-Day Saints, 56; ornamentation and enclosures for, *84*, *87*, 87–92, *91*; popularity of, 90–91. *See also* headstones
Woodlawn Cemetery (Bronx), 46, 307n77
Woodmansee, Eva, *178*
Woodmen of the World: bronze monument for, 235, 260, 290; burial services, 254, 260, 261–63, 281; memorial days,

271–72; monument styles, 23–24, 101–3, *102*, 253, 260, 261–63, *262*, 290–91
Woodward, Augusta and Thomas, 282
Woodward, Willie, 282
World's Columbian Exposition, 112, 118–19, 143, 220
The Wounded Buffalo (sculpture), 119, 121
wreaths, 149, 153, 169, 175, 200, 223, 228
Wright, Edmund F., 153
Wyoming: and imports, 188, 215; iron in, 93; marble in, 4, *80*, 80–81; monument makers in, 79–82, 98, 107, 137; population of, 141; Rauh monuments in, 153; scholarship about cemeteries in, viii; women in, 174; zinc monuments in, 229, 234
W.Z.W. monuments, 214, 227–34, *228*, 328n53

Yellowstone National Park, 3, 4, 300n8
Yerkes, Jamie D., 131
YMCA, sculpture for, 123
Youe, William, 103
Young, Brigham, 59, 67, 79
Yulapen, 273
Yule Creek CO, 34

Zang, Philip, 33, 34, 258
zinc, 214–35; deterioration of, xvi; in Fairmount Cemetery, 225–26; and history of use for monuments, xi, 55; and Latter-Day Saints, 57; in Leadville, 6, 7; monument styles, 219, 220–21, 224, 228, 228–29; qualities of, 217, 227; in Riverside Cemetery, 51, 217–27; women's images in, 171–72, 180, 185, 214, 216. *See also* white bronze